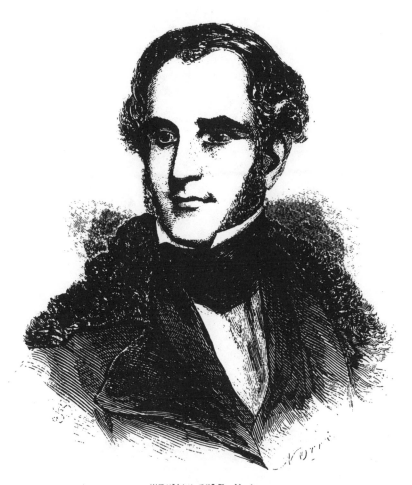

THOMAS COLE, N. A

From a Portrait by A. B. DURAND. Pres National Academy of Design.

THE LIFE AND WORKS OF
Thomas Cole

By
LOUIS LEGRAND NOBLE

Edited by Elliot S. Vesell

BLACK·DOME

Black Dome Press Corp.
RR 1, Box 422
Hensonville, New York 12439
Tel: (518) 734-6357
Fax: (518) 734-5802

First edition paperback 1997
Published by
Black Dome Press Corp.
RR1, Box 422
Hensonville, New York 12439
Tel: (518) 734-6357 Fax: (518) 734-5802

ISBN 1-883789-13-3

Library of Congress Cataloging-in-Publication Data

Noble, Louis Legrand, 1813-1882.
 The life and works of Thomas Cole / by Louis Legrand Noble; edited by
Elliot S. Vesell.—1st pbk. ed.
 p. cm.
 Originally published: Cambridge, Mass.: Belknap Press of Harvard
University Press, 1964.
 Includes index.
 ISBN 1-883789-13-3 (trade paper)
 1. Cole, Thomas, 1801-1848. 2. Landscape painters—United States—
Biography. I. Cole, Thomas, 1801-1848. II. Vesell, Elliot S., 1933- . III. Title.
ND237.C6N6 1997
759.13—dc21
[B] 97-15713
 CIP

Cover design by Carol Clement, Artemisia, Inc.
Printed in the USA

Front cover: *Falls of the Kaaterskill,* Thomas Cole, 1826, oil on canvas, 43"x 36".
From The Warner Collection of Gulf States Paper Corporation, Tuscaloosa, AL.

CONTENTS

CONTENTS

CHAPTER · 5

CHAPTER · 6

CHAPTER · 7

CHAPTER · 8

CHAPTER · 9

CHAPTER · 10

CONTENTS

CHAPTER · 11

CHAPTER · 12

CHAPTER · 13

CHAPTER · 14

CHAPTER · 15

CHAPTER · 16

vii

CONTENTS

CHAPTER · 17

CHAPTER · 18

CHAPTER · 19

CHAPTER · 20

CHAPTER · 21

CONTENTS

CHAPTER · 22

CHAPTER · 23

CHAPTER · 24

CHAPTER · 25

CHAPTER · 26

CONTENTS

CHAPTER · 27

CHAPTER · 28

CHAPTER · 29

CHAPTER · 30

CONTENTS

CHAPTER · 31

CHAPTER · 32

CHAPTER · 33

CHAPTER · 34

CHAPTER · 35

CONTENTS

CHAPTER · 36

Thoughts and Occurrences: anticipations of a great work; birthday; the Tread of Time; death in the family; lost time. Excursion to the Shawangunk. Excursion to South Peak. A new studio. Its views. Excursion to the Adirondack Mountains. Thoughts, &c.: Christmas-day; birth-day; death in the family. Niagara. To Mr. Falconer: sculpture and painting. Thoughts, &c.: New Year's-day; the season. Cole's last letter: mental and moral habits of artists. Thoughts, &c.: Cole's last notes.

CHAPTER · 37

Cole's mental maturity. Cole, a master. His great works yet in anticipation. Feelings with respect to those already accomplished. The consolation for their moral defects found in his hopes of a future, and his greatest work. Pictures preceding it. Pictures succeeding it. Conception of the Cross and the World. The Prometheus Vinctus, and Proserpine gathering flowers in the fields of Enna.

CHAPTER · 38

The Voyage of Life, an exponent of his religious faith at the time it was painted. The Cross and the World, the exponent of a ripened and true faith. Its theology. First picture of the Cross and the World. The second picture, the Trial of Faith. Its unity. Feeling with which it was painted. Its characteristics.

CHAPTER · 39

Manner of life in his last days. Book on art. A volume of poems. Life out of doors. His conversation. Favourite topics. Ripeness of his Christian character. The Triumph of faith, the last of the pilgrim of the Cross. Painted in solitude. Miltonic in its character. The Lord is my Shepherd, last pure landscape. As a work of art. An Italian pine in the Proserpine, his last painting. Death.

xii

PLATES

xiii

INTRODUCTION

THOMAS COLE, generally recognized as the father of the Hudson River School of painting and hence one of the figures most directly involved in the development of a native tradition of American art, has been strangely neglected by historians. Considered by his contemporaries the leading landscape painter in America, he enjoyed great popularity in his lifetime; but his fame was obscured in the late nineteenth century as new styles and tastes became fashionable. In recent decades his paintings and those of other members of the Hudson River School have been gradually rediscovered, but there is still no modern full-length study of his life and work. The major source of biographical material remains the 1853 edition by Louis Legrand Noble of Cole's letters and journals, a volume which, until its present republication, was available mainly in research libraries. The reissuance of the Noble volume is, therefore, appropriate. In addition to making the text itself once again available, it provides an opportunity to consider the process by which an indigenous school of American art developed.

BIOGRAPHY

The Noble volume contains a complete biography of Thomas Cole, but is so interspersed with poems, short stories, letters, and commentary that it is well to begin with a recapitulation of the main events of his life.[1] Thomas Cole was born on February 1, 1801, in England at Bolton-le-Moor, Lancashire, a textile center which epitomized the evils of the industrial revolution. He was the seventh of eight children and the only son of James and Mary Cole. Thomas'

[1] On Cole's biography, see, besides the material in the present volume and its summary in the *Dictionary of American Biography*, William Dunlap, *History of the Rise and Progress of the Arts of Design in the United States* (1834), ed. Frank W. Bayley and Charles E. Goodspeed (Boston, 1918), III, 138–159; Henry C. Tuckerman, *Artist Life: Or Sketches of American Painters* (New York, 1847), pp. 223–232; and on Cole's paintings see "Thomas Cole, 1801–1848, One Hundred Years Later: A Loan Exhibition," issued by the Wadsworth Atheneum, Hartford, and the Whitney Museum, New York, 1948.

father, a woolen manufacturer, was of good family and refined taste but had fallen on hard times due to his poor business ability. Having failed at Bolton he moved to nearby Chorley, where Thomas was apprenticed to a calico designer and learned the art of engraving, although his father wanted him to be a lawyer or an iron manufacturer. Shocked by the crudeness of his fellow apprentices, Thomas found solace in walking through the countryside with his youngest sister Sarah in search of the picturesque for which he already had a remarkable love, playing his flute and composing poetry. Almost his only friend was an old Scotsman who developed Thomas' romantic tastes by singing ballads and telling tales of the wild hills and blue lakes of Scotland. An omnivorous reader, Thomas was fond of books about foreign countries and was especially partial to one volume which extolled in glowing language the natural beauties of the North American states. This book caught his imagination, and he dreamed and talked constantly of the great lakes, the flowery plains and mighty forests of this new land which he longed to see.

Catching Thomas' enthusiasm and hoping to repair his shattered fortunes, James Cole sailed with his family for Philadelphia, arriving July 3, 1819. With a small stock of dry goods which he had brought with him, he began the business of a tradesman while his son took up wood engraving. But by fall, James Cole was dissatisfied and moved by way of Pittsburgh to Steubenville, Ohio. Thomas remained in Philadelphia, and then, in January 1820, with his roommate, a young law student, he sailed for St. Eustatius in the West Indies, which he found a wonder of beauty and sublimity, and where, first viewing nature in her grander forms, he made a number of sketches.

Returning to the United States in May 1820, he joined his father in Steubenville and there for two years aided his father in the manufacture of wallpaper by drawing and designing patterns. He also surrendered himself up to nature, and, according to Noble, "obeyed the call with the quick and silent readiness of a lover, and saw, as he had never yet seen, how full her face was of divine loveliness, and confessed in sentiment that a passion for nature was his ruling passion."[2] He now determined to become a painter, although he had demonstrated talent in such diverse fields as architecture, music, poetry, and prose, each of which appealed to him. At this time a

[2] Noble, *The Life and Works of Thomas Cole*, below, p. 11.

German portrait painter, Stein, arrived in the village; Cole admired his conversation, the expression of his faces, his colors, and, above all, an English book on painting which Stein lent him. This book was illustrated with engravings and discussed design, composition, and color: it was the second book that played a crucial role in Cole's life; it confirmed and strengthened his desire to be a painter.

With home-made brushes and colors obtained from a chair maker for whom he had worked, Cole produced his first canvases. They were landscapes created from recollection or fancy. But landscapes, especially during the economic depression then in progress, were not marketable; and so Cole in February 1822 turned for several months to a picaresque tour of nearby Ohio towns in search of lucrative portrait commissions. Failing in this, he returned to Steubenville where he began work on two religious paintings: Ruth gleaning in the field of Boaz, and the Feast of Belshazzar, the latter a popular theme which Washington Allston later devoted many years of his life in an unsuccessful effort to depict and which the English painter and engraver John Martin had already made famous.

The following spring the family moved to Pittsburgh. Thomas helped his father in the manufacture of oilcloth in addition to sketching landscapes along the Monongahela. In November 1823 he was in Philadelphia, enduring there what he termed "the winter of my discontent." He worked at the Pennsylvania Academy of Fine Arts and wrote poems and prose, one example of which was the melodramatic short story "Emma Moreton," published in the *Saturday Evening Post*. Meanwhile his itinerant family had migrated to New York where he joined them in the spring of 1825, painting in the cramped garret of his father's house in Greenwich Street. Here his luck changed. A painting placed in the window of a store was sold for ten dollars to a G. W. Bruen, who sought Cole's acquaintance and financed a trip that autumn which Cole wished to make to the banks of the Hudson for the purpose of study and sketching. Three paintings resulted from the trip, which, when exhibited for sale at twenty-five dollars apiece, caught the attention of Colonel John Trumbull. Trumbull bought "The Falls of the Caterskill," hung it in his own studio, and rushed off the same day to spread the news to his friend William Dunlap, the great biographer of American painters. Dunlap recalls that Asher Durand, an engraver and portrait painter who be-

came one of the foremost members of the Hudson River School, came in to find Trumbull and himself talking about Cole. The three then went immediately to see the landscapes and the artist who had created them:

> I remember the sensitive and amiable painter then seen by me for the first time, standing in the presence of the three above-mentioned, like a school boy in presence of the trustees, and looking an image of diffidence before men, neither of whom could produce a rival to the works he offered for the paltry price of $25 each. Trumbull had had the first chance—I had the second, and Durand took the third. Trumbull had previously said to me "this youth has done what I have all my life attempted in vain." When I saw the pictures I found them to exceed all that this praise had made me expect. P. Hone, Esq., soon offered me $50 for my purchase, which I accepted, and my necessities prevented me from giving the profit, as I ought to have done, to the painter. One thing I did, which was my duty. I published in the journals of the day an account of the young artist and his pictures; it was no puff but an honest declaration of my opinion, and I believe it served merit by attracting attention to it.[3]

Cole's fame spread quickly. William Cullen Bryant, Cole's close friend, wrote in his funeral oration for Cole that "From that time he had a fixed reputation, and was numbered among the men of whom our country had reason to be proud. I well remember what an enthusiasm was awakened by those early works of his, inferior as I must deem them to his maturer productions,—the delight which was expressed at the opportunity of contemplating pictures which carried the eye over scenes of wild grandeur peculiar to our country, over our aerial mountain-tops with their mighty growth of forest never touched by the axe, along the banks of streams never deformed by culture, and into the depth of skies bright with the hues of our own climate; skies such as few but Cole could ever paint, and through the transparent abysses of which it seemed that you might send an arrow out of sight."[4]

In the summer of 1827 Cole took lodgings in Catskill where he fitted up a painting room and spent many hours walking through his favorite mountains in search of the picturesque, drawing *en plein air*. It was at this time that his method of composition, based on brief

[3] Dunlap, *History*, III, 149–150.
[4] William C. Bryant, *A Funeral Oration Occasioned by the Death of Thomas Cole* (New York, 1848), p. 14.

sketches made on walking trips, evolved into permanent form. His notebooks of that period, and thereafter, contained drawings of trees, mountains, and sky, with verbal indications of the distances from one object to another and of appropriate colors, harmonies, and tones for atmospheric conditions. Frequently notes accompanying the drawings suggested how either the sublime or the beautiful elements observed might later be altered for optimal re-creation on canvas. Rarely painting directly from nature, Cole relied on the passage of time, in accord with Wordsworth's doctrine, to obliterate unimportant aspects of a scene and to clarify the salient faetures which would eventually emerge on contemplation. So he wrote in 1838 to Asher Durand: "Have you not found?—I have—that I never succeed in painting scenes, however beautiful, immediately on returning from them. I must wait for time to draw a veil over the common details, the unessential parts, which shall leave the great features, whether the beautiful or the sublime dominant in the mind."[5]

In 1829 Cole went to Europe for two years, a trip made possible by a $300 loan from his wealthy patron Robert Gilmor of Baltimore. Cole met many influential English artists including Sir Thomas Lawrence, John Constable, J. M. W. Turner, and John Martin, as well as the poet Samuel Rogers, to whom he carried a letter of introduction from James Fenimore Cooper. All were kind to him although he found that the coldness of English artists and the gloomy climate created a melancholy which required several months in Italy to dispel. He exhibited a few landscapes at the Royal Academy and at the British Institution; but they were poorly hung and not well received. After almost two years in England sketching in the galleries, Cole visited Paris, Genoa, Leghorn, Naples, Rome, and Florence. The last particularly pleased him. He remained in Florence nine months, journeying to nearby sites such as Volterra where he noted the "desolate sublimity" which deeply impressed him as he contemplated the ruins which suggested so movingly to him the perishability of man's works. This theme appeared prominently in many of his landscapes, both overtly as the depiction of classical ruins and more subtly as a dominant mood. Eventually it would provide the philosophical germ for *The Course of Empire*.

Cole's European tour enriched him by providing the material and

[5] Below, p. 185.

props around which several of his later landscapes were constructed; it also served, through the growing acquaintance with the masters of European painting it provided, to improve his handling of color and composition. Previously his palette was largely confined to dark browns; now it included grays and even touches of red and yellow. Formerly details were not subordinated, each leaf being distinctly painted; now unnecessary detail was eliminated; broad, bold brush strokes defined the masses, and the parts of the landscape were more unified.

But if Europe provided him with a new sophistication in technique, it also brought into question his devotion to American scenery. Before his departure for Europe Bryant had urged him in a sonnet to keep that earlier, wilder image of American scenery bright amidst the glory and grandeur of Europe, and Cole had visited Niagara Falls in order to "take a 'last, lingering look' at our wild scenery."[6] He evidently struggled hard to maintain this loyalty, but Europe nevertheless affected his work and attitudes. The tour abroad may be conveniently, if somewhat arbitrarily, regarded as launching Cole into the second phase of his artistic career, lasting from 1829 to 1842, in which secular philosophical and historical themes fought for ascendancy in his landscapes with his love for rendering the details of natural scenery.

In New York beginning in 1832, he exhibited his works in rooms at the corner of Wall Street and Broadway. There his canvases attracted the attention of Luman Reed, a wealthy merchant and the foremost art patron in America, who kept a whole floor of his home at Greenwich Street as a painting gallery and opened it to the public once a week. Reed, who encouraged Asher Durand, George Flagg, and William Sidney Mount, among others, commissioned *The Course of Empire* from Cole for approximately $2500. It was a theme Cole had contemplated for some time and for which he already had extensive notes which he wrote out in a full essay, his ideas flowing as readily into prose as onto canvas. This form of expression was one Cole employed not only in *The Course of Empire* but also in *The Voyage of Life* and *The Departure and The Return* as well as in his later spiritual works, many of which were lost or never completed and identified only by Cole's descriptions of them.

[6] Below, p. 72.

Cole's theme in *The Course of Empire* was the rise and fall of a nation, from savage state, to pastoral state, to the great city, to destruction, and finally to desolation, where in the form of ruins the works of art become resolved into elemental nature. The dominant note is one of flux and mutability, not only in the condition of man, but also in that of nature. The changes of nature are illustrated by the fact that the five pictures take place at successive times of the day, the first at sunrise, the second with "the day further advanced," the third at noonday, the fourth during an afternoon tempest, and the last at sunset.[7] In the background of each of the five paintings are several mountain peaks which serve to illustrate that the action of each painting transpires in the same location viewed from different angles. They thus testify to the changelessness of certain aspects of natural scenery. The series was intended less as a warning to America than as the rendering of a picturesque and sublime theme, and as such it was a great success. The showing, in 1836, brought Cole almost $1000. There was a tendency on the part of the popular press to interpret the work incorrectly, as signalizing the destruction of old-world tyrannies and the triumph of American democracy. But many understood it, and everyone praised it. Bryant considered it "among the most remarkable and characteristic of his works," and Cooper wrote, "Not only do I consider the Course of Empire the work of the highest genius this country ever produced, but I esteem it one of the noblest works of art that has ever been wrought."[8]

In 1836, the year of completion of *The Course of Empire*, Cole married Maria Bartow and, taking residence in the Bartow family house, settled permanently in Catskill, where he continued to sketch from nature. He planned several series of philosophical works. *The Voyage of Life*, begun in 1839, is a series of four allegorical canvases: "Childhood," "Youth," "Manhood," and "Old Age." The landscape in each canvas reflects the mood and condition of the voyager, who remains adrift in an elaborately embellished boat with golden prow and sides sculptured into figures of the hours. The allegory is too pointed, the figures too generalized, and even the seascape seems unreal and idealized; but the image of life as a romantic picaresque journey beset with trials was readily grasped by the public. The most

[7] Below, pp. 129–130.
[8] Below, pp. 166–167.

popular of Cole's works, it found its way in the form of engravings by Smillie into many American homes.

The dichotomy between Cole's devotion to natural scenery and to the illustration of moral truths, which was resolved in this series by the triumph of the latter, had unfortunate consequences for his art. Before he had visited Europe he had produced pictorializations from literary sources; in 1827 he had illustrated a scene from Cooper's novel *The Last of the Mohicans*, in which the combatants Uncas and le Subtil, placed on a dramatic plane in the middle distance, are lost in a romantic wilderness of huge crags and mountains. It is obvious in this work that the natural scenery is paramount, the figures being so immersed in it as to be inconspicuous. Cole was unhappy with this solution because he felt that the story was not satisfactorily told, being hidden in the landscape. In *The Course of Empire* the theme and the landscape were more happily blended, except in the third and largest picture of the series: there the landscape was almost completely eliminated, and was replaced by a great gaudy city, the depiction of which dissatisfied Cole despite the great amount of effort he put into it. *The Voyage of Life* represented a deliberate break with Cole's previous approach to landscape and nature. It was almost purely didactic, as were most of his subsequent paintings of the 1840's. To see how far the pendulum had swung one need only compare *The Voyage of Life* to the scene from *The Last of the Mohicans*.

The change was not the result of a weakening of Cole's artistic powers. On the contrary, they had been developed and deepened. As one modern critic has put it, commenting on "The Catskill Mountains," which Cole completed in 1833 after his European tour: "A single glance at the Mt. Washington in Hartford of about 1828 tells the difference. The timidity and minute elaboration have disappeared. Instead, bold masses in simplified outlines sweep up unbroken towards one center of interest. The grandeur of the scene has found congenial expression. Nothing 'provincial' clings to the canvas."[9] It was then by choice, and not through waning artistic power, that Cole abandoned his early minute transcriptions of nature. And it was by choice too that he turned still further from physical representation in what may be called his third phase, which for the

[9] W. L. Nathan, "Thomas Cole and the Romantic Landscape," in George Boas, ed., *Romanticism in America* (Baltimore, 1940), p. 45.

sake of convenience may be designated as beginning in 1842, the year of his baptism into the Anglican Church and of his return from his second European trip.

In spite of his happiness in the Catskills with his "sweet, madonna looking" wife, his two children, his wife's relations who came frequently to visit them, and above all with the beauties of the surrounding scenery, Cole had become increasingly dissatisfied. The public failed to respond favorably to his newly projected plans for allegorical themes, and he was unable to find commissions for them. Increasingly he blamed America for its want of such traditional associations in scenery as cling to scenes in the old world. With some bitterness at the lack of "a higher taste" in the nation, he turned once more to Europe for rejuvenation and for the commissions he had failed to receive at home. He sailed for England in August 1841, and traveled in France, Greece, Switzerland, and Italy. He studied the masters—particularly Poussin, Correggio, Titian and Claude—and gradually recovered his old love of nature and his artistic ambition. By the time he returned to the United States he was able to contemplate American scenery with renewed pleasure. "It has its own peculiar charm—a something not found elsewhere. I am content with nature: would that I were with art!"[10] His health too was much benefited, and he found that he could now go to work with renewed spirit and capacity.

It is at this point, on his return from a second tour of Europe, that one may conveniently date Cole's entry into the final phase of his artistic career. His art now was dominated almost exclusively by strong religious influences. From the start of his career Cole had employed religious themes, but they had served largely as vehicles for depicting the sublime and beautiful aspects of nature. Now religious themes took precedence over nature and became ends in themselves. Art, he wrote, "in its true sense, is, in fact, man's lowly imitation of the creative power of the Almighty."[11] In 1842 Cole was baptized in the Anglican Church, received the rite of confirmation, and came to the communion. His pastor was his close friend and biographer, Louis Legrand Noble, the original editor of the present volume. It was in a mood of heightened spirituality that Cole pro-

10 Below, p. 249.
11 Below, p. 251.

jected in 1845 a grand design for five pictures entitled *The Cross and the World*. The series was intended to depict the pilgrimage of two youths, one to the Cross, the other to the World. Undertaken without commission, the work was never completed, a fate which met many of the spiritual themes of his last period. For these themes grew rapidly in his mind; the details were elaborately conceived and filled the pages of his journals and letters; but seldom did they reach canvas, or reaching canvas were they fully realized. Many, like the projected series of four, "Sowing and Reaping," and the projected series "Life, Death, and Immortality," were never begun. In 1844 he wrote to his patron Daniel Wadsworth of Hartford: "I have been dwelling on many subjects, and looking forward to the time when I can embody them on the canvass. They are subjects of a moral and religious nature. On such I think it the duty of the artist to employ his abilities: for his mission, if I may so term it, is a great and serious one. His works ought not to be a dead imitation of things, without the power to impress a sentiment, or enforce a truth."[12]

Significant in the mood of Cole's last period is the change from the predominant melancholy of his second artistic phase revealed in the theme of *The Course of Empire* to the optimistic assertion of man's glorious rebirth through faith in God illustrated in "The Vision." For this alteration Noble offered the explanation that Cole's early love of nature led inevitably to a broadening religious commitment: God was always implicit in nature and nature was but one part of His creation. The distance from nature to God was not far for the pantheist, and Noble emphasized that Cole's character was from the beginning sensitive and spiritual, requiring only formal religious guidance to achieve the deep faith of the final years. Even in 1836 in his "Essay on American Scenery" Cole had perceived the religious implications of communion with nature: "for those scenes of solitude from which the hand of nature has never been lifted affect the mind with a more deep toned emotion than aught which the hand of man has touched. Amid them the consequent associations are of God the creator—they are His undefiled works, and the mind is cast into the contemplation of eternal things."[13]

In terms of Cole's art the change was of the greatest importance,

[12] Below, p. 266.
[13] "Essay on American Scenery," *American Monthly Magazine*, new ser., I (1836).

for his precocious mastery in rendering natural scenery failed him in his effort to depict religious and spiritual themes. He struggled with these mammoth conceptions at a time when his health began to fail, and one is reminded of the analogous battle waged by Washington Allston with his grandiose schemes for "Belshazzar's Feast" which remained unfinished at his death. It is perhaps the fate of the romantic artist to try the impossible, to envision and attempt that which he knows is doomed to failure.

Cole's turning away from nature to abstractly spiritual and religious material may also be interpreted as a sign of a measure of alienation from American society. He had already tried to escape the tyranny of American critical opinion, for which he had great contempt, by two European tours. On May 26, 1838, Cole wrote of American art critics, "Our exhibition is now open,—the thin-skinned artist in the field, to be hunted, torn, and worried by the mongrel pack of critics that break forth 'ravenous and keen' after their year's fast. I grieve to find criticism so low as it is. Fulsome praise, stupid presumption, and interested detraction make up the amount of newspaper criticism on the fine arts." He dreaded the cities, and his privacy was threatened even in Catskill. In August 1836, a decade before Thoreau objected to the railroad's invasion of nature at Walden, Cole wrote, "I took a walk, last evening, up the valley of the Catskill, where they are now constructing the railroad. This was once my favourite walk; but now the charm of solitude and quietness is gone."[14] It is significant that while he worked on his last religious paintings he demanded complete privacy, permitting no one to interrupt him; even his wife was not allowed to see "The Vision" while he was working on it.

Cole's deeply religious attitude helped to fortify him against the personal adversities which beset his last years. He noted on April 6, 1846, the death of his infant daughter with stoic calm: " 'The Lord gave, the Lord hath taken away.' Our infant daughter died yesterday afternoon. Its pilgrimage in this world has been short and sinless. God, in His great mercy, has taken it unto Himself before the world could defile its spiritual garments." In his last years the journals, in addition to their usual content of natural description, become filled with notices of the death of his friends and relatives. Cole attempted to

[14] Below, pp. 197, 164.

draw sustenance from a faith which now encompassed and fused nature and religion as manifestations of a single force: "This is my birth-day [February 1, 1846]. The air is keen, but calm; the sky almost cloudless at sunrise. The mountains received the first rosy light in deep serenity. It is Sunday and a holy calm seems to rest on hill and valley, and the voiceless air. O that this morning's tranquil beauty may be an augury of the coming year to me!—that my soul may be possessed by that holy peace which descends from heaven!"[15] In 1848 Cole painted his last canvas, which was based on the opening lines of the twenty-third Psalm. He then turned once again to his series *The Cross and the World*, but his health was failing too rapidly for him to make much progress. He was "violently taken with a disease which terminated in an inflammation of the lungs," and he expired a few days thereafter, on February 11, 1848, at the age of forty-seven. His last words were, "I want to be quiet."[16]

THE HUDSON RIVER SCHOOL: DERIVATIONS AND CONTINUITIES

The Hudson River School was a name devised by a hostile New York art critic to designate a group of landscape painters whose work was grouped together because of what this critic considered its provincialism and geographical limitations. Yet, though for reasons other than those which moved the critic to coin it, the designation is apt, and it has become firmly established. The dates of the school may be considered to extend over the fifty years from 1825, when Thomas Cole opened his studio in Greenwich Street in New York, to about 1875, when new themes from Europe began to dominate American art and when Albert Bierstadt, painter of immense landscapes, moved West to start a school of significantly differing techniques which James T. Flexner has termed the Rocky Mountain School.[17]

There are approximately a dozen names prominently associated with the Hudson River School: Thomas Cole, Thomas Doughty, Asher Durand, Alvan Fisher, Frederick Church, John Kensett, Worthington Wittredge, John Casilear, William and James Hart, Sanford Gifford, Jaspar Cropsey, and Thomas Rossiter. These men were

[15] Below, pp. 281, 274.
[16] Below, p. 306.
[17] James T. Flexner, *That Wilder Image* (Boston, 1962), pp. 293–302.

not united by a common style. Each developed a relatively personal style distinguishable from that of any other, a style more or less individually evolved by experimentation in apprentice years as engraver, sign painter, or itinerant portraitist. Nor were these men united by geographical limitations in their selection of scenes to paint. Some traveled northward to the Berkshires and White Mountains; Cole himself sketched in Maine on Mount Desert Island; his favorite pupil, Frederick Church, journeyed to Mexico and went on to South America to paint the Andes. Nor, finally, did the members of the Hudson River School reside together in a single community to work out philosophical principles in their art or life as did, for example, that later group of landscape painters living together in Fountainebleau, the Barbizon School, or their predecessors, the Nazarenes, in Germany, or the pre-Raphaelite brothers in England. What these men did share was a common spirit of devotion to nature and a common background of aesthetic ideas. Their achievement was to present a new view of nature and of man's relationship to nature which had widespread ramifications in American literature as well as in other aspects of American culture. The work of the Hudson River School represents the first, and perhaps the last, systematic attempt to depict on canvas a unified vision of the American landscape. It celebrated the wonders of nature in this country by elaborately describing the facts of natural landscape and by presenting seemingly endless vistas through clear uncontaminated air. There are weaknesses in these canvases: in addition to technical limitations, they suffer from excessive detail that clutters the scenes, failure to concentrate on significant elements, and lack of a unified focus or sometimes even of a single vanishing point, as in some of Cole's early landscapes. But at their best the artists of the Hudson River School manifested a sincere devotion to nature, accuracy in recording the facts of the natural landscape, and freedom from sentimentality.

Their views express a peculiar configuration of historical and environmental influences. In colonial America the virgin continent had been described as a "howling wilderness amidst wild men and beasts."[18] Then, when western expansion, intensified colonization, and developing commercialism had tamed the wilderness, nature be-

[18] Letter from Plymouth Colony, 1680, quoted by Seymour Dunbar, *A History of Travel in America* (Indianapolis, 1915), p. 15.

came less threatening. Its physical aspects could be enjoyed and celebrated as being peculiarly American. Nature became one of the major themes of a growing nationalist movement, and pride was taken in the fact that vast reaches of our land had not yet been viewed by human eyes. This fact offered the landscape painter rare opportunities, for, as Cole wrote, "the painter of American scenery has indeed privileges superior to any other: all nature here is new to art."[19] Economic and political expansion, in addition, had produced a bourgeois culture whose materialism was justified and colored by a powerful strain of idealism. So wealthy merchants such as Robert Gilmor, Luman Reed, and Daniel Wadsworth commissioned American landscapes which were as acceptable as portraits had been in colonial America. In this respect landscape might be considered an extension of portraiture.

There had been, of course, earlier examples of American landscape painting in the work of Ralph Earl, Charles Willson Peale, James Peale, John Trumbull, Washington Allston, John Neagle, and John Vanderlyn; but taken as a whole this body of painting failed to influence subsequent artists and was predominantly English in inspiration, spirit, and technique. Also, beginning in the seventeenth century, picturesque vistas, cities, and large estates had been drawn, engraved, and painted by a group of inexpert craftsmen whose work has been termed topographical. This art is best exemplified in paintings of William Birch (1755–1834) and William G. Wall (1792–1862). The work of this group was sharp, clear, and realistic, the main objective being literal renderings of specific localities in an easily recognizable fashion. But atmosphere was lacking, as was care in defining the transition from middle to far distance. It is obvious that on the average these artists thought little about nature or about the problems of elaborating the details of a landscape.

Besides these elements in the environment conducive to the emergence of the Hudson River School, there were certain abrupt alterations in the American intellectual climate which were reflected in its development. The dominant element in the intellectual climate of early nineteenth-century America was the reaction to the rationalism of the previous age which had relied on the efficacy of reason in resolving human problems. The concreteness of Benjamin Franklin's

[19] Below, p. 148.

logic which eliminated all reference to the spiritual dimension of man's existence was rejected and supplanted by a mode of thought which stressed the emotions and sensations. Imagination was emphasized as opposed to reason, intuition as contrasted to knowledge. In short, the Romantic Movement had reached America. The German romantic writers were exceedingly popular: "Kotzebue," Joseph Story wrote in 1799 from Boston, "is the presiding deity of our theatre. The rage for his plays is unbounded. The development of the bolder and fiercer passions alone seems now to command the attention of an American audience. All must be 'wrapt in clouds, in tempest tost:' alternately chilling with horror, or dazzling with astonishment."[20] The prime importance of sensation in the Romantic Movement, a concern with the beauties of nature as well as with nature's hostile aspects, and the theme of the isolated individual in nature battling for survival with every resource of strength and intelligence were accepted in nineteenth-century America and found expression in the work of American landscape painters.

There was, moreover, an inheritance of aesthetic theory that shaped the work of the Hudson River School—a set of principles which were themselves deeply embedded in the culture of eighteenth- and nineteenth-century Europe.

The Peace of Utrecht in 1715 had made possible for Englishmen the so-called grand tour of Europe, and between 1730 and 1830 there developed as a consequence a new emphasis on landscape which dominated painting, poetry, gardening, and architecture. The works of Claude, Poussin, Rosa, and Titian became exceedingly popular, and English poets relied on paintings by these masters to create in verse landscapes which never existed on English soil. A new interest grew in the physics of vision, in perspective, and in methods of suggesting vast expanses of land within the confines of a painting. Most of these problems had been dealt with successfully long before by Italian landscape artists, notably Titian (1477–1576) and Salvator Rosa (1615–1673), who emphasized nature's grandeur by suggesting the extension of portions of mountains, clouds, and rivers beyond the limits of the observer's vision. But Englishmen of previous centuries, far from regarding vagueness as an aesthetically gratifying device, had looked upon it merely as an undesirable obstruction to clear

[20] William W. Story, *Life and Letters of Joseph Story* (Boston, 1851), p. 81.

vision. Now, however, " 'Tis distance lends enchantment to the view/And robes the mountain in its azure hue."[21] In 1748 James Thomson in *The Castle of Indolence* transformed the landscapes of Claude and Rosa into verse, allowing his pen to linger fondly over: "Whate'er Lorrain light-touched with softening Hue,/Or savage Rosa dashed, or learned Poussin drew."[22]

The popularity of the landscape painter's canvas, transferred to the printed page by the poet, stimulated a renewed interest in the principles involved. This interest generated one of the most creative periods in the history of aesthetic theory. Within a few years of each other there appeared Edmund Burke's *Ideas of the Sublime and the Beautiful* (1754), Sir Uvedale Price's *Essay on the Picturesque* (1794), William Gilpin's *Three Essays on the Picturesque* (1792), Archibald Alison's *Essays on the Nature and Principles of Taste* (1790), among a number of others. So well known had the classifications and subclassifications of these aestheticians become that Jane Austen in *Northanger Abbey* (1818) could satirize them: when Catherine Moorland refers to *The Mysteries of Udolpho* as "nice," a word associated with "the beautiful," instead of as "sublime," technically the opposite of "the beautiful," she is quickly reprimanded and cautioned to change either her word or her escort.

Burke, the most influential of the English aestheticians, maintained that there existed certain general principles of taste that were universally applicable. For a work of art to be successful, it must arouse curiosity by describing novel objects capable of exciting either pain or pleasure. Pain and pleasure are independent, each being of a positive nature. Among the ideas that affect man's emotions, those concerning self-preservation, turning on pain or danger, are sources of the sublime, and are productive of the strongest emotions which the mind is capable of feeling. Those ideas which turn on society are associated with love. Mixtures of the two occur since man takes delight in the misfortunes of others and terror is a passion which always produces delight when it does not press too closely. Burke claimed that astonishment resulting from horror was the principal passion aroused by the sublime, and he listed as the components of the sublime scene or landscape the following characteristics:

[21] Thomas Campbell, *The Pleasures of Hope*, part I, lines 7–8.
[22] James Thomson, *The Castle of Indolence*, canto XXXVIII, lines 8–9.

1. OBSCURITY—(since everyone will be sensible of this who considers how greatly night adds to our dread in all cases of danger).
2. POWER—(for while we contemplate so vast an object, under the arm, as it were, of almighty power, and invested upon every side with omnipresence, we shrink into the minuteness of our own nature and are, in a manner, annihilated before Him).
3. PRIVATION—(for all general privations are great, because they are terrible: DARKNESS, SOLITUDE, SILENCE).
4. VASTNESS.
5. INFINITY.
6. SUCCESSION and UNIFORMITY—(Succession is a property of sublimity since by frequent repetition of the same elements in a painting the imagination is impressed with an idea of the progress of those objects beyond their actual limits).
7. MAGNITUDE IN BUILDING.
8. DIFFICULTY.
9. MAGNIFICENCE.
10. LIGHT—(although mere unvaried light is too prosaic a phenomenon to elicit the emotions of the sublime, a quick transition from light to darkness, or from darkness to light can do the trick. "And this is not the only instance wherein the opposite extremes operate equally in favor of the sublime, which in all things abhors mediocrity.")[23]
11. SOUND and LOUDNESS.

Another section of Burke's *Essay* is devoted to an analysis of beauty. Beauty is opposed to the sublime, since beauty provokes love, whereas the sublime evokes horror and fear. The beautiful is created by the artist who employs the reverse qualities of those which are constituents of the sublime. Therefore, Burke asserts, beautiful scenes are composed of small objects characterized by smoothness and by very gradual variations, in place of sharp contrasts of large, rough objects which are the ingredients of the sublime.

Between the beautiful and the sublime, Sir Uvedale Price inserted a third category, the picturesque, which is essentially a watered-down version of Burke's definition of the sublime, modified to permit a greater facility of treatment in landscape painting and gardening.

Burke's principles of sublimity in natural scenery were remarkably suitable for American consumption, since nature was the commodity the nation was richest in. "Can there be a country in the world," De Witt Clinton asked in 1816,

[23] Edmund Burke, *Ideas of the Sublime and Beautiful*, (1754, ed. New York, 1830), p. 102.

better calculated than ours to exercise and to exalt the imagination—to call into activity the creative powers of the mind, and to afford just views of the beautiful, the wonderful and the sublime: Here nature has conducted her operations on a magnificent scale . . . This wild, romantic and awful scenery is calculated to produce a corresponding impression in the imagination.[24]

The American imagination had been stimulated before the turn of the century to revel in nature's operations conducted on so magnificent a scale, and the celebration was invariably held, as in these words of Jefferson, in the vocabulary of Burke's 1754 essay:

How sublime to look down into the workhouse of nature, to see her clouds, hail, snow, rain, thunder, all fabricated at our feet! and the glorious sun, when rising as if out of a distant water, just gilding the tops of the mountains, and giving life to all nature![25]

Cole's writings show a similar absorption of the contemporary aesthetic jargon:

The perfect repose of these waters, and the unbroken silence reigning through the whole region, made the scene peculiarly impressive and sublime: indeed, there was an awfulness in the deep solitude, pent up within the great precipices, that was painful.[26]

And his paintings reveal an equally literal reliance on Burke's theory of the sublime. In "The Mountain Ford," for example, the vastness of nature dominates the canvas. A high cliff whose lower sides bristle with magnificent trees is placed in the middle distance, and a light blue sky occupies a comparatively large area. Vastness is further suggested by the methods of succession, uniformity, and infinity; the myriad mountains, trees, and shrubbery seem to merge with each other and extend uninterruptedly. Power is touched on in the foreground by asymmetrical disposition of a few ragged tree stumps which bear witness to the forces that lurk behind the calmness of nature's visage delineated in the other elements of the landscape. Light, as Burke advises, is utilized as an element of contrast; broad shadows throw certain portions of the cliff, forest, and mountain ford into obscurity

[24] Quoted in Thomas S. Cummings, *Historic Annals of the National Academy of Design* (Philadelphia, 1865), p. 12.

[25] Thomas Jefferson to Maria Cosway, Oct. 12, 1786, in Julian P. Boyd, ed., *Papers of Thomas Jefferson* (Princeton, 1950–), X, 447.

[26] Below, p. 67.

while others are focused sharply by the sun's beams. The central theme of isolation, solitude, and silence is underscored by what Burke terms Privation. A single figure on a white horse challenges the immensity of nature's domain. He is completely alone. The eye runs for miles without encountering another human form. The rider's back is toward the observer, further emphasizing his isolation. The intransigence of the land which surrounds him serves only to stimulate his haste to journey through it and evidently inspires no fear within him.

In "The Titan's Goblet" Cole employed symbols to suggest the limitless dimensions of his vision of the sublime qualities of nature in America. The goblet is a symbol of the tree of life from the Norse legend, and the conception is, indeed, a cosmic one. The stem of the goblet is a massive tree trunk. The unfolding branches support an ocean dotted with sails. The shores of this ocean contain forests and plains among which appear Greek ruins and modern buildings, typical of ancient and modern civilization. All the artifacts of civilization are subsumed in the enfolding cradle of nature's luxuriance. The breadth and grandeur of the conception are on a scale with the magnificent sun whose beams illuminate the goblet's surface and flood the land spreading endlessly and peacefully far below at the goblet's base.

The concept of nature as expounded by Thomas Cole and the Hudson River School should be compared also with the ideas of a number of influential writers, particularly Cooper and Emerson. Both, in different ways, associated nature with virtue and civilization with degeneracy and evil. Nature for them was synonymous with both personal and national health and was understood to be opposed to civilization as personified in the city, the bank, and the railroad. Civilization would produce sickness by encroaching on nature and finally by destroying it. Americans, particularly close to nature, were still virtuous, but with the march of civilization as measured by the progress of the axe through the forests, virtue would vanish, health would be destroyed, and the nation's personality lost. And as man ravished nature, his sins multiplied, for nature belonged not to man but to God.[27] This conception was clearly enunciated in Cole's *The*

[27] For a more extensive development of this theme and the position of religion in mediating between nature and civilization, the reader is referred to Perry Miller's article "The Romantic Dilemma in American Nationalism and the Concept of Nature," *The Harvard Theological Review*, 48 (Oct. 1955).

Course of Empire, which showed that the replacement of nature in the savage and arcadian phases by the city in the third canvas resulted in the destruction of the fully developed civilization. Could America arrest this cyclical course of empire at the savage or arcadian stage before nature was destroyed and while virtue was intact? Cole and Cooper as well as Thoreau, Melville, and Whitman urged at least a recognition of this problem. But their cries went unheeded and the ironic dilemma of their position was that it was formed in the midst of the exuberant optimism of the Jacksonian age when the country became fervently committed to expansion and material development. Joined in their warning and their dissent with writers contemplating nature's inevitable destruction before the forces of civilization, the painters of the Hudson River School attempted to fix on their canvases this fleeting moment of nature's sublimity.

Much as Claude Lorrain and Nicholas Poussin stand at the fountainhead of French landscape painting whose tradition may be traced from them through Watteau and Corot to Monet and Cézanne, so in America Thomas Cole may be regarded as the father of our landscape school. His romantic spirit may be traced in the work of subsequent artists: in the Barbizon compositions of George Inness, in the mystical dream-lit canvases of Albert Ryder, in the realistic depictions of the sublime qualities of sea and forest by Winslow Homer, in the fantasies of Arthur B. Davies, and in the anthropomorphic interpretations of nature by Charles Burchfield.

LOUIS LEGRAND NOBLE[28]

Louis Legrand Noble was born in Lisbon, New York, on September 26, 1813, and in 1837 graduated from Bristol College in Pennsylvania. Three years later he was graduated from the General Theological Seminary in New York City, and in the same year, 1840, he was ordained deacon in the Anglican Church; one year later he became a priest. He traveled widely and served in many churches. In 1840 he was assistant minister in St. Peters Church, Albany, New York. Between 1841 and 1844 he was in North Carolina and served as rector of Christ Church in Elizabeth City. In 1844 he moved to

[28] On Noble, see Appleton's *Cyclopedia of American Biography* (New York, 1888). IV, 528.

Chicago to serve as rector of Grace Church; but after a quarrel with his vestry he left.[29] In 1856 he returned to New York, and became rector of the Church of the Messiah in Glens Falls. The year 1857 found him in Fredonia, New York, as rector of Trinity Church, and in 1859 he moved to Christ Church in Hudson, New York.

He was never happy in the ministry, and wrote frankly to his close friends of the hollowness of his life as a clergyman and of his desire to escape from his confining duties. Perhaps with such hopes in mind he accepted in 1874 a professorship of English and history in St. Stephen's College, Annandale, New York. Here for one of the few times in his life he had a house of his own and could invite his close friend, the landscape painter, poet, and naturalist Charles Lanman, to enjoy "this rural drama of the fresh and beautiful."[30] But in 1876 Noble wrote Lanman that the life in Annandale was monotonous and no longer suited him.[31] In 1880 he went to Michigan as rector of St. John's Church, in the town of Iona. There, two years later, he died.

It seems that Noble shared with his close friends Cole, Lanman, J. S. Kidney, and Church a deep devotion to natural scenery and a love of traveling through untamed regions in search of the picturesque: "I have a passion for life in the wilderness . . . I have read up most all books of travel . . . the fatal disease, love of the wilderness was caught young, in the woods and plains of Michigan. [I] never shall recover from it. Die of it, I have grave suspicions, if I live [sic]."[32] Unpublished material in Cole's journal identifies Noble and Kidney as two of the members of Cole's party to the South Peak and further identifies Noble as the gentleman who, "familiar with Indian life and manners, sang with characteristic gestures an Indian song. From low gutteral tones the voice rose in mournful strains, higher and higher, to the utmost loudness; then, sinking to the same deep note from whence it first commenced, it presently swelled again in fitful modulations to the shrillest pitch, and concluded abruptly with a yell."[33]

[29] Louis L. Noble to Charles Lanman, May 28, 1856, Noble MSS, New-York Historical Society.
[30] Noble to Lanman, July 5, 1875.
[31] Noble to Lanman, January 1, 1876.
[32] Noble to Lanman, February 8, 1876.
[33] Thomas Cole, Thoughts and Occurrences, August 14, 1846, Cole MSS, New-York Historical Society; Noble, below, p. 279.

Noble published a number of short poems as well as *Ne-Ma-Min, an Indian Story* in three cantos in 1852. As the minister and close friend of Thomas Cole, Noble edited Cole's poems, stories, letters, and journal, and in 1853 published selections from them with a running narrative in the book reproduced in the present volume. In 1857 Noble published *The Lady Angeline, a Lay of the Appalachians; The Hours, and Other Poems;* and in 1861 an account of his journey to Labrador with Church, Cole's pupil, entitled *A Voyage to the Arctic Seas in Search of Icebergs, with Church, the Artist.*

A NOTE ON THE TEXT

Although Noble had some difficulty in finding a publisher—he was rejected by Putnam, Appleton, Harper, and Scribner—three printings of the present book appeared within three years, attesting to the warmth of the reception on publication. The first and second "editions," or printings, were published in 1853 and 1854 in New York by Cornish, Lamport and Co., and by Sheldon, Lamport and Bakeman respectively, and bear the title *The Course of Empire, Voyage of Life, and other Pictures of Thomas Cole, N.A., with Selections from his Letters and Miscellaneous Writings: Illustrative of his Life, Character, and Genius*. The title of the third printing, published in 1856 by Sheldon, Bakeman & Co., in New York, was simplified to *The Life and Works of Thomas Cole, N.A.* Except for the title and one or two spelling corrections, the three printings are identical. The title of the 1856 printing was chosen for reproduction here since it was the final and permanent name under which Noble presented the book.

No editorial changes in the text have been made in the present edition other than the correction of occasional typographical errors. Noble's starred footnotes appear as in the original; to some the present editor has added information in brackets. The present editor's notes to the text, indicated by Arabic superscripts, appear in a section following the text. The indexes are part of the new edition, and the illustration section has been gathered for this edition with an intent to convey the range and chronology of Cole's works.

The original Cole manuscripts which Noble edited in composing this book are in the New York State Library, Albany, New York, and in the Detroit Institute of Arts, Detroit, Michigan. Photocopies and typescripts of this material made by E. Parker Lesley were purchased by the New-York Historical Society, in whose library they were studied by the present editor. Comparison of the original letters with those reproduced in Noble's volume shows an overall fidelity to the spirit of the originals. But Noble had so much material

available that selection became necessary and the omissions Noble made are not fortuitous. He explained to Lanman, for example, why he omitted from his book two of Cole's letters to him: "I did wish to insert two letters of Cole to you. But I thought they rather reflected upon you, than otherwise: and your reputation is dear to me, as well as Cole's. So I put them aside."[34]

In spite of the disavowals made in his introduction, Noble was very much concerned with the general image of Cole which he was projecting. He was particularly anxious to present him as a saintly man, a paragon of virtue. The religious aspects of Cole's life were consequently emphasized, and evidences of acrimony—sharp letters to dissatisfied patrons and extended correspondence concerning disputes over exhibition rights—were omitted. Cole's shifts in mood, his eccentricities, humors, and occasional outbursts of ribaldry Noble chose to ignore. The image Noble created is therefore unnaturally pale: more saintly, unworldly, and pacific than Cole in fact was. He possessed the qualities Noble emphasized; but he was also capable of writing the following, in a letter of 1839, to William A. Adams:

I am afraid that the building when finished will be like most other buildings erected in this country, a monument of Bad Taste and Architectural Ignorance. *My only hope is in you.* My dear friend do not yield—do not I beg you give your consent to the absurdities that will be attempted nor let your name be coupled with those whose only Knowledge is conceit, whose only taste caprice. The work you are engaged in, be it unmeaning and deformed as possible, will *endure* and be your monument through ages to come as certainly as if the proportions were as beautiful as ever the mind of man conceived. As it respects my share of the design—if you cut off the mouth and ears and in their place put a proboscis or a plug—I shall not acknowledge the likeness. Regarding the alteration that your fellow commissioners and architect insist upon, I merely advise that when finished a painted cross be made in each recess . . . with the words "Rispetti la Croce" in large letters over it, or the more obvious sentence "Non si urina Qui," though in plain English, for the temptation will be very strong to all passers-by.[35]

Noble also underplayed the more technical aspects of Cole's art. The unpublished journals contain essays and comments on color and harmony and also drawings illustrating technical points. The draw-

[34] Noble to Lanman, June 2, 1853.
[35] Thomas Cole to William A. Adams, December 1839, Cole MSS, New-York Historical Society, quoted with the kindness of Mrs. Edith C. Hill and Mrs. Mary C. Van Loan.

ings include excellent figure studies which belie the common criticism of Cole as a painter of the human form. In the journals are also lists of subjects for future paintings as well as the financial details of some of Cole's numerous commissions. There are, finally, among the papers Noble omitted several long narrative poems in Cole's hand, the most prominent of which are "Voyage of Life" and "The Spirit of the Wilderness," some essays on art, the most notable of which are on American scenery, a number of long letters from Cole to his wife, and the early stylized story "Emma Moreton."

Finally, it should be noted that Noble, himself a man of letters, occasionally took liberties in editing Cole's journals; but the changes made are generally in style rather than meaning. Cole's original prose is often simpler in structure though occasionally longer in content than what Noble chose to publish. Thus on p. 65 the following two sentences appear:

We came out, at length, to a lonely and deserted clearing, just at the foot of the mountain. The cause of this abandonment is, they say, the poisonous effects of the water upon the cattle; the result, according to tradition, of the curse of Chocorua, an Indian, from whom the peak, upon which he was killed by the whites, takes its name.

Cole's original is quite different:

The name of this mountain is pleasing and I have made some inquiry respecting its origin. It appears that after the French and Indian War had ceased a hunter residing in this part of the country cherished, for some cause now unknown, a feeling of revenge against an Indian named Chocorua. He, therefore, mustered a party of hunters, his friends, and went in pursuit of the unfortunate native of the wild. They chased him up the high and almost inaccessible mountain now called by his name, and at length found him on the summit. There they gave the poor despairing and defenceless wretch the cruel choice of whether he would leap from the dreadful precipice on the top of which he stood or die beneath their rifles. The ill-fated Chocorua refused to destroy himself by that terrible leap and suffered death beneath their hands. The country round the foot of Chocorua is inimical to the raising of cattle. Such as are taken there always die by an incurable disease. This superstition was alleged to a curse which Chocorua is said to have uttered with his dying lips that "all the cattle of the white men brought on to his hunting ground should die."

Such radical condensation is uncommon, however. Most of Noble's alterations affect only very minor matters.

THE LIFE AND WORKS OF
Thomas Cole

TO

WM. CULLEN BRYANT, Esq.,

WHOSE PEN,

WITH THE PENCIL OF COLE,

IS ALIKE IDENTIFIED WITH

AMERICAN SCENERY,

This Volume,

IS

RESPECTFULLY INSCRIBED.

L. L. N.

PREFACE

An apology for undertaking a work, from some incompetency, is almost as common as a preface. Such an apology, however, common as it is, the present writer feels himself bound to offer. He confesses himself incompetent, for several reasons, with which he will not trouble the reader, to write well of the genius, character, and life of a true artist.

Why then was it attempted? Because it was thought that he could, at least, do justice in part; and because the work seemed naturally to fall to him. The relation of pastor, and that in the retirement of the country, admitted him, at length, to an intimacy with the painter, in which he told him much of the story of his life, and, at its close, committed to his discretion most of his papers.

It might be asked, in the present flood of publications, why the memoirs of a person, whose life is usually so quiet as that of an artist should be written at all? It may be said, that the history of any man who was simply a model of conscientiousness and moral purity, and of earnestness in the pursuit, and reproduction of the beautiful and true,—who, with strong will and great purpose, had a vast patience, is well worth the writing and the reading. Much more so, if, to the above qualities, there were added those of a fine genius.

It may also be said, that not all readers, even in these times of haste and excitement, love only books which resound with "the weaving of chance and the rolling of accident;" and, that the many who do, might "rise wiser and better" from the story of a quiet life.

Cole, however, is somewhat an exception among artists. The stream of his life is very frequently broken by touching and stirring incident, amusing and romantic recital.

The first intention was to have made, comparatively, a large work, —interweaving with his personal history full notices of all his finer pictures, most of his correspondence, and copious selections from his poems and various prose writings. Under advice, this first intention was given up, after it was partially carried into effect, and the present

I

work taken in hand; which is, virtually, but an abridgment of the one originally designed,—having interspersed with what is strictly biographical—always from the painter's own pen, when it could be made to serve the purpose—such letters and selections from his literary remains, and such notices of his pictures as help to unfold and illustrate his character and genius.

In what is just said, the author hopes, may be found the propriety of the somewhat novel title of his book, adopted for certain reasons, instead of the more natural one of Life or Biography.[1]

Should it be thought that he has drawn more from his own imagination than from actual fact, in speaking, for instance, of the artist's pictures, and of his feelings, thoughts and intellectual processes in the study of nature and the old masters, let the reader be reminded of some years of intimacy between the painter and the present author, when those very studies and pictures—with some of which he was permitted to be familiar, from the time of their conception to their completion on the canvass—were perpetually recurring themes of conversation.

The wish to present Cole, particularly in the moral and spiritual, only on the heroic side, is not only disavowed, but the confession frankly made of a frequent feeling of inability to do full justice to his admirable character. Of all men, he seemed to have naturally the smallest taint of vice, and the rarest virtues. These were subsequently multiplied, and made "beautiful exceedingly" by religion. "There goes a man that never trifles, even in his merriment,—never loses the native sense of his proper dignity, in homeliest scenes and commonest circumstances:" such was the spontaneous utterance of the heart, more than once, while following him through the fields and mountains.

In conclusion, while the author of the present volume (where he is the author) would remind the critical reader that he undertook it as a work of love, and accomplished it, from time to time, as the manifold duties of a clergyman would permit, he would also acknowledge his indebtedness to the Rev. C. S. Henry,[2] D.D. of the University of New York, to Mr. Bryant, and many other persons, in different parts of the country; some of whose names are in no way alluded to in the following pages.

CATSKILL, *May*, 1853.

2

CHAPTER ❧ 1

Cole's Birth and Parentage. School-days. Wood Engraving. A Companion. Recreations. Poetry. Reading. Enthusiasm for America. At Liverpool.

T HOMAS COLE, the only son of James and Mary Cole, and the youngest but one of eight children, was born at Bolton-le-Moor, Lancashire, England, on the 1st of February, 1801. His father, a woolen manufacturer, was better fitted to enjoy a fortune than to accumulate one. Possessed of the kindest heart, a gentle disposition, and of perfect honesty, in connection with much poetic feeling, taste and fancy, he never thrived as a man of business, and succeeded infinitely better in attaching his children to him by a lasting affection, than in providing for their advancement in the path of wealth. He failed eventually in his manufactory, at Bolton, and finally removed to Chorley, a town in the same shire.

Now in his ninth year, Thomas was sent to school, at Chester, where, from harsh discipline, poor fare and sickness, he suffered so severely as to carry the remembrance, if not the effects of it, through life. While his first lessons in suffering were at school, it was at Chorley that young Thomas was more intimately made acquainted with those trials and privations which attended him for several years. He there entered a print-works as an engraver of simple designs for calico. Although his father wished to apprentice him either to an attorney or to an iron manufacturer, for which there occurred good opportunities, yet there was a secret impulse in his breast, even at that early age, which turned him from those substantial vocations to make, what seemed to others, but a foolish choice. In the designs and colours, with which his daily work was making him familiar, there was a charm of which he could never dream in the subtleties of the law, and the ponderous operations of iron-making.

From the rude character of many of his fellow-operatives, his moral

3

sense, which, from earliest childhood, was most delicate and lively, forbade him to form any intimate acquaintances with those of his own age. Almost his only associate was an old Scotchman, who could repeat ballads, and talk of the wild hills and blue lakes of his native land. This of itself well nigh compensated for the loneliness of his situation, and the many petty annoyances to which, from his finer organization, he was almost necessarily subjected by the youthful inmates of the works. That he had so congenial and proper a companion, at a time when otherwise the evil around him could scarcely have failed to give some taint to his unfolding character, was a cause of gratitude in after years.

But if he was subjected to much loneliness and vexation during the hours of work, he had his happiness in the intervals of leisure. The park-scenery, the ivy-mantled walls, and even the sounding rooms of some of the old halls in the vicinity, afforded a range for his eye and fancy. With his flute, upon which, even then, he was a tolerable player, it was his delight to wander off into the shady solitudes, and mingle music and lonely feelings with dreams of beauty. Another favorite pastime was to go with his youngest sister, Sarah, through the surrounding country, in search of the picturesque, for which he had already a remarkable love. When weariness, or the allurement of some pleasant spot, invited them to stop, they would fill up the time with song and melody—she singing, and he accompanying with his flute.

From the manner in which the youthful Cole then rejoiced to spend his hours of freedom, a careful observer would not fail to see that he was one of "the many poets sown by nature." In fact, he had, for some time, enjoyed this reputation in the family circle, and even beyond it; for a lady of some literary taste, having by chance seen several of his effusions, pronounced them very clever. Thus passed the days at Chorley, engraving designs for calico, as an employment, and passing most of his leisure in the sweet indulgence of sentiment and fancy.

It must not go unnoticed that master Cole was a great reader, especially of books about foreign countries. None, however, made so lively an impression upon him as a book which set forth, in glowing language, the natural beauties of the North American states. The great lakes, the flowery plains, the mighty forests, the Alleghanies,

the broad rivers, particularly the Ohio, kindled all his enthusiasm. He dreamed of them, talked of them, longed to cross the ocean and behold them. That the eloquence of the boy, on this subject, should have given a new direction to the mind of the father, we may well imagine when we consider that his character was tinged with an element of romance. In fact, the parent sympathized with the son, and heartily wished himself over the sea among the wonders of the New World. This wish became, at length, too strong for suppression; and he proposed, in order to repair his shattered fortunes, at once to bid a final adieu to England, and embark, with his remaining effects and family, for America.

A short time previous to this we find Thomas at Liverpool with an engraver. Whatever may have been his advantages or improvement there, it is certain that he presently made himself familiar with the choice views within and around the city, and endeavoured, upon the arrival of the family, as far as the time up to their embarkation would allow, to renew with his sister Sarah that rural and poetic life which was theirs at Chorley.

CHAPTER ❧ 2

*The Family removes to America. Mr. Cole a Tradesman in Philadelphia.
Thomas, his Employment and Recreations. The Family removes to Steu-
benville. Thomas continues his Wood Engraving in Philadelphia. Man-
ners and Character described by Companions. Sails for the West Indies.
Incident of the Voyage. St. Eustatia. Return to Philadelphia. Journey to
Steubenville.*

IT was in the spring of 1819 that Mr. Cole sailed with his family for
America. After a prosperous voyage, he arrived, on the 3rd of July,
at Philadelphia. Here he resolved to settle, at least for awhile, and
make a new trial to gather a competence. Accordingly he rented a
house and shop, and began, with a small stock of dry-goods which
he had brought over with him, the business of a tradesman. Change of
country, though, had wrought no alteration in the tastes of Thomas.
The new calling of his father was as little to his mind as almost any-
thing well could be. The best to which he could turn his hand for
any immediate profit was wood-engraving, at which he very presently
found employment, in a small way, with a person who supplied wood-
cuts for printers. A specimen of his work still remains with his family,
in a little block four or five inches square, the design of which is
Grief leaning against a monument beneath a weeping-willow, and
probably intended for a stone-cutter's advertisement. Instead of exe-
cuting these simple works in the shop of his employer, he was per-
mitted to take the blocks and work them off at home. While this
arrangement was less profitable than to have worked, at regular hours,
in the shop, it was nevertheless greatly to his liking. He was in the
sound of his sisters' voices and music: occasionally he could join them
with his flute, and help to make their new home in the New World
resound with melody that awakened touching remembrances of the
old. And when the hours of recreation came, he was ready, with his
sister, to enjoy the woody squares of the city, or the green pastures
and groves along the banks of the Delaware and the Schuylkill.

In this manner passed the summer and a portion of the autumn,

6

when his father, becoming dissatisfied with his prospects in the city, resolved, in accordance with his earlier wishes, to seek a home in the distant and romantic regions west of the Alleghanies. As has been already intimated, the banks of the Ohio appeared to the eyes of his fancy wonderfully fertile and beautiful. They spread themselves out to his mind, in the midst of his ill success at Chorley, like regions of the fabled Eldorado: and now that his expectations from trade in Philadelphia were far from being realized, he felt that nothing should keep him from immediate efforts to seek a permanent settlement in the valley which had at first taken so powerful a hold upon his imagination. With the exception of Thomas, all reached Pittsburgh, late in the fall, from whence, in a few weeks, they removed to Steubenville.

For what reasons Thomas remained behind, it is not now distinctly known. He continued wood-engraving until in the winter, and lived in an amiable and respectable family of the society of Friends. "I well recollect," writes a member of that family, "his working on a pine table in the back-room of our old Second Street house. He was engaged upon illustrations of an edition of Bunyan's Holy War, and used sometimes to complain of the rudeness and indelicacy of his employer, who called him a wood-cutter, speaking lightly of his craft, and wounding his sensitive mind. He had a fine natural ear for music, and played very sweetly upon the flute. From him I learned some of the most beautiful of the old Scotch airs. He frequently mingled with us children, (who all loved him dearly,) in our plays in the yard, at marbles, and the like. I well remember what a privilege I used to think it to be admitted to his room, and look at the works of his graver."

In the course of the fall, a law-student came to board in the family, and was his room-mate. "Young Cole," says the person alluded to, "was employed in engraving on wood for a publisher of school-books. He had his little work-bench put up in our room, under the window-sill, that he might have the benefit of the light. We sat with our backs to each other: while he plied the graver, I studied Blackstone. At intervals he whistled, and sung, then laid aside the tool with which he was working, took up his flute, his constant companion, and played some sweet air. He was an admirable performer, and many a time brought tears into my eyes. At the time referred to, I was in feeble

7

health, and seldom went out: I was therefore much in his company, and had a good opportunity of studying his character. I had not been long with him before I perceived that his was a mind far above the common order, and his morals pure and spotless. An improper word never seemed to escape his lips. Artless and unsophisticated, he was without the least hypocrisy. The more I knew him, the better I loved him."

On the 4th of January following, Cole, with his room-mate, whose health required a trip to the South, sailed for St. Eustatia.[1] The only incident of note upon the passage, an unusually long and rough one, was a visit from a piratical ship. Their own little brig, now within the tropics, was coursing pleasantly along one beautiful moonlight night. The companions were on deck, enjoying the splendour peculiar to those seas and skies, when a dark vessel bore down upon them, and gave them a shot through their main-sail. A short time was sufficient to bring the pirate along side. As the Philadelphians were found not to be the particular object of search, a small pillage of liquors and provisions, and some fright, were about all the mischief to which they were subjected. The wild desperadoes bounding on board—the gleaming of their sabres in the moonlight—the drollery of leave-taking, by a shake of hands all around, was a scene that Cole could afterwards render both merry and picturesque.

St. Eustatia was a wonder of beauty and sublimity to the youthful Cole. He had enjoyed his first American autumn in the rural outskirts and squares of Philadelphia; but here, in this mountain island of the tropics, he caught his first view of nature in her grander forms. Out of the bright ocean sprung the rifted rocks into the blue heaven: cliffs bathed their feet in the surf, and their brows in the clouds of the Atlantic: fields of flowery luxuriance, groves of dark and glistening green made the spaces between the sea-shore and the distant slopes look to his enamored eyes like Paradise: a glory sat on the rugged peaks after the sun went down into the shining waves. All this was a new world indeed to the young voyager, and moved his heart with mingled love and astonishment.

Among the numerous excursions he made through the island, one to the summit, and into the crater-like hollow of the mountain, manifested the spirit for which he was afterwards remarkable as a pedestrian. He started at day-break, on foot and alone, and returned

8

only with the evening, "more altered," says his friend, "in appearance than almost any person I ever saw, in the same space of time. He appeared to have lost pounds of flesh, so great had been his fatigue, and so copious the perspiration."

At his intervals of leisure, he busied himself in making for a gentleman a copy of a view of St. Eustatia; and also drew some heads in crayon. These were among his earliest artistic efforts.

In the May ensuing, he returned to Philadelphia, and left, at the close of summer, to join his father at Steubenville. The lengthy journey was performed, with a single companion, almost entirely on foot, with the greatest delight and alacrity. They rose at the peep of day, and went along merrily, singing songs, and playing upon the flute. At noon, they usually took their rest and refreshment by some shady brook or spring; and at dusk, stopped at the inn or farm-house which seemed most likely to be favourable to their slender purses. Humour and frolic, under the circumstances in keeping with the freshness of youth, now and then broke the sameness of their hours, and sped them forward. Among several instances that might be given, more remarkable for oddity than innocence, perhaps, one was to burst in, with their faces, now and then, a pane of the oiled-paper windows of the small houses close on the roadside, and wish the startled inmates, while yet in their beds, a loud and cheerful good morning. Thus with light foot and joyous bosom, gathering into his heart almost unconsciously some new beauty every day, the future artist made the journey to his new home on the banks of the Ohio.

CHAPTER ❧ 3

Life in Steubenville. Influence of Nature upon him. Develops his Powers.
Finds him his Vocation, and his proper Language. Influence of a Portrait
Painter. Resolves to become an Artist. Enters upon his Profession. First
efforts. His Timidity. Becomes a Portrait-Painter from necessity.

T HE two years which followed Cole's arrival at Steubenville, during
which he remained mostly at home in the service of his father, though
marked by little that could strike ordinary observers, were perhaps
two of his most important years. It was then that he formed the great
determination of his life. Naturally timid and retiring, he had ever
sought with eagerness to be much alone: now he was thrown by
circumstances into comparative solitude. What was once the object
of search, now could hardly have been avoided, had he been disposed
to escape it. The scenes of childhood, the show and noise of cities, the
tame loveliness of long-pastured fields, the sounds and motions of the
mighty sea, were all behind. The great wall of the Alleghanies lifted
itself darkly between him and them: the waters rolled away majes-
tically to the west: the current of his thoughts and feelings set in a
new direction, and flowed through vistas of a new world indeed. All,
parents and sisters, were with him, and quietly settled in that region
so fascinating to their imaginations while in old England: but all were
lonely as they had never been before, and he the loneliest of all. It was
the still and solitary pause on that romantic ground where youth first
gazes feelingly forward into manhood. His breath was the odorous air
of solitude: the voices to which he listened were voices of solitude:
the objects of his contemplation rose up before him clothed with the
apparel of the wilderness. The native loneliness of his soul and the
loneliness of nature embraced and kissed each other. Then he fell
back upon himself, as he had never fallen back upon himself before,
and began sounding into the deeps, and winding through the mazes of
his own affections and imagination. Longings of a shadowy nature
began to rise within his heart, and move him with strange power. At

times he strove to grasp them, and lead them captive in the bonds of poesy; at times they grasped, and mastered him. He could feel them, but with no power adequate to their utterance. Then there were melancholy hours, and long wanderings in the woods, and by the streams flowing merrily, and the great river moving solemnly, when he thought himself into moments of stillness, full of joys and sorrows, not without tears. There were pleasures and duties at home—in his father's little manufactory of paper-hangings—combining colours, drawing and designing patterns, and engraving, as usual, upon wood: there were pleasures though abroad in nature, of a kind that showed the strength of her claims upon his deepest sympathies. She carried him, a creature of feeling, far into his own spirit, and called him to gaze upon her, a creature of beauty. He obeyed the call with the quick and silent readiness of a lover, and saw, as he had never yet seen, how full her face was of divine loveliness, and confessed in sentiment that a passion for nature was his ruling passion. Of this brief period of his life he would sometimes speak, long afterwards, in a strain that could not fail to remind one of these lines of Wordsworth:

> For nature then
>
>
>
> To me was all in all.—I cannot paint
> What then I was. The sounding cataract
> Haunted me like a passion: the tall rock,
> The mountain, and the deep and gloomy wood,
> Their colours and their forms, were then to me
> An appetite: a feeling and a love,
> That had no need of a remoter charm,
> By thought supplied, or any interest
> Unborrowed from the eye.[1]

In unfolding the Story of Cole, it is much less important to inquire what *he did*, at the time I am now speaking of him, than what *was doing* within him. The tones and expressions of the outer world found answering tones and expressions in his soul. He was beginning to behold in that something of himself, and to see in himself something of that. Somewhat of the truth and secret life, both of his own being and the visible creation, were opening up to him, revealing harmonies

and relations, and asserting the fact—for others afterwards, rather than for himself then—that he was a poet, and a very great poet, whose mission upon earth, like that of every fine creative genius, was to make men see and feel, with respect to nature and the human heart, as he saw and felt himself.

What, up to this time, he had been feeling after, amid faint hints and doubtful whisperings, was now, in his lonely communion with the visible without and the spiritual within him, revealed, namely, his *vocation*. Silent wanderings with nature found him his true vocation. Those still walks, though, did not rest here: they found him also the appropriate *language* by which he should most effectively speak his thoughts and feelings, and best accomplish his mission among men. That language was the form and countenance, the colours, qualities and circumstances of visible nature. To some extent music was to him a language. He had a native fondness and ability to express by music many of the finest sentiments. Architecture was also to him a very expressive language. Vastly greater than these, and equally natural, were the power and love to express himself in verse. Higher than all was the natural gift to speak his soul through the medium of that visible, sensuous language which nature supplied in her light and darkness, her masses and spaces, her lines, her textures, and her hues. These were the true language of his love and genius. His choice of it, however developed by circumstance or accident, was spontaneous and inevitable. Hence the poet was to speak by the pencil, rather than the pen, and delight and teach through the means of pictures, instead of verse, or any of the several instrumentalities by which genius gives to man its creations.

An incident that had something to do in hastening a determination to which Cole could not have failed very soon to come, was the arrival in his village of a portrait-painter by the name of Stein. His conversation, the expression of his faces, the witchery of the colours on his palette, above all, a book that he lent him, an English work on painting, illustrated with engravings, and treating of design, composition and colour, wrought like magic on his mind. The book was studied thoroughly, and with the greatest enthusiasm. A curtain suddenly rose, and exhibited to him a vision of renown. His heart was on fire. While the long train of old masters, Raphael, Titian, Claude, Salvator, passed before him like so many celestials, the names of

modern artists sounded like titled heroes. His ambition and resolve to become a painter were complete.

He had already acquired some knowledge and facility in drawing. He had sketched in childhood the picture on the face of the family clock, and afterwards the figures and landscapes on English china-ware. Then he rose to copying engravings, sketching heads and natural objects occasionally, and finally to making some few simple designs of his own. What was now wanting in order to step at once into the path of his chosen art, were the requisite materials. With these he presently supplied himself, very rudely, by making, in part, his own brushes, and getting his colours from a chair-maker, by whom he was employed, for a short time, as a kind of ornamental painter. His easel, palette, and canvass corresponded. His first efforts were chiefly landscapes, dictated by recollection or fancy. Crude as they were, one of them had the good fortune to please a gentleman of the town,[2] an amateur artist, who invited him to look at a portrait, a copy of his own from Stuart, (whose student he had been for a short time,) and gave him, with some good advice, a few pencils and colours, and the loan of a palette. This, however, he broke, unfor-tunately. But from a constitutional timidity, which made him shrink, even in the presence of persons in no way distinguished, he could never gather sufficient courage to make the least explanation or apology, although keenly alive to the impropriety of the neglect, and frequently meeting the gentleman in the street. This incident serves graphically to illustrate that peculiar trait of his character which led him, before he could overcome it, to commit many foolish mis-takes.

Cole's second efforts were portraits. These, though, were more a work of necessity than of love. A glance at society, and the circum-stances under which it was placed, at that period, in Ohio, will show how this necessity arose. From certain causes, not important to mention, a commercial crisis had taken place. The banks had sus-pended: men of business were hopelessly involved in debt. Produce, and not money, was the medium of exchange. So great was the scarcity of money that the transactions of a whole community were frequently carried on, for weeks almost, without the sight of a dollar. Recently a frontier, and without proper roads, the country was new and isolated. Men were utilitarians from necessity. Things

were valued in proportion to their capability to supply the common wants of life. Thought for the fine arts, in such a state of affairs, could not reasonably be entertained. In fact, it was as far from the mind as from the ability of society. Under such adverse circumstances, in such a community, young Cole began his career in a profession which was regarded by the mass of individuals as idle and worthless, and commanded, not even from the few, much encouragement or sympathy.

But even in such a condition of things as this, there were some who would gladly possess a likeness of a friend or relative, and others, one of themselves. Portraits, then, would occasionally sell at a trifling cost, while pictures, such as Cole wished to paint, would moulder on his hands. Struggling, in common, with all around him for a living, the youthful artist was therefore compelled to turn his energies in that direction where alone he could have any hope of emolument. Landscape was resigned with regret, and portrait-painting, a department of art for which he had neither taste nor ambition, taken up with reluctance.

CHAPTER ❧ 4

Cole an itinerant Portrait-Painter. His first day out. Night at Mount Pleasant. Arrival at St. Clairsville. Life at St. Clairsville. Adieu to St. Clairsville. Walk to Zanesville. Life at Zanesville. Finds a Friend. Falls into Difficulties. On his way to Chilicothe. Entrance into Town. Letters of Introduction. Discouragements. Brighter prospects. A total Failure. Returns to Zanesville. Paints a Picture. Adieu to his Friend. Returns home.

By way of pluming his wings for a passage of fortune through several of the more flourishing villages of the state, he first tried his pencil at home. His father, then a friend of the family, and, lastly, a little girl, sat successively for their pictures. As they were pronounced to be "like," the preparation was deemed sufficient, and he took his departure.

This was in the February of 1822, when Cole had just completed his twenty-first year. With a green baize bag slung over his shoulder, containing a scanty stock of wearing apparel, his flute, colours, brushes, and a heavy stone-muller, he left his father's house, on foot, in the clear, keen morning. With hopes as brilliant as the frost-crystals on the boughs around him, and with a purse nearly as light, he quickly took, from the hill-tops, a last look at the early smokes of Steubenville. St. Clairsville, the place at which he proposed to make, in good earnest, his entrance into the world as a painter, was distant some thirty miles. For one like himself, with a foot trained for travel, and thoughts more inspiriting than the talk of a merry companion, this distance, on the hard road and in the bracing air, was only a walk of pleasure. All went gaily till the warm mid-day made the footing heavy and slippery. To complete the ills which so soon began to worry him, he broke through in crossing a frozen stream. Fortunately, the water was only breast-deep in the deepest, and the cold current not of sufficient force to sweep him under: by breaking the ice with one hand, and holding his treasures on his head with the other, he succeeded in reaching the opposite bank in safety. At the

end of two miles, up hill, all of which he ran, was the little village of Mount Pleasant, where he stopped for the night. Through the kindness of the inn-keeper, who supplied him with dry clothes and the comfort of a blazing fire, the toils and perils of the day warmed into pleasant recollections; and like a hero who had conquered one powerful enemy, he felt himself quite equal to all that were before him.

Poor youth, he little dreamed of the trouble he was to encounter next morning. Upon his arrival at St. Clairsville, he learnt from the tavern-keeper, with whom he took up his lodging, that a German had already reaped the harvest which, but the day before, he had so fondly hoped to gather himself.[1] Although his scanty funds were now nearly exhausted, he was too proud to resign the field without an effort, and return. A look at the portraits revived him; and he determined to compete with this German master, at the earliest opportunity. This, to his great delight, was presently afforded by a saddler. For five whole days, well nigh from morning till night, the kind-hearted craftsman sat to his painter, and saw himself slowly coming out upon the canvass, in a manner that gave him, finally, no little satisfaction, and called forth the encomiums of an old man who had once been in Philadelphia. In his own emphatic language, "the handling was excellent." To this cheering compliment was added, on the part of his employer, the more substantial reward of a new saddle. And while no one, in the course of the three succeeding months, was so liberal as to bring him a horse, which, in the bloom of his good luck, he had faintly hoped, yet there came an ugly-looking militia officer, and a dapper tradesman, whose united pay for their portraits was an old silver watch, and a chain and key that turned out to be copper. Whether it was owing to the natural generosity of the captain that his compensation was more liberal than that of the shopkeeper, or to the fact that there was a martial hint given to his rugged countenance by a red battle-piece in the background of his picture, is uncertain. But if the purse of the artist was growing no heavier, while his paints and his patience were getting on towards their end, he was evidently increasing in reputation. Not that there were growing symptoms of a throng of persons sitting in their turn in his little low chamber for their likenesses, but that he was called in, on account of superior skill, to retouch, in a single instance, the works of his rival. For this he received a pair of shoes and a dollar,

to take the place, for a long time to come, of the one with which he set out in the world.

St. Clairsville, it was evident, was not the field for a portrait-painter. His flute would do as well for him there as his pencil, and perhaps better. It introduced him among the élite of the village, and drew forth a suppressed, but sincere applause, when it melted off the rough edges of discord in the singing-school, at which he was invited to attend as an honorary member.

With the life and beauty of spring came the impulse to seek a more generous clime. A gentleman from Zanesville, a small town at a hundred miles distance, happening, at this crisis, to make Cole's acquaintance, encouraged him to try his fortune there. Accordingly, after settling with his landlord at the expense of all his emoluments, (the dollar excepted,) and a bar-room scene in addition, he re-commenced his journey, as before, on foot, and with his wallet over his shoulder. What between the blooming month, the shades of the past, and the lights of the future, keeping his heart and fancy like fountains playing alternately in the sun and shadows of an April afternoon, his walk of three days was one of pleasure on the whole, although his melodies were sweeter than his fare.

His first impressions of Zanesville, like those of St. Clairsville, were other than what he had expected. To his great annoyance, he found, at the tavern where he put up, that he had been following in the footsteps of the German. The tavern-keeper and his family were all newly painted. What he would have finally resolved on is uncertain, had not his host encouraged him to make himself quiet by intimating than an *historical picture* would be received in payment for his board and lodging. For the present, then, our painter felt himself at home, and in a fair way to thrive. A room was arranged for painting, and the gentleman who had encouraged the visit sat for his portrait. The beginning, though, was better than the end. After a few patrons more, dropping in at painfully long intervals, his pencil, in its professional capacity, was laid to rest. Before the arrival of this disheartening period, however, Cole had found some agreeable companions, and among them a friend, who proved to him not only a source of pleasure, but the sequel, of substantial benefit.[2]

Though a student of law, his friend was an amateur artist, and possessed congenial tastes and habits. They walked, conversed upon

art, and painted together. In one instance they painted a large landscape jointly from nature, Cole yielding to his friend as his superior in drawing the figures.

The low condition of his purse would not permit a long continuance of this pleasant companionship, and he looked forward to a speedy departure, upon the completion of the historical picture for the landlord. To his amazement and distress, he found that his deceitful host had no intention of receiving anything in payment less precious than the ready money. In vain did the poor young painter reason, and expostulate: he must promptly pay the charges, or go to jail. As the first was utterly impossible, an arrest would have inevitably consigned him to the other but for the generous interference of his friend, who, though poor as himself nearly, became, with two or three other young men, bound for the debt—the small sum of thirty-five dollars.

On a sultry afternoon, near the close of August, Cole found himself on the bank of the Sciota, in sight of Chilicothe. It was his third day from Zanesville, a walk of seventy-five miles. As may well be imagined, both his strength and spirits were much spent. But in the timid young man of slender frame there was a power of endurance that would have carried him forward as long as there was a prospect upon which to hang the least hope. Of this invincible temper a simple and touching incident, in the course of that day, is an illustration. "Here goes poor Tom," said he, "with only a sixpence in his pocket." The sound of his own voice actually staggered him, and brought the tears to his eyes. He sat down upon a fallen tree by the roadside, took out his flute, chased away the evil spirit of melancholy with a lively air, and then went forward through the heat and dust of midday, as if his sixpence had multiplied to pounds. After a quiet hour in a little wood on the river-bank, a refreshing bath, and some slight change of raiment, he made his entrance into town with an anxious heart, and silent invocations to his good angel to give him better fortune.

In his pocket were two letters of introduction, from his Zanesville friend, to persons of some consideration, which he proceeded at once to deliver, whispering to himself, as he reached the door of the first, to hold up his head, and look like Michael Angelo.

While the reception he met with from the persons spoken of was

kind, the encouragement they gave him was little calculated to elate. To one less enthusiastic and hopeful than himself, the prospect, under the circumstances, would have been utterly cheerless. Indeed, it was almost too much for patience and energy like his own. The many weary miles that he had journeyed, his perpetual disappointments, the heartless treatment from the inn-keepers, his want and penury—in a word, all that had worn upon, and smitten his sensitive and generous nature, and now the likelihood of failure where he had felt there was ground of some tolerable success, brought on, for a moment, that sickness of heart which is the harbinger of despair. It was, however, but momentary. He seized a bit of paper, and hastily inscribed upon it, with a pencil, these words—"ALL IS NOT OVER—HOPE FOR GOOD LUCK YET."

For a brief season, that "good luck" seemed to be actually approaching. The hotel-keeper, by whom he was favourably received through the introduction of his new friends, engaged him at once in his own family. He made some agreeable acquaintances, and was invited occasionally to an evening party. In a letter to his friend in Zanesville he portrayed, in warm colours, the prospect before him. But this was of short duration. Affairs soon relapsed into their former condition. A few sat for their portraits; a few took lessons in drawing; he sold a picture or two, one of Washington, copied from a print: these were the fruits of those glowing anticipations during his first few days at Chilicothe. So great was the strait to which he was at last reduced, that he had not only no money to pay for the washing of his linen, but no linen to be washed. But for the kindness of a young physician of the place, his friend and frequent companion, he would have left without a solitary shirt.

Intelligence from home, of a proposed removal of the family to Pittsburgh, now put an end to all thoughts of further travel, and he returned speedily on his way as far as Zanesville. Here he remained a few days in the vain attempt to find employment. In the meantime, he busied himself painting a picture for his friend. The subject was a feudal scene,—moonlight—beacon-fires blazing on the distant hills —in the fore-ground men in armour. The picture still exists. Its manipulation is pronounced by a judge to be as free and bold as many of his later works, with indications throughout of great invention and fine imagination.

On the morning of his adieu, he held with his friend an earnest conversation, in which he laid open to him something of his future intentions. He proposed to himself a grander and more genial field of operation. He was going to Philadelphia. With all the eloquence of which he was master, he then endeavored to persuade his friend to bear him company, to abandon his studies, and become a painter, describing the glories of art in enthusiastic language, referring to the renown of the great masters of Italy, and contrasting the pleasure of their lives with the labour and drudgery of the law, "its statutes and recognizances." Considering the truly touching contrast to this fine picture which was, at that very moment, presented in himself, there is little cause for wonder that his eloquence was lost. His friend continued quietly at his studies, and he, in his usual way, on foot and alone, with his green wallet over his shoulder, journeyed home—one day, it is said, at the rate of sixty miles—to Steubenville. Thus ended Cole's first and last pilgrimage for fortune, if not for fame, as a portrait-painter.

CHAPTER ❧ 5

Cole remains at Steubenville. Scene-painting. Further Disappointment.
Conclusion of his Life in Steubenville. Letter to William A. Adams.
Life in Pittsburgh. Studies nature. Method of Study. Industry in Drawing
from Nature. Acts upon his earlier Resolution to pursue Art in a wider
Field. Leaves for Philadelphia. His Journey.

Upon his arrival, he found the family only waiting his return in order to their removal to Pittsburgh. The chance of immediate employment for himself, however, decided that he should remain, for the present, in Steubenville. He took lodgings accordingly, after their departure, and held himself ready for all commands in his profession.

The first object to which he proposed to devote the proceeds of his pencil, after paying his current expenses, was the discharge of the debt due to his friends in Zanesville. Of this they were duly apprized by letter, in a way which intimated his sanguine expectations, and also that simplicity and trust which often made him rely with singular confidence on the slightest promises.

What had chiefly induced him to remain behind at Steubenville, and which now so raised his hopes, was some scene-painting for an association of amateur actors, called the Thespian Society. The scenes were satisfactorily painted, but proved, in the sequel, far more illusory to him than to the play-going villagers, whose eyes their showy colours deceived and amused for a merry hour. The Thespians paid him, to be sure, but not with that liberality which left him much for the debt in Zanesville. There was a chance, though, he hoped, for that yet. He had on hand a landscape, and forthwith commenced two pictures more, one suggested by Ruth gleaning in the field of Boaz, and the other by the feast of Belshazzar:[1] these he proposed to send in lieu of the money. A letter, partially anticipated in the foregoing, will tell the story of his further ill luck, and furnish the conclusion to his life in Steubenville.

TO WILLIAM A. ADAMS, ESQ.

Steubenville, February 8, 1823.

DEAR SIR,—Those only who have been placed in circumstances similar to my own, can feel the sorrow and pain that arise from not being able to perform a promise, so generously confided in as mine has been by you, and my other friends, at Zanesville: but I hope you will not consider me as altogether unworthy of your confidence and regard, when you have learnt the reasons why that promise has not been punctually performed. I trust, when you have read this letter, you will forgive me my seeming negligence. I think I said, in my last letter, that there was some probability of my having a job from the Thespian Society. I have done it. But the pay of a Thespian Society is very poor; and when I had finished it, I found that the money I received was hardly sufficient to defray my expenses of board, &c. I then saw that there was no probability of sending you cash. I therefore painted two pictures, which, with another that I had, I intended sending to you by the first opportunity. But here again I was disappointed. As my parents have moved away from this town, I took a room to paint in, in which I put all my pictures: one Sunday my room was broken open by boys, who cut and tore my paintings so as to render them not of the least value: they also mixed all my paints, and destroyed my brushes. The boys I found out: but they were young, and their parents poor: I could get no redress except a promise of ten dollars from the father of the younger boy. The other boy has no father, and his mother is a poor old woman. I got advice from a lawyer, but found that nothing could be done except to send the older boy to the penitentiary, and that I disliked to do. My loss I estimated at about forty dollars, at the lowest, besides the time I have lost, as I have no brushes to paint with. I had, at that time, two portraits to paint: I had laid the grounds for both; but the delay has lost me the job.

My parents are at Pittsburgh, where I intend to go shortly. They did intend going over the mountains, but found they could not, from inability, in a pecuniary way. They intended residing at Pittsburgh; and I hope they will succeed better than they have done here. But we have been so often disappointed that we dare not flatter our-

selves. The gay and bright prospects I once pictured to myself are all faded except some faint lingering lights of hope.

But I am sure you are sick of this stuff, for I am ashamed of it. It is a fact, that I scarcely ever knew what are called the "blues" before I came to Zanesville; but they have been pretty regular companions ever since. You would confer a favour on me if you would write. If you do not, I shall feel that you will not notice me because you consider me an ungrateful fellow. I hope it may not be so. I have still some hopes of sending you either the money or the pictures before the time—I have lost the date when you were bound for me. I should be glad to know it. I must conclude by hoping that you enjoy health and prosperity, and that you will never labour under the same pecuniary difficulties as your sincere friend, THOMAS COLE.

The ensuing spring found Cole with his parents in Pittsburgh. While affection and a sense of filial duty, for which few were more remarkable, called him to assist in his father's employment—the manufacturing of floor-cloths—still, art was the subject in which his earnestness was enlisted.

It was now that a great thought came to Cole, and told him he had gone to work wrong. Hitherto he had been trying mainly to make up nature from his own mind, instead of making up his mind from nature. This now flashed upon him as a radical mistake. He must not only muse abroad in nature, and catch her spirit, but gain for his eye and hand a mastery over all that was visible in her outward, material form, if he would have his pictures breathe of her spirit. This thought set him at work right: it changed his whole mind and method at once, and turned him from his easel and the dreams of fancy to seek first, as a humble learner, the rudiments of his art out in the fields under the open sky.[2]

Once in possession of the golden thought, revealing *where he should go*, it was not long before there came another equally precious, revealing *how he should do*. And this was that he must go to the centre, and work outwards: that he must not first skim the surface, and touch the outline, reversing the order of the vital processes of nature, but must begin, as nature herself begins, at the heart, and move outward and upward to the extremes, seeking the principle under the fact,—coming up with the living spirit through the earth,

the stone, the water, and the wood,—rising from elements to masses, from minutest details and particulars to general forms, thus reaching the surface and the outline last.

According to this thought he worked: it was henceforth his law of proceedure, and the path to a great mastery over nature, both in her sublime unity, and in her infinite and beautiful variety. At its first and last light, many a spring, summer, and autumnal day found him on the wild banks of the Monongahela, carefully drawing, from the crinkled root that lost itself in the mould to "the one red leaf . . . on the topmost twig that looks up at the sky"—to the mountain-line on the skirts of the sky—to the clouds far up in the sky, and the blue sky far away from the clouds.

With the return of autumn, ripened the resolution, expressed the year before in that parting conversation with his friend in Zanesville, to seek a more favourable field of action. In this he was discouraged by his father, who urged some substantial calling. His mother, though, who had taken the truer measure of her son's genius, entered, as she did at the outset, warmly into all his wishes, and incited him forward in the path of his choice. From her sympathy and encouragement did he gather heart to face the disapproval of his father, and strengthen himself in his determination.

A mere trifle, often, lights up a person's circumstances and character, and instantly decides a question that affects his whole life. A singular illustration of this is the following incident. Cole was taking a solitary walk, unusually agitated by a recent conversation with his father: "Well," said he to himself aloud, at the same moment picking up a couple of good-sized pebbles, "I will put one of these upon the top of a stick; if I can throw, and knock it off with the other, I will be a painter; if I miss it, I will give up the thought forever." Stepping back some ten or twelve paces, he threw, and knocked it off. He turned, and went home immediately, and made known his unalterable resolution.

That autumn, Cole took a final adieu of the west, and came to Philadelphia. It was in the month of November, 1823. In addition to a small trunk, and a purse of six dollars, he had, in lieu of an overcoat, a cloth cover which his kind mother drew from the table, and threw about his shoulders with her blessing and her parting tears. Unlike that bright inspiriting morning upon which he left home for

St. Clairsville, the early hour of his departure from Pittsburgh was dulled with the leaden gloom which usually broods over the threshold of winter. To one whose spirit took an impress from the aspect of nature as easily as the new-fallen snow then took the print of his feet, there was something in the sad feelings with which he set out upon his journey prophetic of the suffering that awaited him at its end. He felt, as he went along, widening the distance between himself and home, that the melancholy around and within him was the foreshadowing of trials such as he had never yet experienced. But away beyond them was there a prospect, and deep within his heart were there energies and hopes, which girded him for the onset, and made him impatient to "run upon the thick bosses of their bucklers."

The long journey was accomplished: and a miserable journey it was—very different from that, a few springs before, along nearly the same road, with a pleasant companion. Now both the season and his fellow-traveller (a low waggoner who carried his trunk) were against him. At the inns it was usually drinking, brawl and profanity, and sometimes insult from the coarse creatures, with whom he was occasionally compelled to pass the evening at the bar-room fire: on the road, as his clothing was not well adapted to the mists and chills of late and early hours, he suffered much from cold. Not unfrequently, after sunset, he went back long distances on the dismal, muddy road in search of the slow-paced, tippling waggoner, to be assailed by his ribaldry for having walked on as one who felt himself too fine for a teamster's company.

CHAPTER ❧ 6

*Life in Philadelphia. Privations and Sufferings. Energy and Industry.
Pictures. A Portrait. Cole at Law. Character of his Pictures. An early
Landscape. Cole an Author. His Poetry. Prose-writings. Emma Moreton.*

THE hardships related in the last chapter were in a measure soon
forgotten in a crowd of others more bitter. "That was indeed," he
afterwards said, "the winter of my discontent." A youthful stranger
in a humble quarter of a great city, in a little upper room, without
bed, fire or furniture, saving a few articles needful for a painter,
alive with sensibility, friendless and nearly penniless, with a baker's
roll and a pitcher of water for refreshment by day, and the table-
cloth for a cover at night, is no exaggerated picture of Cole at the
edge of that wider field of action to which he had come with so
much enthusiasm. That he did not lose it, and retreat, is more sur-
prising than that he lost his health. For weeks, the inmate of a poor
family, whom he had no pecuniary means of compensating for their
affectionate kindness, he was, from the cold, and the meagre fare to
which he had been subjected, the victim of inflammatory rheumatism.
Although his ardour was damped, it was not extinguished. He re-
turned to his work and his privations as soon as he was able to bear
them. An unobserved spectator might have seen him laying down his
palette and brushes, from time to time, and with benumbed hands and
shivering limbs almost embracing the shattered stove which his inge-
nuity had at last provided.* On some particularly cold days he inter-
spersed these cheerless warmings with the brisk exercise of whipping
his hands about him as he ran up and down a neighbouring alley.
Who could think, as he looked out of his chamber window, in the
sharp morning, upon the countless columns of warm smoke, and

* It was what was called a ten-plate stove, smoky at the seams, and without doors
to the oven. Through this oven, the openings of which were opposite, he often
used to thrust his limbs up to the body.

2 6

caught the sound of Christ-Church bells, that there would have been a cheerful light in his eyes, and hopeful anticipations in his bosom? There were both. Though the passing days could not but tapestry his inhospitable room with gloomy imagery, a strong faith, that blessed attendant on real genius, ever looked forward to times of prosperity. The trials were severe indeed, but conquerable: and the many already surmounted were always wrought into an argument that there were but few more remaining. And when the moistening eye and stifling sensation at the heart intimated a momentary giving upon, his flute, the ever-ready harp for his sadness, soothed his disturbed spirit, rekindled his enthusiasm, and gave new life and force to his resolutions. Nor, as Coleridge says of Hamlet, was the power of action lost in the energy of resolve. He was unremittingly industrious. He painted numbers of pictures, sketched from nature, and drew in the Academy.

What is remarkable, considering the sad circumstances under which he laboured, his subjects were mostly of a comic character, "The most laughable scenes," he was once heard to say,—"indeed, about the only ones of the kind I ever painted, were those executed in my most forlorn situation." This, though, was rather the dictate of necessity, than of any natural taste. Scenes of frolic and drinking would sell in the bar-room, the barber's shop and the oyster-house, when simple representations of nature could not find a purchaser. The small avails of these trifling works were not the only benefit he gained from them: they invited attention, and procured him some little reputation. He received a commission from a gentleman to paint a couple of landscapes for his parlour. Upon these he tried an experiment of baking, which, at the time, he thought quite successful: it gave them, he fancied, finer tone and mellowness, and the air of old pictures. As he was going to deliver them, he was met and accosted by an artist, who wished to know what he had got there. With much reluctance he permitted the stranger to look at his pictures, who at once inquired where he obtained them. "I painted them myself," said Cole, with much diffidence. "Indeed," said the stranger; "and what do you ask for them?" "Eleven dollars, sir." "Eleven dollars! is that all?—young man, you are doing wrong; you are lowering the art; it is by no means their value." This was no disagreeable rebuke: it stole into his breast with a pleasure that made the

delivery of the landscapes a more agreeable undertaking than he had anticipated.

Prolific as was his pencil in small landscapes and comic scenes, Cole was still too close upon beggary to refuse the offer of regular employment. The nature of his work was to ornament with figures, views, birds and flowers, various articles, such as bellows, brushes, and Japan-ware. The last work upon which he engaged for his employer was one more to his mind: a picture from an engraving of Louis XVI. parting with his family. Had his pay corresponded with the dimensions of his canvass, he would have hailed it as the advent of good fortune indeed. "I recollect, perfectly well," says a friend, "meeting him one morning, in Third Street, in a very cheerful mood. He said that he was painting a piece from French history, and invited me to come and see him. His room was in New Street, below Third, and the picture filled up nearly one end of it."

Among the several engagements into which Cole entered, at this period, the least grateful to his taste was one to take the portrait of a dead man. Necessity was a terrible master, and drove him to the task, repulsive as it was to his finer feelings. Easel, paints and palette, in short, nearly the entire apparatus of his poor studio, were duly transferred to the room of his ghastly subject, and he began. As the desire was intense, on the part of the friends of the deceased, that the picture should be both good and true, he bestowed uncommon pains in the drawing, and wrought with all the rapidity and excellence possible. Unfortunately, the corpse was obliged to be taken to burial sooner than was expected, and he had to finish the portrait from recollection. During this part of the process he was continually annoyed by the relatives, male and female, each making some suggestion vitally important to a beautiful and perfect work. It was, at length, completed: but, alas! not at all to the satisfaction of the friends. "It was not a true likeness—it lacked the fine expression:" and the poor painter, with all his expenditure of time, patience and materials, was forced to retire unrewarded. For once he was roused, and determined upon having his due. A suit was instituted, and he recovered thirty dollars.

With some abatement of the difficulties of the first few months, the remaining portion of Cole's life, in Philadelphia, is too much like that already related to need further notice.

Of his pictures, up to this time, it is necessary to say little more than that they contained the germs of future excellence. A landscape, painted in the summer, at Pittsburgh, and now in the possession of his family, is perhaps a tolerable specimen of them. By the side of one of his later productions it would undoubtedly provoke a smile from a connoisseur. But when allowance is made, not alone for want of science and experience, but for other difficulties with which he had to contend, all wonder may well cease at the excessive difference. It is painted on muslin, prepared by himself, and with the coarsest pigments. With such materials, and without the proper implements of his art, one need not be surprised at the roughness of execution, and the defects of colouring. Although in some parts faded, and in others deepened into unnatural darkness, it still bears certain evidences of the same hand that left upon the canvass the beauties of the Mountain Ford and The Good Shepherd. Beneath a heavy stone bridge in the foreground, a deep, calm stream glides out of the picture,—the outlet of a lake, quietly sleeping among hills. Glancing in to the right and left, where the little bays lose themselves behind the rocky points, the eye slides forward into the luminous distance with something of the pleasure that it does in nature. Pouring in from the east, the broad light brightens the water before you, contrasting finely with the rugged dark foreground, upon which stands a tree with much of that lightness in its top, and woody, bark-like effect in its trunk and limbs that distinguish many of his finest trees. The sky, unusually far off, is filled with white clouds, carefully studied from those that were floating in the heavens. One cannot avoid feeling, though, that they serve the purpose of a curtain to conceal a sky which he could not touch with sufficient assurance to expose. It may appear out of place to make any mention whatever of so crude a work: but let it be remembered that if The Good Shepherd was the last pure landscape of the artist, this was among the very first after he went earnestly to the study of nature. They occupy the two extremes of his artistic life: one exhibiting the skill and power of the master, the other the learner in his simplest rudiments; but still a learner that writes in almost every stroke of his pencil a promise of the excellence which, in the lapse of a quarter of a century, could well nigh rival nature herself.

One of the very best of these earliest landscapes, an Autumnal Sunset, with rich bright foliage, still remains in Philadelphia with a

lady, for whose father it was painted—a pleasing memento of the artist, who helped to save her life, when a child, from fire.

Before taking leave of Cole, in Philadelphia, a few words may be said of his efforts as an author. The passion for writing poetry did not subside in his enthusiasm for painting. During the intervals of toil at the easel, he took the pen with earnestness, and composed many poems. While these, for the most part, would find little compassion with a critic like the one who said of the Excursion, "This will never do," yet they exhibit, in spite of many faults of measure and diction, tokens of true poetic genius in a far higher degree than his early pictures. What is more, they throw a light upon the purity and religious tendency of his mind, which the works of his pencil, at the time, do not. His poems were the outpouring of his thoughts for himself: his pictures were more for others. He painted for bread and raiment, fire and lodging, and he must paint for those who would pay. But poetry, in the written word, was a work of secret love. He could not but shed it around him, in his poor solitude, for its own sake. The exquisite pleasure which its creation brought was more than compensation for all the pains it cost him. Once penned, though, it was laid away, and never permitted to wander forth to offend by any simplicity or rudeness of its apparel. The following lyric, from a blank-verse poem, written in the sad days with which the reader has just been made acquainted, and containing some truly fine passages, may claim his indulgence for the moral picture it presents of its author:

> Thou art like the young breeze of the morn:
> Over hill, over valley it swept;
> On a gay heedless wing was it borne;
> And it reck'd not the place where it slept.
>
> Round the rough mountain brow was its play,
> And afar on the ocean's blue breast;
> O'er the green velvet lea was its way,
> And the full blushing rose it caress'd.
>
> But, alas! was there aught for it there,
> On the bleak mountain rock, or the deep?
> Where all is so restless, and bare,
> There was naught for the zephyr to reap.

It is true, that the leaves of the grove,
　　With a worship bent low as it pass'd,
And the rose, in return for its love,
　　On its raiment her spicery cast.

But what of the leaves or the rose
　　Could it carry away in its breast?
In a moment, they sank to repose,
　　As if nothing had broken their rest.

So forever it fared with the breeze:
　　Though a world full of beauty it met,
It could find, but no treasure could seize:
　　'Tis a poor careless wanderer yet.

Cole wrote prose as well as verse. A tale, called Emma Moreton, written soon after his return from St. Eustatia, and subsequently printed in the Philadelphia Saturday Evening Post, is a story of some interest. The seas and the scenery of the West Indies, especially that of St. Eustatia, took a strong hold of his feelings and imagination. In the exhibition of this is the chief merit of the tale. We see there the first wrestlings of genius with the grander forms of the visible world. That it is a fair recital of suffering, and finally prosperous love, with the merit of language that paints sunsets and surf and the splendours of a tropical evening in fine colours, is of little importance when compared with the evidence, which the writer unconsciously gives, of the way that nature strikes a poet when she strikes him strongly. What was said of the tale of Emma Moreton by the readers of the Saturday Evening Post, its poor author presently ceased to think, in the change which carried him into entirely new circumstances. He left the city which had failed to give reality to those delightful visions of prosperity, in whose beauty he had walked behind the Alleghanies, and settled in that, where both fame and fortune began, at last, to smile upon him.

CHAPTER ❧ 7

An unexpected arrival. Leaves Philadelphia, and settles in New York.
Life in New York. Coles' Studio. His difficulties. His energy and cheerful
industry. First pictures, and their effect upon the public. Their results.
A student of nature again. The Hudson and the Catskills. Pictures of
their scenery. First acquaintance with artists. Success and reputation.

It was early one Saturday morning, near the close of April, 1825, that Cole thought with delight he was taking his final leave of Philadelphia. His effects were already waiting at the door, no heavy load, upon the porter's wheelbarrow. The unexpected arrival of Dr. Ackerly, his brother-in-law, and his sister Sarah, both recently from the West, and on their way to join the family, then living in New York, caused him a joyful delay until the following Monday. With these dear and welcome ones he visited, during the day, the Academy of Fine Arts, a place where he had more frequently studied than drawn, and pointed out what appeared to him, at the time, the almost unattainable excellencies of several of its landscapes. In the evening, which happened to be a moonlight of unusual brightness, he took them round his favourite walks, and desired his sister, on passing through an old and finely wooded square, to point out to him the tree which, of all others in the city, he loved the most. This, to his great delight, she happened to do.

As intimated in the foregoing chapter, the epoch of Cole's prosperity was his settlement in New York, at twenty-four years of age. Of the coyness of fortune he had, therefore, notwithstanding his many disappointments, no great reason for complaint; for seldom have the hopes of genius come to the dawn of their realization at a period earlier than this. Had her devotion been as lasting as her welcome was warm and speedy; had the city of his adoption been faithful, in after years, to foster the talent which it was prompt in finding out and rewarding in the beginning, the artist would not have felt, as frequently he could not help but feel, though would seldom

mention to his intimate friends, that he was defrauded of a just due, a reward ample enough to place him where, above all mere money-wants, he could work out such things as can only be accomplished when genius expatiates with entire freedom in the fields of art. Only four years later, when he went to Europe, Cole left behind him many pictures, some of high price comparatively, and the reputation of a fine painter. When study and practice enabled him to execute works of higher order, his reward did not answer the promise of his opening success. But let us follow him through this bright youth of his good fortune, as we have already done through seasons of adversity.

For the first two years, his studio was in Greenwich street, in the garret of his father's house, a room so narrow as to afford him barely space enough, in his process of painting, to retreat the requisite distance from his canvass. To increase its inconvenience, it had only the half of a small window. Could the young artists of these better days look in upon that poorly lighted closet, they might possibly wonder how anything good could have been done in a situation so pinched and blinded. There it *was* done, nevertheless. There, perpetually fighting with a kind of twilight, and that too almost in fetters, elbowed and pushed by mean partitions, worked the young man of serious mind, and strong heart—more serious from suffering, stronger from painful endurance and great faith,—a faith made still greater through release from trials that were sometimes actually perils.

In a word, training had made Cole at home with difficulties. Where most men would have retired with impatience and disgust, and many have surrendered in despair, he could labour on not only resigned, but with hope and right good cheer. Obstacle was his stepping stone, and embarrassment his element: but he had energies which lifted his foot surely, if not quickly, upon the one, and moved him certainly, if not rapidly, through the meshes of the other. Born with the will to persevere, exercise gave it such a force, and ostrich-like breath, that he could run long against a gale of opposition, and work almost freely in the fretting entanglements of a huge perplexity, trip and hamper when they would. Unlike the impatient person in an old play, he was one that could sing with truth, as well as with a grace, "My mind to me a kingdom is:" and so, in the narrowness of his father's garret, he had a wide patience, and a lofty spirit, and a luminous chamber in his soul. A light flowed out upon his canvass from the silent cave of

thought, though but little entered the moiety of his dormer-window. And when his small pictures were dismissed from their humble birth-place to be startled by the brilliancy of strong day-light, and the bold gaze of the public eye, and the keen glance of criticism, they did not shrink away, but stood still, and looked back out of their freshness and live beauty, till they smote the quiet beholder with the conviction of their truth and originality, and prompted him to ask the name and place of the unknown artist.

His first picture, according to an obscure pencil-list, is marked simply, "Composition;" his second, "Composition—a Storm;" the third, "A composition;" the fourth, "A Tree;" the fifth, "A Battle-piece."

These were his first pictures in New York, and were placed for exhibition in the shop of an acquaintance, Mr. Dixey, where they attracted the attention of Mr. George Bruen, who purchased three of them for the sum of twenty-one dollars. Of the remaining two one was sold to Mr. Dixey for ten dollars, and the other to whom, or at what price, is unknown. Forty dollars, at the most, (a fair compensation at the time according to the judgment of the painter himself,) was the amount realized for five pictures, any one of which, inferior as it might be comparatively, was well worth the sum. Trifling as they were, Cole had reason, in the end, to be satisfied with his prices. The pictures were the means of his introduction to the public.

Among the substantial friends which they gained him, was Mr. Bruen, through whose liberality he was enabled for a while to suspend his labours at the easel, and devote himself to drawing and painting from nature. From the moment when his eye first caught the rural beauties clustering round the cliffs of Wehawken, and glanced up the distance of the Palisades, Cole's heart had been wandering in the Highlands, and nestling in the bosom of the Catskills. It is needless to say that he followed its impulses at his earliest liberty in the autumn ensuing.

If it be interesting to know what were his first impressions of the romantic scenery, now made familiar to art by his pencil, it is certain that they were even more lively than he had himself anticipated. It charmed his eye, and took his soul captive. And what his affections so readily embraced, only became dearer to him, the more he enjoyed it. Wherever he subsequently travelled, whether among the

lakes and hills of England, the Alban heights or the Alps, up the sides of the Apennines or of Ætna, along the sea-shore, down the Rhone or the Rhine, he always turned to the Hudson, and the summits that pierce its clouds, and darken its blue skies, with the strength and tenderness of a first-love. It is questionable whether, after this, he ever painted a picture, with the exception perhaps of his European landscapes, which does not bear witness to some feature peculiar to this land of his heart.

The works executed, upon his return to the city, were "A view of Fort Putnam," A view of some locality not named, "Lake with dead trees," and "The Falls of the Caterskill." Three of these, upon their being offered for sale, were presently purchased, at twenty-five dollars a piece, "by three artists, who generously and cordially acknowledged their merit, and continued ever after his friends—Trumbull, Dunlap, and Durand."*[1]

The first that happened to discover their excellence was Colonel Trumbull, whose choice was "the Falls," which he hung up at once in his own studio, and invited Durand to come and see it, and also make the acquaintance of the painter, who was to be there by appointment. Trumbull also expressed to Dunlap on the same day "his admiration of the unknown young man's talent."

At the hour appointed, Cole came—a young man, in appearance not more than one and twenty, of slight form and medium height, soft brown hair, a face very pale, though delicately rosy from agitation, a fair fine forehead, and large light blue eyes, in which it would have been difficult to say whether there was more of eloquent brightness, or feminine mildness. For the first few minutes, a painful timidity, indicated by a quick, nervous movement occasionally, and which no reasoning with himself could overcome, restricted all conversation on his part to the briefest replies. But this subsided only to give place to another species of embarrassment with which he was much less familiar—that which arose from the complimentary language of Colonel Trumbull: "You surprise me," said he, asking him some few questions with respect to his circumstances, "you surprise me, at your age, to paint like this. You have already done what I, with all my years and experience, am yet unable to do." Into what-

* Bryant's Funeral Oration. [*A Funeral Oration Occasioned by the Death of Thomas Cole* (New York, 1848), p. 10.]

ever confusion this generous compliment might have thrown Cole, at the time, its recollection was undoubtedly inspiring. Indeed, the whole affair of the three pictures was very gratifying, and well suited to raise hopes. They were not raised in vain. Through the kindness of his new friends, the attention of the public was enlisted, and the way opened to success. He soon received abundant commissions, some from distant cities. "His fame spread like fire," said Durand, in conversation on that subject, many years afterwards; a spirited remark, corresponding with the fine strain in which Bryant speaks in the following passage.* "From that time he had a fixed reputation, and was numbered among the men of whom our country had reason to be proud. I well remember what an enthusiasm was awakened by these early works of his, inferior as I must deem them to his maturer productions,—the delight which was expressed at the opportunity of contemplating pictures which carried the eye over scenes of wild grandeur peculiar to our country, over our aerial mountain-tops with their mighty growth of forest never touched by the axe, along the banks of streams never deformed by culture, and into the depth of skies bright with the hues of our own climate; skies such as few but Cole could ever paint, and through the transparent abysses of which it seemed that you might send an arrow out of sight."

* Funeral Oration [p. 14].

CHAPTER ❧ 8

Cole the Dupe of an unworthy Patron. National Academy of Design.
Life in the Catskill Mountains. Miscellany: Sunrise from the Catskills;
Extracts from the Wild, a poem; Thoughts on Nature; Characters of
Trees; Trip to Windham; Storm in the Catskills.

T HE ensuing winter, we look in vain for Cole in his narrow painting-room. Whatever might have been the regret of friends at his absence, it certainly could not bear comparison with that which he felt himself. The victim of patronage far more pitful than that of Gainsborough's Philip Thicknesse,[1] he was lured away by fine promises to the upper waters of the Hudson, there to toil, through the solitude of the cold months, for a person who had neither the mind to appreciate, nor the honesty to reward the ability he had entrapped into his service.[2] To this cruel injustice his heartless employer added the grossest insult. He caused his apartments to be rendered cold and cheerless, and not unfrequently embarrassed, and mortified him at table. For the kind of picture which Cole then delighted to paint he affected a contempt, and advised him to turn his pencil to the bullocks of his farm-yard. Apprehension that his friends in the city might attribute his retreat to fickleness, or an over-sensitive nature, alone prevented his quitting the place with indignation in the depth of winter. He resolved, therefore, to bear quietly with his wrongs, for the time stipulated, and labour on as well as possible.

Of the works then executed, and which (perhaps with a single exception retained by the artist) were apparently presented by his very worthy patron to his friends, as specimens of the genius he had found and fostered, but really, to enlist attention to the beauty of the country in which was his own estate, "one of them was," as Bryant describes it, "a wild mountain scene, where a bridge of two planks crosses a chasm, through which flows a mountain stream. It has not the boldness and frankness, the assured touch, of his later productions, but it is full of beauty. There are the mountain summits, unmistakably

3 7

American, with their infinity of tree-tops, a beautiful arrangement of light, striking forms of trees and rocks in the foreground, and a certain lucid darkness in the waters below. The whole shows that Cole, amidst the discomfort and vexations which surrounded him, suffered no depression of his faculties, and that the vision of what he had observed in external nature came to him, in all its beauty, and remained with him until his pencil had transferred it to the canvass."

Among those incidents of his early history of which Cole, in the small circle of his intimates, would occasionally talk with gaiety—and he could talk, at times, with ineffable humour—his falling in with this unlucky patron was one. The story of his grand expectations, as he removed the implements of his art from the humble chamber in Greenwich Street for what he fondly imagined delightful rooms in a species of rural palace, and of his brilliant fancies of happy fortune, on the passage up the Hudson, in pleasant intimacy with his opulent friend, all in broad contrast with the disappointment, annoyance and chagrin that succeeded, was irresistibly ludicrous.

Cole was now a member of the newly-formed National Academy of Design, of which also he was one of the founders.[3] Of the originators of this institution he speaks, several years afterwards, in his private journal, in terms of high praise,—as men high-minded, distinguished as artists, and bound together by congenial feeling.

At its first exhibition in the spring, that of 1826, he contributed one of the pictures, the exception mentioned above, painted in the foregoing winter. Its subject quite corresponds with his then cheerless situation,—a snow-piece, thrown off at the moment when his feelings were crisp with the frost about him;—"not one of his most remarkable works, perhaps," says Bryant, "but bearing the characteristics of his manner."

With autumn came another release from the toils of the painting-room, and the joyous freedom of the romantic Catskills. It is quite impossible to convey a true impression of that blissful feeling with which Cole both anticipated, and enjoyed a season of retirement in the regions of the picturesque. He himself could not have spoken of it intelligibly had he seriously made the attempt. Long companionship and sympathy with him could alone make the discovery. Religious fellowship with nature ever fills the bosom with an incommunicable happiness, more especially the bosom of a true poet; and Cole walked

with her as such, even while he looked, and laboured as an artist. He thought and felt as one that was making himself ready for the lofty task of sublime song, rather than the great picture, even while he was seeking the knowledge needful for the painter—the knowledge of all that can be mastered by the eye in the material creation. It was an axiom with him: "To walk with nature as a poet is the necessary condition of a perfect artist."

It was usually his habit at the close of the day, particularly in these choice haunts, to write some little description of the scenes and incidents of his rambles, or to embody in verse a thought or sentiment. These, at his leisure, were sometimes copied, and improved. They are interesting chiefly on account of the occasional illustration they afford of that exquisite feeling of which I have just been speaking. The reader is presented with the following:

SUNRISE FROM THE CATSKILL MOUNTAINS.

The mists were resting on the vale of the Hudson like drifted snow: tops of distant mountains in the east were visible—things of another world. The sun rose from bars of pearly hue: above there were clouds light and warm, and the clear sky was of a cool grayish tint. The mist below the mountain began first to be lighted up, and the trees on the tops of the lower hills cast their shadows over the misty surface—innumerable streaks. A line of light on the extreme horizon was very beautiful. Seen through the breaking mists, the fields were exquisitely fresh and green. Though dark, the mountain side was sparkling; and the Hudson, where it was uncovered to the sight, slept in deep shadow.

A similar prospect is painted in fresh colours in the passages below, taken from a poem called The Wild:

 * * * * * * *

Friends of my heart, lovers of nature's works,
Let me transport you to those wild, blue mountains
That rear their summits near the Hudson's wave.
Though not the loftiest that begirt the land,
They yet sublimely rise, and on their heights
Your souls may have a sweet foretaste of heaven,
And traverse wide the boundless. From this rock,

The nearest to the sky, let us look out
Upon the earth, as the first swell of day
Is bearing back the duskiness of night.
But lo, a sea of mist o'er all beneath;
An ocean, shoreless, motionless and mute.
No rolling swell is there, no sounding surf;
Silent and solemn all;—the stormy main
To stillness frozen, whilst the crested waves
Leap'd in the whirlwind, and the loosen'd foam
Flew o'er the angry deep.
 See! now ascends
The lord of day, waking with heavenly fire
The dormant depths. See how his luminous breath
The rising surges kindles: lo, they heave
Like golden sands upon Sahara's gales.
Those airy forms, disparting from the mass,
Like winged ships sail o'er the marvellous plain.
Beautiful vision! Now the veil is rent,
And the coy earth her virgin bosom bare
Slowly unfolding to the enraptured gaze
Her thousand charms.

The following from the same poem shows the finest eye and feeling
for nature:

* * * * * * *
 O, for an hour
Upon that sacred hill that I might sleep,
And with poetic fervour wake inspired!
The would I tell how pleasures spring like flowers
Within the bosom of the wilderness;
And call from crumbling fanes my fellow-men
To kneel in nature's everlasting dome,
Where not the voice of feeble man does teach,
But His, who in the rolling thunder speaks,
Or in the silence of tenebrious night
Breathes in his power upon the startled ear.
Then would I tell the seasons' change:—how spring
With tears and smiles speeds up the mountain side,
And summer sips the moisture of her steps;—
Tell how rich autumn, decked in coloured robe,
Laughing at thirsty summer, ceaseless shakes
The juicy fruits from her luxurious lap;—
And winter, rending in his angry mood,

40

With cold remorseless hands, the mantle bright
His dying sister left him, rudely sweeps
His snowy beard o'er all the beauteous world.

* * * * * * *

The sun was set in peace. It was the hour
When all things have a tone of sadness;—when
The soft cloud moves not on its azure bed,
Left by the purple day to fade and die,
But beautiful and lovely in its death
As is the virgin who has died of love.

* * * * * * *

THOUGHTS ON NATURE.

In the shady vale, on the mountain top, in the forest, by the stream, a banquet is ever spread; and he who feasts may exclaim: Here is pleasure that neither palls nor brings remorse.

The most inattentive observer of nature is often struck with a transient delight as her beauties are disclosed: what then must be the enjoyment of one who contemplates her with the ardour of a lover?

Nature has secrets known only to the initiated. To him she speaks in the most eloquent language. * * * *

CHARACTERS OF TREES.

Treading the mosses of the forest, my attention has often been attracted by the appearance of action and expression of surrounding objects, especially of trees. I have been led to reflect upon the fine effects they produce, and to look into the causes. They spring from some resemblance to the human form. * * There is an expression of affection in intertwining branches,—of despondency in the drooping willow.

In sheltered spots, trees have a tranquil air, and assimilate with each other in form and character. So with men secluded from the world. They have an equality seldom broken by originality of character. Expose them to adversity and agitations, and a thousand original characters start forth, battling for existence or supremacy. On the mountain summit, exposed to the blasts, trees grasp the crags with

their gnarled roots, and struggle with the elements with wild contortions.

Attracted by the wild scenery of Windham, one of the Catskill Mountain towns, Cole made an excursion there in the autumn of 1826. The following is a description of an ascent to a mountain summit:

TRIP TO WINDHAM.

*　　*　　*　　*　　*　　*　　*

October 8th.

At an hour and a half before sunset, I had a steep and lofty mountain before me, heavily wooded, and infested with wolves and bears, and, as I had been informed, no house for six miles. But I determined, in spite of all difficulties and an indescribable feeling of melancholy, to attain my object: so, pressing my portfolio to my side, I dashed up the dark and woody height. After climbing some three miles of steep and broken road, I found myself near the summit of the mountain, with (thanks to some fire of past times) a wide prospect. Above me jutted out some bare rocks; to these I clambered up, and sat upon my mountain throne, the monarch of the scene. The sun was now nearly setting, and the shadows veiled in dim obscurity the quiet valley. Here and there a stream faintly sparkled; clouds, flaming in the last glories of day, hung on the points of the highest peaks like torches lifted by the earth to kindle the lamps of heaven. Summit rose above summit, mountain rolled away beyond mountain,—a fixed, a stupendous tumult. The prospect was sublime. A hasty sketch or two, and I commenced my descent. After a hurried walk of two or three miles, I came to a log-house, a rude swinging sign pointing it out as a place of sojourn for the night. I walked in, and it appeared comfortless enough. The floor was covered with dirty water—a process of cleaning, I suppose. I felt as though I should be more comfortable in the woods. I was relieved, however, a little when my landlady appeared with clean and smiling face, and asked me to walk up stairs. A scene of neatness here presented itself that I had not expected. After a plain supper of cheese, rye-bread and butter, I was entertained by an old hunter with a recital of feats of the chase. Here, in this valley, he and his wife had resided for more than twenty years, and raised, without

the help of any hands beside their own, the first log-house. Those were days of privation and hardship for the pioneer; but he looks back upon them as days of happiness. "There were few of us then," the old hunter said, "and we loved one another, and helped one another; but it is not so now." I believe all the people in the little settlement flocked together, this evening, to see me,—a strange animal, surely; and a hard-featured, long-bearded, long-legged company they were. My portfolio was an object of universal curiosity. One wiseacre pronounced it, with low voice and a look of profound wisdom, "*a grammar.*" They took the liberty, when my back was turned, of opening it, in order to see what so large a book might contain. What discoveries they made, in their own estimation, I hardly know: I simply heard something about maps. As I could see but one room and two large beds with a trundle-bed under each, I began to suspect that I should have to turn in with the family. I was agreeably surprised, however, when I was shown into a closet, the door of which could not be shut until I was fairly in bed. But I slept soundly, and rose early, ate a good breakfast, and desired of my kind host what was to pay. *One shilling!* I offered them a bank note, as I had no silver: unfortunately, they could not change it, and so I gave my note for *one shilling*, payable on demand, at ——'s, about nine miles distant. I then took my way back, "over hills, over dales, thorough brush, thorough briar."

STORM IN THE CATSKILLS.

In one of my mountain rambles, I was overtaken by a thunder storm. In the early part of the day, the sky was brilliant and unclouded. As it advanced, huge masses of vapour were seen moving across the deep blue. Though there was some reason to expect a storm, I contented myself with the hope that the clouds would pass over the mountains without unburthening themselves. My hope proved fallacious. A sudden darkness enveloped the scene, which a few moments before was beaming with sunlight, and thunders muttered in the distance. It was necessary in a few moments to seek a shelter, which I found beneath an overhanging rock. Under this massy canopy of stone I took my station, with the feeling of one who knows himself out of the reach of peril, while it is all around

him. Here, thought I, as I paced the rocky floor of my temporary castle, I will watch, unharmed, the battle of the elements. The storm came on in all its majesty. Like a hoarse trumpet sounding to the charge, a strong blast roared through the forest, which stooped in its weakness, and shook off its leaves thick as in October. To this tremendous onset succeeded a death-like calm. The deep gorge below me grew darker, and the general gloom more awful: terrific clouds gathered in their black wings upon the hollow, hushed abyss closer and closer. Expectation hung on every crag. A single pass of one long blade of lightning through the silence, followed by a crash as of a cloven mountain, with a thousand echoes, was the signal for the grand conflict. A light troop of rain-drops first swept forward, footing it over the boughs with a soft and whispery sound; then came the tread of the heavy shower: squadrons of vapour rolled in,—shock succeeded shock,—thunderbolt fell on thunderbolt,—peal followed peal,—waters dashed on every crag from the full sluices of the sky. I was wrapped in the folds of the tempest, and blindfolded to every prospect beyond the rugged doorway of the cave. Then came up a thousand fancies. I fancied anything and everything. I thought myself careering, in a chariot of rock, through airy wastes beyond the reach of gravitation, with no law but my own will: now I rose over mountainous billows of mist, then plunged into the fathomless obscure: light shot athwart the darkness, darkness extinguished light: to musical murmurs succeeded quick explosions: there was no finish, no fixedness, nor rest. But the storm kept on, strong and furious: no fancy could dissipate the awful reality, no imagery of the mind could amuse the fears that began to throng around my heart. Trees fell with a stifled crash, cataracts mingled their din with the general uproar. I actually began to fear the rocks would be loosened from the brow of the mountain above me, and roll down with overwhelming force. The lightning played around my very tenement, and the thunder burst on my door-stone. I felt as feeble as a child. Every moment my situation was becoming more comfortless, as well as romantic. A torrent, to all appearance parted by the projecting crag which formed the roof of my shelter, came rushing down on both sides of me, and met again a short distance below me. Here I was, a captive to the floods, and actually began to meditate the possibility of having to pass the night in this dismal nook. There was the hard rock, a little

mat of moss, and the remains of a mountain dinner in my knap-
sack. In a word, my lodging furnished almost everything but comfort.
The wind now drove the chilly vapour through my portal, the big
drops gathered on my stony ceiling, and pattered on my hat and
raiment, and, to complete my calamity, the water began to flow in
little brooks across my floor. My anticipated bed of moss suddenly
became a saturated sponge. I was reduced to the hard necessity of
piling up the loose flakes of rock that lay scattered through my in-
hospitable hall, and courting contentment on the rugged heap. I had
one remaining hope, the sudden cessation of the storm. I knew the
sun was hardly yet setting, although the darkness had deepened fear-
fully within the last few moments. But this turned out, to my great
joy, to be the crisis of the tempest. All at once, a blast, with the
voice and temper of a hurricane, swept up through the gulf, and
lifted with magical swiftness the whole mass of clouds high into the
air. This was the signal for general dispersion. A flood of light burst
in from the west, and jewelled the whole broad bosom of the moun-
tain. The birds began to sing, and I saw, in a neighbouring dell, the
blue smoke curling up quietly from a cottage chimney.

CHAPTER ❧ 9

Cole in Catskill. Miscellany: The Bewilderment.

Natural aversion to a city and the gay society in which he now occasionally mingled, with the love for rural life which finally settled him in the country, led Cole to Catskill again, early in the summer of 1827, where he took lodgings, and fitted up a painting room. As usual, much time was spent in the open air, painting and drawing natural objects, and wandering alone through his favourite mountains.

The following singular story, very likely in part a fiction, is, nevertheless, a lively and exciting sketch of the poetic artist in the midst of the fatigues and dangers not unfrequently incident to his walks for the picturesque.

THE BEWILDERMENT.

The sun hung low in the sky, and to me seemed to hasten down with unaccustomed speed, for I was alone, and a stranger in the wilderness. The nearest habitation I knew to be on the other side of a mountain, that rose before me, whose tangled woods were well known by the hunters to be the haunt of wild animals. I had walked far that day, but my path had been through regions of nature that delight and impress the mind. Excitement had well nigh carried me above the reach of all fatigue. Though not quite as buoyant in spirit as in the morning, still my feet were not slow upon the leaf-strown path. In the midst of society and the stir of cities, men do not experience those vicissitudes of feeling which result from the change of natural objects: a lone man in the wilderness is affected by every change, by the light and by the shade, by the sunshine and the storm. In the fine morning, his spirits are fresh and elastic as the breeze he breathes, sad thoughts vanish like mists in the sunbeams, and he feels as though weariness could never overtake him; but when evening is dropping her dusky

curtains, the wind has a tone of sadness, and the sound of the water-
fall steals through the arches of the forest like the voice of a moaning
spirit. Thus was it with me; joyous as I had been through the splen-
dour of the day, I could not but feel a tone of melancholy as I
threaded the deepening shadows of the woodlands. The road was
steep and difficult, and the thick boughs, on both sides, shut me in
from every distant object. I reached, at length, the top of the
mountain, and enjoyed a glorious prospect. The sun was sinking be-
hind a dark fringe of pines and rocks, leaving the vales in solemn
shadow: here and there beams of reflected light shot up from the
depths, and discovered the quick brook or the quiet pool: on every
hand, the mountains bore their ancient burden of woods; far as sight
could stretch, through glens and craggy passes, and up to the mountain-
line melting away in misty distance, all was the old, woody wilder-
ness. Here and there, piled on the overtopping pinnacles, clouds
bathed themselves in the last, red sunbeams. Before I could leave this
glorious solitude, I was breathing the chilly air of twilight. Anxious
to reach my intended resting-place for the night, I hastened forward
with redoubled speed. My path was steeply down into a deep valley:
the shades thickened at every step, and rendered its windings more
and more obscure: several times I hesitated in doubt of its course; at
length, I lost it entirely. A tornado had recently passed this way, and
laid prostrate almost every tree in its track of desolation. How long
I struggled through the entangled roots and branches, I could not
tell; but they seemed interminable. I went forward and back, to the
right hand and to the left; I went every way, and finally became so
perplexed and bewildered as to be utterly incapable of deciding in
what direction I ought to go. I suspect that I went round and round,
not unfrequently, through the same toils and entanglements. The
truth, at last, crept over me—*I was lost*—lost past finding out; or
being found, at least for that night. Fatigued, dripping with perspira-
tion, and disheartened, supperless and vexed, I sat down in the briars
with the resolution of waiting patiently the break of day. This was
but a transient resolve: the air grew very chilly, wild clouds hurried
across the sky, and the wind sounded hollow and forebodingly in the
forest. Inaction I could endure no longer. Again I endeavoured to
extricate myself from the windfall with a desperate energy: I climbed
and stooped, scrambled, crawled and dodged; now a limb struck me in

the face, and I fell backward among the brambles; then I made a mis-step, or a rotten bough broke beneath my foot, and I plunged forward with a crash. I was momentarily in danger of breaking my limbs, and putting out my eyes. At length, to my unspeakable delight, I struck into open ground, and advanced for a few yards with as much spirit as if the difficulty was all over, and the end of my efforts was attained. This again was of short duration. The ground was a pitch black; I could no more detect the nature of its surface than a blind man. One moment, I fancied it was smooth when it was rough; another, I seemed on the edge of a hollow, and started back, when the surface was actually rising. This kept me in a succession of false steps nearly as annoying, if not so dangerous, as my scramble in the windfall. I came in a short distance to a stand. With all the penetration of a keen eye-sight, I found that the various objects around, logs, hillocks, hollows, outlines of neighbouring rocks and ridges, were all imagination: it was dark as Egypt. No human eye could sound the black obscurity. Again I ventured forward a few rods, and then stood still as before. I stood perfectly still. Although the next few moments were amongst the most strange and critical of my life, I stood without the least sense of peril, listening to the rapid beating of my heart, when the sod burst from beneath my feet, and I shot down an almost perpen-dicular bank of earth, with a force and swiftness that outstripped the loose earth and stones that came on pell-mell in my pursuit. In vain did I throw out my arms with the hope of grasping rock, root or shrub: it was only plucking more mischief down with me: every-thing I seized gave way instantly, and joined in the general plunge. How lengthy was the earthy steep, or how high was the rock over which, at last, I dashed headlong, I formed no calculation: deep water received me in its cold embrace. By what manoeuvre (for I never could swim) I managed to escape instant drowning I cannot tell: an involuntary struggle brought me from the depth, and clinched my hands with an iron grip to a rock that rose above the surface of the water. Upon this cold, yet kindly mass, I pulled myself up with some difficulty, and lay for a while almost motionless and exhausted. In a few minutes, I was sufficiently recovered to sit up, and look around: the centre of the earth could be no darker than the chasm into which I had fallen. Saving a small spot of blue sky, far, far overhead, with a single star, all was dark as Erebus itself. I soon discovered that the

rock on which I rested was in all likelihood in the very middle of the pool, of whose depth and dimensions I was entirely ignorant. My first thought was to sit out the night; a few minutes of inactivity were enough, however, to convince me that I was on the rack; my hands and feet began to ache with cold, and my whole frame to shiver. The lone star was now extinguished, and the wind began to howl in the forest above me in token of a coming rain: the trees moaned sullenly, and chafed each other, and a large rain-drop fell upon my face. My situation, I felt, was one of exceeding peril, and I grew restless with painful uncertainty. A heavy rain I knew would speedily swell the brooks to raging torrents, and sweep me inevitably from my little islet. Something must be done quickly in order to relieve me from my present critical situation. Taking firm hold of the rock, I lowered myself carefully into the water, and found it, to my distress, beyond my depth: it was with the greatest difficulty that I regained my former situation. I then tried in the same cautious way the other side of the rock, and with better success; I could touch the bottom. Quitting with no small reluctance my strong hold, I turned, breast deep in the water, and waded slowly and cautiously towards— the darkness. A few steps satisfied me that I was approaching something; I felt it with my face so sensibly that I put forth my hands, and laid them flat upon a wet, solid wall. As wide a circle as I could describe with both hands was on the same perpendicular surface: my heart sunk within me, my blood ran with a sort of chilly tingling through my veins, a cold sweat stood upon my forehead. I was imprisoned in a dungeon of precipices, and the rain was falling in sheets. A kind of sickness seized me, the sickness of despair. "Here, then," I exclaimed aloud, "I shall perish: my friends will never know what has become of me." Almost involuntarily I hallooed; but all to no purpose. My voice was smothered instantly in the roar of the wind and rain. A sort of desperation now took sudden possession of me, and I determined to rescue myself at every hazard. My fears subsided, and I stood up by the dripping wall of my prison with the calmness of one that knows at last his deliverance. I first tried by holding my hand in the water to ascertain the direction of the current, in order to search for some escape by the outlet: the water was in perfect repose, duller than Styx. With complete self-possession, I then commenced a process of exploration, wading round the pool with one hand upon

the rock. The caution with which I took my steps, sometimes in water almost too deep to admit of further advance, necessarily made my progress very slow, and prolonged the distance; the pool seemed of tedious extent, although I have no doubt it was comparatively small. A rumbling murmur, as of a stream running in a cavern, now came distinctly upon my ear, in a momentary abatement of the storm: a few yards of further wading confirmed my conjectures that I was at last approaching the outlet of the dungeon lake, and the door of my escape. Judge of my terror, when I found the water tumbling into the mouth of a cavern, the arch of which I could feel with my hands, as I stood in the rapid, though fortunately shallow current. But the paroxysm of fear was quickly over, and I boldly made my way down among the crags and foam, let the event terminate as it would. I was now working with the energy of a desperate man, and felt equal to anything, and afraid of nothing. I clambered down the subterranean rapid, which luckily was more turbulent than deep, without the least difficulty, and landed on a smooth, rocky floor, over which the water flowed silently. Whither into the earth all this was going to lead me was a matter with which the imagination was fearfully busy; but there was no return, and no delay. I waded forward carefully, but boldly: the dash of my footsteps rung strangely through the hollow antre, and I felt a wild and vivid pleasure as I advanced. I shouted —sung—whistled for the very horror of the thing, and strode on courageously and strong. All at once the floor perceptibly declined, and the water deepened. I paused a moment, returned upon my steps, and struck my head against the limb of what proved a small dry tree, lodged in a freshet on a projecting crag of the cavern. An instant was sufficient to conceive, and commence the execution of a plan: I rolled off the dry fragment of the tree with a loud plunge into the water, and pushed it on before me until the depth was too great for wading, and then mounted it, and committed myself to the mercy of the current. Tedious was the time consumed in this strange voyage: for a while it was doubtful whether I advanced, or remained still, so gradual was my progress down the grim and silent chamber. At length, the motion of my odd bark was evident, and I heard the low murmur of falling water. By the movement of the tree I became satisfied that the stream was becoming swift and whirling, and that the crisis of my fate was fast approaching. The murmur had now increased into the

dashing of a cascade, and the oppressive stillness of the cavernous atmosphere was broken by gusts of misty wind: I held myself rigidly still, and floated on smoothly and swiftly: there was an almost instantaneous lighting up of the darkness: my bark struck. I sprang involuntarily into the shallow rapid. I was indeed on the verge of the waterfall; but, to my inexpressible joy, I found myself in the open air. A few steps brought me to a sandy bank, where I sat down in a state of mingled excitement and gratitude, and rested till my stiff and chilly limbs warned me to make some further efforts to find a dwelling. The tempest had passed over; the moon, now clipping the rugged outline of a distant peak, shot her soft light through the shattered clouds; a faint blush in the east announced the dawn; and the barking of a dog gave delightful intelligence of a house. Wet and weary, I once more picked my way through the vexing brushwood, and soon fell upon a path that conducted me to the log cabin, of which the dog had kindly given me the signal. A rousing fire and a venison steak came in pleasing succession, with many "wonders" and "guesses" by mine host, a rough, but hospitable woodman. Among the most remarkable, was the wonder, how I came to get into the "pot," as he called the perilous gulf where I had spent a part of the night so delectably.

CHAPTER ❧ 10

Cole's Spirit in the Study of Nature. His Pictures the Embodiment of Simple, wild Nature. A higher kind of Art naturally suggested, and growing out of the Elements of his Character.

T HE reader will hardly fail to perceive the main design in introducing these earlier miscellanies of Cole: they exhibit his eye and feeling for nature, and his manner of life in its pursuit. With what exactness, as a student of art, he studied, and copied nature, in her manifold dispositions, in all the infinitude of her figure and complexion, her motions and attire, would come rather within the pale of criticism upon his drawings and pictures. At present, it may be permitted to speak less particularly, as I am more engaged in describing the *field* of his studies, than the studies themselves,—the way of his thinking, feeling and looking, in the hour of his work, than the work itself. To know the *spirit* in which he went is, at first, more important than to know just the *individual things* for which he went, and the precise manner of his dealing with them; and for the reason, manifestly, that in the study, for instance, of forms, he always himself first sought to penetrate their vital principle or spirit; laying it down as a law, that knowledge of the subtle truth of form, even in its most palpable outline, was impossible without a knowledge of its informing power; which, in order to be reached, must be sought with that earnestness that knows no abatement, and with that faith and affection whose characteristics are docility, humility and growth; whereby one only, at length, "sees into the life of things;" and, it may be added, thereby reveals the fact that there is a creative power within him, constituting him a genuine maker or poet. With this earnestness, this faith and affection, I am now rather engaged; and think to show Cole the possessor of them, in such high degree, that he was always the poet, when he was the painter—which, of course, is to say almost more than can be said of any landscape painter that has appeared.

5 2

Did life bear the least proportion to art, Cole would have walked the earth over and over, under the impulse which was ever carrying him with devout spirit into the crypt, and up to the pinnacles of nature's temple, as well as with reverent footsteps towards her altar. As life is,—too short, in his own case, if one may breathe his natural regrets—he went far, and saw many things, and gleaned heavy sheaves. He laid his warm hand, day by day, upon what was to him the live, palpitating breast of the world; and where time and man had made deep wounds, and left the great scars, there he placed his fingers thoughtfully upon the bones. And then he took hold lovingly of the world's raiment, the sea, and the green turf, running waters, and forests; and watched the changing expression of the great countenance; and lived upon the gloom and glory in which the world moves, and which repose upon its bosom, and give at once majesty and awe, sweetness and beauty, to its brow and temples,—namely, darkness, distance, sunshine and colours, clouds and air. "Why do not the younger landscape painters walk—walk alone, and endlessly?" was a remark of his to a friend, as they were footing it along the road from Glens Falls to Lake George, over which wild track he was a solitary pedestrian, some twenty years before. "How I have walked" —and surely he might mention it without egotism—"how I have walked, day after day, and all alone, to see if there was not something among the old things which was new!" Certainly there was, and would have been forever; and the consciousness of that made him count as little what he had gotten, and as much that which he was yet to acquire. Hence his eye must not be satisfied with searching, nor his hand be wearied with securing, nor his soul cease to thirst for new beauty. Was there a lake in a distant solitude, wondrous mirror of the sky?—go and see: he had seen a thousand lakes glassing the trees, the rocks and the heavens, but not the one there: therefore, go and see. Were there lichens on the precipice, blackness and brightness straying among the ruins of the chasm, foam on the lip of the pool?—go and see: foam, lichens, light and shadow were familiar, but yet might, nay, must be new, under new circumstances: therefore, go and see. Such was the law to which his footsteps were ever patiently obedient; such was his way. A walk from dawn to mid-day might stretch between him and the object of his seeking; no matter, such was his way; and he went, not as one turned out to a task, but as a lover; not as one that

had beaten the track till he could follow it blindfold, but with the sweet wonder of a boy's first time. If there ever was a mortal that pressed towards the visible works of God with the fresh enthusiasm of one who goes newly to behold the wonderful, that mortal was Cole. He went, at the hundredth time, as one going for the first time, —not in words, not in outward excitement, but in all gentleness and quietness, and in spirit, for he went to seek spirit: and when he found it under the shuck and crust of things, shuck and crust were all beating and throbbing with life; they were living creatures, ever beautiful, ever new: and so the last time of looking was as the first, and nature grew to him youthful instead of older, and covered tokens of heaven and immortality in its mouldering trunks, as ashes cover the living coals.

In speaking of his earnest seeking after nature's excellence and truth, of his gentle fearlessness, his quiet energy, his modest boldness, subtle, penetrating watchfulness, endless diligence, one's thoughts multiply like concentric circles from a steady dropping on a pool. With all the industry of a pilot's apprentice, he sounded with his eye, from many high places of the earth, the great airy deep,—the dawn, and the pure, dark depth before the dawn,—the coloured west, and the north in the hour of its mysterious glow,—up into the etherial blue, and the fleeces of heaven,—down into the dusty atmosphere of the valley. Things which never could be painted, creatures which never could appear in the skies and the air of art, but which, nevertheless, must be known in order to a true painter,—the wing of the pigeon flashing in the sun, the thistle-down sparkling on the breath of the lucid afternoon—were caught in the meshes of his glance, and held till the grace of their motion, the brightness of their show, and the life and splendour of which they were suggestive, were written on his memory, and immersed in the spring of his feelings. This may be counted fancy: no, it is only illustrative of fact. Neither is it less than true that of all on the earth, upon which, from the loftiest height, *you* can let fall the eye, there was literally nothing which to him was not the object of earnest affectionate contemplation. His diligence could find out more than we have ever found, from the aerial sweep of the mountain-line to the curves of the sea-shore. Easy slopes from the plain, stony steps into the clouds, he went up and down, even when others were asleep. What wonder then that the sweet com-

pany of green-sward dews and flowers, washing and scenting his footsteps, and of mists sprinkling their purity in his face, moving silently upward, were as household things, and all worked into his very love a blooming, precious embroidery? From the swell of the mountain's bosom, and the bristling crest of the bushy hill, to the pebbly bottom of the brook, running under the velvety bank through the meadow, was a study, rather ties of studies: broad shadows, shadows broken by the sun, broad sunshine, sunshine striped by shade, the wide sea of sunlight sparkling along the shore of the deep wide shadow, were the grandest studies: the vapoury curtain dropped in the distance was a delicate study: airy spaces separating nearer and remoter objects were profound studies: fissures and chasms, tokens of the earth's primitive upheaval, the broken bank and the snapped tree, and the rotting tree with its jewsears, the rock in its vesture of mosses and the rock in its lichens, the rock under its fern and the bare wet rock, were all careful studies: the bright eye of the pond and the black lock of night secreted from the noon-day among the boughs of the wood and in the roof of the cave's mouth, were rare and subtle studies: the force and not the curve only of the waterfall, the breaking back and not the rushing onward only of the torrent, the revolving masses and the power and not the surface only of the billow, the ghostly lightness, the spirit, the silent breathing and not the mass and motion only of the cloud, were all studies, studies of strong thought, studies of feeling, kindling often into glowing warmth: the forest-tops myriad, each moving into each like waves on the yellow grain or the blue ocean, the solemn depths of the forest under, all surfaces and outlines broken and melting into wavy smoothness, ragged edges and points, grappling roots, silken fibres sewing the seams of the soil, webs timid of the softest airs, luminous dust darting into shadow from the gleaming ray, were also studies asking and receiving the scrutiny of the patient piercing eye: landscape lapped in the vale, tilth and groves, crystal winter, vernal bloom and tenderness, summer's calm and tempest, brightness, richness and rain, ripe mellow September, crisp October morning and her funeral pomp, and man, his works, the ruins of his pride, his living home, were studies, beautiful, wonderful studies, calling out the affections of his inmost heart.

From the visible forms and spaces, qualities and forces of nature, her motions also, and her rest, Cole went on to the audible and in-

visible. With him there was no pause inside of the bounds of the material and sensible. His tracks were plain and manifold up to the line where sense ends and the spiritual and the imaginative begin. He inquired after the expression of the viewless winds and sounds. His ear, delicately attuned to the preciousness of music, caught the far-off harping of silence and the whispery melodies that glide under heavier voices and mightier harmonies.

The writer is aware that, in some degree, he is repeating himself, and also anticipating something of what belongs more strictly to the artist's works themselves. His excuse is the desire to open to the reader the field of Cole's studies, in some small measure, as it opened out to him; and also to make manifest the enthusiasm, energy, and untiring industry, above all, the earnest, affectionate spirit with which he laboured in it.

If there be anything more which one would fondly snatch from the thoughts still multiplying around the subject in hand, it is that Cole clearly saw, and heartily rejoiced in the great and all pervading principle of the universe, *unity arising out of infinity*. As in the humblest object, a pebble or a fungus, there is a hint, an expression of the infinite, so in the innumerable assemblage of all things there is a language eloquently expressive of unity. Infinitude in each; a harmonious union, a oneness out of all. To realize this was Cole's, at an early period.

Nature, pursued with such assiduity and love, would, if such a thing were possible, be bounteous to a common mind. To one like Cole she not only spread out the fairest folds of her robe, but threw it around him, and clasped him to her bosom, and told him of her mysteries. From one so nurtured at such a breast, and so tenderly admonished at such hands, (for nature gives gentle warnings, though faithful, to them that love her,) what other pictures could have been anticipated, prior to his study of Italian scenery, than the very ones he painted? They are precisely what might have been looked for—the embodiment of scenes in which his mind delighted, and with which the reader must now feel himself familiar. One that can picture to himself those scenes with any degree of faithfulness, may also see the painter's representation of them. To all who have a knowledge of them the expression of the artist, Huntington,[1] in a paper on the character of Cole, must commend itself: "In early life," says he, "the love

of nature, as she exhibited herself in the untamed loneliness of our forest scenery, was his chief passion. He studied to embody whatever was characteristic of the singular grandeur and wildness of mountain, lake and forest, in the American wilderness. He rejected, at this time, all that was conventional, all the usual methods of the picturesque, everything that looked like cultivation, or the hand of art softening the rudiments of uncontaminated nature. He would scarcely admit into his productions the hut of the adventurer, or the lonely fisherman; but preferred the Indian canoe, or the savage himself stealthily moving among fallen trees, or the deer fearlessly drinking the waters of the lake. Could one have looked over a portfolio of his sketches, at this time of his life, it would have been found stored with those materials which are abundant in the most terrific and inaccessible fastnesses of our mountain scenery. Silent and transparent lakes shadowed by impenetrable woods, reflecting the bold outlines of precipitous mountains; huge masses of rock, which had once strown the forest with ruin and confusion, now enriched with wild vines; shattered oaks and mighty pines, and all features of wildness and boldness would have continually greeted the eye. His desire, at the time, appeared to be to seize the true character of our own scenery, and to identify his pencil with it."

From one, whose pencil answered so well that which could have been anticipated of him, is it not reasonable to suppose that there might have been expected something more? Need we wonder that while earth and sky yielded to him their body and their spirit, their clothing and their marvellous life and forces, they should moreover suggest to him things grander than themselves, themes above and beyond themselves, (in which, indeed, they would be called to act a part, and a great one, but yet, often, only a subordinate part,) even themes, in which the mind of man and the Maker should be expressed, as it is not possible for any mere likeness of simple nature to express?

It has been occasionally said of Cole that, at this earlier period, he seemed to have few or no *thoughts* of painting anything but wild nature. He painted such mainly, and with a passion, it is true; but that he had few thoughts for anything further is a mistake. It is a mistake, though, very naturally made by judging him from his works, rather than from certain elements of character. Says the chief captain of living poets:[2]

THE LIFE AND WORKS OF THOMAS COLE

"The child is father of the man."

Cole was a remarkable example of this. His youthful and manly days were

"Bound each to each by natural piety."

He was born with a sensibility which, as he grew, manifested itself to be most exquisite to all impressions of beauty, to all physical delight and suffering, and also to all moral distinctions. He could not himself bear to inflict, nor to see others inflict pain upon the meanest animal; and hence he could never be taught to love the sports of the huntsman or the angler. Of moral delinquency, however slight, his boyish judgment was so severe as frequently to earn him the epithets of fault-finding and cynical. So intense was his passion for the beautiful, that, in his case,

. "the hour
Of splendour in the grass, of glory in the flower,"

seemed never to wane, and pass away. With all this fine moral feeling there was blended, notwithstanding the lack of a true religious training in childhood, strong religious sentiment. He had a profound sense of the antagonisms of life, and of the deep yearning of humanity for release and consolation under the spiritual blight that had fallen upon it, and of which innumerable things in the material world were mournfully typical. This lively consciousness of moral distinctions, this sensibility to suffering, this sense of the bitter contrasts of life, and of the sadness and sorrow which human life and nature both do really express,—which sadness and sorrow are virtually a mute prayer to be set free, and comforted—these all were Cole's in an eminent degree. And so his was truly a religious temperament: and one well acquainted with his youth might have foretold that he would never rest until both freedom and consolation were found,—until religion should cease to be merely a sentiment, and become a life. A temperament like his could only bloom and fructify in the full light and warmth of Christianity. Short of that, nothing would be able to satisfy his spiritual longings. For him there could be no peace, no

repose, but in a redemptive faith, "the faith once delivered to the saints."

With so keen a sense of life's contrasts, its joy and sorrow, its prosperity and adversity, its blooming and mouldering, growth and decline, perfection and ruin, in short, all the symbols of good and evil, would it have been possible for him not to have thought of them as essentially related to art? He thought of them in that light most earnestly. The subject of profound contemplation, they must have been expressed in his works. Not at once, though, necessarily: for while his enjoyment of creation's loveliness, loneliness and awfulness, was in its dews and early fragrance, he would naturally rest with the wish and the effort to reveal that enjoyment. In the first rush of joys over physical beauty, it would have done violence to his heart to have sunk at once to the deeper moral meaning of that beauty. When those joys should have subsided into their quiet stream, then should we look to see that profounder meaning burst forth from his works. Now what is the truth of all this? Does not the theory find an exact correspondence in the fact that his pictures, for a season, were simple reproductions of the scenery with which he was captivated, and then began to speak a language strong, moral and imaginative?

CHAPTER ❧ 11

Cole enters upon a higher style of Art. Its consequences. Letters to Mr. Gilmor: picture painted for him; remarks on pictorial composition; pictures in the Academy; the Garden of Eden; the Expulsion. Trip to the White Mountains.

LET us now return with Cole to the quiet labours of the painting-room. From pictures merely descriptive of wild nature, he went on to paint those poetically expressive of himself. This was at once regarded as an unfortunate step for one whose pencil was so true to the great features of American landscape. Even the judicious among his friends feared that he was forsaking his only proper path. Cole, however, had done what it was impossible for them, at the time, to do: in his searching of nature he had sounded his imaginative feelings, and taken the partial measure of his own powers of working, and the capabilities of the department of art which had been opening upon him as something new and original. And now, so far as circumstances would permit, his task henceforth was not indeed to abandon landscape, but so to paint it as to make it a true reflection both of the visible creation and of himself. Ever faithful to the scenes external to himself, ever true to the spirit and the forms of beauty everywhere before his sight, he wished his canvass at the same moment to speak a language eloquent of God, and man, and human life. To feed with a fleeting pleasure the beholder's eyes, he felt was not half the mission of an artist. He could only be worthy of the pencil when he should also aim to delight, and teach the mind. Within the pavilion of the seasons, with all its wonderful and glorious garniture, must he toil, musing and talking in art's pictorial language of man, a restless wanderer on earth, or as a pilgrim and stranger passing forward to a repose in heaven.

He soon felt, alas! that it would have been better for his future interest and popularity had he confined himself to the species of painting which had made so lively an impression, and gained him so rapidly an enviable distinction. Portraiture of mornings and evenings, storms

and waters, under circumstances of the picturesque and savage, was on a level with the public mind, and the fancy of the connoisseurs; and he who could so well reach that mind, and gratify that fancy, and yet would presume to withhold the favourite morsels, in order to furnish a refined repast, for which there was little taste, and less real appetite, must take the consequences of his presumption. Could he have always kept himself to that earlier kind of picture, he would have been, all through his day, the most popular of painters. But Cole was constituted more an artist for the future than the present. He could not, therefore, be even nature's mere portrait-painter, although her features were the grandest, and her countenance and apparel the most beauteous and winning. Fond as he then was of praise, he felt that it was a smaller thing to sacrifice than the nobler vocation to which he aspired: much as he really needed money, more for others who were dear to him and dependent than for himself, he could not dare to turn back from that ascending and original path upon which his vision had fastened, and content himself to walk in a lower and easier one, leading quickly to golden success. No; the determination was made: he pondered well his setting out, and advanced boldly and alone.

Among his pictures, at the exhibition of the National Academy, in the spring of 1828, appeared the Garden of Eden and the Expulsion. For their poetic conception, manner of composition, and other artistic merits, they had their admirers; particularly the Eden—a picture remarkable for its flowery luxuriance.

"In this work," says Bryant, "he attempted what was almost beyond the power of the pencil, a representation of the bloom and brightness which poets attribute to the abode of man in a state of innocence. In the distance were gleaming waters, and winding valleys, and bowers on the gentle slopes of the hills; but nearer, in the foreground, the painter has lavished upon the garden a profusion of bloom, and hidden the banks, and oppressed the shrubs with a weight of 'flowers of all hues,' as Milton calls these ornaments of his Paradise. A single flower, or a group of several, may be very well managed by the artist; but when he attempts to portray an expanse of bloom, a whole landscape, or any large portion of it, overspread, and coloured by them, we feel the imperfection of the instruments he is obliged to use, and are disappointed by the want of vividness in

the impression he strives to create. The Eden of Cole has great merits as a scene of tranquil beauty, but there was that in its design to which the power of the pencil was not adequate."[1]

The circumstances of their tardy sale, especially that of the Expulsion, proved, however, that they marked the era when the swell of general applause began to subside, and that the first note was struck of that censure which too often is inflicted upon original genius, when, in opposition to some popular taste, or conventionalism, it has the daring to think for itself, and act according to laws of its own.

Portions of his correspondence, commenced soon after his settlement in New York, with the late Robert Gilmor, Esq., of Baltimore, an early friend and generous patron of the artist, will confirm, in some degree, parts of the foregoing, and give us something of his history up to his departure for Europe.

TO ROBERT GILMOR, ESQ.[2]

New York, July 2d, 1825.

DEAR SIR,—I have received your letter of 27th of last month, enclosing fifty dollars. I was much gratified to learn that the picture pleased, and am greatly indebted to you for the criticisms. I agree with you in thinking that the general effect is rather monotonous; but the scene in nature was so grand in its monotony as to induce me to paint it. Perhaps the admiration with which I behold the wild and great features of nature diverts attention too much from interesting accessories. I think the colour of the sky will be much improved by varnish; but whether it will have the true saffron tint of morn I cannot say. Mornings vary much in their tints—sometimes rosy, sometimes pale yellow, golden, and often of a greenish tint.

I hope to profit by the excellent advice your letter contained, and shall endeavour to show, in the pictures I have to paint for you, that I have not forgotten it. It would give me great pleasure to see your collection of pictures: I have never yet seen a fine picture of any foreign landscape painter. * * * I am,

with respect,

Yours, &c.,

THOMAS COLE.

CHAPTER · 11

New York, December 25th, 1825.

Dear Sir,—I received your letter with pleasure, and must thank you for your opinions respecting the introduction of figures, &c., into pictures. * * *

I hope you will pardon me if I make a few remarks on what you have kindly said on compositions. I agree with you cordially about the introduction of water in landscapes: but I think there may be fine pictures without it. I really do not conceive that compositions are so liable to be failures as you suppose, and bring forward an example in Mr. ——. If I am not misinformed, the first pictures which have been produced, both Historical and Landscape, have been compositions. Raphael's pictures, and those of all the great painters, are something more than imitations of nature as they found it. * * * If the imagination is shackled, and nothing is described but what we see, seldom will anything truly great be produced either in Painting or Poetry. You say Mr. —— has failed in his compositions: perhaps the reason may be easily found—that he has painted from himself, instead of recurring to those scenes in nature which, formerly, he imitated with such great success. It follows that the less he studies from nature, the further he departs from it, and loses the beautiful impress, of which you speak with such justice and feeling. But a departure from nature is not a necessary consequence in the painting of compositions: on the contrary, the most lovely and perfect parts of nature may be brought together, and combined in a whole, that shall surpass in beauty and effect any picture painted from a single view. I believe with you, that it is of the greatest importance for a painter always to have his mind upon nature, as the star by which he is to steer to excellence in his art. He who would paint compositions, and not be false, must sit down amidst his sketches, make selections, and combine them, and so have nature for every object that he paints. This is what I should endeavour to do: and I think you will agree with me, that such a course embraces all the advantages obtained in painting actual views, without the objections.

I am yours, with respect,

Thomas Cole.

Philadelphia, May 21st, 1828.

MY DEAR SIR,—In your last letter, you kindly intimated, that a line from me would be acceptable, whenever I should feel an inclination to write. Having a leisure hour, I shall indulge myself in addressing you, trusting you will not consider it an intrusion.

The Exhibition of the Academy of Design is now open. It is perhaps the most numerous collection of the works of American artists that has been exhibited. Most of the Pictures have been painted within the last year: and amongst them are many of merit. Morse, Inman, Ingham, exhibit good pictures.[3] Fisher and Doughty have several which are agreeable.[4] I exhibit a number. Amongst them are two attempts at a higher style of landscape than I have hitherto tried. The subject of one picture is The Garden of Eden. In this I have endeavoured to conceive a happy spot wherein all the beautiful objects of nature were concentred. The subject of the other is The Expulsion from the Garden. Here I have introduced the more terrible objects of nature, and have endeavoured to heighten the effect by giving a glimpse of the Garden of Eden in its tranquillity.

I wish you to consider that I have been speaking of what *I wished* to accomplish in these pictures, rather than what I *have done;* for I may have failed in these efforts. I should, nevertheless, be much gratified if you could see them, even if it were only to point out wherein I have not succeeded.

My going to Europe this fall depends, in some measure, on the sale of these two pictures. The price I ask for them is a high one. The labour and study have been great. In setting it, I have left it to my friends to judge for me, not feeling myself a competent judge of my own works, for every artist will have a love for his own productions, being more in the habit of looking for their beauties than for their defects. In your last letter you made me a kind offer of assistance, in case I should go to Europe: I hope I shall not find it necessary to task your generosity. But it would be a satisfaction to my parents if, in case of accident or sickness overtaking me when abroad, I should have the power of drawing on some friend for a

small amount. If the pictures now exhibiting sell, I shall be enabled, with economy, to study in Europe a year or eighteen months. * *

I remain, yours respectfully,

THOMAS COLE.

The ensuing autumn, Cole, in company with a friend,[5] visited the mountains of New Hampshire. The following comprises, in part, his notes penciled from day to day on the blank leaves of his sketch-book.

TRIP TO THE WHITE MOUNTAINS.

October 3d, 1828.

* * We set out to climb the Chocorua peak. * * On the path through the wood, we came to windfalls, the track of the tornado, where every tree is laid prostrate. We came out, at length, to a lonely and deserted clearing, just at the foot of the mountain. The cause of this abandonment is, they say, the poisonous effects of the water upon the cattle; the result, according to tradition, of the curse of Chocorua, an Indian, from whom the peak, upon which he was killed by the whites, takes its name. The beginning of our ascent was more difficult on account of briars and fallen trees than from any abruptness; but we soon entered upon a steep and terribly laborious journey. It would seem that the wind-fiend had raged around this mountain with unsparing power; the loftiest and the most strongly-rooted trees are alike laid prostrate. To pass through these windfalls was both perilous and difficult; tall pine and gnarled birch, with branches confusedly mingled, were heaped together in the wildest manner. But we gained the summit, and were rewarded for our toils. On every side prospects mighty and sublime opened upon the vision: lakes, mountains, streams, woodlands, dwellings and farms wove themselves into a vast and varied landscape. Of the numerous lakes, some glistened like polished silver, others were dark blue: clouds cast their shadows far and wide, and produced wonderfully fine effects of light and shade. With all its beauty the scene was one too extended and map-like for the canvass. It was not for sketches that I ascended Chocorua, but for thoughts; and for these this was truly the region.

65

We remained several hours on the granite peak, and then took our way down its perplexing steeps towards the village, where we arrived after dark.

* * * * * * *

October 6th. The morning opened in a threatening manner, but we left Crawford's prepared for the worst. We had before us that wild mountain-pass called the Notch, through which descends the Saco, a rapid river without bridges, these having been washed away by late floods. The distance is twelve miles, and not a house except the deserted Willey House; but with our luggage strapped on our backs we set forward, and footed it through. The wind blew violently down the pass as we approached, and the gray, heavy clouds were rushing round the overhanging crags, as if contending which should sit upon the mountain throne.

* * * * * * *

We now entered the Notch, and felt awe-struck as we passed between the bare and rifted mountains, rising on either hand some two thousand feet above us. With the exception of a few curling round the airy pinnacles, the clouds had now dispersed, and the sun shone down brilliantly upon this scene of wild grandeur. The sight of the Willey House, with its little patch of green in the gloomy desolation, very naturally recalled to mind the horrors of the night when the whole family perished beneath an avalanche of rocks and earth. * * It is impossible to give a true picture of this desolate and savage spot: we made some sketches, and proceeded up the gorge. The mountains close in upon you as you ascend towards the higher end, and have a peculiarly grand and picturesque appearance. The stream runs over a broken bed of rocks, and the wild variety of views, as we crossed and recrossed, amply repaid our toils. Up the rocky steeps, hundreds and hundreds of feet above our heads, we saw waterfalls that shone in the sunshine like streaks of silver. * *

October 7th. Mr. Pratt left me on his way to L——, and I spent the day in making drawings from trees, rocks, banks, &c. The next day I set off, through the Breton woods on the bank of the Ammonoosuc, for Franconia. * *

66

Through the pass, called the Franconia Notch, there is a good road, over which passes a small coach to Plymouth. After a hearty meal, and with a little bread and cheese in my pocket in case of necessity, I set off with the expectation of the coach overtaking me in the Notch. For five or six miles the road ascends, and, as the day was mild, I found it rather fatiguing before I reached the entrance of the pass, where you begin to descend. This has nothing of the desolate grandeur of the other Notch. The elements do not seem to have chosen this for a battle-ground, and the hoar mountains do not appear wrinkled by recent convulsions. One of the two lakes, you here meet with, is presided over by the Old Man of the Mountains, as the people about here call it, a singular crag some fifteen hundred feet aloft, having the features of the human face. The perfect repose of these waters, and the unbroken silence reigning through the whole region, made the scene peculiarly impressive and sublime: indeed, there was an awfulness in the deep solitude, pent up within the great precipices, that was painful. While there was a pleasure in the discovery, a childish fear came over me that drove me away: the bold and horrid features, that bent their severe expression upon me, were too dreadful to look upon in my loneliness: I could not feel happy in their communion, nor take them to my heart as my companions. The very trees were wild and savage in their forms and expression. This I have found a kind of law, the law of congruity in nature. Where the region is one of savage character, the trees in their predominant traits correspond: in places where the aspects of nature are more gentle, there the expression of the woods is soft and pleasing, and the general outline of the trees graceful and beautiful. As I walked on down the road, darkened by the forest, and rendered doubly gloomy by heavy masses of clouds breaking round the cliffs, I listened with anxious ears for the wheels of the coach, but always found them filled with the sound of waters, falling either with a whispery voice in the distance, or with an angry roar near at hand. In spite of a timid excitement, and the prospect of a shower, I sketched several trees by the road-side. In the course of my walk, I came to a bark-covered hut, in the midst of burnt trees, with a swarm of unwashed, uncombed, but healthy-looking children, who ran out to stare with amazement at the passing stranger. I reached, at length, a better looking abode, where the horses of the coach were to be exchanged, and awaited its

arrival. From the door I made a sketch of the mountains, to the surprise and admiration of the people of the house, who put me down for a surveyor making a map. The long looked-for coach at last came down, and gave me a pleasant ride into Plymouth. Passing through Concord, I arrived at Boston, October the 10th.

CHAPTER ❧ 12

Cole anticipates going abroad. Letters to Mr. Gilmor: asks a favour; a favourable reply. A Visit to Niagara.

The succeeding winter was one of great industry, and singular interest to Cole. His hands and his heart were full. He was approaching, in expectation, a long desired event; an event which, like a great rock in a river, might shoot the current of his visible life wide from its present direction, and exert he knew not what influence on his life within: I mean his visit to Europe as a student of art.

For a long season, comparatively, his course had been forward with steady footsteps to one point. That point now seemed to be gained; and he was in the enjoyment of his first still breathing-time. The last few years had been prosperous and pleasant, by far the most pleasant of his life. "My brother," said his sister Sarah, "was very happy in those days. With our music and songs we used frequently to sit up until midnight and after, talking also a great deal, especially about the past." Now that they were over, there were few things upon which he conversed with more satisfaction than the many serious difficulties he had encountered.

This pleasing retrospect, however, did not alone occupy those hours of sweet, but earnest musing. The past met by the future, with its swift-coming and mysterious tide, awakened deep and sometimes painful emotions. Too timid and alive with sensibility not to shrink from the uncertainties of the field he was about to enter, all that was, nevertheless, little in comparison with the thought of leaving home. It may appear trivial thus to mention what is common, in some degree, to every person of proper sense and feeling. But not to note the child-like, intense affection which made Cole grow to all included in the word Home, and the pang of separating from it, would be to miss one of the great moral forces of his character, one of the essential marks of poetic genius.

A true poet loves the very dust of his habitual walks. The steps that wear out the grass, and indent the sod, win his affections for the brown, crooked path so entirely, that to wander there is to walk closest to Paradise. Of that which is perpetually near, even the smoke of a neighbour's chimney, he takes delightful account. Common, simplest creatures, the yellow-bird and the thistle-seed, the mossy fence-rails and wall-stones, and the wren chattering between them, are the last to be overlooked: familiarity breeds no disgust with aught but the evil and unlovely. His ways are the reverse of those who seek their joy in novelties, and expect the wonderful only in the remote. The golden azalea of the Apalachians, the great scarlet rhododendron of the Catawba blaze along the distant heights with a cold splendour to the heart that gathers into its warmest centre the dandelion, buttercup and ox-eye, spangling the soft, green knolls of home. Peeping up from that blessed turf the early violet, nay,

> "The meanest flower that blows can give
> Thoughts that do often lie too deep for tears."[1]

And this, think not, is the symptom of sickly sentiment, but the breathless eloquence of a genuine poet's healthiest, honestest feelings. Separation from these creatures of his tenderness brings with it a real grief. He anticipates the hours of its arrival as one of the afflictions of his earthly lot. So felt, and so thought Cole in the prospect of parting with things and scenes "carried far into his heart." How much more then, in view of leaving his family. But, in his judgment, a pilgrimage to Italy was a painter's duty; to him not indeed without its poetry and pleasure, but still a duty requiring precious sacrifice, which he yet felt willing to make in order to prove fully true and faithful to a high calling.

Of his winter's works one was a New Hampshire mountain picture of great force and motion.* "Your clouds, sir," said a visitor, "appear to move." "That," replied the artist, "is precisely the effect I desire." Another was a picture of somewhat a dramatic character, entitled Hagar in the wilderness, of which mention is made in one of the following letters.

* Chocorua, or Corway Peak.

TO ROBERT GILMOR, ESQ.

New York, January 5th, 1829.

DEAR SIR,—I hope I shall need no apology for taking the liberty of writing to you, although, perhaps, I ought to offer one for presuming to ask a favour.

I believe you are acquainted with the strong desire I have long had to visit Europe for the purpose of studying the works of the Great Masters, and know the advantages young artists may derive from that study. For a few years past I have laboured unceasingly, that I might obtain means for the accomplishment of my desire: hitherto I have been unsuccessful. Owing to the wants of my family, my expenses have been equal to my income; and I am brought reluctantly to the conclusion that my purpose must be abandoned unless I have other means of accomplishing it than those I now possess. Your former favour and kindness have encouraged me to ask if you will assist me. My Garden of Eden and Expulsion are not yet sold. May I venture to propose that you take them into your hands, and advance me a sum that shall enable me to visit Europe, which sum should be repaid in money or pictures, when and as you shall think best. I will not dwell on the greatness of the favour you would confer by granting my request, but hope, if it be an improper one, you will find an excuse for me in my earnest desire for improvement in my art. * *

I remain, yours very respectfully,

THOMAS COLE.

TO THE SAME.

New York, February 2d, 1829.

DEAR SIR,—I know that I intrude on your time in writing so often; but I trust my doing so may be attributed to your kindness which encourages me to trespass. You have made me a kind offer, and I cannot resist the pleasure of acknowledging it, particularly as it is one that facilitates to me the study of the art to which I am devoted, and which you so highly appreciate. I aim at the highest excellence, though not confidently, by any means: and to whatever eminence I may attain I shall always remember that you have greatly assisted me in the ascent. * * * * * * *

I am, with great respect, your obedient servant,

THOMAS COLE.

New York, April 20th, 1829.

DEAR SIR,—Since I last wrote to you, I have experienced disappointment and mortification. I have been full of hopes and fears. *

The raffling of my pictures has caused me much delay and expense; but I do not wish you to suppose I have been idle. I have been painting a picture to take with me, Hagar in the Wilderness. I hope it is my best effort. It would gratify me exceedingly to show it to you. *

I am living in anticipation: but my anticipations are not all pleasing, for in going to study the great works of art, I feel like one who is going to his first battle, and knows neither his strength nor his weakness. Perhaps I betray some vanity in what I have just said, for I am not going to fight, but to *learn* to fight. * * * * *

I am, yours very respectfully,

THOMAS COLE.

TO THE SAME.

New York, April 26th, 1829.

DEAR SIR,—* * I do not think I shall be able to sail before the 15th of May, and therefore hope to have the gratification of seeing you in New York. I am very anxious to be on my voyage. Next Wednesday, I intend setting off for the Falls of Niagara. I cannot think of going to Europe without having seen them.[2] I wish to take a "last, lingering look" at our wild scenery. I shall endeavour to impress its features so strongly on my mind that, in the midst of the fine scenery of other countries, their grand and beautiful peculiarities shall not be erased. * * * * * * *

I remain, yours respectfully,

THOMAS COLE.

Cole's first sight of Niagara was not what he had anticipated. He was disappointed. Lifted by no rapture, burdened by no sense of overpowering grandeur, he gazed upon it almost without an emotion above that of surprise at himself. The old vision of his imagination vanished on his first look, and left him labouring in a kind of mental void, which the reality, in whose presence he stood, altogether failed

to fill. Cole, though, had leaned too long upon the breast of nature not to have humility and wisdom, not to know that it was his own infirmity, and no deficiency in the object before him. Its failure to affect him at once lay in its very greatness. Contemplation, though, would give width and penetration to the faculty of seeing, and wake up power after power to the last and loftiest of his soul,—a consolatory reflection, the truth of which at last found its proof when, mind and feelings wrestling together, he strove to his utmost to give answer to the awful call, and to make confession of the strength, purity and glory (the arms of the universe) wrought by the finger of God on the folds of that ever-unrolling banner of the earth.

And yet, taking it the year round, or even for the single cycle of sunshine, shade, storm and calm, Niagara to Cole was, by his own declaration, far less than the mountains. They were symbols of the eternal majesty, immutability and repose, which no cataract could ever be. And no multitude of such symbols could ever detract from the dignity and force of each single one. Nay, the greater the multitude, the more impressive the symbolism of each, arising from the greater skill which the mind would naturally acquire in tracing it, and the ever-deeping insight into the divine realities which were symbolized. Niagara was great in its loneliness. Let its equal, though its neck be clothed with ceaseless thunder, and its vestment be the countless beauties of successive day and night, appear in a thousand places, and one might look for an effect little corresponding with that which it now produces in its solitary supremacy. But the mountain, with a fulness of might in itself, is yet mightier as one of an innumerable brotherhood, in each of which you behold an image of everlasting repose,—from its summit can escape into the infinite, and upon the perpetual rocks hear voices from the bosom of inwrapping clouds, talking of the presence of the Almighty, and say, with both a lowly sense of your own present littleness and restlessness, and a lofty sense of your immortality and final rest, "it is good for us to be here."

It is needless to relate that Cole made drawings of Niagara. He sketched it at various points, particularly from below, and upon Table Rock, and from a projection on the eastern brink, where the eye commands, at a glance, the entire sweep of the cataract with the rugged cliffs of Goat Island. For the study of water, especially under all its circumstances connected with torrent-motion, Niagara far

exceeded, in his opinion, all other places. A favourite study was a singularly fine swell, beautifully breaking back upon itself, in the rapid below the bridge crossing to the island. Well nigh twenty years afterward, he pointed it out to a friend, the same "thing of beauty" which he had studied with more pleasure and effect than almost any other single object at the falls.

Footing it down the river with sketch-book in hand, the Whirlpool afforded fine opportunities for water-studies, and the heights of Queenston opened to his view an expanse of forest-tops, then unbroken but by the mighty river, and bounded by the distant Ontario, which he did not fail to secure for future purposes.

CHAPTER ❧ 13

Cole in England. Delight at its Rural Beauties. Studies Nature rather than Pictures. Disappointment at English art. To his Parents: rural scenery; London; Westminster Abbey; pictures; the poet Rogers, Hagar in the Wilderness. Life in London. Disappointments. Sir Thomas Lawrence. English art. Notes on Art: Turner; Hogarth; Claude; Rembrandt; Elzheimer; the effects of time on pictures; of detail in pictures. To Sarah Cole: pictures in the Exhibition; a musical gentleman. To Mr. Gilmor: Sir Thomas Lawrence; opinions of painters. To Mr. Cummings. To Sarah Cole: The Storm. To Mr. Gilmor.

On the 1st of June, 1829, Cole sailed from New York for London. For nearly two years he applied himself there assiduously to the study and practice of his art. His sketches, taken at his intervals of leisure in various parts of the city and country, show how greatly he delighted to expatiate in the open air, and how little in the picture-galleries. The lines below, penned on the cover of a sketch-book, are a true expression of his feelings.

> Let not the ostentatious gaud of art,
> That tempts the eye, but touches not the heart,
> Lure me from nature's purer love divine:
> But, like a pilgrim, at some holy shrine,
> Bow down to her devotedly, and learn,
> In her most sacred features, to discern
> That truth is beauty.

Although an English sky was too often "a grief of mind," the landscape, with the burden of its own peculiar beauties, stole upon his heart with a charm. To one, whose mind had been reaping where nature sows grandeur broadcast, and gathering where she straws her awful things, English scenes opened with the soft and quiet splendour of pleasant dreams. All abroad he saw something of the poet's vision:

> "And fruits and flowers together grew
> On many a shrub and many a tree:

And all put on a gentle hue,
Hanging in the shadowy air
Like a picture rich and rare."[1]

"Embowered in groves of the densest, darkest foliage I ever beheld, nothing can be richer than the green of an English lawn," is a note among his first sketches at Twickenham, Hampton Court, and Richmond Hill. Of elaborate studies in the galleries there is not in his collection a single specimen. A few minute and hasty sketches from Turner, and one or two others, are the amount of his drawings from modern English pictures. In a solitary instance he reluctantly effected a copy of a pastoral scene by Wilson,[2] whose truthfulness to nature he admired.

As already intimated, Cole looked across the Atlantic with the hopes and fears of enthusiastic genius. While he could not imagine less than that the realm of the true and beautiful in art was about to open upon him in a manner to excite his "wonder and love," and give him fresh impulses and lofty teachings, there were times when he could not reason himself out of the dread that he was going abroad for revelations of sad weakness and deficiency in himself. Forgetful, at such moments, that the Creator's own living works had been his great instructors, and that his own mind, winged and warmed by love, had been the sole interpreter of their language,—facts which paralleled his case with that of the imaginative masters of old time, most of all, perhaps, with that of Salvator Rosa,—it is not surprising that he was agitated. He was soon to stand in the presence of the master-pieces of those who had been trained in the high schools of art, and pampered with their choicest literature and examples. Faith in his own powers, faith in nature herself—nature as she had lured him to her, and as he had lived with her apart from the world—had not yet grown to the stature when it walks without fear and trembling. Actual sight, however, dispelled alike his hopes and alarms. England in herself, not counting her purchased treasures from the continent, her Claudes and Salvators, was, after all, no Utopia of painting. He had not over-measured himself, nor misplaced his trust. There was a new gladness in his heart, but with a mingling of sorrowful disappointment.

But Cole in England is best seen in his letters and criticisms. Of

the latter it may be said, that they were penned with no thought of their ever being published, mainly hasty notes for his own future reference, but expressing views which were sanctioned by the wisdom of later years.

London, June 28th, 1829.

DEAR PARENTS,—I hasten to inform you of my arrival in London, which was last evening. * * I have nothing particular to relate respecting my voyage, except that it was what the sailors call a lady's voyage. * * Fine as it was, I had a great deal of sea-sickness. The weather was delightful as we coasted the south of England from Land's End to Portsmouth; and, I can assure you, I enjoyed the scenery very much. The country was clothed in the richest verdure, with here and there a village and its church peeping out from among the trees. * * Nothing can be more picturesque than the variety of sails to be seen along the English coast. Every vessel seemed rigged after a different fashion, and many have red sails. The vessels in general were finer than I expected; and I find that the Americans are not the only people in the world that build beautiful ships. Of Portsmouth I have little to say, as it rained the night I arrived. * * From my window I had a view of numbers of men-of-war, and among them the Victory, the ship in which Nelson died. * * *

* * Mr. C——, another gentleman and myself took a post-chaise, and came to London. * * Nothing can exceed the excellence of English cultivation; all is a perfect garden. As we passed between the hedge-rows we were gratified with the most delightful fragrance of the wild-rose and honey-suckle. There is a wonderful neatness in the cottages; the very poorest of them has its little garden before the door, and is almost buried in flowers.

I entered London by way of Fulham, and was in the midst of it almost without knowing it, so many are the gardens and trees on that route. * * I took a walk to Westminster Abbey to-day. It far exceeds my expectations: no prints or descriptions can give a true notion of its grandeur. As it is Sunday, I happened there at the time of service, which was imposing. The sermon was delivered in a fine manner by a very haughty-looking man. To-day the Abbey is free

to all, and I went over a great part of it, and viewed the numerous monuments that decorate it. * *

Your loving son,
THOMAS COLE.

TO THE SAME.

London, July 10th, 1829.

DEAR PARENTS,—As an opportunity offers of writing by the packet, which sails in a few days, I have determined not to neglect it. I hope my last, which gave you an account of my voyage, found you all in health. I have taken lodgings at a Mr. Upton's, No. 11, London Street, Fitzroy Square. * * You may suppose that when I visited the exhibition of the Royal Academy I went with great expectations: I was going to see the works of painters highly estimated; and I almost trembled for fear I should find my own littleness. A view of the fine pictures have not discouraged me. There were many excellent ones by Turner, Calcot and others, of whom you have often heard me speak. But I really think that most of them are very far from perfection in the art. They do not altogether come up to my expectations; and I cannot but think I have done more than any of the English painters. Many of them go beyond me in parts; but, as a whole, I certainly have reason to be gratified with the advances I have made. What I have just said I should not wish repeated to any of my friends; they might take it for vanity: and, after all, I may form a wrong estimate of my own merits. I think I shall improve very fast here, having the advantage of seeing so many fine pictures, both ancient and modern.

I called on Samuel Rogers,[3] a day or two since, and he received me with cordiality. He expressed himself highly pleased with the picture I had sent him, and invited me to dine with him to-morrow, which I intend to do. He has not yet seen my Hagar. He has a fine collection of pictures of the most distinguished artists, and worth, at the least calculation, twenty or thirty thousand pounds. I have seen pictures, at the Royal Academy, which I should consider very inferior, fetch high prices. Artists seem to be doing very well here; the exhibitions are crowded to excess from morning till night. * *

I dined with Mr. Rogers yesterday, as I intended. Everything was

in the finest style, and he behaved in a very friendly manner. He has not yet seen my Hagar. * *

From your loving son,
THOMAS COLE.

Poor Hagar! whatever the impression she might have made upon the accomplished poet, it is certain that her fortunes in no way corresponded with what the artist had at first ventured to predict. "Cole," said a friend one day, "what has become of Hagar?" "Ah, sir," replied the painter, with no little sadness in his humour, "she is in the bottom of the sea." He had painted another picture over it: the mimic waters were actually freshening above her.

In a correspondence with Dunlap, some time subsequent to this, he says:

I did not find England so delightful as I anticipated. The gloom of the climate, the coldness of the artists, together with the kind of art in fashion, threw a melancholy over my mind that lasted for months even after I had arrived in sunny Italy. Perhaps my vanity suffered. I found myself a nameless, noteless individual, in the midst of an immense, selfish multitude. I did not expect much, scarcely anything more than to have an opportunity of studying, and showing some of my pictures in the public exhibitions, and to a few persons of taste, in my own room. I did study; but the pictures I sent, two seasons, both to the Royal Academy and to the British Gallery, were, without exception, hung in the worst places, so that my acquaintances had a difficulty in knowing them. I was mortified, not that they had been so disposed of, but because the vilest daubs, caricatures, and washy imitations were placed in excellent situations.

The last time I sent pictures to be exhibited, I expected a little different treatment; for one of the hanging committee of the Royal Academy had led me to expect something better. I was disappointed. At the British Gallery I had hopes also: Rogers had promised to intercede for me. But, unfortunately, he was called out of town at the very moment he could have aided me; and my pictures had to stand on their own merits, which, in the eyes of the hangmen, amounted to nothing. On the varnishing day I found them in the most *exalted* situations.

At the Gallery of the British Artists I exhibited once, and was

better treated. My picture of a Tornado in an American forest was placed in a good situation, and was praised exceedingly in several of the most fashionable papers.

I have said that I found the artists in London cold and selfish: there may have been many exceptions, but I found few. My own works, and myself most likely, had nothing to interest them sufficiently to excite attention: the subjects of my pictures were generally American, the very worst that could be chosen in London. I passed weeks in my room without a single artist entering, except Americans. L—— was friendly, although he never appeared to think there was any merit in my works, and N—— called on me twice in two years.[4] * * *

To Sir Thomas Lawrence[5] I was introduced by a letter from Mr. Gilmor, of Baltimore. He treated me in a very friendly manner, was pleased with my pictures, and sent his carriage for me to come and breakfast with him. We breakfasted at eight, in a spacious apartment filled with works of art. We conversed on the fine arts and America. * * After breakfast he took me into his painting-room, which was a picture wilderness. A short time after, I met him at the British Gallery, and he invited me to go with him to Sir Robert Peel's, in a few days, to see his collection. But death, whose hand was already upon him, deprived me of that pleasure. I lost a valuable acquaintance, and the world a distinguished man. * * *

Although, in many respects, I was pleased with the English school of painting, yet, on the whole, I was disappointed. My natural eye was disgusted with its gaud and ostentation. To colour and chiaroscuro all else is sacrificed. Design is forgotten. To catch the eye by some dazzling display seems to be the grand aim. The English have a mania for what *they* call generalizing, which is nothing more nor less than the idle art of making a little study go a great way; and their pictures are usually things "full of sound and fury signifying nothing." The mechanical genius of the people exhibits itself in the mechanism of the art—the dexterous management of glazing, scumbling, &c. Frequent and crowded exhibitions of recently-painted pictures, and the gloom of the climate, account for the gaudy and glaring style in fashion. There are few exceptions among the artists of England to this meretricious style. * *

These opinions of English art, I know, may be considered heterodox; but I will venture them, because I believe them correct. The standard

by which I form my judgment is nature: and, if I am astray, it is on a path which I have taken for that of truth.

NOTES ON ART.

December 12th, 1829. I have just returned from visiting Turner and his pictures.[6] I had expected to see an older looking man, with a countenance pale with thought; but I was entirely mistaken. * *
He has a good gallery, in which hang many of his finest pictures. The Building of Carthage is a splendid composition, and full of poetry. Magnificent piles of architecture fill the sides, while in the middle of the picture an arm of the sea or bay comes into the foreground, glittering in the light of the sun, which rises directly over it. The figures, vessels, &c., are all very appropriate. The composition resembles very closely some of Claude's. The colour is fine, and the effect of sunshine excellent; but the sky around the sun appears to me to be too raw and yellow.

Hannibal crossing the Alps in a snow storm is a sublime picture, with a powerful effect of chiaroscuro. In one picture, a magnificent scene, there was a dazzling effect of sunshine in the water: it seemed to be produced, independent of colour, by a multitude of small, very dark spots amid the waves.

His later pictures I admire very much. They appear to me, however, to have an artificial look. When considered separately from the subject, they are splendid combinations of colour. But they are destitute of all appearance of solidity: all appears transparent and soft, and reminds one of jellies and confections. This appearance, I imagine, is the effect of an undue dislike to dulness or black. In light and shade all is of the richest, brightest colour. Nature, in her most exquisite beauty, abounds in darkness and dulness; above all, she possesses solidity.

The first of Hogarth's pictures I saw were that series called Love a la Mode. In colour and handling they were far beyond my expectation. Objecting to the study of pictures, Hogarth says, "The most original mind, if habituated to these exercises, becomes inoculated with the style of others, and loses the power of stamping a spirit of its own on the canvass." There is truth in this remark. * *

I think there is in Alison's work on taste a passage in which he

attributes the decline of the fine arts to the circumstance of painters having forsaken the main object of art for the study of its technicalities.[7] The same cause yet exists to the very great deterioration of painting. The means seem a greater object of admiration than the end,—the language of art, rather than the thoughts which are to be expressed. The conception, the invention, that which affects the soul, is sacrificed to that which merely pleases the eye. Painting now is more ingenious than true and beautiful. Take away from painting that which affects the imagination, and speaks to the feelings, and the remainder is merely for sensual gratification, mere food for the gross eye, which is as well satisfied with the flash and splendour of jewelry. The conception and reproduction of truth and beauty are the first object of the poet; so should it be with the painter. He who has no such conceptions, no power of creation, is no real painter. The language of art should have the subserviency of a vehicle. It is not art itself. Chiaroscuro, colour, form should always be subservient to the subject, and never be raised to the dignity of an end. The language and imagery of Paradise Lost are but the instruments by which the great poetic creation is evolved.

Many old pictures have pleasing qualities, which did not exist when fresh from the hand of the artist. We see in them a mellowness and lustre, a kind of inward light which is the effect of the touchings of time, and not of the pencil, that gave them their new being on the canvass. The cause of this highly valued quality appears to me extremely simple. It arises, evidently, from an artificial atmosphere, formed by particles of opaque matter gradually deposited upon the surface. This medium through which we see the picture is dark and negative, and the light that breaks through it has greater value from the contrast.

In subjects of a quiet character it is proper, it appears to me, to introduce much detail. When we view the lovely scenes of nature, the eye runs about from one object of beauty to another; it delights in the minute as well as in the vast. In the terrible and grand, when the mind is astonished, the eye does not dwell upon the minute, but seizes the whole. In the forest, during an hour of tempest, it is not the bough playing in the wind, but the whole mass stooping to the blast that absorbs the attention: the detail, however fine, is comparatively unobserved. In a picture of such a subject *detail* should not

attract the eye, but *the whole*. It should be, in this case, the aim of the artist to impress the spirit of the entire scene upon the mind of the beholder. Detail, however, ought not to be neglected in the grandest subject. A picture without detail is a mere sketch. The finest scene in the world, one most fitted to awaken sensations of the sublime, is made up of minutest parts. These ought all to be given, but *so* given as to render them subordinate, and ministrative to the one effect. In confirmation of this doctrine I have only to appeal to Claude, G. Poussin, and Salvator Rosa.

TO SARAH COLE.

London, February 15th, 1830.

MY DEAR SARAH,—I had the great pleasure of receiving your letter on my birth-day. I hope it was a good omen. You complain of my not writing more often: I am sure you cannot complain of my letters being short; and you know that my time is fully occupied. * * *
I have not much to tell you either of good or bad. The exhibition of the British Institution opened a day or two since. It is managed by gentlemen who are not artists, and profess to be quite impartial: but I am informed, by all who know anything of the matter, that they are both ignorant and illiberal. It is to my sorrow that I did not know it sooner. * * *

I have now told you about all the bad news, and will try to get up something better, though I hardly know how. But I have great hopes, and reasonably so, that my pictures will not always hang in bad places. Leslie and Constable, two Royal Academicians, tell me that their pictures have often been treated in the same manner: this by way of comfort. * * *

I wish you could hear the doleful ditties which are sung by the ballad-singers, who usually go three or four together. Sometimes you hear a whole family—man, woman, and half-a-dozen children—squalling along the street most musically. The man and woman jog steadily on with the ditty, while every now and then the young-ones give a squall in a hard place by way of a lift. There lives next door to me a most musical gentleman. He formerly figured in the most intellectual and dignified calling of harlequin in a company of strollers; and it appears he danced about to some purpose. A woman of for-

tune was smitten, and took him from the boards—the boards of a barn. No wonder he should prove a calf. Well, this harlequin calf, or what you will, and Mrs. Calf live, as I said, next door to me, and every morning, at ten o'clock precisely, the calf begins to bellow. Calves, you are aware, have no great variety of tunes; neither has this calf, for he runs over three or four notes, steady fire, till twelve o'clock, to the very great edification and delight of all persons living in the neighbourhood of Grafton Street. He has been at it, I am informed, for three years; and in summer, when the windows are open, many imitations or oppositions may be heard: calves bellow in all directions. Several attempts have been made to put down this nightingale. The boldest was one made by a gallant shoemaker, who, whenever the bird struck up, used to pop his head out of his nest, and join in. The shoemaker, however, has long since sunk silently down among his wax and leather, and only twitters a little on his lapstone, finding it a vain attempt to compete with our fowl, who, heedless of the chirpings round, continues daily to please himself, and plague others, and will most likely continue to do so until he is in his coffin; and even then, when the undertaker is twisting in the last screw, I much doubt whether he will not be heard, so thoroughly is the habit in him. * * I must now conclude with the hope that I shall send you some positively good news before long. * * *

<div style="text-align:right">

Your affectionate brother,

THOMAS COLE.

</div>

The following lines, hastily written upon a loose leaf, on his birth-day, express somewhat passionately the sorrow of which he speaks to his sister, Sarah, in the foregoing letter.

* * * * * * *

How oft the voice of praise breaks forth o'er works
More fortunate than mine; and then descants,
How skilfully the art does mimic nature,—
How tint and form are beautiful and true;
Then pass me by, as though I ne'er had drank
One draught at nature's universal spring.

Ye mountains, woods and rocks, impetuous streams,
Ye wide-spread heavens, speak out, O speak for me!

Have I not held communion deep with you?
And like to one who is enamoured, gazed
Intensely on your ever-varying charms?

* * * * * * *

TO MR. GILMOR.

London, March 1st, 1830.

MY DEAR SIR,—

* * The letters you had the kindness to favour me with have
been of great value to me, particularly the one that obtained for me
the acquaintance, and, I may say, friendship of the distinguished and
lamented Sir Thomas Lawrence. When I delivered your letter, he
received me with the greatest politeness. I breakfasted with him a few
mornings after; and in the course of conversation I said that, con-
sidering the length of time that had elapsed since he saw you, and the
absorbing nature of his profession, his recollection of you might
possibly have been rendered indistinct: he immediately replied, "No,
no! Mr. Gilmor is not a man to be forgotten." He had seen a picture
of mine which is in the possession of Rogers, the poet, and com-
mended it in terms that were very gratifying to me. He always treated
me with more attention than I had any reason to expect, considering
how fully occupied his time must have been. I can assure you his
death was as painful to me as it was unexpected: only a few mornings
previous to that event I met him at the British Gallery, when he in-
vited me to call on him.

I have seen much since I have been in England, and hope I have
profited much by what I have seen. The works of the Old Masters
have been my greatest study and admiration. In Landscape my
favourites are Claude and Gaspar Poussin; but not to the exclusion of
others. I could particularize the pictures I most admire, and the quali-
ties for which I admire them; but as it is most probable that you have
seen the same, I am afraid it would give you more trouble than
pleasure.

I have not neglected to study the work of modern artists: but with
the exception of two or three, the living English Landscape Painters
are either below mediocrity, or going widely astray in pursuit of
effects that have not their foundation in truth and nature. I should

consider Turner as one of the greatest Landscape painters that ever lived, and his Temple of Jupiter as fine as anything the world has produced: but in him there is a great falling off. His present pictures are the strangest things imaginable: and as far as respects colour, (colour independent of truth of representation,) they are splendid: but as the Greeks have said, The most brilliant composition of colours is nothing better than a gaudy show, dazzling the eye for a moment, but passing afterward disregarded. To this colouring let the painter add the solid beauties of design and sentiment, and he will convert an empty amusement of the eye into an elegant entertainment of the Fancy.

With the exception of a few weeks that I spent at the Lakes of Cumberland, I have been painting ever since I have been in England. You will be surprised when I tell you that I have not copied a single picture. I never copied a landscape in oil in my life, and am almost afraid I shall not be able to bring my mind to it. When the weather becomes a little warmer I intend to make the attempt. I am of the opinion too that it is more profitable for me to paint pictures in the style, keeping their peculiarities always in view, than to copy them.

<div style="text-align:right">Yours, truly,
THOMAS COLE.</div>

<div style="text-align:center">TO THOMAS S. CUMMINGS, ESQ.[8]</div>

<div style="text-align:right">London, October 19th, 1830.</div>

MY DEAR SIR,— * * * * More than a year is now gone since I last saw you; and as time never passes without effecting some change, it must have wrought change with us—in our persons, our acquirements, our anticipations. I trust that, ere this time, you begin to meet with that success in your profession which, I am confident, you deserve. For my own part, since I wrote to you last, I have been painting unremittingly. But you will perhaps be surprised when I inform you that I have not yet copied a single picture: I intend to commence very soon, if I can have a fair opportunity. You must not imagine that, because I have not copied, I have not studied fine pictures. Though I have not copies on canvass, I hope I have the recollection of many pictures in my head. * * *

J. L. Morton[9] gave me a very encouraging account of our exhibi-

tion; and I hope the same harmony and good-will prevail among the artists of New York which existed when I left you. * * You may tell Mr. Hatch[10] that his engraving of Chocorua has been very much admired. * * I have not heard a word from Morse for a great length of time. I hope to be able to send a picture or two for your next exhibition: one, I think, will be a view of Newstead Abbey, which I visited lately.

I must now desire you to remember me to Inman, Ingham, Morton, Dunlap, Durand, Weir,[11] and all others for whom, you know, I have a friendship, and tell them that to be with them I "pant like the hart after the water-brooks." * *

<div align="right">Your sincere friend,
THOMAS COLE.</div>

TO SARAH COLE.

<div align="right">London, March 17th, 1831.</div>

MY DEAR SARAH,— * * My last gave you an account of the manner in which my pictures had been treated in the British Gallery. I have scarcely been there since. I have sent two pictures to the exhibition of the British Society of Artists, Suffolk Street; one of them a Storm—the grandest picture, perhaps, I have painted. I do not yet know how they have been hung; but I am determined not to expect much. * * The few who have seen the Storm think it very fine, and I have some hopes of it. I shall soon know its situation in the gallery; when I do, I will write and let you know.

I am now engaged in copying a picture or two to bring home with me; and I am seriously thinking of making a move that way before long. If my means will permit, I think of making a hasty trip to the continent: but I intend to be with you before next winter; I shall determine in a few weeks. * * I should like to see Switzerland and Italy; but there is a great deal of commotion on the continent at present, and I shall not run into trouble, if I can avoid it. * *

You do not say a word about music, or anything of the sort. I suppose you have hung up your harp. * *

<div align="right">Your loving brother,
THOMAS COLE.</div>

TO MR. GILMOR.

London, May 1st, 1831.

My dear Sir,—

** I am now on the eve of visiting the Continent, where I intend remaining several months. Returning by the way of England, I hope to arrive in America November next. With me I shall bring several pictures, and most likely the Falls of Niagara, of which I spoke: from them, if it is agreeable, you shall have your choice. I hope such an arrangement will suit your wishes; and I feel that your kindness demands from me more than I shall ever be able to perform.

I have sold several pictures since I have been here, and some of them have been spoken of in terms of high commendation, in several of the most respectable periodicals. But public criticism is seldom worth much. Though I may think lightly of the remarks made on my pictures, I know that my friends are gratified in hearing that they are noticed. I have found no facilities for copying pictures in England: I hope to find more on the Continent. I have only copied a Wilson, but have been painting incessantly; I hope improving somewhat.

Yours, very truly,
Thomas Cole.

CHAPTER ❧ 14

Eᴀʀʟʏ in May, Cole left London for Paris. The contrast between the two cities had the finest effect upon his feelings. Here in the French capital he could once more look up into something like an American sky. Everything around was light and cheerful. Clear skies and fine weather were ever essential to the happiness of Cole. In their absence his natural spirits ceased to flow, and he sank, without some effort to the contrary, into melancholy. This cheerfulness, though, was scarcely sufficient to balance the disappointment he felt on going into the picture-galleries.

NOTES ON ART.

I visited the Louvre, but was painfully disappointed on finding that the works of the Old Masters were covered with the productions of modern painters. Although I had been informed that the present French artists were low in merit, I did not expect to find them, with little exception, so totally devoid of it. I was disgusted in the beginning with their subjects. Battle, murder and death, Venuses and Psyches, the bloody and the voluptuous, are the things in which they seem to delight: and these are portrayed in a cold, hard, and often tawdry style, with an almost universal deficiency of chiaroscuro; the whole artificial, laboured and theatrical. This is alike applicable to portrait and landscape. In landscape they are poor, in portrait much inferior to the English, and in history cold and affected. In design they are much superior to the English, but in expression false.

Scheffer's pictures are an exception.[1] He has real feeling. A Tempest by him is admirable. In several others he approaches fine colour; and in expression and composition he is truly fine.

The gallery of the Louvre itself is magnificent. A pleasing circumstance in connexion with this great exhibition is that it is free to all. The distinctions which obtain in England are unperceived in Paris. In the Luxembourg, I was again disappointed in not finding the pictures of the Old Masters on the walls, but in their place those same wretched French productions. A picture of Scheffer's there possessed the merit of good colour, but was hung in a bad light. * * *

The room of Mary de Medici I do not admire, with all its splendour of glass and gilding. The pictures of Rubens which decorate it are fine specimens of colour. * *

On the 14th of May, Cole left Paris for Florence, noting in a journal whatever was most interesting.

JOURNAL.

May 22d, 1831. * * * * *

The scenery on the Rhone is exceedingly fine, resembling very much that of the Hudson. Crowning the abrupt precipices, which sometimes rise into very grand forms, are numerous castles in ruins. Occasionally a village clusters below. These castle-views carry the mind back to feudal times. Through the crumbling gate-ways fancy easily calls forth the steel-clad warriors, and sounds the trumpet, or sees the dark-eyed ladies looking through the narrow windows of the mouldering towers for the return of their beloved knights from the wars.

The Rhone is indeed the "Rapid Rhone." We glided down with great speed: villages, vineyards, castles, towers, crags and mountains all passed like a dream. I often wished it was in my power to linger in those scenes. An artist would be amply repaid for the labour of a pedestrian tour on the banks of the Rhone. * * *

Approaching Avignon, the wild scenery of the banks gives place to views of extent and varied beauty. In the distance the Lower Alps rise sublimely on the sight. * * Avignon is surrounded by ancient walls; and crowned as it is with immense turreted towers overlooking the surrounding country, it has a grand effect. When I remembered it was once the residence of those kings of the Romish church, the popes, and of Petrarch and Laura, feeling and imagination waked into busy play. * * *

CHAPTER · 14

Marseilles, May 26th, 1831.

MY DEAR PARENTS,—I have not yet reached Italy, as you will see by the place from which I date, having been delayed here, and at Lyons, on account of steamboats. To-morrow I go for Leghorn, from whence I shall proceed by land to Florence. I sail for Leghorn in a fine steam-vessel called the Francisco Primo, and hope to have a pleasant voyage, though, I can assure you, I am completely tired of voyaging. Had I time, I could give you a long account of what I have seen.

* * The people of Marseilles are finer looking than those of Lyons: their complexions are olive, but their features good. The views from the surrounding heights are delightful, and the blue Mediterranean a fine object. You may think from my slight knowledge of French that I have some difficulty in getting on; but I make my way tolerably well. The people are as civil, or more so than in England. I hope to reach Florence in four or five days; from there I will write to you again. * * The ship by which I send this letter sails to-morrow, and I write rather in haste. * *

Your loving son,

THOMAS COLE.

JOURNAL.

From Marseilles to Genoa and Leghorn the voyage in the steamer would have been pleasant but for sea-sickness. The weather was delightful, and the coast is truly beautiful and grand, rising into lofty mountains frequently clothed with verdure, the vine, the olive and the fig. Once or twice the glistening Alps showed a summit in the distant sky. Along the sides of the adjacent mountains castles, villages and convents, often most romantically situated, give a pleasing variety to the scenery. The approach to Genoa by sea is magnificent. It looks indeed like, as it has been called, a city of palaces. The porters and beggars of Genoa are, without exception, the wildest, the most savage-looking creatures I ever saw. * * *

I had always understood that Italy was the land of music; I did not, however, imagine that I should be roused, at four o'clock in the

morning, by a chorus of fifty asses, as I was, thanks to the market people. After breakfast, I went to a church built after the model of St. Peter's, Rome. From the dome we had a fine view of the city and the sea.

<div align="center">*　　*　　*　　*　　*　　*　　*</div>

Some of the palaces of Genoa are superb, built in great measure of white marble. It seems to me I never saw more people walking the streets without any apparent object than in this city.　*　　* Last night I went to the theatre, a grand and capacious building of white marble, larger, I think, than any theatre in London. The piece performing purported to be a tragedy—to me the strangest of all tragedies—a sort of opera. There they were, actors and actress, singing and squalling at each other, through marvellously exciting scenes of the most burning love, most furious rage, the deepest despair, and here in the box was I, like a Goth, laughing when I should have wept. The most awful scene was one, in which a tall fellow with a pig-tail pinched the fingers of a little fat man in his snuff-box, upon offering him snuff. A fearful revenge truly for some tremendous wrong! In fact, the tragedy was so deep and harrowing in its nature, that it was necessary to resort to some pleasant expedient to prevent the house from becoming too terribly affected. The expedient was a pantomime between acts, of sufficient length to allow the feelings and interest of the people to cool. After all there was some tolerable singing; but as the *audience* kept up a continual talking all the while, as is usually the case in an Italian theatre, I could only catch a strain now and then.

<div align="center">TO HIS PARENTS.</div>

<div align="right">Florence, June 7th, 1831.</div>

My dear Parents,—I have at length arrived at Florence, where I intend to remain a short time. I wrote you from Marseilles: from thence I came to this place by way of Genoa, and have seen much that is charming in nature and art.　*　　*　　* Genoa is the finest place I have ever seen. It is situated at the foot of a range of mountains which rise grandly from the Mediterranean, and are clothed with verdure to their very summits.　*　　*　　* The churches are numerous and magnificent in the interior, and the palaces splendid, and decorated with fine works of art.

<div align="center">9 2</div>

Whilst I was there, I lodged at a hotel in the principal square with a kind of market-place. Looking into it, could be seen soldiers, priests, monks, beggars and country folks, asses, mules, goats, and things too numerous to mention: and although there is little noise from carriages in Genoa, yet, from the jabbering and squalling of the people, and the everlasting clang of bells of every size and tone, there is little peace. What annoyed me more than anything else was being disturbed, at four o'clock in the morning, by the braying of asses, which the country people bring with them to market. Just under my window there were at least fifty asses braying at one time, to my great delight.

From Genoa I came to Leghorn, and then set off in what is called a vettura for this city. * * * * I have taken rooms in a house in which Mr. Greenough had apartments. * * My painting-room is delightfully situated. From my window I have a fine view of Fiesole, a hill that Milton mentions in his Paradise Lost. My bedroom is neat; and over my bed is a small picture, covered with an embroidered curtain: it is "The true image of the Madonna of comfort."

I have seen fine collections of pictures here of the Old Masters, and hope to profit by them, as they are open to the public, and artists are at liberty to copy any of them. The weather is the most delightful that can be imagined—lovely skies and fresh breezes. About Florence there are some enchanting views which I must paint. * * *

You cannot think how much I wish to be with you again; but I must go through with this ordeal in order that I may have no further necessity of travelling. I assure you, I have never been so happy as I was before I left home; and that circumstance will insure my return as quick as is judicious. * * I have sent Emma a pink leaf or two: could I send anything in a letter more valuable, I would. * * My love to all again and again.

I remain, in good health and spirits,
Your affectionate son,
THOMAS COLE.

CHAPTER ❧ 15

AFTER a lapse of nearly three months, spent with his usual industry in painting, sketching, and studying the pictures with which Florence abounds, Cole made several delightful excursions. The following is, in part, his Journal.

VISIT TO VOLTERRA.

JOURNAL: August 24th, 1831.—I am afraid that the days of romantic feeling are passing quite away. Converse with the world is daily deadening that sense of the beautiful in nature which has been through all my early life such a source of delight. Intercourse with men, I conceive, has induced this apathy, especially since my sojourn in Europe; and yet I cannot see how it should have so benumbing an effect upon the soul. I have now been in Italy three months, and really how little I have felt. Italy!—where all beside me seem wrought to transport!—I am grieved: still I hope to feel again; the dull cloud surely will pass over.

I am writing this in P——,¹ a village about twenty-three miles from Florence, after supper, sleepy and tired, and in a room where there is a bed which will require a ladder, it appears to me, to climb into. At one o'clock, P.M., I left Florence in company with H—— G——² and C——;³ we travel by vettura. Little that we have passed to-day is worthy of notice.

August 25th. I slept, or rather tried to sleep, last night, for about three hours; the mosquitoes were terrible. At three o'clock this morning we set off, and came at sunrise in sight of Colle, a village on the summit of a hill in the midst of some very fine groves. On this part

of the road the scenery is very agreeable, many pleasant woods, some trees, generally oaks, by the wayside, which would have made admirable studies. As we approached Volterra, the country changed from fertile to the most sterile I ever saw. The hills, rounded in form and destitute of verdure, promised little for the painter. Ascending a hill long and steep, we came upon the town on a side from which it presents no very imposing appearance. The walls and fortifications near the gate are in good style. After dinner we sallied forth in search of the picturesque. I cannot bring myself to the drudgery of writing a regular Journal: but I know from experience that the freshness of one's feelings, and even the memory of scenes and circumstances, will fade with the lapse of time. I must, therefore, make a memorandum at least of the interesting scenes of Volterra.

More ancient than Rome itself, Volterra was a colony of Lydians. The tombs of several of its kings, and many of those elegant vases called Etruscan, have been from time to time discovered in its ruins, and attest the genius and refinement of its people. At one time it is said to have contained as many as four hundred thousand inhabitants. This, I imagine, must be a marvellous exaggeration, although its remains prove that it must have been once much more populous and extensive than at present. It numbers now only a few thousands. In ancient times it was a stronghold, and experienced the varied fortunes of war—victory and defeat. Its streets have been often deluged with blood, and the scenes of terrible carnage. Once it capitulated to one of the Medici upon honourable terms, and then was treacherously given up to indiscriminate massacre, when the monster had marched his army within the gates.

Volterra is encompassed by one wall, and the fragments of several more, of different ages and constructions. Its streets are narrow, and many of its buildings of massive and peculiar architecture, having small windows and projecting blocks of stone at intervals along the walls. These edifices are the erections of an iron age, strong and rude like their builders, but remarkably striking and expressive, many of them, even in their dilapidation. The principal square of the city presents an aspect entirely new to me. Its buildings around it, with their fissure-like loopholes and windows, and craggy projections, look more like natural precipices than the dwellings of a city. Around this square are several towers; two huge ones in particular, sur-

mounted each by four smaller ones, are the dominant peaks of the range. There are the remains of several Pagan temples, which have been converted into Christian churches; the loose Venus and the chaste Diana have long since abandoned their altars to the more potent Madonna. I was induced though to pay a visit to Volterra less for itself than for its views and scenery. It is situated on an eminence of very great height, and commands a vast prospect over mountains and plains to the distant Mediterranean. The geological structure of the country is remarkable—a mass of loam without a framework of rock. Even the stupendous pile upon which Volterra itself stands is of the same soft consistence, and washes away rapidly in the rain.

Nothing is more singular than the appearance which is presented below; all looks as if it had recently emerged from a deluge. It is scored with innumerable ravines, and exposes a light coloured and shining surface of baked earth to the sun. In some directions are seen tracts of verdure, and in the distance, spreading out its dark shade, the forest of Brignione, where the wild boar is hunted to this day. The mountain of Volterra is extremely fertile on one of its slopes, and embosoms some rich romantic valleys with fine woods, and here and there a cottage of striking form and colour nestling in their shades. The western side of the mountain is a broad contrast to this: here all is bare and savage. The Balzi or cliffs afford a spectacle of desolate grandeur. Standing on the brink of a precipice, you throw your eye down a gulf fearfully deep, the sides of which are almost perpendicular walls of earth. This gulf gradually widens from where you stand, and opens, with ridgy sides, into a vast and dreary plain, ribbed with countless ravines. Afar off, you catch a scanty stream that struggles with many windings and turnings through the thirsty desert, and finally loses itself in the dark and more kindly distance. In another direction, and on the very bound of vision, ranges of grand mountains mingle with the heavens. What a study for a picture of Elijah in the desert! I shuddered as I stood upon the edge of this abyss, and feared for a moment that the crumbling earth would slide from beneath me. I have often mused upon the brink of a rocky precipice, without a thought of its destructibility; but here the great mass, bearing marks of rapid and continual decay, awakened the instantaneous thought that it was perishable as a cloud. I sat under the

ruin of an old Etruscan wall, and gazed long and silently on the great scene of desolate sublimity. The sun was high, and the herbless ravines gave back his rays with a fierce splendour. To me the scene was more awful and impressive than at any other hour. Profound stillness reigned through the whole dreary expanse. At the moment when my heart was drinking in the fearful silence most deeply, I was startled by the convent bell. High above the depths of the abyss, it swung in its venerable tower, and poured its solemn wail into the immeasurable air without an echo. Brief, thought I, are the limits of mortal life: man measures time by hours and minutes, but nature by the changes of the universe. Here, before me, is one of her hour-glasses, in which the sands have seen untold ages, and yet the mind cannot reckon their exhaustion.

We have now been several days at Volterra, and are delighted. The principal fortress, called the Maschio, is a fine specimen of castle architecture. Having permission from the commander to visit it, we were conducted through it by an old soldier with a huge bunch of keys and a lantern. We first entered the central and loftiest tower by means of a drawbridge which spanned the encircling moat. Following our guide down a flight of worn and narrow steps, we were introduced into a small vaulted dungeon. It was destitute of light, with the exception of a few faint rays which came through a grated aperture, opening against a blank wall. In this narrow and gloomy prison the Count Felicini was confined by one of the Medici for twenty long and miserable years. In the wall there still remains a part of the bolt to which his chains were attached, and the solid stone floor bears deep impressions of his footsteps. It is scarcely possible to conceive that a man could survive long in such a dreadful abode— that he could bear to live. It shows the marvellous power of adaptation which the human mind possesses; hope makes him live, when reason bids him die. At the end of those dreadful years, an order came for his liberation; his chains were stricken off, and the Count Felicini was conducted up once more into the open air: for a moment he looked aloft upon the sky, and then sank back, and expired. Himself a cruel character, his fate was most cruel. From this fearful dungeon we descended to another still lower and smaller. In this and several similar ones we were told that many had perished. They were the prisons of the Medici: there they used to incarcerate secretly those

whom it was not policy to put publicly to death. These walls, I whispered to myself, have resounded to the moans of suffering and hunger, and the curses of despair. As I retreated through the gloomy passages, the sense of human cruelty bore with a crushing weight upon my heart, and I was glad when we recrossed the drawbridge, and stood again beneath the pure blue sky. How falsely the lofty and powerful among men are estimated! how the world is imposed upon! THE MEDICI!—It is a great name—a noble, a magnificent name, in the tomes of Roscoe:[4] but why are we offered such a picture of lights without shadows? Why not at least a few touches of the tyranny and "damned deeds" of these great men?

I have laboured hard since I have been in Volterra, sallying forth with my sketch-book every morning at five, and, with the exception of an hour at dinner, continuing out until evening. I have had many delightful walks, and the more I see, the more I am pleased. A vast horizon is perpetually before you, and the grandest effects of sun, clouds, and storms are ever succeeding each other. Blue shadows are continually moving from mountain to mountain, from plain to precipice, ever and anon wrapping in their gloom distant villages and towers, which a few minutes before were glittering in the sun-light. Then thunder-storms sweep with their tumultuous clouds over the great expanse: as we see them advancing, a power almost supernatural seems to move the soul: it cannot direct their course, but the eye measures their extent, and marks the village that will soon be enveloped in their troubled darkness. I have witnessed some truly glorious sunsets, and lovely twilights: one in particular from the western declivity of the mountain, I watched with feelings of singular delight as it faded away. The tone of the landscape was most heavenly; all the great plain was in deep shadow, reposing in an atmosphere whose hues can never be expressed in language; the ordinary terms, "silvery" and "golden," give but a dim notion of it. It was such an atmosphere as one could imagine angelic beings would delight to breathe, and in which they would joy to move. Here and there dark hills, softly emerging with their white turrets, glittered like stars on the breast of the lower gloom. One lone cloud still lingered in the amber sky. I am not surprised that the Italian masters have painted so admirably as they have: nature in celestial attire was their teacher.

I am now writing in a dirty locanda of Colle, a town about half-

way from Volterra to Florence. From the beauty of its environs we were induced to spend a few days here: had we known at first, as we now know to our vexation, what myriads of fleas infest this prime locanda, I think we should have discarded the picturesque for the comfortable, and proceeded at once to Florence. Last night I slept, it appeared to me, five minutes: the fleas kept me well awake the early part of the night, and the braying of asses, that lodged in the stable beneath us, the latter, to make no mention of the pleasing odours that stole up through sundry holes in the floor.

After a sojourn at Volterra of ten days, we left it with regret. Our ride to Colle was agreeable. At sunset we walked out and took a view of the town, the greater part of which is situated on a hill whose abrupt sides are clothed with rich woods that bury in their charming shades the remainder. Through the valley, in which we were loitering, a stream flowed handsomely along under high banks of rich coloured earth and luxuriant herbage. While we were gazing, a balloon ascended from among the trees at the foot of the hill, and floated away across the purple evening sky. To-morrow we set off for Florence.

TO J. L. MORTON, ESQ.

Florence, January 31st, 1832.

DEAR SIR,—* * * * There is much that I could write from this land of poetry and beauty, which might interest you. I really find it more difficult to write, from the abundance of matter than from any paucity: it is sometimes easier to invent than to select. You will perceive that I am still in Florence, in which place I have spent several agreeable and, I hope, profitable months. I have been painting, painting incessantly. You will be a little surprised, perhaps, when I tell you I have not made a single copy here. I trust though the original pictures I intend to send you for the next exhibition will show that I have not neglected to study.

I have several pictures on the easel. One is a large picture representing a romantic country, or perfect state of nature, with appropriate savage figures. It is a scene of no particular land, but a general idea of a wild: and, when you see it, I think you will give me credit for not having forgotten those sublime scenes of the wilderness in which you know I so much delight; scenes whose peculiar grandeur has no coun-

terpart in this section of Europe. I am also painting a scripture subject, The Angels appearing to the Shepherds. * * * * *

In August we had an exhibition in the Academy here,—one of the worst I ever saw. With a few exceptions, it was made up of cold, affected, academical things. * * * * * * *

<div align="right">

Yours, very truly,

THOMAS COLE.

</div>

Amid all the varied scenes of European art and nature, Cole, as the foregoing letter serves to show, could not forget the natural scenery of America. He fulfilled the prediction, and heeded the counsel of the poet, breathed in the following sonnet:

> Thine eyes shall see the light of distant skies:
>> Yet, Cole! thy heart shall bear to Europe's strand
>> A living image of thy native land,
> Such as on thy own glorious canvass lies.
> Lone lakes—savannas where the bison roves—
>> Rocks rich with summer garlands—solemn streams—
>> Skies, where the desert eagle wheels and screams—
> Spring bloom and autumn blaze of boundless groves.
> Fair scenes shall greet thee where thou goest—fair,
>> But different—everywhere the trace of men,
>> Paths, homes, graves, ruins, from the lowest glen
> To where life shrinks from the fierce Alpine air.
>> Gaze on them, till the tears shall dim thy sight,
>> But keep that earlier, wilder image bright.—*Bryant.*

Previous to going to Rome, he says in a letter to Dunlap, I passed nine months in Florence, which I spent in studying the magnificent collections there, and in painting several pictures, among which was a small Sunset on the Arno, and a wild scene for Mr. Gilmor, of Baltimore. The Arno was exhibited in the Academy of St. Luke, and seemed to attract attention. The Grand Duke is said to have been much pleased with it, but he did not buy it. I studied the figure part of my time, and drew from the life at the Academy, and painted my dead Abel, which was intended as a study for a large picture to represent Adam and Eve finding the body of Abel.

Nothing more than the "study" was ever executed. The primary intention of the "wild scene" is given in the succeeding letter.

CHAPTER · 15

TO MR. GILMOR.

Florence, January 29th, 1832.

DEAR SIR,—Although I have seldom written to you since I have
been in Europe, I have not been forgetful how much I am indebted
to your kindness. I now write to offer something in return for the
pecuniary obligation under which you have placed me. A variety of
circumstances has concurred to render this return so tardy: but I
hope the lateness of it will not render it the less acceptable. I have
sent to the National Academy of Design, New York, a picture, the
painting of which has occupied the greater part of seven months that
I have been in Florence, and is by far the most laboured, if not the
best of my works. I offer it for the three hundred dollars you ad-
vanced me, and your acceptance will be considered a favour. * *

This picture was intended for the first of a series which I have long
contemplated. In order that you may understand the subject it is
necessary that I give you the plan of the series.* * But while I
think it my best picture, I have the plan of another, which, perhaps,
would be finer for the subject. * * *

You will probably smile at my castles in air, for probably they are
nothing more: it is likely I shall never have the means of executing
this subject. And should I ever be fortunate enough, I may disappoint
myself, as is frequently the case, and discover that the living pictures
of the mind, in the attempt to embody them, are transmuted into
lifeless clay. * * *

I am delighted with what I have seen of Italy,—its scenery, and its
works of art. The galleries of Florence are paradise to a painter. I have
found, though, no natural scenery yet which has affected me so
powerfully as that which I have seen in the wilderness places of
America: and although there are a peculiar softness and beauty in
Italian skies, ours are far more gorgeous. * * I intend to set off
for Rome and Naples in a few days, hoping to fill my sketchbooks
with abundant material for future pictures. * * *

I have had the happiness of residing in the same house with Mr.
Greenough,[5] almost ever since I have been in Florence, and I shall
regret leaving him very much. The Medora, that he is executing for

* See letter to Mr. Reed, p. 129, chap. 19.

you, I have had the pleasure of seeing in the clay model: it is very original, and full of pathos.

I have sent, with the large picture to New York, a small one—a Sunset on the Arno: it is a simple effect. I should wish you to see it.

*　　*　　*

<div align="right">Yours, truly,

Thomas Cole.</div>

In speaking of his own works, Cole was an example of modesty. The conclusion of the above letter is a good specimen of his manner on such occasions. It is the merest hint of a picture full of evidence that the painter was one of the few who could truly say:

> "And I have felt
> A presence that disturbs me with the joy
> Of elevated thoughts; a sense sublime
> Of something far more deeply interfused,
> Whose dwelling is the light of setting suns."[6]

Genius, unless seduced by pride to hold a falsehood, regards its own creations with humility. Where there is a right heart, a healthy moral feeling, it will ever be conscious of imperfection in its best efforts. It will know, of a truth, that they "come short of the glory" of the perfect, and speak of them with unaffected modesty. The view down the Arno, at the close of day, was one to which Cole gave long and frequent contemplation. It took his spirit captive; and his picture of it (though attractive to the Florentines themselves, and really, as Bryant calls it, "a fine painting, with the river gleaming in the middle-ground, the dark woods of the Cascine on the right, and above, in the distance, the mountain summits half dissolved in the vapoury splendour which belongs to an Italian sunset") was, he felt, but a dim reflection of the living beauty, which, as time ripened his powers, and gave his greater mastery of the pencil, he might hope more nearly to approach.

Twice was the attempt made afterwards on a larger scale, and with the same lowly sense of distance from the glorious original. One of these later sunsets on the Arno—unfinished in the foreground, yet very beautiful even in its incompleteness—is still in the possession of his family.

The picture for Mr. Gilmor,—a landscape of the highest order—although originally intended, as he says, for the first of a long contemplated series, was presently given up for the finer conception of which he speaks, and which, in fact, was the one ultimately embodied in the first picture of the Course of Empire.

A short time previous to the date of the foregoing letter, a small affair transpired, which came near terminating the connexion of Cole with Florence in a very sudden and disagreeable manner. It is worth relating as an illustration of a point in the painter's character that was seldom visible.

He was walking in company with a friend on the Cascine, when a mounted dragoon, dashing down one of the paths, came very near riding upon them. To punish either his insolence or carelessness, Cole instantly broke his cane over the horse's flank; and received, next morning, an order from the authorities to quit Tuscany. From fulfilling this peremptory command he was only relieved by the intervention of friends.

Next to home itself, Florence was to Cole the happiest place in which he ever lived. Its sweet-tempered, shining climate, its calm seclusion, its works of art, reflecting the truth and splendour of nature, made it, to use his own oft-repeated expression, the painter's paradise. There, remote from the spirit of politics and money-making,—an evil spirit from which he always shrunk—he enjoyed a freedom from care and disquiet, for which he ever yearned intensely, and rose consciously both in the science and practice of his art. Although at first, from the gloom which his stay in England had thrown upon his mind, nothing could

> "Bring back the hour
> Of splenaour in the grass, of glory in the flower,"

yet it gradually returned, and filled his heart with a gladness he never could forget, and made his residence in Florence one of his choicest remembrances.

*Cole at Rome. In his Studio, and in Society. Among the works of Art.
In Nature.*

On the 3d of the following February, Cole left for Rome, where, after a journey of five days, much of the time on foot, he arrived, and took rooms in the Via del Tritone. These he presently exchanged for more eligible lodgings on the Pincian Hill, and painted in an apartment which tradition has consecrated as the studio of Claude. The building, sometimes called the Temple, which contains this noted room, commands from its balconies a grand and impressive view: all Rome is spread out below. Here he worked with his usual assiduity until the ensuing May.

COLE IN HIS STUDIO, AND IN SOCIETY.

His constant sense of the value of time called him to his easel at an early hour. With the exception of short intervals given to reading, to the sunrise, to breakfast, always slight and simple, to watching from his windows the varying effects of the day upon the wonderful landscape, he painted till dinner, usually late, with an industry quite surprising to the easy Italians. "Ah, madam," said the quiet old Roman with whom he took lodgings, in conversation with an American lady about him, "he works like a crazy man." In his dress he was perfectly neat, but plain, and without the least appearance of singularity. In nothing did he affect the artist and the genius. He was in Rome what he was at home, simply Cole. In society, which he frequented but little, he was cheerful, though quiet and retiring, with an air of gravity, except when stirred by wit and humour, or overcome by the ridiculous, for which he had the keenest sense; then he resigned himself, for a moment, to the heartiest laughter.

His habits were of religious purity. Profanity and irreverence

shocked him, indelicacy of language or manner offended him. He felt it degrading to speak of the licentiousness too often indulged in by foreigners in Rome. Passion, appetite never led him astray. The light wines of the country he used sparingly, but rejected all ardent spirits, and tobacco in every form. The luxury of tables never brought a cloud over his mind or feelings. Clearness of intellectual perception and serenity of mind, to which simple healthy tastes so wonderfully contribute, were as much his here as among the brooks of the Catskills. He would dine frequently on fruits, bread and cheese, as well in the city as in wildest parts of the country. Perfect temperance was his rule, and that not from any mere pecuniary or physical necessity, but from the dictates of choice and propriety.

Habits and manners so redolent with virtue, while they breathed the loftiness and purity of his character, seldom failed to win the love and admiration of his associates. Women are proverbially the nicest judges of moral qualities. It was the remark of an American lady, who, with that delicacy peculiar to her country-women, shrunk, at first, from some of the most celebrated pieces of art, that with Cole she experienced no feelings of embarrassment. Such was her involuntary trust in the purity of his mind, and the propriety of his taste, that she followed him through the galleries as she would have followed a child. In these great treasuries of art let us now contemplate him as a student.

COLE AMONG THE WORKS OF ART.

Here again his way, in a measure, was peculiar to himself. At first sight, he did not see the superlative excellence of the master-pieces. He was already too wise, though, not to know that in that fact lay one of the first evidences of their real greatness. This lesson he had learned over and over again in the galleries of nature.

What does not in some degree "dwarf itself in the distance" to the mind, in its first act of contemplation, is not truly great. Extremes here certainly meet. There is a brief season when the ictus of an imperfect work may come down among the thoughts with the same force as that of a perfect one. During that season, but for that only, both may be said to tremble on the point of decision. With the first strong onward thought, though, a space is discerned between the two,

which to traverse will surely give, at each progressive step, the ability to see the one always lessening, and the other growing grander.

It was no matter of surprise, therefore, to Cole, that his first impressions in the Vatican were not remarkable. Faith that he was in the presence of consummate art held him quiet, hopeful and confident of an hour when he should reach it, and realize the fulness of its power and beauty. That hour was not long in coming. It brought, however, no expressions of rapture, no bounding ecstacy. Raphael, Michael Angelo waked little visible, and less audible evidence of delight. Their effect, like that of nature in her grander, more glorious aspects, was to carry him away into shadows of the most solemn repose. They hushed him into their own impressive silence, and fixed him in the serenity of adoration. But then were the moments when electric thought flashed like the northern light through his mental skies. From the midst of feelings veiled and mantled, "his eyes made up of wonder and love," his whole spirit went forth, and winged a breathless flight through the deeps, piercing alike intensest light and shadowy mystery, and wrestling with the subtlest life of their creations.

Purer, profounder pleasure perhaps no man ever felt than Cole in these searchings—in this *living*, call it rather, of his in and through a great work of art: certainly no one ever expressed it, when he did so at all, with a chaster, sweeter brevity. An artist of distinction has observed —intimate friends confirm the remark for other times and countries— that Cole, when travelling in Italy, never used the common language of admiration with respect to the striking objects of nature. "Fine"— "beautiful"—"very beautiful," spoken in a voice subdued and low, served to express his liveliest feelings. Such were his words and manner of speaking in the presence of highest art. The utterance of a breath only told, and eloquently, the whole story of his emotions.

It was usually the signal too that he felt himself competent, at that moment, to witness to the truth and greatness of the work before him. It was less a principle with him, than an instinct *to keep still* till he felt that he comprehended his artist, holding himself "ignorant of his understanding, until he understood his ignorance." Then, if required, he would render, in a single sentence, frequently a verdict of such justice as seldom failed to convince, or asked for any reversing.

In thus speaking of the student in the galleries, I have given virtually his method of study. It was *criticism*, and that in its nature re-

productive, involving the employment of the entire inward and spiritual, and but little of the outward and physical man. He never copied, seldom or never seriously drew. A few hasty sketches are the only remaining evidences that he ever did anything more than exercise his mind and heart upon the pictures and sculptures of the masters.

But that, as I have already intimated, was something else than elegant-extract-making for the purpose of future quotation, or more pitiful plagiarism: something more than mere idle surface-excursion to pilfer his bundle of beauties, rooted up here and there for transplanting in his own parterre at his leisure: even far more than a spending of energies to climb the steeps of a single grandeur, or the refreshment of fancy in the shade of some one bewitching effect, enjoying a festival of shadows, but tasting no substance, and leaving the solid fact for the empty husk of a general and indistinct impression: it was a telescopic look that resolved the nebulæ of common eyes into separate orbs of light. To drop the figure, it was analysis, quick, searching, effectual; seizing things manifold as they unfolded each out of the other down to the last; snapping a fibre never, never dissipating relations, never cutting off from the general communion one of the great assembly of parts; never sinking a member below its level into dusky nothing, nor raising one out of its due place into glowing prominence, but leaving to each its own proper position and individuality: above all, never killing with the frost of an unfeeling spirit that fragrant, live beauty, which only blooms in virtue of drawing its ambrosial juices through infinite and all pervading fibres.

Thus, while it was analysis, it was also synthesis. Albeit the life-holding vase cracked under the force of the mental stroke, and fell to pieces, revealing thereby its earthly qualities and textures, its hidden inside surfaces, and the method of its making, yet a kindlier power wrought the miracle of restoration, and recalled the departing soul. Again to drop the figure, so deeply was the dissecting faculty immersed in his imagination that the idea of an organic whole was simultaneous with the act of resolving a given work of art into its elemental parts. In other words, space and matter, motion and rest, colour, light and shade, were all known by his higher, imaginative power as so many members composing one body,—a body or creation full of life, thought, feeling, through the potent energies of one

indwelling spirit, informing and disposing all things according to its own good pleasure or law.

Men of genius, when they hold their gifts with a right heart, love to be viewed, when viewed at all, in their integrity, wishing to be counted neither less nor more than they really are. Could the same be said of their works—works of art like the greatest of Raphael— they would of all things have loved the presence of a man like Cole. His intellectual eye was of a perfect clarity. He never looked into the atmosphere of art through the rosy breath of his own fancy, but with a vision simple and single to the objective fact. Hence all things rose up, and came to him in their own native simplicity and purity without disguise, distortion or false colour. Hence there were no horses or chariots of fire merely of his own seeing, nor spirits of beauty of his own conjuring: clear waters did not reflect images, shores did not resound with voices, of which the painter never dreamed. With a sight clean from stain or mist, he saw only what *was*, and *how* or the way by which it was. In brief, lighting on the place where the painter left with his pigments, he sped away through the point where he entered with his imagination. By thus taking position with the artist, he advanced with him, and, in a sense, reproduced his work. This was perfect study, and the ideal of criticism. It was mind, imagination, fancy, passion, all of them painting—painting as they did of old in the persons of the masters. And while a fair memory, and a power of recalling processes of thought to a high degree, enabled him to repeat these reproductions at will, for lengths of time, so as to paint them, (which he never did,) yet was not his style rendered thereby less original, less peculiarly his own.

To deny him, though, a benefit from his study of the masters would be to deny him all genius, whose very nature and privilege it is to feed on excellence wherever it can find it, and whose offspring are healthy, beautiful and perfect in proportion to the richness of the pastures in which it expatiates. But as art in its perfection is but a defective continuation of God's marvellous nature, how could Cole stay long to glean, though golden handfuls, in its scanty patch, while hard by were the great fields into which he could go forth, and "doubtless come again with joy, and bring his sheaves with him?" Wonderful, divine *almost* as are some of the creations in the bowers of art, more wonderful and *quite* divine were the creations beyond

their precincts: and to prophecy of these, to claim them as the source from whence they themselves were derived, to point to them, as the many waters from which every called and consecrated artist should drink, and fill his vessel, he felt was the silent, yet eloquent word, the voiceless yet expressive counsel of the rarest beauties of canvass, fresco and marble. The time, therefore, spent in the contemplation of art was short in comparison with that devoted to things of the veritable earth and heaven. It is but a step aside from the fact to say that Cole went even to Rome purposely to study nature. To nature then let us follow him.

COLE IN NATURE.

If we were not already acquainted with his manner there, it would be enough to say that he went out into the open, Roman air with the same eye, mind and heart which he tasked in the galleries and churches, except that they were ordered with a loftier reverence, and shaped to greater issues, and attended with the most diligent manual exercise. And this is only saying that he was but the same man walking from one department of fine creations to another—from the less to the greater—from the doings of the mortal to those of the Immortal, adding *work* to study. Roman nature then was to him as another Vatican or St. Peter's infinitely expanded, into which he now went forth with palette and portfolio. When we come to see how this nature of Italy differed to him from all other nature, as Italian art differed from all other art, we shall see Cole, at that point of his life, in a right light.

While the main features of the landscapes of Italy waked no feeling of grandeur with which he was not already familiar, yet they were more picturesque and better disposed than any he had ever yet beheld. As painters would say, the composition was finer. And while spring in America touched in her hues with all tenderness and delicacy, and autumn there was the most gorgeous of all colourists, and every season decked the scenery of the skies with a magnificence quite unrivalled, there was a richness in the aerial draperies of Italian landscape that gave to its complexion, countenance and form a beauty peculiar to themselves, and to him hitherto unknown.

Nature rose up before him with a glory round her head, caught

from some diviner realm of sunshine: the threads of her hair were golden; her eyes swam in a soft and dreamy fire; her bosom palpitated with delicious passion; her very breath was tinctured with the hues as well as fragrance of all flowers; she walked in airy splendours, and reposed with all the beauties of atmosphere, of light and climate at once dissolving around her.

About the earth there was a tender, blissful warmth, in the unfathomable heavens a blush, and in all a mellow, ripe effect that perfumed the mind, and dropped upon it a fruitlike flavour, and charmed the soul with the sweetness of entrancing melodies. Never sunshine fell into the arms of a lovelier, softer air; never air embraced a lovelier sunshine; and both, in embraces blissful, never sank on the bosom of a land more beauteous.

To speak of Cole's thoughts and emotions, in the presence of a world so glowing with passionate life, in such perfection of sweetness, grace and beauty, is, at this moment, needless. And to tell how he wandered with the streams, and immersed himself in the softness of distances, and in the living fires of aerial depths, and grasped at heights and breadths, and met the day, in its virginity, tossing its roses, and parted with it pensive and garlanded for its passage; to tell how he walked, for days, to and fro, over the solitary Campagna, watching and touching objects manifold that catch the light, and fling shadows, would be but to repeat what has already been said of him, in the region of the Catskills.

The great difference between Italian scenery, and all other, with which he was acquainted, lay, with Cole, less in its material, than in its moral and historical elements. Hitherto he had walked with nature in her maidenhood, her fair proportions veiled in virgin robes, affianced indeed to human associations, but unpolluted, unwasted by human passion. But now he was in converse with her, after long centuries of marriage with man. As the word and worship of God carry faith into the events of the great future, so the very verdure of solitudes and the solemnity of voiceless evening skies swept his spirit back to mingle with the doings of past ages. Everywhere was the repetition of one awful, grand expression: —mortal triumph and defeat—mortal strength and weakness—mortal pride and degradation—man's rise and fall—man's wrestling with his fellow—his feeble strife with time, and childish struggles on the

bosom of his mother earth. He saw himself on the seashore of history, and the wrecks of human passion, pride, ambition, joy and sorrow, pricking through its sands. "There were giants in those days" who clove the mountains, and thrust back the very waves: they fell along the earth; and lo! the white remnant of their frames. In the red breath of sunset he beheld both the memorial of the glory of kings, and of the flames of their funeral pyre. In the crumbling ruins, beneath the mantle of the seasons, lay the bones of empire.

What to Cole was nature in her fresh, lone sublimities, in her divinest beauties, to nature thus married to mortal deeds and generations? As a creature perpetually rejuvenated, she peopled his vision with the old imagery of life, blooming, joyous, energetic life; but as sown with relics, and haunted by story and tradition, she spake to his inner heart, touching his deeper sympathies, and teaching him lessons of his own fallen nature. Hitherto the external world had been to him a creation speaking mainly of itself; now, speaking mainly of humanity, in tones pathetic and impressive.

It was here that he began to feel his strength for the grander issues of his art. He had now reached an elevation in the great ascent, one of the shoulders of the heaven-cleaving summit, from which he could survey both man and the visible world in vast, moral perspective. It was no mere feeling, but the conscious want of freedom and assurance, that made him abandon, in Florence, the thought of having the admirable picture painted there the first of a contemplated series. He had something more to learn both of his subject, and of himself; one view more, at least, to take of his noble theme, and of his capabilities to seize and master it. Here, at Rome, a grander book had opened: he read its profounder lessons, and felt assured and free to enter upon his task, when fortune should favour him with an hour.

Returning, once, from a long walk with a few friends, he seated himself on the fragments of a column to enjoy the sunset. As its splendours faded into the twilight, all lapsed into a stillness suited to the solemn repose peculiar, at that time, to a scene of ruin. There came through the deepening shadows few sounds louder than the beating of their hearts. After some minutes of silent, mournful pleasure, seated a little apart by a lady, Cole, a thing rather unusual with him, was the first to speak. This he did in his own low, quiet voice, but with such earnestness as told the depth of his emotions, and

the greatness of his thoughts. The subject was that of the future Course of Empire. In his own brief and simple way, he passed from point to point in the series, making, by many a clear and vivid outline, the liveliest impression upon the mind of his listener, until he closed with a picture that found its parallel in the melancholy desolation by which, at that moment, they were surrounded. Such was Cole, the poet artist, at Rome.

CHAPTER ❦ 17

To his Parents: from Florence to Rome; Roman labourers; the Carnival.
Notes at Naples: the Colosseum; Pantheon; St. Peter's; the Vatican;
Apollo; Venus; Transfiguration; St. Jerome; Moses. Panorama of Naples.
Paestum.

TO HIS PARENTS.

Rome, March 4th, 1832.

My dear Parents,—My last was from Florence, and written to the Doctor, containing the information that I was about to set off for Rome. The journey was performed safely, and with some pleasure, in the vettura. My companions were Mr. A——, and Mr. L——, from Boston, an Irish Roman Catholic lady and an Italian priest; and what with Irish and Italian arguments and disputes, we contrived to get over the ground between Florence and Rome, in five days, a distance of a hundred and seventy miles only.

I should not forget to note the fine weather, and the flowers by the wayside, in February too, and the wretched inns, where you sleep over the stable always with an entertaining company of fleas, if the beds are not too wet to drown them. Of the two evils, I always choose the fleas, and got into bed with my old baize-lined cloak, of American memory, whose services have been great, and deserve commendation, especially in this land of milk and honey, where you have to pass day after day without being able to get either of them, and to travel through countries where coffee is known only in name, and tea utterly unknown; where the shepherds of the hills wear skins, and are no more civilized than Indians, and somewhat more stupid and superstitious. To relate these things will make you think that I am indeed in a foreign country: but you must not believe in the exaggerated stories of bandits, and all that; they are all nonsense. There is quite as much safety in travelling here, as in America or England, and the peasants are infinitely more civil and obliging.

I could say much about Rome; but I cannot venture into the subject far, it is such an infinite one. I have seen St. Peter's; but am not so much affected by it as some. It is a stupendous building: to me, however, it is much inferior in effect to St. Paul's, London. Its interior is encrusted with precious marbles of every hue, and adorned with gold, sculpture and painting: it is quite a wilderness of riches. The Vatican, which adjoins St. Peter's, is to me a paradise. There are the finest statues of the antique that exist; there are the pictures of Raphael, and of others, whose works are among the highest efforts of human genius.

But the things that most affect me, in Rome, are the antiquities. None but those who can see the remains can form an idea of what Ancient Rome was. * * * All these things fill the mind with wonder, and we cannot but contrast the energy of the ancient Romans with the effeminacy of the modern. A great part of ancient Rome lies buried, in an unaccountable manner, under an accumulation of rubbish, in places, to the depth of twenty and thirty feet. Here and there, excavations have been made, and we can now step on the pavement upon which Cæsar trod. These excavations are small; although, to watch the Roman workmen constantly employed in them, you would be astonished that so much has been done. What a difference between the builders of these great works, and the beings engaged in their excavation!

You would laugh heartily to see modern Roman labourers *at work*. In the first place, they have wheelbarrows that hold about a good shovel-full; these they load about half full, with small spades having long handles, that the poor fellows may not break their backs in stooping. You will see them, on a fine, warm, sunny morning, as thick as flies on a lump of sugar, some with their cloaks on, leaning upon their spades either with gloves on or with their hands in their pockets, others sitting on the sides of their wheelbarrows, or perhaps, which is a rare occurrence, lifting slowly about a spoonful of earth at a time, resting some five minutes between each effort: if they find a piece of earth as big as the fist they break it before lifting it. Sometimes you will see groups of them going along at the slowest possible pace with their *loads*, conversing and smoking to make their labours light, or, overcome by the toil of wheeling ten yards, sitting on their barrows, reposing from the *dreadful* fatigue. It is certainly a most laughable

sight. You may think this an exaggeration, but, I assure you, it is almost impossible to exaggerate.

It is now the Carnival in Rome, when it is usual for the people to abandon themselves to all sorts of gayety. But this season the Carnival is dull, because the Pope has interdicted masking, which takes away much of the interest. However, it is extremely amusing, for many persons appear dressed in character; and the Corso, the fashionable street, is filled, every afternoon, with a motley assemblage of harlequins, Turks, Greeks and jesters, and from every window is hung a gay piece of drapery. There are showers of sugar-plums and flowers, with which the people pelt each other. I have stood the fire, and returned it with interest, as I ride, every afternoon, in the carriage of some American friend. * * * I have just received your letter, written as long ago as November 17th. * * * * *

<div style="text-align:right">

Your loving son,

THOMAS COLE.

</div>

NOTES AT NAPLES.

Naples, May 14th, 1832.—I left Rome almost without making a memorandum of the many objects of interest I there saw. In the midst of Naples, as I am, with all its enchantments around me, I must devote an hour to the "City of the soul," and save from oblivion the already fading records of memory. * * *

From the great multitude of wondrous things, I would select the Colosseum as the object that affected me the most. It is stupendous, yet beautiful in its destruction. From the broad arena within, it rises around you, arch above arch, broken and desolate, and mantled in many parts with the laurustinus, the acanthus, and numerous other plants and flowers, exquisite both for their colour and fragrance. It looks more like a work of nature than of man; for the regularity of art is lost, in a great measure, in dilapidation, and the luxuriant herbage, clinging to its ruins as if to "mouth its distress," completes the illusion. Crag rises over crag, green and breezy summits mount into the sky. To walk beneath its crumbling walls, to climb its shattered steps, to wander through its long, arched passages, to tread in the footsteps of Rome's ancient kings, to muse upon its broken height, is to lapse into sad, though not unpleasing meditation.

But he who would see and feel the grandeur of the Colosseum must spend his hour there, at night, when the moon is shedding over it its magic splendour. Let him ascend to its higher terraces, at that pensive time, and gaze down into the abyss, or hang his eye upon the ruinous ridge, where it gleams in the moon-rays, and charges boldly against the deep blue heaven. The mighty spectacle, mysterious and dark, opens beneath the eye more like some awful dream than an earthly reality,—a vision of the valley and shadow of death, rather than the substantial work of man. Could man, indeed, have ministered either to its erection or its ruin? As I mused upon its great circumference, I seemed to be sounding the depths of some volcanic crater, whose fires, long extinguished, had left the ribbed and blasted rocks to the wild-flower and the ivy. In a sense, the fancy is a truth: it was once the crater of human passions; there their terrible fires blazed forth with desolating power, and the thunder of the eruption shook the skies. But now all is still desolation. In the morning the warbling of birds makes the quiet air melodious; in the hushed and holy twilight, the low chanting of monkish solemnities soothes the startled ear.

At the Pantheon all is simple and grand. What a portico! what masses of light and shadow! But enter within—the dome opens like an eternity: the impression is simple and overwhelming: there are no bounds: the eye wanders over it incessantly: if it fixes upon any one point, that point seems always retiring. So skillfully is it contrived that its dimensions cannot be measured by the eye: the perspective lines of its quadrangular compartments make it appear larger than it really is. The light falls through a circular opening at the top of the dome; and looking up at the sky and the passing clouds of the zenith, one might easily imagine himself in the centre of a globe that was rolling through the infinite depths of heaven.

How different is that greatest modern temple, magnificent and immense as it is. It affects but by its richness. Columns piled upon columns support that most beautiful dome: while I wonder, I can scarce admire; the effect is so inadequate to its size, and to the world of material employed. One point destroys another, and the vast dome sinks amid a crowd of huge statues that encumber the portico. The long colonnades on each wing, built sloping with the hill in front, by counteracting the natural perspective lines, destroy the effect

which would otherwise be produced by the mere size of the edifice. Enter, and you are astonished at the richness of the materials, and the beauty of its parts. Marble, porphyry and precious stones, bronze and gold, are all around you as profusely as if the earth had yielded up her riches to adorn the stupendous fane. The lavishness of precious materials, applied without regard to the effect of the whole, is barbaric: it may please by its costliness and variety: but costliness pleases only the vulgar, and variety without order is not beauty. Standing beneath the dome, which we know to be larger than that of the Pantheon, we are surprised at the smallness of its appearance; it seems but a few feet in diameter. This effect is owing to the bright and staring colours with which it is bedizened; colours which *cannot* be made to appear distant without making others of corresponding intensity appear near to the beholder, which is not the case The chequered contrasts of colour greatly injure the effect of St. Peter's. Had the colours been arranged simply in broad masses, with attention to their peculiar qualities—the hue, the light and shade, whether soft or violent—with well-arranged gradations, how majestic, I can imagine, the interior of this noble pile would have appeared.

To speak fully of the treasures of the Vatican would require volumes; and to criticise with judgment is a still more arduous task. But I cannot, on account of my incapacity to retain impressions, allow them to fade away for the want of a written record, although it must be brief and imperfect.

I go to the Apollo first, which, if not the most, is one of the most, perfect of human productions. I can conceive of no description finer than Byron's in his Childe Harold: but description can never convey an adequate idea of that embodiment of majesty and motion. Critics have found fault, and artists, learned in the clay, rather than in the spirit of art, have declared that the neck is not set aright on the shoulders. Shallow observers! Do they imagine that he who modeled those symmetrical limbs placed that neck as it is through ignorance or inadvertence? No! it was intentional: and by breaking a rule the sculptor has "snatched a grace beyond the reach of art." Expression, grace, motion, were the objects of the artist. Those objects he has gained. It is not in this statue alone that we find among the antiques a deviation from what is now called *good drawing*. It is perceptible

in most of the finest Greek statues. The head of the Venus di Medici is not alike on both sides. This irregularity is in order to keep up that flowing line of beauty, which the artist considered as absolutely essential to the perfection of the statue; and all the unmeaning and mechanical rules of measurement were sacrificed to obtain something far more valuable.

We see also in that grand colossal head of The Dying Alexander a great deviation from exact measurement. Render both sides of the head precisely the same, and you deprive it of a great part of its expression.

How my admiration of the Greeks increases as I become more conversant with their works! With what sagacity they explored nature, discovered her secret influences, and found the essence of beauty!

From the Apollo I turn to the Transfiguration of Raphael. I approached it with fear lest I should be disappointed; but it far transcends my expectation. Its chiaroscuro, though not disagreeable, is not as a whole complete, compared with many pictures of inferior merit in other respects. The upper part, where Christ is lifted from the earth like a bright exhalation, and the two apostles are suspended near like etherial beings, is beautiful in colour and chiaroscuro. The lower part of the picture, where are the Maniac and the Doctors, is not so pleasing in effect and colour as the higher. The shadows are rather black. But here we see a wonderful exhibition of expression in perfect gradation from the distressed parent, the unbelieving Saducee, to the confident believer who points up to the Saviour as the Great Healer. These have their intermediate grades of expression in the surrounding figures, and come down to the perplexed Doctors who have sought in vain for a remedy for the maniac. Expression is the soul of this picture: in this it surpasses all others. This great work has also been subjected to criticism. It is said that Raphael has taken too great a liberty in bringing the Transfiguration of Christ into the same scene with the maniac boy. I should be extremely sorry if it were otherwise, even though it might be an impropriety, which, to me, it certainly is not. Raphael has sacrificed perhaps a little in order to a great gain. It is said to be two pictures on one canvass: but what would the lower part mean if broken from the upper? The picture might possibly have been better connected in its light and shadow,

but the pointing figures are quite sufficient to give a unity to the composition.

Standing opposite the Transfiguration is Domenichino's celebrated picture of the Communion of St. Jerome. It is supposed by some to equal the Transfiguration. It is certainly a noble picture. Everything is finely executed in chiaroscuro, composition and colour: but nothing is carried to the perfection that may be seen in many other pictures. The colouring of Domenichino is often fine, but inferior to Titian. His shadows, in flesh even, are often black, and the texture of his substances not so well understood as by the Venetians.

In the Vatican is an Entombment, by Caravaggio, which, for chiaroscuro, is grand. A picture by Andrea Sacchi, of some monks dressed in white, is wonderfully fine in tone and chiaroscuro. The landscape is in a fine style. That grand statue, the Moses of Michael Angelo, is one of the things never to be forgotten. In character it is not surpassed by the works of any age. It is less pure in style than the fine Greek, and perhaps there is a tinge of barbarism about it. *

While at Naples, Cole entertained the then novel thought of painting, on his return to America, a large panorama of the bay and city, and actually advanced in a series of sketches for the purpose. But to make drawings from the castle that commands the town and its finest scenery he found was not permitted by the authorities, and he gave up the undertaking in disgust.

After a fortnight among the wonders of that enchanting region, he set off with a small party, in defiance of all guides, note-books and physicians, for the solitudes of Paestum. A night spent at one of those wretched shelters for the marsh labourers, where, among the mosquitoes, no ordinary fatigue can minister draughts of sleep strong enough to dull the sharp incentives to keep awake, became the subject of long and amusing recollection. Grim, robber-like visages faintly lighted by the single candle—black bread and sour wine, served on a broken chair—vermine on the chilly couch, and darkness as the only covering of the holes and fissures of the old plaster floor, all composed a picture too grotesque to lose a particle of its character and freshness in the lapse of years. A washing though, at daybreak, in a rivulet close by, cooled the fever of the night's vexations, and began one of those impressive days which rather grew, than lessened

in his remembrance. " 'Why do you go to Paestum?' said an Englishman, who had just returned from it to Naples. 'You will see nothing there but a few old buildings.' He went, however, saw the old buildings, the grandest and most perfect remains of the architecture of Greece, standing

Between the mountains and the sea,

in a spot where in the beautiful words of the same poet,

The air is sweet with violets running wild,

but which the pestilential climate has made a desert; he saw, and painted a view of them for an American lady."*

* Bryant's Oration [p. 21].

CHAPTER ❧ 18

COLE determined to spend the ensuing summer and autumn in Florence. The following is, in part, his diary on his way thither from the south of Italy.

FROM ROME TO FLORENCE.

June 5th, 1832.—Getting off is always a disagreeable piece of business. The loading the luggage, the fixing, the altercation with the vetturino faction, &c., are matters that put a man into ill-humour; and he may bless his stars if he can leave any city in Italy without being in a rage. Experience though wears off the keenness of vexation, and he learns to bear with patience those ills that cannot be removed by opposition.

We, Master L——[1] and myself, had taken the cabrioli to ourselves, and, after seeing our baggage loaded, prepared to mount: a tall gentleman with green spectacles prepared to do the same thing. The vetturino told him, however, he would have to go in the carrozza: against this he protested, saying he had taken a place in the cabrioli, and was determined to have it. The altercation grew fierce; and whilst the war of words was raging we got quietly into the cabrioli. As possession is nine points of the law, we retained our places in spite of the tall gentleman.

Snugly seated ourselves, we now looked calmly on the troubles of others. The tall gentleman refusing to ride in the inside was left, and the vetturino proceeded to another hotel to take in other passengers.

The next that got in were a Frenchman and a young man with a claret-coloured coat: these had a quarrel about front and back seat. Now came up the man of spectacles, a little calmed down, and wisely concluded it was better to go inside than not at all. Then came a lady with a gray face, a Balena: she saw the back seat was taken by the gentlemen, and protested that she was a woman, and they not men, but brutes. She conquered, as women generally do in such cases, and gained the back seat, and from thenceforward was the sweetest creature in the world. Now the claret-coat had to get out; he had forgotten something. Then came another lady, an elderly person; she found the back seat, the seat of preference, occupied by a lady and gentleman: back she flew from the carriage, and whisked round nimbly in a rage: these whiskings produced their effect, for she effectually whisked the man from his place. Now the claret-coat came back—found the back seat filled—fretted and fumed, but all to no purpose: he had to drop in tightly between the two women.

We reached the gate of Rome, and while our passports were getting ready, up came a little priest with thread-bare coat, new hat and large crucifix. He had engaged a place on the inside, and insisted upon getting in: but the Balena, the old lady, the Frenchman and claret-coat and spectacles, all resisted. Poor priest, he was compelled to take a hard seat by the vetturino, where, without great-coat as he was, he would be exposed to the vicissitudes of the weather. I now came in for a portion of vexation, for the priest sat directly before me, and his cocked-hat obstructed my view.

With fine horses we proceeded at a good pace for several miles, until we came to a part of the road undergoing repairs: here we found, in the temporary road, a waggon stuck fast in the mud, and it was impossible for us to pass. It was curious to see what efforts were made to extricate it, and what a variety of animals was attached— horses, mules, asses, oxen, cows; all these were in requisition, but all in vain. With half the means in England or America the waggon would have gone through: but there is a surprising want of energy and promptness in the Italians in any emergency. We had to make a new road for ourselves, and so got safely along. * * * *

TO MR. GILMOR.

<div align="right">Florence, July 7th, 1832.</div>

MY DEAR SIR,—I am induced to remain in Italy a few months longer: and not having heard anything from you of the large picture that I sent, last winter, I now write with the desire that you will say if it was acceptable.　*　　*

Since I last write I have seen the wonders of Rome, and the beauties of Naples. I have been much gratified, and I hope benefitted. I have now returned to Florence with the intention of painting several pictures. Indeed, the facilities here are so great, and there is so much of beauty in the atmosphere, and also the means of living are so inexpensive, that I concluded it would be well to remain a little longer.

Mr. Greenough is hard at work, producing things full of beauty. The Medora is far advanced, and will touch every heart that is capable of feeling.　*　　*　　*

I am now engaged in a picture that is a view of the Campagna of Rome,—broken aqueducts, &c. But I long for the wild mountains of the West.

<div align="center">Anxious to hear from you, I remain,</div>
<div align="right">Yours truly,</div>
<div align="right">THOMAS COLE.</div>

Fresh from these "wonders" and "beauties," Cole fulfilled his "intention of painting" to an extent that afterwards surprised himself. Reviewing his sketches and studies, especially those of the Campagna, he went to his canvass with redoubled enthusiasm, and worked from day to day under that kind of afflatus which sweeps one forward to success almost unconsciously. "I was in the spirit of it," he afterwards said; "and O that I was there again, and in the same spirit!" Picture after picture descended from his easel, and of an excellence surpassing, in some qualities, anything he had hitherto done. A large view of the Claudian aqueduct, A view in the Apennines—Il arco di Nerone, A small view near Tivoli, The Cascatelles of Tivoli, The Fountain of Egeria, with several more, large and small, chiefly Italian scenery, all succeeded each other in the short space of three months.

In the luxury of this enthusiastic and successful toil, his longing "for the wild mountains of the west" had scarcely subsided when he

was unexpectedly called to turn his eyes towards them, an unwelcome prospect for the first time almost during his absence. News of the cholera in New York, and of the illness of his parents, suddenly brought his delightful labours in Florence to a close, and hastened his departure for America.

Before we attend him thither, a few words are ventured upon the judgment which was passed upon what may be called his Florentine pictures, when they first made their appearance at home.

While a judicious eye could not fail, at a glance, to see that they were full of Cole's feeling and imagination, they differed enough from his earlier works to make them appear, in the opinion of some, the productions of another and inferior hand. Perceiving a marked change in his manner, they took no proper account of the reasonableness or true causes of the change, and either grieved over the artist's loss of his first wild freshness and originality, or, in a less charitable spirit, pronounced his Florentine paintings overcharged copies of the old masters, and no longer faithful to nature. Let us see.

"What shall I say of Modern Italian art?" as he writes some time subsequently to Dunlap. "I am afraid you will think I looked at all with a jaundiced eye. I have been told that I did at the ancient also: if so, I have lost much enjoyment. I can only speak as I have felt. Italian painting is perhaps worse than the French, which it resembles in its frigidity. In landscape it is dry, and in fact wretched. There are a few German and English artists in Rome who paint with more soul than the Italians. It would scarcely be credited that, surrounded by the richest works of the old schools, there should be a total ignorance of the means of producing brilliancy and transparency, and that among the greater part of the Italians glazing is unknown: and the few who, from seeing the English at work, have acquired some knowledge of it, use magilps and varnishes as though they were deadly poisons. Indeed, of all meagre, starved things, an Italian's palette is the perfection.

"The pictures of the Italian masters gave me the greatest delight, and I laboured to make their principles my own: for these, which have stood the criticism of ages, are produced on principles of truth, and upon no abstract notion of the sublime and beautiful. The artists were gifted with a keen perception of the beautiful of nature, and imitated it in simplicity and single-heartedness. They did not sit

down, as the modern artist too often does, with a preconceived notion
of what is, or ought to be, beautiful: their beau ideal was the choicest
of nature. They often introduced absurdities and things of bad taste
into their pictures, but they were honest, there was no affectation.
I do not believe that they theorized as we do: they loved the beauty
which they saw around them, and painted.

"Many of the Old Masters have been praised for their defects; and
the blackness of age has been called tone; and there are some whose
merits appear to me to be but small. Salvator Rosa's is a great name:
his pictures disappointed me. He is peculiar, energetic, but of limited
capacity comparatively. Claude, to me, is the greatest of all landscape
painters: and, indeed, I should rank him with Raphael or Michael
Angelo. Poussin I delighted in, and Ruysdael for his truth, which is
equal to Claude, but not so choice.

"Will you allow me here to say a word or two on landscape? It is
usual to rank it as a lower branch of the art, below the historical.
Why so? Is there a better reason than that the vanity of man makes
him delight most in his own image? In its difficulty * * it is
equal at least to the historical. There are certainly fewer good land-
scape pictures, in proportion to their number, than historical. In
landscapes there is a greater variety of objects, textures, phenomena to
imitate. It has expression also, not of passion, to be sure, but of senti-
ment, whether it be tranquil or spirit-stirring:—has its seasons, sun-
rise, sunset, the storm, the calm, various kinds of trees, herbage,
waters, mountains, skies. And whatever scene is chosen, one spirit
pervades the whole: light and darkness tremble in the atmosphere,
and each change transmutes."

One with such an opinion of the dignity and capabilities of his
own branch of the art; one who so well understood, and rejoiced
over the secret of the great artists' success—their devotion to nature;
and also knew so well where the rock lay upon which such numbers
of contemporaries were splitting—an "abstract," "preconceived no-
tion" of beauty, induced by studying works of art to the neglect of
nature, would never have run upon that rock with open eyes, where
we are bound to insist that he must have run, if we would give any
reasonable account how he lost his early excellence, and became un-
natural and a copyist. Every hour of his study and practice, within
doors and without, is proof not only against the existence of the cause

to produce the faults with which he was charged, but in favour of the fact that he grew in knowledge and skill to manifest his power, and express truth.

Indeed, in this very growth lay the secret of the misconception. Works which had satisfied the public with the artist were the offspring of his youth in art; and lively expressions too of the feeling, grace and freshness, wild bloom and luxuriance of that youth; of its immaturity, doubt and timidity, its gentleness and delicacy also. But when he came back from a pilgrimage into the still land of thought and labour, as well as into the land of art, every step of which had been taken with an acceleration of which little or no thought was had at home, he was too far in advance to be looked at by the eyes of the old criticism. "Distance lent," not "enchantment," but obscurity "to the view,"—a littleness and deformity. He was not *where* he had been, he was not *what* he had been: it was now uncertain just where or what he was, and therefore he was just that which they were pleased to call him—lost to this excellency—changed in that—while in reality he was only well beginning to move with the freedom, to strike with the assurance, and to glow with the fire of one who sees both his own force, and the means of wrestling with difficulties, and of attaining ends, and knows how to use them with fear, trembling and uncertainty, no more. The case was simply: The critic had not kept pace with the painter. His own notion of excellence in landscape (to which he had not unfrequently been helped by the very pictures Cole had left behind) was therefore no longer an adequate measure of that which had gotten beyond and above him. Besides, the artist was now presenting subjects with which the public was no longer familiar. He re-appeared with a disadvantage similar to that with which he first appeared abroad, especially in England. When his American autumnal, and forest views, Corway Peak, and the Tornado in the Forest, for instance, were first seen in London, they were condemned as false to nature, particularly in colour. We do know, and time will inevitably place it beyond all dispute, that none, in that quality, were ever more true. More taking to the eye that is tickled by the tricks of art there were doubtless thousands, but none more true. To the thorough consciousness of this, and of the injustice of the verdict of the English critic, and not to bad feeling at the real merit of any one, should every word of that be set down which Cole felt

and said disparagingly of English art. An Italian would have vindicated the truthfulness to nature of those pictures which were considered false to it here. True, it was not nature in America, but it was in Italy, that inspired the warmth and splendour, beaming and panting on this new canvass.

CHAPTER ❧ 19

*Cole in New York. Luman Reed. Letter to Mr. Reed: plan of the Course
of Empire. Cole's gratitude. To Mr. Adams. Rebuked for Ingratitude. To
Mr. Adams: vindicates himself. To the same: renewal of friendship. To
the same: Il Arco di Nerone. Cole's generosity. To Mr. Alexander: paint-
ing in Catskill. To the same. Angels appearing to the Shepherds. Picture
for Mr. Alexander.*

COLE embarked, at Leghorn, on the 8th of October, 1832, for New
York, where he arrived on the 25th of the following November. For
several ensuing months he occupied, for painting and exhibition,
rooms on the corner of Wall Street and Broadway. With these apart-
ments was afterwards associated one of the most fortunate incidents
of his life; an incident which may be called the harbinger of a friend-
ship which influenced his success, as a painter, far more than any
other. There came in, one day, a person in the decline of life,—took
rather a hasty turn round the room, serving for a gallery, and went
out without a word. There was that, however, in the appearance of
this silent visitor, as he looked quietly, but intelligently from picture
to picture, which could not be readily forgotten. Cole had a rare
power of judging character correctly at once. The favourable
opinion, instantly formed of the person whose look and manner
struck him, was soon happily confirmed by an introduction and
acquaintance. It was Luman Reed.[1]

In the course of the winter, Cole received from him a commission
for a large Italian landscape, and conversed with him about pictures
for a private gallery he was then contemplating. The somewhat
lengthy letter below, written from Catskill, to which place he retired
in the succeeding spring, will unfold the character of those conversa-
tions.

Catskill, September 18th, 1833.

My dear Sir,—The desire you expressed, that I should paint pictures to fill one of your rooms, has given me much pleasure; and I have made some rough drawings (which I send you) of the arrangement that appears to me most suitable, and in accordance with the subjects I should wish to paint. I mentioned to you a favourite subject that I had been cherishing for several years with the *faint* hope that, some day or other, I might be able to embody it. Your liberality has presented an opportunity; and I trust that nothing will now prevent me from completing what I have so long desired. In the drawings you will perceive that I have taken one side of the room for this subject; and, as my description to you of my plan was very imperfect, I will now take the liberty of making an extract from my memorandum book of what I have conceived about it.

A series of pictures might be painted that should illustrate the history of a natural scene, as well as be an epitome of Man,—showing the natural changes of landscape, and those effected by man in his progress from barbarism to civilization—to luxury—to the vicious state, or state of destruction—and to the state of ruin and desolation.

The philosophy of my subject is drawn from the history of the past, wherein we see how nations have risen from the savage state to that of power and glory, and then fallen, and become extinct. Natural scenery has also its changes,—the hours of the day and the seasons of the year—sunshine and storm: these justly applied will give expression to each picture of the series I would paint. It will be well to have the same location in each picture: this location may be identified by the introduction of some striking object in each scene —a mountain of peculiar form, for instance. This will not in the least preclude variety. The scene must be composed so as to be picturesque in its wild state, appropriate for cultivation, and the site of a sea-port. There must be the sea, a bay, rocks, waterfalls and woods.

The first picture, representing the savage state, must be a view of a wilderness,—the sun rising from the sea, and the clouds of night retiring over the mountains. The figures must be savage, clothed in skins, and occupied in the chase. There must be a flashing chiaroscuro,

and the spirit of motion pervading the scene, as though nature were just springing from chaos.

THE SECOND PICTURE must be the pastoral state,—the day further advanced—light clouds playing about the mountains—the scene partly cultivated—a rude village near the bay—small vessels in the harbour—groups of peasants either pursuing their labours in the field, watching their flocks, or engaged in some simple amusement. The chiaroscuro must be of a milder character than in the previous scene, but yet have a fresh and breezy effect.

THE THIRD must be a noonday,—a great city girding the bay, gorgeous piles of architecture, bridge, aqueducts, temples—the port crowded with vessels—splendid processions, &c.—all that can be combined to show the fulness of prosperity: the chiaroscuro broad.

THE FOURTH should be a tempest,—a battle, and the burning of the city—towers falling, arches broken, vessels wrecking in the harbour. In this scene there should be a fierce chiaroscuro, masses and groups swaying about like stormy waves. This is the scene of destruction or vicious state.

THE FIFTH must be a sunset,—the mountains riven—the city a desolate ruin—columns standing isolated amid the encroaching waters —ruined temples, broken bridges, fountains, sarcophagi, &c.—no human figure— a solitary bird perhaps: a calm and silent effect. This picture must be as the funeral knell of departed greatness, and may be called the state of desolation.

You will perceive what an arduous task I have set myself; but your approbation will stimulate me to conquer difficulties. These five pictures, with three smaller ones above, and two others by the fire-place, will occupy all that side of the room. The three high pictures will be something in character with those over which they hang. * *

To fill the other side of the room and the ends will require eighteen or twenty pictures, five of which will be larger than the Italian Scene. * * For the completion of all these pictures I cannot reckon upon less than two years' labour; and they may require more time: at all events, nothing should prevent me from using every means and exertion to make the work satisfactory to you, and creditable to myself.

You will wish me to say something about the price: it is the subject I am least willing to encounter. My desire to undertake a work

on which I may hope to establish a lasting reputation, and the fear that such an opportunity may never offer again, may make me forget, in a measure, my pecuniary interests: on the other hand, the profitable commissions I already have, the consideration that a painter's wants are like those of other men, and the necessity, in undertaking a work like yours, of neglecting for a time my general reputation, may cause me to make a demand greater than you have calculated upon. I trust I shall not be unreasonable nor extravagant. For the ten pictures occupying the side with the fire-place I must ask $2,500. Five of the pictures will be much larger than your Italian Scene, and will require greater study, as the figures, though small, will in some of them be numerous, and I should desire to paint them carefully. For the other side and the ends—five of which will be large pictures—I cannot ask less than the same, making $5,000 for the completion of the whole room. This may appear a large sum; but I assure you that if I calculated according to the prices I have received for my pictures lately, the amount of the last mentioned side alone would be double the sum I ask: but I shall be happy to do them, so that I may have an opportunity of executing the others. * * I am, yours truly,

THOMAS COLE.

In a letter to Mr. Gilmor, speaking of the Wild Scene, painted for him in Italy, and which had gone on its way no further than New York, he says: "there are no interested motives in wishing you to take this picture, for I have received the same sum for those that did not occupy me more than one third of the time in painting that this has done. But, at the same time, I shall always feel deeply your debtor, even had the work been one of much more labour than it really was. Pecuniary debts are much more easily paid than those of gratitude."

To be lastingly grateful for favours was a distinguishing trait in the character of Cole. The following correspondence illustrates the truth of this perhaps more signally than the above, and carries us back to the trying, but romantic period of his outset in his profession.

TO WILLIAM A. ADAMS, ESQ.

Catskill, November 4th, 1833.

MY DEAR SIR,—I am afraid that if you still remember me it is with

the recollection also of what must have appeared ingratitude for favours that you and several other gentlemen of Zanesville conferred on a stranger. I contracted a debt with a hard man, and was unable to pay it: the liberality of yourself and friends relieved me from its burden. Years have passed away since the transaction, and I have not yet cleared myself from the appearance of dishonesty or ingratitude. But circumstances, the detail of which would be useless, have hitherto prevented me from doing what I have ardently desired to do for years. I now wish to clear myself from the pecuniary obligation: but being uncertain whether this will find you, I will wait your answer. * * *

Please write to me, and say something of yourself and the few friends I *did* possess in Zanesville: for although the season of my life, at which I became acquainted with you, was one of misery, I look back to your kindness with pleasure. I have been more successful in my profession than my highest anticipations reached when I was with you. I shall be happy to hear that success has attended your usually more profitable profession. Direct to me at 20 Greene Street, New York. * * *

<div align="right">

Yours truly,
THOMAS COLE.

</div>

By a singular coincidence, Mr. Adams, hearing of Cole's prosperity, and thinking both himself and his little claim forgotten, wrote, at the same date nearly as the above, rebuking him for ingratitude, and demanding payment. The regret of Adams on receiving the communication of his old friend was keen: what were the feelings of Cole upon reading the epistle addressed to him, which, for some reason, he fancied might have been written after the receipt of his own, may be learned from his instant reply.

<div align="center">

TO THE SAME.

</div>

<div align="right">

New York, April 7th, 1834.

</div>

SIR,—Yours was an agonizing letter. But were I as culpable as you consider me, and less unfortunate, I should not have felt what I did feel at its perusal. If, sir, you had known all the truth, you would not have rebuked me so severely. I have suffered keenly from the un-

fortunate predicament in which I have been placed; but ingratitude I will not acknowledge. It was pain enough to feel the incapability of saving my character from the stigma of ingratitude: but when I had found means of freeing myself from the imputation of dishonesty, to be so rebuked by you was to have poison poured into the wound. I know you have every reason to think as you do: but, in justice to myself, I cannot allow you to remain entirely ignorant of the circumstances which have made me *seem* so base: and if, in the facts I shall state, you do not find a full excuse for my conduct, you will admit there is something in extenuation.

It is indeed ten years since my former friends, actuated by the most disinterested motives, relieved me from my distress. Of those ten years, the first three were spent amid the deepest deprivations and poverty. For some weeks I lived on bread and water, until a painful sickness came upon me: this was, in part, in Philadelphia. After my recovery my prospects improved a little. But our large family, which at this time was in a great measure dependent upon me, an only son, came on to me from the West, and with it debt, contracted by my father, for which I was bound. Since that time I have been the support of the family. My father's health has been bad for many years. Nearly four years I spent in Europe, not in the pursuit of pleasure, but in the earnest endeavour to acquire the means of supporting an affectionate family, and of paying those debts that crushed my very soul to think of. A little more than a year since I returned. I have been rather successful, and the first money which was not required by the necessities of myself and family I have offered you. The continuance of adversity has not been the result of idleness, for I have laboured incessantly. And if economy and temperate habits could ensure prosperity, it would be mine. * *

I assure you, sir, that at no time have I been able to pay the debt without immediate danger of depriving my family of what was needful. I have at times—although not so frequently as might have been well—endeavored to let it be known that I had not forgotten my obligation. I saw Mr. D——[2] in Philadelphia when I was almost destitute; I have since written to him. I could enter into further details of my adverse circumstances: but if in what I have written you can find no excuse for my conduct, then I have already said too much. I enclose the amount in cash. * * I was perhaps unfortunate

in my letter in speaking of the amount of the debt; I should have calculated the interest myself, and forwarded the full sum.

As to my promise of painting a picture in place of paying the money, it had escaped my memory. I can say this—if I had remembered that you had acceded to such a proposition, the debt should have been paid long ago, joyfully. No, sir, I will pay the money: I cannot do anything less than fulfill my original engagement. If, after this, I should be so happy as to be regarded more favourably by you, and you would accept a picture as a token of my unchanged regard for you, and an evidence that I am not ungrateful, you will confer an infinite favour. I trust this will be the case. I enclose a fifty-dollar United States bill. * * * I am sorry that in your letter you did not acknowledge the receipt of mine. Yours truly,

THOMAS COLE.

From the letters which succeed, it will be seen that the friends were placed upon their former footing. The friendship continued undisturbed ever afterwards.

TO THE SAME.

New York, April 23d, 1834.

MY DEAR SIR,—Your letters of the 4th, and 14th instant have been received, and have relieved my mind from what it could ill bear. I am rejoiced that you again think of me as you once thought, and I look forward to a renewal of our acquaintance with great pleasure. You had more reason for writing harshly, as you did, than I supposed; I do not remember receiving a single letter from you; if I did, I am sure that I answered it. But we will forget the unpleasant circumstances that have occurred.

Your desire to possess a picture of mine is gratifying, and I shall let you have one, although in returning the twenty-five dollars you have deprived me of an opportunity of making a small return for your former kindness. I have not, at present, a picture that I should like you to have, but in a few weeks I shall be ready for you. I have several pictures on hand, but their size and subjects prevent me from offering them. I wish to paint something expressly for you. I hope you will come yourself, as you have intimated. I shall be extremely

glad to see you, as also your picture, which, if I may judge from what I saw when in Zanesville, has great merit. I assure you that when I was there, I really felt you were my superior in the art, but necessity perhaps made me presume to be superior.

It is my custom to spend the summer at Catskill, on the Hudson, and I intend to go there about the second week in May. If it should happen that I am there when you come to New York, either come up, or send me a note letting me know of your arrival; it will reach me in a few hours, and I will be with you. If you will come to me, I will show you some glorious scenery, and my workshop. * *

Yours truly, THOMAS COLE.

TO THE SAME.

Catskill, August 5th, 1834.

MY DEAR SIR,—For fear that you should think me forgetful of my promise, I will once more trouble you. I have not been able, from a variety of circumstances, to paint any picture expressly for you: and as, at present, I see no opportunity of doing so, except at a sacrifice which I know you would not wish me to make, I offer you a picture that I painted in Italy. If you will let me know how it shall be forwarded to you, it shall be done as soon as can be conveniently—as I am at present at Catskill, and the picture in New York. The picture is a view near Tivoli, representing a bridge, and part of an ancient aqueduct, called "Il Arco di Nerone:" a road passes under the remaining arch: it is a morning scene, with the mists rising from the mountains. For pictures of the same size, and painted to commission, I have a hundred dollars. This I mention, not with the intention of making a display, but to show you that I feel the debt I owe cannot be paid by a thousand pictures. This picture was mentioned favourably in several of the journals, at the last year's exhibition. * *

I remain, yours sincerely, THOMAS COLE.

It was not only under circumstances like those with which the reader has just been made acquainted that the fine, generous nature of Cole showed itself: the most tender and delicate feelings were continually made manifest in little things. A trifling incident, occurring about this period of his life, is an example of this. A sawyer, one day,

after having finished his load of wood, applied, at the door, for his pay. Cole came in while his sister was expostulating with him for an extortionate charge. "O, Sarah," said he, "pay him his price: never economize out of the poor."

TO FRANCIS ALEXANDER, ESQ.[3]

Catskill, September 1st, 1834.

MY DEAR FRIEND,— * * I trust you do not think that I have forgotten you, my old companion in travel; and I write this in order to prove to you that I neither forget, nor intend to be forgotten.

What have you been doing since your return? I have heard that you were going to lay aside your single blessedness; and perhaps the thing may have been done before now: if so, I wish you all happiness and prosperity. For my own part, in spite of the rumours you get hold of, I am still single, and, alas! am likely to remain so. I am not so fortunate as you: I find no congenial spirit to mingle soul with soul. But, thank heaven, I have sisters, and am not one of those wretches who find none *to love.*

Do you know I have been thinking of Italy of late? I do not know what has come over me; I feel as if I should go there again. Thus it is to be a bachelor—*restless.* I am not determined on bachelorship by any means—the contrary: but the fact is, I find that when I fall in love it is with an ideal character, which I have attributed to some earthly fair: and as the ideal does not wear very well in this world, I too soon behold that the object of my adoration is no goddess. And, indeed, I have no wish for a goddess. What I want is one who is good-looking, has a pleasing expression of countenance, amiable, of good sense, and some sensibility: one who would make one's feelings her own, and love one heart and soul. Are such to be found? Have you found such? I trust you have. What nonsense I have been writing! You will think I am no wiser than when I used to put on the kettle for tea in never-to-be-forgotten Via del Tritone. Those were queer times. How Master L——[4] used to giggle before tea, but after, the *tears* used to trickle down his cheeks, as he sat by the fire-side, thinking of his brothers and sisters far away.

Do not think I have forgotten your picture: no, it haunts me; it ought to have been done. * * * I am spending my summer

in Catskill—painting—painting. What have you been doing? painting too, I suppose, and making money, which is what I cannot do much of. I hope you will go and see my big picture of the Angels: but be indulgent. It was painted in about two months, I could not afford more. * * * I am yours, very truly,

THOMAS COLE.

TO THE SAME.

Catskill, September 23d, 1834.

MY DEAR SIR,—Your letter did me good. It really does one good to hear from an old companion, and to find that he has attained a happiness that he himself scarcely anticipated. I am obliged also for the description of the treasure you have found: it encourages me to believe that our brightest hopes are sometimes realized, and that amid the earthly rubbish of the world a jewel may sometimes be found. You are fortunate, and I believe deservingly so. For my part, I dare not look for what I so much desire: to find it would be to feel more keenly my peculiar situation. You know something of my circumstances—what depends upon me. Your branch of the profession is more lucrative than mine. Yours is one of great profit with some disagreeable concomitants; mine of much labour, much pleasure in the pursuit, but of small pecuniary results; and in this world, where to be poor is to be considered criminal, there is much to be suffered by those whose purses are usually empty. You will think I am turning melancholy; it is not so: and even if I were inclined to be so, your letter would dissipate such inclination. If I come to Boston, (which I may do before winter,) I shall have to steel my heart, or it may suffer from the eyes of La amica della sua amatrice.[5] This may appear ungrateful to you, but it must be so; and yet I do not pretend to be invulnerable, for the arrows of love are keen and searching.

You say you have not seen my picture now exhibiting in Boston. Do go and see it. I want to know what you think of it, although I am conscious of its great imperfection. I am still at Catskill, and in the neighbourhood of the mountains, and shall probably remain here till winter drives me away. * * My dear sir, I am battling for the existence of myself and family. * * *

Your sincere friend,
THOMAS COLE.

The large picture of the Angels appearing to the Shepherds, spoken of in the foregoing, was painted, during the preceding winter, in the city, in less than eight weeks,—too short a time for the character of the work, and the extent of surface upon which he chose to delineate it. The conception of the subject is grand, and the general effect of its representation striking. Time would have enabled him to make it one of his finest imaginative landscapes.

The picture of which he speaks, in the first letter to Mr. Alexander, as haunting him, was intended as a return for a small pecuniary favour, twenty-five dollars, for some cork models of the temples of Paestum, rendered while they were travelling-companions in the south of Italy, and affords another instance of Cole's generosity and gratitude. Finding, though, no convenient time to paint it, he subsequently sent, in its stead, one painted the summer before: A Tornado passing over an American Forest—in part a duplicate of the one executed in England—a large landscape of great spirit and beauty. It was upon his great series for Mr. Reed that he was at work, when he says, in the same letter, that he was "painting—painting."

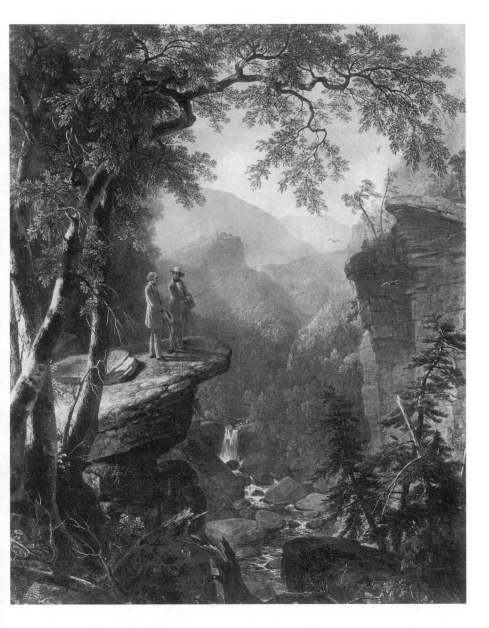

1. *Kindred Spirits: Thomas Cole and William Cullen Bryant*, Asher B. Durand, 1849, oil on canvas, 46" x 36". Collection of The New York Public Library; Astor, Lenox and Tilden Foundations.

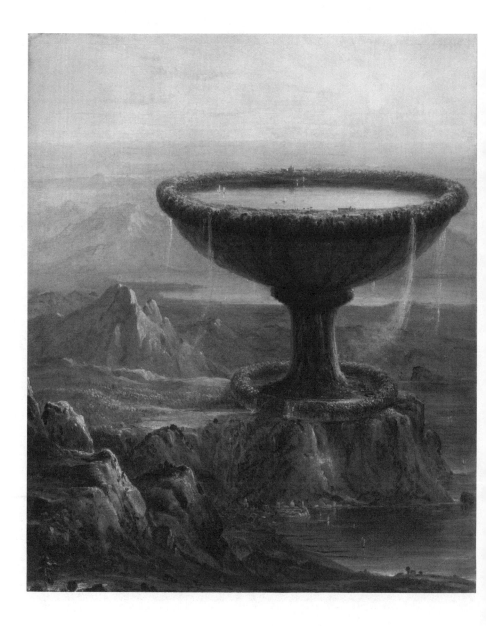

2. *The Titan's Goblet*, Thomas Cole, 1833, oil on canvas, 19 3/8" x 16 1/8".
The Metropolitan Museum of Art; Gift of Samuel Avery, Jr., 1904.

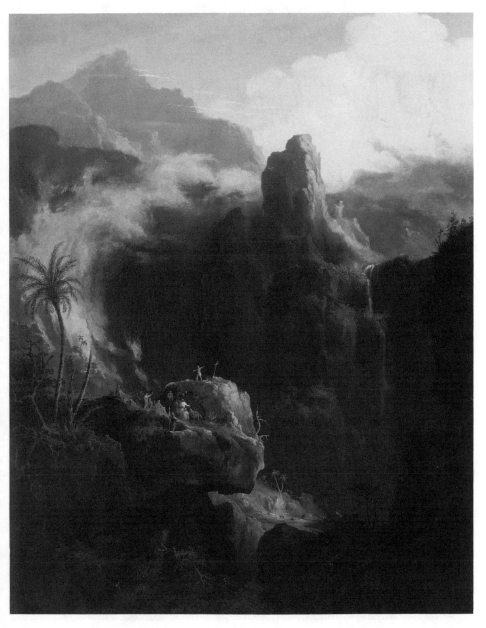

3. *Landscape Composition, Saint John in the Wilderness,* Thomas Cole, 1827, oil on canvas, 36" x 28 15/16". Wadsworth Atheneum, Hartford; Bequest of Daniel Wadsworth.

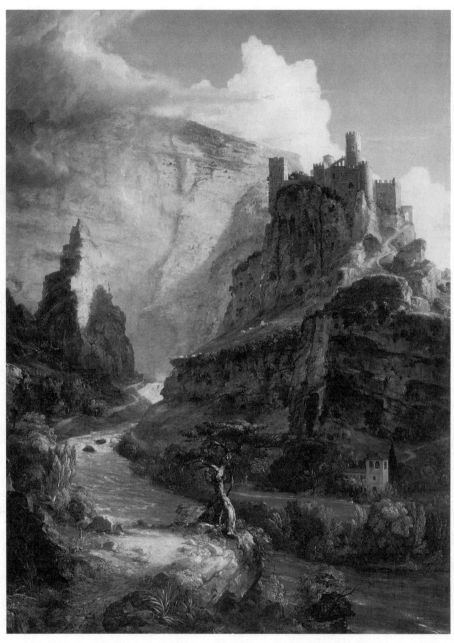

4. *Landscape—The Fountain of Vaucluse*, Thomas Cole, 1841, oil on canvas, 69" x 49 1/8".
The Metropolitan Museum of Art; Gift of William E. Dodge, 1903.

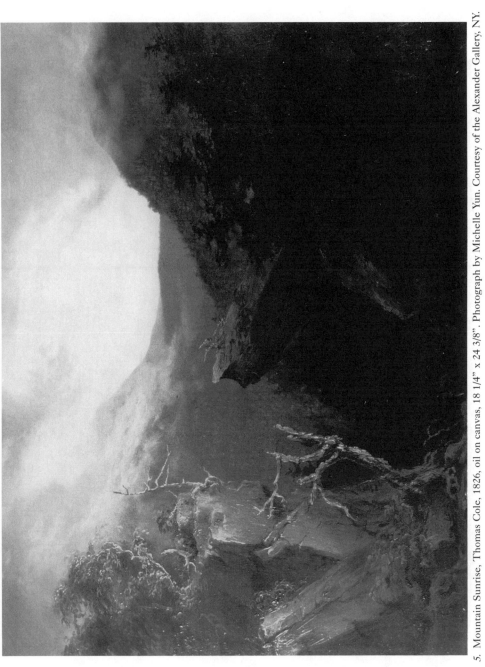

5. Mountain Sunrise, Thomas Cole, 1826, oil on canvas, 18 1/4" x 24 3/8". Photograph by Michelle Yun. Courtesy of the Alexander Gallery, NY.

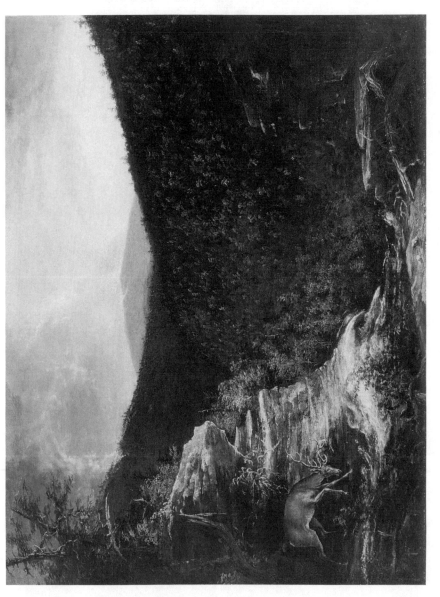

6. *From the Top of Kaaterskill Falls*, Thomas Cole, 1826, oil on canvas, 31 1/8" x 41 1/8". Photograph 1985. The Detroit Institute of Arts; Founders Society Purchase, Dexter M. Ferry, Jr. Fund.

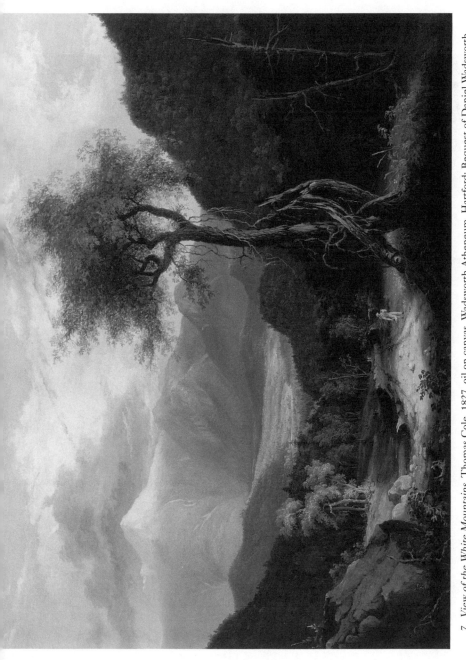

7. *View of the White Mountains*, Thomas Cole, 1827, oil on canvas. Wadsworth Atheneum, Hartford; Bequest of Daniel Wadsworth.

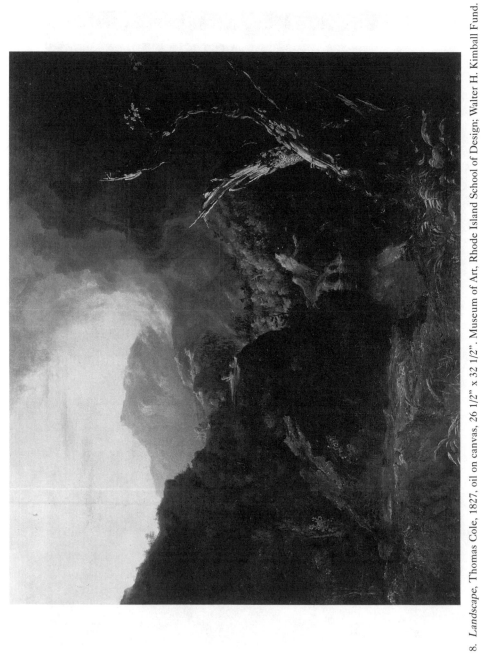

8. *Landscape*, Thomas Cole, 1827, oil on canvas, 26 1/2" x 32 1/2". Museum of Art, Rhode Island School of Design; Walter H. Kimball Fund.

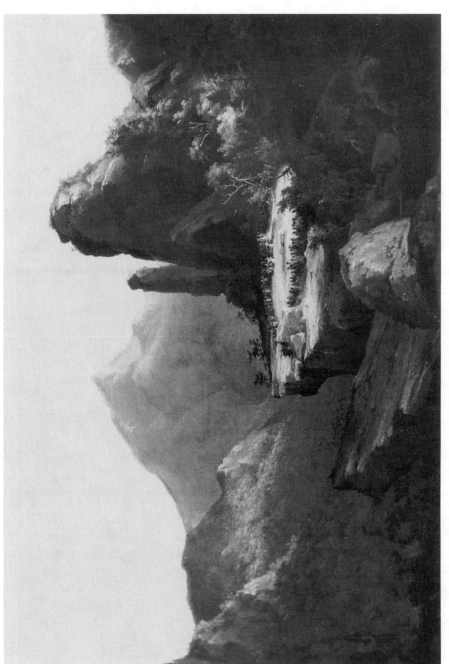

9. *Scene from "The Last of the Mohicans", Cora Kneeling at the Feet of Tamenund*, Thomas Cole, 1827, oil on canvas. Wadsworth Atheneum, Hartford: Bequest of Alfred Smith.

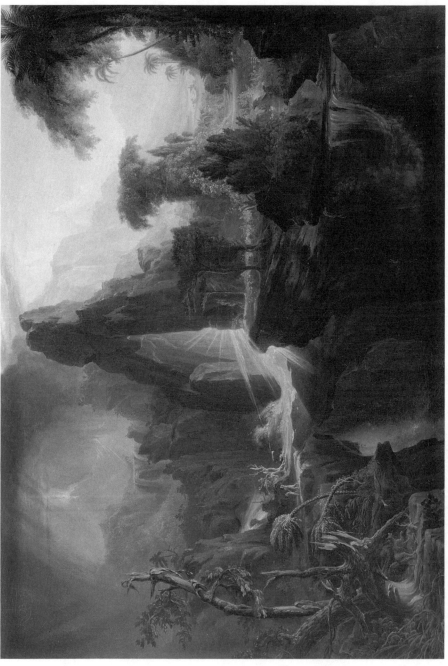

10. *Expulsion from the Garden of Eden*, Thomas Cole, 1828, oil on canvas, 39 3/4" x 54 1/2". Courtesy, Museum of Fine Arts, Boston;

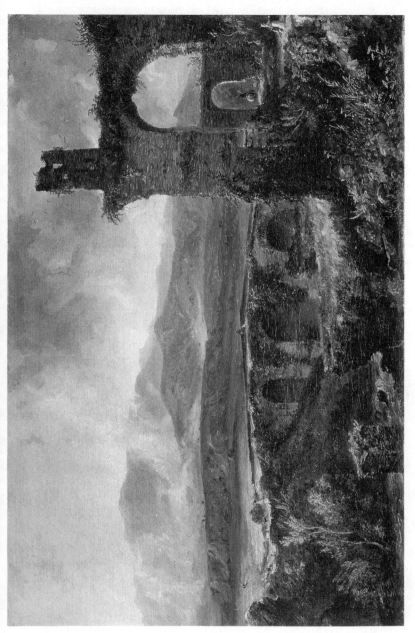

11. *A View Near Tivoli (Morning)*, Thomas Cole, 1832, oil on canvas, 14 3/4" x 23 1/8".
The Metropolitan Museum of Art; Rogers Fund, 1903.

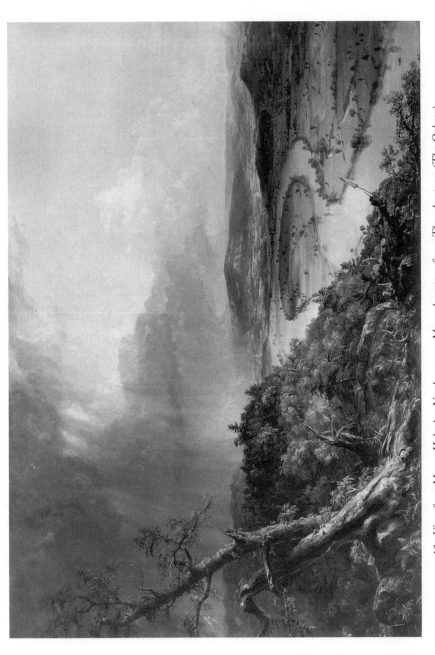

12. *View from Mount Holyoke, Northampton, Massachusetts, after a Thunderstorm (The Oxbow),*
Thomas Cole, 1836, oil on canvas, 51 1/2" x 76" . The Metropolitan Museum of Art; Gift of Mrs. Russell Sage, 1908.

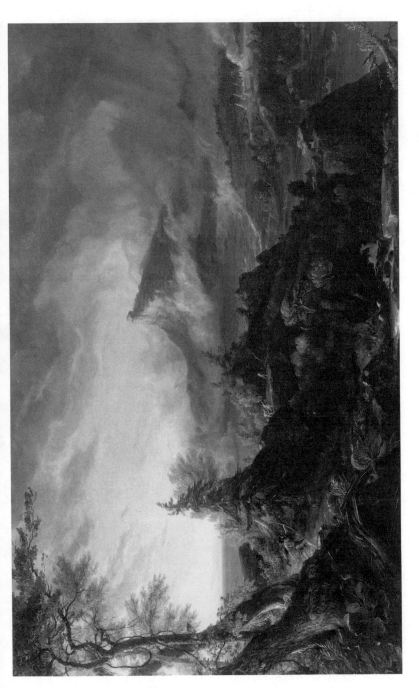

13. *The Course of Empire: Savage State*, Thomas Cole, 1836, oil on canvas, 39 1/2" x 63 1/2". Collection of The New-York Historical Society.

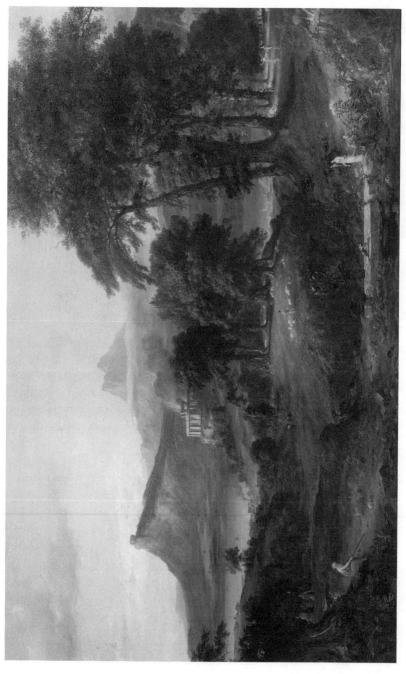

14. *The Course of Empire: The Arcadian or Pastoral State*, Thomas Cole, 1836, oil on canvas, 39 1/2" x 63 1/2". Collection of The New-York Historical Society.

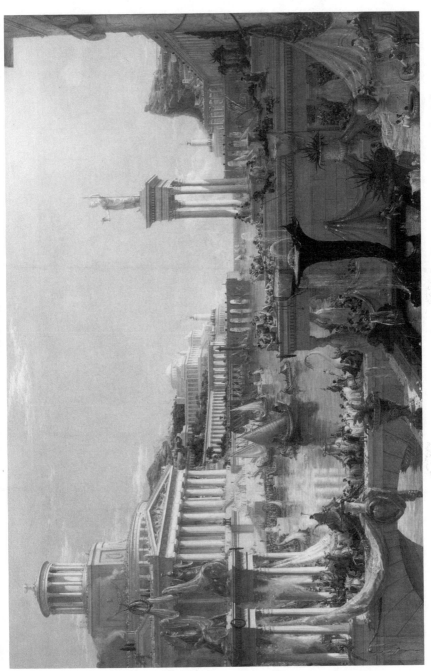

15. *The Course of Empire: The Consummation of Empire*, Thomas Cole, 1836, oil on canvas, 51" x 76". Collection of The New-York Historical Society.

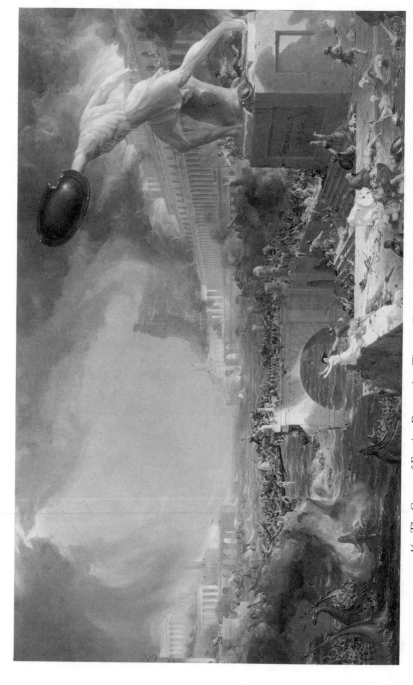

16. *The Course of Empire: Destruction*, Thomas Cole, 1836, oil on canvas, 39 1/2" x 63 1/2". Collection of The New-York Historical Society.

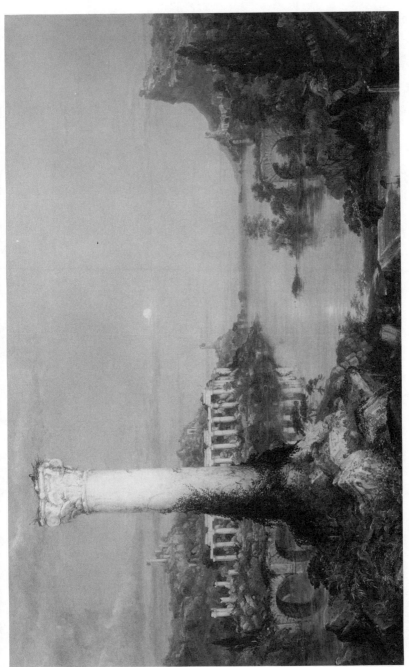

17. *The Course of Empire: Desolation*, Thomas Cole, 1836, oil on canvas, 39 1/2" x 63 1/2".
Collection of The New-York Historical Society.

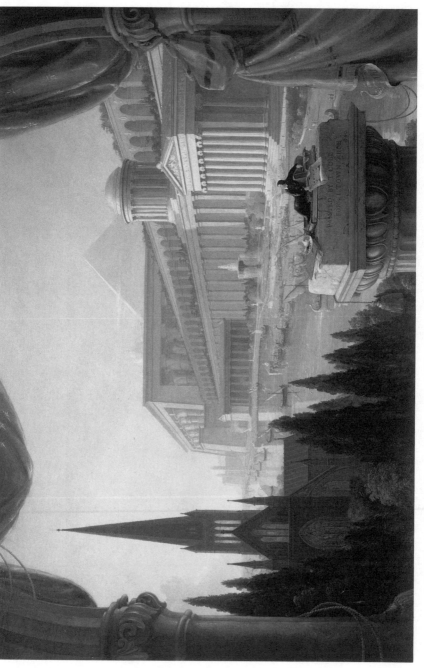

18. *The Architect's Dream*, Thomas Cole, 1840, oil on canvas, 53" x 84 1/16". The Toledo Museum of Art; Purchased with Funds from the Florence Scott Libbey Bequest in Memory of her Father, Maurice A. Scott.

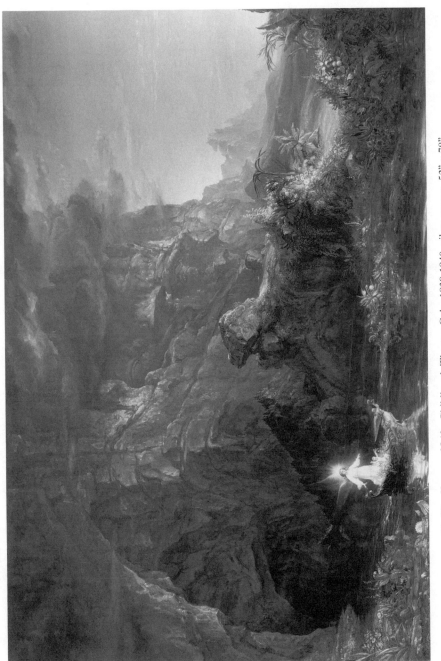

19. The Voyage of Life: Childhood, Thomas Cole, 1839-1840, oil on canvas, 52" x 78". Munson-Williams-Proctor Institute, Museum of Art, Utica, NY.

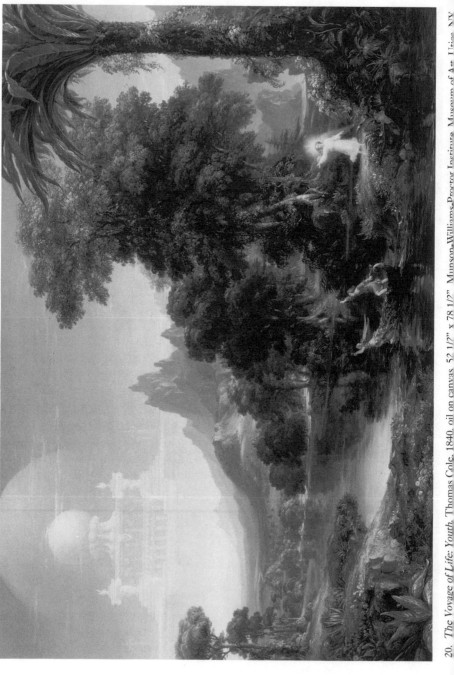

20. *The Voyage of Life: Youth,* Thomas Cole, 1840, oil on canvas, 52 1/2" x 78 1/2", Munson-Williams-Proctor Institute, Museum of Art, Utica, NY.

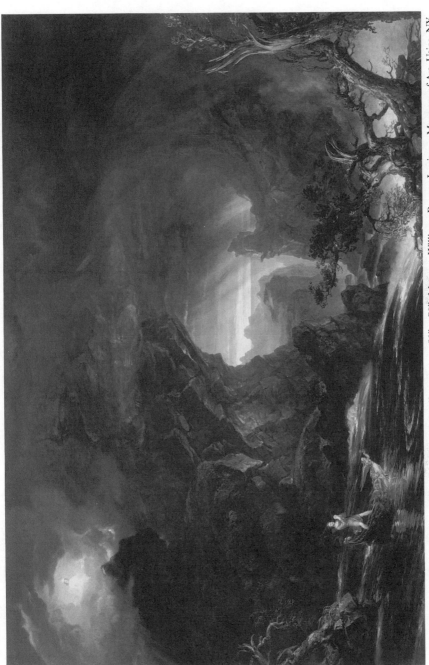

21. *The Voyage of Life: Manhood*, Thomas Cole, 1840, oil on canvas. 52" x 78". Munson-Williams-Proctor Institute, Museum of Art, Utica, NY.

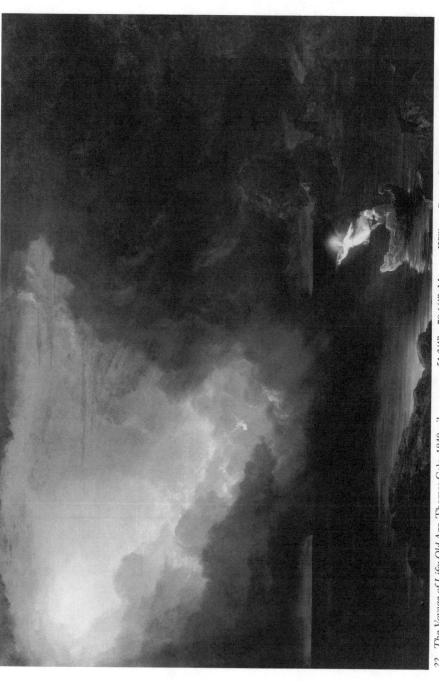

22. The *Voyage of Life: Old Age*, Thomas Cole, 1840, oil on canvas, 51 3/4" x 78 1/4". Munson-Williams-Proctor Institute, Museum of Art, Utica, NY.

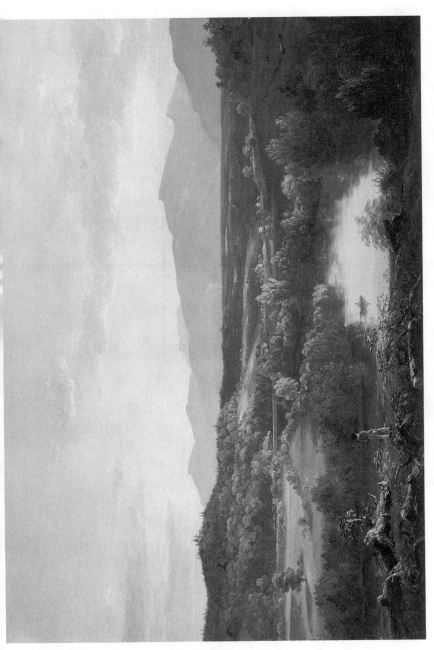

23. *River in the Catskills*, Thomas Cole, 1843, oil on canvas, 28 1/4" x 41 1/4". Courtesy, Museum of Fine Arts, Boston; Gift of Martha C. Karolik for the M. and M. Karolik Collection of American Paintings, 1815-1865.

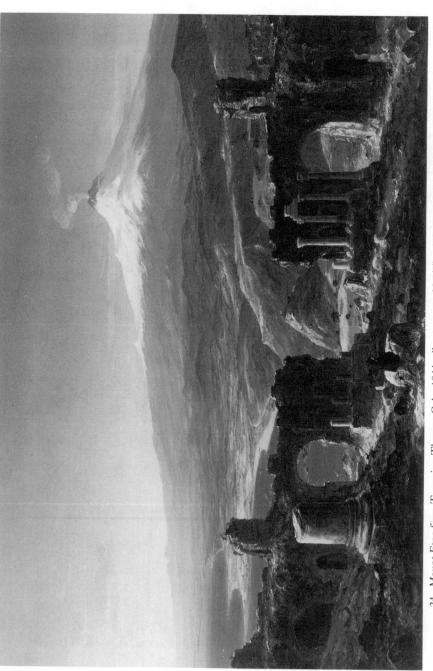

24. *Mount Etna from Taormina*, Thomas Cole, 1844, oil on canvas, 32 1/2" x 48". Wadsworth Atheneum, Hartford; Purchased from the artist by Daniel Wadsworth for the Wadsworth Atheneum, assisted by Alfred Smith.

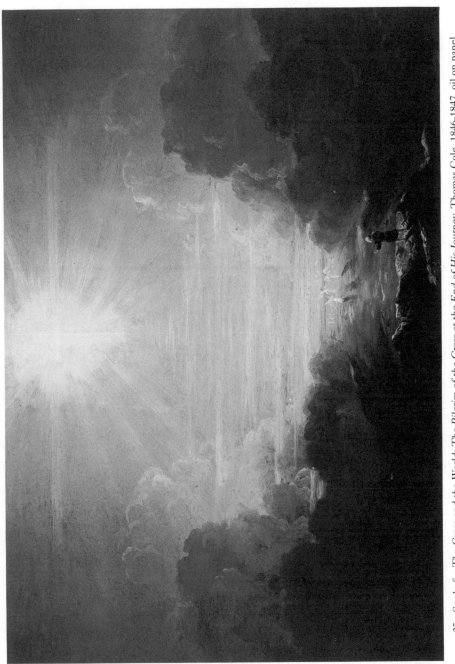

25. *Study for The Cross and the World: The Pilgrim of the Cross at the End of His Journey*, Thomas Cole, 1846-1847, oil on panel, 11 15/16" x 18 1/8". The Brooklyn Museum; Gift of Misses Cornelia E. and Jennie A. Donn.

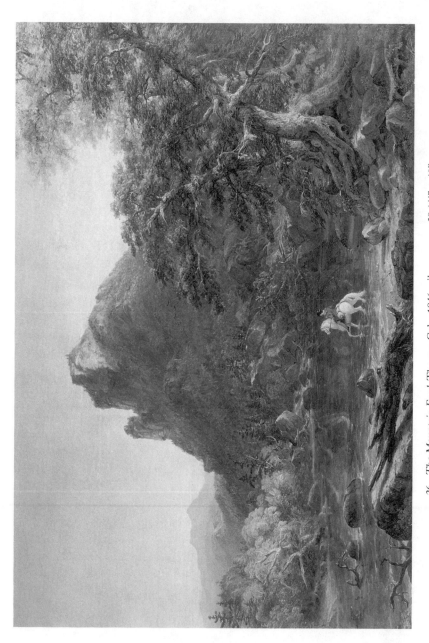

26. *The Mountain Ford*, Thomas Cole, 1846, oil on canvas, 28 1/4" x 40". The Metropolitan Museum of Art; Bequest of Maria De Witt Jesup, 1915.

CHAPTER ❧ 20

The Journal, which is now reached, is mainly what it proposes to be in its opening paragraph, and is carried forward nearly to the painter's death. As it was a private diary, and composed with no thought of its ever being read by others, much less given to the public, it would naturally abound in matter rapidly written, and of little interest to general readers. Such portions of it, however, will be selected as may best serve the purpose of the work in hand. The present writer would add, that if he has taken an occasional liberty with the language, it is less than the artist himself would have wished, and not in a way to change its sense.

THOUGHTS AND OCCURRENCES.

November 5th, 1834.—Memory is but a leaky vessel. The purest spirit is most likely to escape, and leave nothing but dregs behind. I have often regretted that interesting things of daily occurrence, and thoughts suggested by them, fade away, or are buried under subsequent accumulations, thus rendering my experience very narrow. * * * It is desirable to have it as wide as possible. With this view I intend to record some of the passing incidents and thoughts of my life, that I may look back to the experience of the past, and be amused, if not instructed.

November 6th.—Last night I dreamed that I was descending a

precipitous mountain, and had to cling to roots and shrubs to aid me in the descent. One shrub, towards which I had stretched my hand, attracted my admiration by its beauty. I paused to gaze at it. As I gazed, I perceived, to my horror, that it was a serpent coiled in an attitude to spring upon me. How this dream is like many of the realities of life! Objects the most beautiful, and which we desire to clasp, are often fraught with poison.

This afternoon, in company with Miss B——,* I took a walk through a favourite dell, which we call the Vale of Tempe. A little stream winds between two wooded hills, having a meadow-like margin. * * * Here and there is a little pool of pure water, in which are numbers of small fishes, that lead, one may suppose, a quiet and contented life. A spirit of tranquility seems to dwell in this little valley. We gathered mosses, noticed the beautiful effects of sunlight and shadow on the now almost leafless woods, and conversed on days past, when the woods were in their glory, and of a distant and dear friend, my sister, who was with us the first time we visited this sweet place. While we were there, we heard the shouts of a company of men, rejoicing at the defeat of their political enemies. *Their party* was victorious!

November 8th.—To-day I commenced packing for my return to New York. It is rather a melancholy business. After my summer in the country, I always go to the city with a presentiment of evil. I am happiest in the country. In the city, although I enjoy the society of my family, and of artists, and other persons of taste and refinement, yet my feelings are frequently harrowed by the heartlessness and bad taste of the community, the ignorant criticisms on art, and the fulsome eulogiums, that so often issue from the press, upon the vilest productions. I also dislike fashionable parties. I have either not confidence enough or small talk to shine. I escape from them with as much delight as if just liberated from a jail.

I made a small circular diagram of colours to-day. It reminded me of an experiment I have long wished to try, and have thought a good deal about. The idea was suggested by something I read, when a boy, I do not know where. It is what may be called the music of colours. I believe that colours are capable of affecting the mind, by combination, degree, and arrangement, like sound. * * It is evident

* [Bartow.] His wife subsequently.

that there is an analogy between colour and sound; and with study and experiment it might be traced through all its ramifications. I am not aiming to prove the analogy, but to show that there is plausibility in the theory that an instrument might be constructed by which colour could be played, and which would give to those, who had cultivated their taste in the art, a pleasure like that given by music.

If I attempted to make an instrument, I should try the experiment with six colours and their semitints. * * The instrument might be played by means of keys, like those of a piano, except that, instead of their moving hammers to strike strings, they might lift, when struck, dark or black screens from before coloured compartments. Transparent compartments, with either sunlight or artificial light behind, would perhaps produce the most brilliant effect.

November 25th.—A fortnight has now elapsed since I left Catskill. And so much has my time been occupied that I have had no leisure to write a line, although some things of interest have occurred. How I regret the country with its delightful tranquility. Here is nothing but turmoil: my mind is distracted with a thousand cares: and although I have commenced painting, yet it is not with love.

This day, two years ago, I returned from Europe. The day was delightful: and after a tedious voyage of seven weeks from Leghorn, it is not surprising that almost everything I saw gave me pleasure. Well nigh a four-years' absence made the shores of the bay, its white buildings and the approaching city, very welcome to my eyes. As its roar came across the waters upon my ears, accustomed for so long a time to the sounds and solitudes of the ocean, it was deeply impressive. We had come from the pathless deserts of the sea: this was our first hearing of the mingled voices of the multitude, and the din of wheels and footsteps in the stony streets. * * * *

January 24th, 1835.—The wings of time are heavier and heavier laden as he flies. Each hour brings its own trouble without dissipating that of the past. This reconciles one to death: rest is welcome to the weary soul.

> "O that I had wings like a dove!
> For then would I flee away, and be at rest."[2]

Although pain and trouble may accumulate, as we pass along, hope sheds a light upon our path, and brightens like a star, as the darkness

deepens. In the depth of night we see not the earth around us, while there are visible splendours in the fields of heaven: so divine joys shine from eternity when trouble flings a gloomy obscurity around the things of time.

This afternoon I walked down to the Battery to see the sun set for the first time since I left the country, where I daily watch him. It was glorious; the water perfectly calm; not a cloud in the sky. Like a golden dome the sun lingered a moment on the horizon, and then sunk, as if by the wand of an enchanter, from the sight.

I count the winter-days, for they are slow-footed: but the summer-days, which I enjoy in the country, fly too quickly to be counted.

February 25th.—My soul dwells in a mortal tenement, and feels the influence of the elements. Still I would not live where tempests never come; for they bring beauty in their train.

> I sigh not for a stormless clime,
> Where drowsy quiet ever dwells;
> Where crystal brooks, with endless chime,
> Flow winding through perennial dells.
>
> For storms bring beauty in their train:
> The hills below the howling blast,
> The woods, all weeping in their rain,
> How glorious, when the storm is past.
>
> * * * * * * *
>
> So storms of ill, when pass'd away,
> Leave in the soul serene delight:
> The gloom of the tempestuous day
> But makes the following calm more bright.

TO MR. ALEXANDER.

New York, March 26th, 1835.

MY DEAR SIR,— * * About the picture;—you must not be surprised if a large one, about seven feet long, makes its appearance on your coast, not as a sea-serpent, but as a Tornado. If you do not see this in a week or two, you may expect *me* in Boston, next summer, when I will do something for your Paestum favour. The Tornado I speak of was painted the summer before last: it is sketchy, but I believe you are fond of such. * * *

Can you yet be called "happy?" I hope so; and that you will long continue so. We will speak about the ladies when I come: you will perhaps find my heart more adamantine than you suppose. I am in the midst of *thinking* about moving; I intend to spend my summer in Catskill. * * *

<div align="right">Your friend, THOMAS COLE.</div>

April 17th, 1835.—I am once more in the midst of preparation for the country. Within a few days I shall leave for Catskill, my favourite haunt. My anticipations in coming to the city, last autumn, were not very pleasing; the realities have been sad. The sickness of my father and mother has loaded me with care and anxiety: interruptions of various kinds have frequently occurred: many things have conspired to destroy the tone of mind necessary for the successful pursuit of my profession. * * * I have scarcely done anything; not finished a single picture. I have made an outline of the third in the Series, but it is unsatisfactory, and I shall commence another. Choice days are passing away without my being able to apply myself so entirely to my art as I should wish. * * * But I will not repine nor anticipate evil. He who has made me, and given me the capacity to rejoice in the beauty of His works, will, I humbly trust, continue to me His bounteous goodness. * * And O, may I pursue the art I love with an undivided mind! may my works be worthy the scenes and subjects I would choose to depict! * *

Arrived in Catskill, April 23d. Snow on the mountains, and everything bearing a wintry aspect.

On the 16th of May I went down to New York to the annual meeting of the National Academy of Design. I also read my lecture on American Scenery before the New York Lyceum. In consequence of embarrassment I read very badly. On the 13th I returned with my sister Sarah. The country still has a wintry appearance: the snow yet lingers on the mountain tops. When will the summer come!

May 24th.—The spring has come at last. We have had a few days truly delightful: the softest temperature, the purest air, sunshine without burning, and breezes without chilliness; soft and cloudless skies. The mountains have taken their pearly hue, and the streams leap and glitter as though some crystal mountain was thawing beneath the sun: the swelling hills with their white and rosy blossoms blush

in the light of day: the air is full of fragrance and of music. O that this could endure, and no poison of the mind fall into the cup!

May 28th.—To-day my feelings have been cruelly wounded. * * * He whose affections extend to many is like a wide-spreading vine in the forest. It is exposed to peril in proportion to the number of trees upon which it depends. One by one are they liable to fall, either by the axe or the tempest, or by the rot silently eating at the core, and leave, at last, the poor vine, with all its fruit and foliage, prostrate on the earth.

> Cast off the bands that bind thee now;
> Each strand is steep'd in pain:
> Thus spake a voice; I made a vow
> To break them all: 't was vain.

* * * * * * *

May 31st.—I did not go to church to-day. I should have spent my time more profitably if I had. I read a little, wrote, and walked, and looked at the landscape. In the evening I took a walk on the road to the village of Athens, which, for half a mile from Mr. Alexander Thompson's,* is my favourite morning and evening walk. The south wind blew strongly, and dark masses of cloud moved across the twilight sky, the heralds of approaching storm. A leaden hue overspread the vale, the woods, and the distant mountains. How contagious is gloom! A flow of melancholy thoughts and feelings overwhelmed me for a time. I thought of the uncertainty of life; its bootless toil and brevity. The south wind, I thought, would still continue to blow, and bring up its dark clouds for ages after my works, and all the reputation I might gain had faded away, and become as though they had never been,—swept by the wing of time into oblivion's gulf. And shall it be? Shall the spirit, that mysterious principle, unknown even to itself, that vivifies this earth, and generates these thoughts, sink also into the gloomy gulf of non-existence, nor feel again created Beauty, nor see the Nature that it loved so much? It cannot be. The Great Originator, the Mighty One, the Unspeakable, hath not created for purposes vain and useless this power of conceiving,—this wish and "longing after immortality,"—this hope,—this faith which gives an energy to virtue, and raises in the breast these lofty aspirations,—this

* Ultimately Cole's permanent residence.

fear of sinning, of deception and delusion. No! There are no fallacies with God. To prove that, if not to disprove all existence, would be to render all things doubtful.

June 1st.—Monday morning. The storm has passed; the day breaks over the earth in freshness and in beauty. In the east, sullen and dark is the retiring storm: in the west, the deep-green mountains rise into the pure blue: around their summits float the light, white clouds, like hope upon the bosom of reality. * * * *

 * * * * * * *

 A sad remembrance of departed love
 Stole softly o'er my mind:
 It came like moonlight on the grove,
 Or music on the wind.
 It had a sweet regretful power,
 Like fragrance from a withered flower.

June 4th.—I now give myself forty days for completing my large picture of the Series. How near shall I come to it?

June 24th.—I have been reading Irving's Abbotsford. It gave me real pleasure. What a healthy genius was that of Scott. No mawkishness, no morbid sensitiveness, no feverish fancies; but a sound heart, a grasping, a creative, powerful mind, and an herculean body knit wonderfully together. I love both Scott and Irving for their decided fondness for domestic animals. Such love is indicative of a truly benevolent heart. Irving was rather disappointed in the scenes in which Scott was so much delighted. After all, beauty is in the mind. A scene is rather an index to feelings and associations. History and poetry made the barren hills of Scotland glorious to Scott: Irving remembered the majestic forests and the rich luxuriance of his own country. What a beautiful exemplification of the power of poetry was that remark of the old carpenter who had been a companion of Burns: "and it seemed to him that the country had grown more beautiful since Burns had written his bonnie little sangs about it."

A lovely trait in Cole's character was an extreme tenderness of heart, manifested often in that same fondness for domestic animals which he speaks of in Scott and Irving. An illustration of this amiable quality is furnished by the following,—an amusing incident, happening while he was engaged upon one of his last pictures.

A fine, large stag-hound, a present to one of the ladies of the family, yet no great favourite with Cole himself, was to be shot. His crime, for which he had been repeatedly spared at the cost of both money and trouble, was that of sheep-killing. Tiger, though, was now a doomed dog, and the very pistol loaded which was to put the bloody sentence into execution. "Martin," said Cole, one morning after breakfast, to his man, a simple-hearted Hibernian, "Martin, you must kill Tiger. Here—take this pistol—call him to the gravel-pit, at the end of the grove, and shoot him."

With evident signs of timidity and reluctance, Martin took the deadly piece, and whistled for the dog, the painter going at the same moment into his studio. A full half-hour having elapsed, and still no report, for which he had been anxiously listening, Cole with considerable impatience sallied forth to learn the cause of the delay. A short walk into the grove brought him in view of the gravel-pit, around the brink of which were seen Martin, slowly moving here and there, taking dreadful aim, and Tiger just before him, apparently in great glee, jumping first to one side and then to the other, as if determined to dodge the shot, and turn the whole affair into mere sport.

"Martin," said the painter, quite sharply, "what is the matter? What are you twisting about here for? why have you not shot the dog, as I bid you?"

"Ah, sir," said Martin, with the brogue peculiar to his countrymen, "I am discouraged, sir—I am discouraged, sir."

"*Discouraged, sir!*"—repeated the half-vexed, half-amused artist. "Here, sir,—hand *me* that pistol."

Poor Tiger, his last moment seemed to have come. Not so thought Tiger, who began again his jumping and skipping, the instant that the pistol was pointed at him, leading now both master and man, here to the right—there to the left, though frequently pausing long enough to have been shot ten times. At last, as if either sick of his frolic or surrendering to his fate, the dog sat down, and with his full fine eyes looked his master steadily in the face. Now came the long, still, last aim. "Martin," said Cole, suddenly turning round, "here—take the pistol—I am discouraged too!"

So far as we know, Tiger yet flourishes, though in a distant neighbourhood.

CHAPTER ❦ 21

Thoughts and Occurrences: holidays on the mountains; a walk; Rip Van Winkle's dell; the Mountain House; the lakes; a voyage; mountain landscape; title of the series of pictures; musings. To Mr. Reed: painting the third picture of the Course of Empire. Thoughts, &c.: Schroon scenery; musings on nature; monument to Washington; want of a congenial spirit; true lovers of nature few. Spirits of the Wilderness, a poem.

J ULY 6th, 1835.—I have just returned from the mountain, where I spent two of the happiest days I remember. Upon the evening of the third, after close application to my work all day, in passing through the village, I met the stage enveloped in a cloud of dust. As it went rattling along by me, who should I see within but ———.[1] I followed him immediately to the tavern. We soon came to the determination of spending our "fourth" among the mountains. In the expectation that a stage would, of course, be going up to the Mountain House within an hour or so, after packing up a few articles of dress, we loitered about the village. Continuing this until nine o'clock in the evening, and no stage appearing, we set out to walk. The night was fine, and the moon, though small, gave a pleasant light. We passed over the first seven miles right merrily. Then the moon sunk behind the piny ridge of the North Mountain, and we began to be thirsty. Not finding a spring at Lawrence's, and the people being soundly asleep, we thought it better to pursue our way a three miles further, to Rip Van Winkle's hollow. The long mile from the foot of the mountain to Rip's is exceedingly steep. Thirst, however, gave wings to our feet, and we sped upward with a swiftness not quite agreeable to our comfort. We arrived, at last, with parched mouths and wet skins. It was midnight when we sat down by the stream that comes leaping from the grand amphitheatre of wooded mountains. There was a tin vessel glittering by the rill, placed there for the use of travellers, by some generous soul, or perhaps fairy, that expected us at that silent hour. Be that as it may, we drank from it the cool, pure water again and

again, and the draughts were even more delicious than those of Rip's from the famous keg. It was a solemn scene. Dark forests, rugged rocks, towering mountains were around us, and the breeze brought to our ears the sound of waving trees, falling waters, and the clear chant of the whip-poor-will. * * We did not sleep twenty years after our potations, but prepared to scale the remaining part of the mountain. We conquered. After a little difficulty in getting into the house, —it being one o'clock—we got into a comfortable bed.

We did not rise remarkably early, but were ready for breakfast. * * * We strolled down to the small lake which lies a few hundred yards from the house. It is diminutive, but has beautiful, as well as grand features—rich forests and mountains. * * * We pursued our way to the lower one, which is much larger and more beautiful. I pointed out a view that I once painted; which picture, I believe, was the first ever painted of the lake that will be hereafter the subject of a thousand pencils. * * * Several years ago I explored its shores for some distance; but thick woods and swampy grounds impeded me in those attempts. I enriched my sketchbook with studies of the fine dead trees, which stand like spectres on the shores. * * As we made our way to an opening through the woods, which disclosed the lake in a charming manner, we perceived a rude boat among the bushes: this was exactly what we wanted. We pushed it off, and leaped into it, as if the genius of the deep had placed it there for our special purpose. * * Before us spread the virgin waters which the prow of the sketcher had never yet curled, enfolded by the green woods, whose venerable masses had never figured in annuals, and overlooked by the stern mountain peaks, never beheld by Claude or Salvator, nor subjected to the canvass by the innumerable dabblers in paint of all past time. The painter of American scenery has, indeed, privileges superior to any other. All nature here is new to art. No Tivolis, Ternis, Mont Blancs, Plinlimmons, hackneyed and worn by the daily pencils of hundreds; but primeval forests, virgin lakes and waterfalls, feasting his eye with new delights, and filling his portfolio with their features of beauty and magnificence, hallowed to his soul by their freshness from the creation, for his own favoured pencil.

A little promontory, forming a fine foreground to a charming view down the lake, invited us. Looking down, we had some fine perspec-

tive lines of forest, on our right, with many dead trees standing near the shore, as if stripped for the element. These dead trees are a striking feature in the scenery of this lake, and exceedingly picturesque. Their pale forms rise from the margin of the deep, stretching out their contorted branches, and looking like so many genii set to protect the sacred waters. On the left was another reach of forest, of various hues, and in the centre of the picture rose the distant Round Top, blue and well defined, and cast its reflection on the lake out to the point where our boat swung like a thing in air. This headland was picturesque in the extreme. Apart from the dense wood, a few birches and pines were grouped together in a rich mass; and one giant pine rose far above the rest. On the extreme cape a few bushes of light green grew directly from the water: in the midst of their sparkling foliage stood two of the bare, spectral trees, with limbs decorated with moss of silvery hue, and waving like grey locks in the wind. We remained here long enough to finish a sketch, and then returned to our harbour in order to refit. * * *

After dinner, * * * we again launched our vessel for a longer voyage of discovery. We now crossed the lake, paddling in the manner of Indians. Our boat glided beautifully over the tranquil water, and swept aside the yellow water-lilies. We got into a strait between the main-land and a low islet, where the water was very still, and the woods were reflected beautifully. I never saw such depth and brilliancy in the reflections. * * The dead trees on the margin added, by their silvery tints, to the harmony of colour, and their images in the water, which had a gentle undulation, appeared like immense glittering serpents playing in the deep. * * At every stroke of the oar some fresh object of beauty would break upon us. We made several sketches; and about sunset turned our prow. * * As we returned, we struck up the Canadian boat-song; and though our music was rude, the woods answered in melodious echoes. What a place for music by moonlight! it would be romance itself. This may be, and I may enjoy it.

* * * * * * *

July 28th.—I have had some little trouble in finding at once a comprehensive and appropriate title for the Series of pictures I am now painting for Luman Reed. The one which I have at last adopted,

although some may consider it lofty and ostentatious, appears very well to me. I call it "The Course of Empire."
August 16th.—Night.

> Mine eyes bedimm'd with tears aloft I raised;
> Call'd by some spirit of a higher sphere;
> And through the universal ether gazed
> Up to the golden orbs that did appear
> Trembling amid the dark abyss profound:
> But yet they falter'd not, nor sank, nor swerved;
> Keeping their gloriously appointed round,
> In everlasting harmony preserved.
>
> "O, is there cause for tears," the spirit said,
> "When all these wondrous worlds are thus sustain'd
> By an Almighty hand, and gently led
> Through the wide fields of heaven, like sheep restrain'd
> From wandering by the shepherd's kindly voice?
> Within His care are held thy heart, thine all:
> List! thou wilt hear that shepherd's loving call:
> Then wipe those tears, and bid thy soul rejoice."

August 18th.—It has been a glorious day. A cool and crystal atmosphere is upon the mountains. After work, I walked up the valley of the Catskill. The sun was down, and the woods, fields and mountains never looked lovelier. All is fresh as June. What a blessed season. Would that it might pass slowly. * * * *
 August 23d.

> When evening in the sky sits calm and pure,
> And every fleecy cloud is still and bright,
> And earth beneath the silent air obscure
> Waits for the stars, first on the verge of night,
> Then is the spirit melted as with love;
> And tears spring forth upon the brink of joy:
>
> * * * * * * *
>
> O, whence that shade of sorrow o'er us thrown
> When thoughts are purest in the twilight hour?
> From sense of sin arises that sad tone?—
> From the deep consciousness of passion's power,
> Which touches not the woods, nor mountains lone?

Or is it that the fading light reminds
That we are mortal, and the fearful day
Steals onward, swiftly, like the viewless winds,
And years like vapour vanish quick away?

August 25th.—A gloomy day. Windy and dark. The country yet looks green,—green almost as June. * * I am fearful that the many interruptions, to which I seem more and more liable, has an evil effect upon my temper. I am most happy when I can escape most from the world. The longer I live in it, the more its common cares and troubles seem to claim me. Nothing makes me so melancholy as that which prevents me from the pursuit of my art.

Though time has sadden'd every thought,
And kill'd the fresh and flower-like joy;
Sweet hope and memory have brought
A bliss that lives without alloy.

TO MR. REED.

Catskill, September 7th, 1835.
My dear Sir,—When you open this letter, you will expect to hear that the large picture is finished: but I am not yet so happy, and write to ask your patience yet a little while. I have been engaged upon this picture solely since you were here. I really think it will not occupy me more than three weeks or a month longer. The figures take more time than I expected. Another reason for the length of time is, I have had to tear down some of the buildings that were nearly finished, in order to make improvements, a la mode New York. I sincerely hope that when it is completed you will not be sorry I have spent so much time on the work. I know that I cannot satisfy myself in all particulars, and can only hope that you will be pleased. * * *

Yours, very truly,
Thomas Cole.

October 7th.—I have just returned from an excursion in search of the picturesque towards the head-waters of the Hudson. * * In the neighbourhood of Schroon the country is more finely broken.

The lake I found to be a beautiful sheet of water, shadowed by sloping hills clothed with heavy forests. Rowing north for a half an hour or so, you will see the lake expanded to the breadth of two or three miles. Here the view is exceedingly fine. On both hands, from shores of sand and pebbles, gently rise the thickly-wooded hills: before you miles of blue water stretch away: in the distance mountains of remarkable beauty bound the vision. Two summits in particular attracted my attention: one of a serrated outline, and the other like a lofty pyramid. At the time I saw them, they stood in the midst of the wilderness like peaks of sapphire. It is my intention to visit this region at a more favourable season. I set off on my return, next morning, and had a cold and rainy day.

A LOOSE LEAF.

At this season, when nature puts on a garb of splendour, when the days are brilliant, and the sunsets are full of glory, there are moods of mind when I feel that things are ill-timed, and out of harmony. It is the saddest season of the year: blight is on all the vegetable world. The woods are glowing with strange beauty; but it is the hectic flush, that sure precursor of death. There are days though when I feel no incongruity, those days of clouds without rain, when shadow subdues the pomp of the earth, and the air is crystalline; when the woods repose in sombre stillness, and the waters take the hills upon their bosom, and veil them with transparent loveliness.

October 10th.—There is an article in the "American," addressed to the American people, on the subject of erecting a monument to Washington. * * As to the design of such a monument, I would say, let it not be a statue; for however great its size, its many parts and projections would render it less durable than something more simple: time would destroy the original beauty of the sculpture of a statue. I would not have a column; for that is only an architectural member, and not a complete whole. Although it were crowned with a statue, it would not appear to me either consistent or in good taste. A pyramid would answer in durability of structure; but that is unmeaning. To my mind a colossal altar would be the most appropriate, and the most capable of uniting beauty of form with durability. Let it be hundreds of feet in height; let a fire burn upon it perpetually; let it never expire

while the nation recognized Washington as the Father of his country. Morning, noon, evening and midnight, let its flame rise in the heavens a symbol of his glory, and a Pharos to light the children of freedom to deeds of virtue and greatness, for ages to come.

October 30th.—The weather for a month has been truly delightful; but this day above all. A pure crystal-like atmosphere has floated round the landscape; and the brown of the leafless woods has been tinged with the purest ultramarine. The sky is clear and cloudless, the air is still, but fresh. O Nature, to the loving eye thou art seldom without smiles.

November 21st.—In consequence of having a number of sketches to paint, my afternoons are so fully occupied that I have little opportunity of writing. Gloomy days have come at last, and brought with them to my mind a shade of their own sadness. Want of sunlight and exercise is to me a great cause of mental depression.

I cannot but consider myself unfortunate in not having found here a companion of congenial soul; one whose spirit would mingle with mine in unreserved communion. I feel an enduring want, a lasting and unsatisfied desire to have intercourse with one to whom I could reveal thoughts which can never be spoken to the world. I feel that I stand alone. Those around me only know me in part. The foot of the mountain may be bare, and the summit lost in clouds. Not that I feel myself superior or exalted above my fellows, but that my thoughts and feelings run, for the most part, in a different channel: if revealed, they would be little understood or appreciated. How few really love, and live upon the beautiful! How few cast off worldliness, and clear away from their eyes the film which prevents them from beholding the truth and glory of nature! But am I better or wiser for this sense and perception of the beautiful, which I imagine myself to possess in a greater degree than the many? That is a hard question. I can only say, I believe that I ought to be. But I know that, at times, my admiration for the beautiful is a source of irritability and uncharitableness towards those who do not seem to feel, and see as I do. Instead of pitying them for their obtuseness and want of taste, I speak of, and to them, as if they were vile and criminal.

The intensity of Cole's love for the beautiful in nature frequently carried him into a species of solitude, both of the intellect and feelings, quite away from the walks of ordinary minds. That few or none

would follow him there, would very naturally irritate, and beget a spirit of misanthropy. He possessed, though, too loving and sound a heart to approve of such a temper. He knew and felt, in calm and thoughtful moments, that his path was not aside from, but among men, and that true philosophy was in loving "not *nature* less, but *man* the more."

It was in the midst of such convictions that he found leisure, during the year of 1835, to compose a kind of dramatic poem, in twelve parts, called The Spirits of the Wilderness, a work of singular originality, and much poetic power and beauty. In the spring of 1837 it was rewritten, and prepared in a measure for publication. The scene of the poem is among the Crystal, or White Mountains.

Thoughts and Occurrences: a new year. First winter in Catskill. An
Attachment. To Mr. Reed: ornamental designs for doors. To the Same:
the fourth of the Course of Empire begun. To the Same: how far ad-
vanced. To the Same: difficulties of the third picture. To the Same: the
fifth picture proposed for the approaching exhibition of the Academy of
Design. To the Same: the third picture finished. To the Same: motives to
labour; maledictions on tree-destroyers. To the Same: nature of the mal-
ediction. To Mr. Durand: sickness of Mr. Reed. To the Same: effect
upon Cole's spirits. Thoughts, &c.: cares of life. To Mr. Durand.
Thoughts, &c.: death of Mr. Reed. Thoughts, &c.: beauty of the season;
a walk up the Catskill river. To Mr. Durand: the fourth picture. To the
Same: country air for a painter. Thoughts, &c.: completion of the
Course of Empire.

J ANUARY 1st, 1836.—Another year is gone. Who shall redeem it?
The gates of a new year are opening, and I enter; but darkness is
before me. A year is a palace of many chambers, all dimly lighted.
We know not what they contain until we explore them. I proceed
with faltering footsteps: but the mind rushes forward in spite of the
gloom; but it is only to inquire what may be, and not what is. I carry
the lamp of experience in my hand; but it throws a feeble, flickering
light on the mysterious darkness around.

From anything in his journal or correspondence there is no intima-
tion of an under-current of thoughts and feelings, which, at this time,
was flowing in the breast of Cole. The inconvenience, if not loss of
returning, as usual, to the city, absorbed as he was in the Course of
Empire, would naturally suggest the expediency of remaining, dur-
ing the winter, quietly in the country. Whether that under-current,
spoken of, did not lend some influence to make also what was ex-
pedient a pleasing choice, an incident related by a friend perhaps will
show.

The painter, with a large softening brush, was giving the last

touches to the sky of the central picture—the Empire in its glory. All the rest from the horizon to the foreground was dead canvass,—such being his process of painting. At this moment, the friend alluded to, who had come on a visit from a distant city, was announced. After the artist's usual simple hearty welcome, and a moment's conversation, they ascended to his painting room, where, upon a centre-table, lay a splendid bouquet of roses and other flowers,—the same that he had seen, a few minutes before, in the hands of a youthful lady, as he came in by the shrubbery. Upon returning to the hotel in the village, he told a companion that he had seen the lady that Cole would certainly marry. Time fulfilled the prediction.

TO LUMAN REED.

MY DEAR SIR,—I received your kind and encouraging letter, and am much gratified to learn that your visit proved agreeable. It certainly was so to me; and was well-timed, for the weather has been wintry ever since. I also received the plates, &c., for which I am much indebted to Mr. Durand. The drawings for the doors are very complete, indeed more so than was necessary for the purpose.

I have made great alterations in the architecture on both sides of the picture,—something in the manner I contemplated when you were here. The golden dome is yet standing, but has taken a different appearance.

The subject of the doors has not been entirely absent from my mind; but whether my thoughts have been at all profitable is yet to be determined. I shall offer them as *first* thoughts, and am quite prepared for their being considered as inappropriate, or of little worth. I give them more in the hope that they will suggest something better, than that they themselves are good. * * *

Yours, &c.,
THOMAS COLE.

TO THE SAME.

Catskill, Jan. 13th, 1836.

MY DEAR SIR,—Your letters always bring pleasure with them, for they are always full of kindness. * * * I really am happy

in having so generous a friend. Had I painted this series of pictures for some who call themselves patrons, I should have been completely ruined. * * * I have been waiting this day or two for the large picture to get sufficiently dry for glazing, and have occupied myself on the fourth picture. If I succeed as well as I anticipated, I am in hopes you will consider it the finest. I believe I am best in the stormy and wild. The design, as far as I have imagined it, (for there is yet very little on the canvass,) pleases me; but these unembodied designs often do. * * *

<div align="right">Yours, very truly,
THOMAS COLE.</div>

P.S.—I forgot to say that we have had a snow-storm, such as I have not seen for a long time. The weather is now pleasant, and the mountains have on their winter beauty. I saw a scene the other evening, which I should delight to paint; but for the present my hands are full.

TO THE SAME.

<div align="right">Catskill, Feb. 6, 1836.</div>

DEAR SIR,— * * I did expect to be with you before this time; but I did not expect that great and seemingly unconquerable difficulties would yet be in the way. The big picture is not yet finished. * * * I will tell you how much appears to be about finished. All the distance and sky, the temple on the left, the water and all the vessels, the bridges with the figures. The conqueror, I think, looks magnificently—that is as I can make him. The right side of the picture, the fountain, figures, etc., is not yet completed; and the general effect of the whole depends on this part. I am yet uncertain whether my general effect will be good; there is great danger of its being spotty. * * * *

I am glad that Durand and Flagg[1] are getting on so rapidly with the doors. There will be something for me to see when I come down. I hope you are pleased. If you do leave any panels for me, let them be all together, and not every other, for that would entirely break up any series that I might wish to paint. But this for your consideration. The statuary might look extremely well, if judiciously selected.

<div align="center">157</div>

I think, though, Mr. Durand would execute it better than myself; he is a more correct draughtsman of the human figure than I. I shall be sorry, though, not to have a little share in the door painting. * *

Yours, &c.,

THOMAS COLE.

TO THE SAME.

Catskill, Feb. 18th, 1836.

MY DEAR SIR,—I would give a great deal if you were here, for I know you would encourage me, and perhaps suggest something. I took the picture down stairs to-day, to see it at a greater distance, and in another light, and I am disappointed. It does not look as well as I expected, and my hope now is that I am no judge. I hardly know what the faults are; it may be all fault. I intend to leave it for a few days: perhaps some good genius will work at it in the mean time, and when I see it again it will be improved.

I have been looking at a canvass of the same size, that is in my room, with a longing eye, and even made some chalk-marks upon it. If my circumstances permitted, I certainly would, after finishing this picture, make another attempt, and when done, give you your choice. In another picture I would paint the objects larger and fewer, with the horizon lower. It would be grander and easier. In this I had to encounter a difficult and complicated composition; and to obtain breadth of light and shade, with such a multitude of parts, is next to impossible. * * Tomorrow I shall work on the fourth picture.

I remain, &c.,

THOMAS COLE.

TO THE SAME.

Catskill, Feb. 19th, 1836.

MY DEAR SIR,—I have been thinking of your obliging advice to paint some picture for exhibition, and leave yours for a short time, but I dislike to do so. * * * One thing I have thought that I might do, if it meets your approbation, paint the last picture in the series. * * I might paint this picture, and even find time to paint one for Mr. Charles King[2] before exhibition.

You will ask, perhaps, why I choose to paint the last of the series now: it is because it will take less time, and—I don't know why, except that I am tired of the gaud and glitter of the large picture, and not quite in the humor for the tumult of the fourth. I want to work awhile on something quiet and sombre. The large picture is yet down stairs: but I have *looked* at it. It appeared to have improved a little: but I see where I shall have to work yet. I am much pleased with Durand's subjects, and shall undoubtedly have a treat when I come down. It is gratifying to learn that Flagg's picture is so fine. I will not forget cheese-basket and ladder. Durand is determined to have a good likeness of you: you know I have a promise that you will sit to me sometime. I am afraid, though, my portrait-hand is out. * *

Believe me, &c.,

THOMAS COLE.

TO THE SAME.

Catskill, March 2d, 1836.

MY DEAR SIR,— * * I shall take advantage of your kind advice and Mr. Durand's, and paint a picture expressly for the exhibition, and for sale. The only thing I doubt in the matter is, that I shall be able to sell it. I think I never sold but two pictures on exhibition in my life. * * * Fancy pictures seldom sell, and they generally take more time than views, so I have determined to paint one of the latter. I have already commenced a view from Mount Holyoke; * * * but you must not be surprised if you find it hanging in my room next year. I have written to ——[3] to make me a frame like your large ones; * * you know "a frame is the very heart of a picture," and I have never yet had in the exhibition a picture with a good heart. * * * *

Yesterday I was at the big picture again. It was the first rainy day we had had since the fall, and I thought it would be a good time to paint the water in the fountain. It looks some better, and I think a good day's work would complete it. I feel like a man who has had a long fatiguing journey, and is just taking off his knapsack. * *

Yours &c.,

THOMAS COLE.

Catskill, March 26th, 1836.

DEAR SIR,— * * * I trust you do not fear that exaggerated praise can affect me with pleasure, and lead me to see nothing but beauty in my productions. On this subject I will open my mind to you as my best friend, and hope that by so doing, although I may run the risk of being egotistical, I shall dissipate any lingering doubt that may remain in your mind.

Formerly my love of approbation rendered me very sensitive to newspaper praise; but I always turned away from fulsomeness and exaggeration with disgust. My love of approbation still exists, perhaps, as strongly as ever; but the sources from which it is fed are changed. Newspaper paragraphs in praise or blame affect me with no more than a momentary feeling. I have ceased to labour to please the multitude of critics, and it may be said of me, as the Italian epitaph has it, "He implores peace." My stimulus to exertion is now the approbation of the few, in whose taste and judgment I have confidence, the desire to obtain a lasting reputation, and love for the beauty and excellence of my art, which of itself brings enjoyment, and is entirely independent of the approbation of the world. Newspaper praise is often injudicious, and much of it can be purchased by meanness, even for mediocrity: but the praise of the few, who possess true feeling, knowledge, and taste, is a sure, and what gives zest to it, a quiet reward. These, with my necessary pecuniary wants, and an inclination to contribute my mite towards the refinement and well-being of society, are the causes that stimulate me to exertion.

Will you excuse me if I say, I am afraid that you will be disappointed in the reception and notice my pictures will receive from the public, let them be exhibited to ever so good advantage? * *
Very few will understand the scheme of them,—the philosophy there may be in them. I hope I am prepared for all this. My leading hope is that when they have passed through the ordeal I shall find your esteem for them and myself undiminished. I have wrought with a strong desire to make them worthy of note hereafter, and that your name shall never be mentioned as of one whose generosity and taste were misapplied.
* * * They are cutting down all the trees in the beautiful

valley on which I have looked so often with a loving eye. This throws quite a gloom over my spring anticipations. Tell this to Durand—not that I wish to give him pain, but that I want him to join with me in maledictions on all dollar-godded utilitarians.

<div align="right">

I remain, &c.,

THOMAS COLE.

</div>

<div align="center">

TO THE SAME.

</div>

<div align="right">

Catskill, March 28th, 1836.

</div>

MY DEAR SIR,— * * * After I had sealed my last letter, I was afraid that what I had said about the tree-destroyers might be understood in a more serious light than I intended. My "maledictions" are gentle ones, and I do not know that I could wish them any thing worse than that barrenness of mind, that sterile desolation of the soul, in which sensibility to the beauty of nature cannot take root. One reason, though, why I am in so gentle a mood is, that I am informed some of the trees will be saved yet. Thank them for that. If I live to be old enough, I may sit down under some bush, the last left in the utilitarian world, and feel thankful that intellect in its march has spared one vestige of the ancient forest for me to die by. * *

<div align="right">

I remain yours, very sincerely,

THOMAS COLE.

</div>

<div align="center">

TO MR. DURAND.

</div>

<div align="right">

Catskill, May 13th, 1836.

</div>

MY DEAR SIR,—I am indeed disappointed: but my sorrow for the cause is far greater than my disappointment. I need not say how your intelligence affects me, for you feel as I do. But as Mr. Reed was better when you wrote, I hope that there is no danger, and that our kindest, best friend will soon be restored to health. Do write immediately, for you know how anxious I shall be to hear of Mr. R.'s recovery. I am not in tone for working; yet I should like to have canvass up soon.

<div align="right">

Yours, very truly,

THOMAS COLE.

</div>

Catskill, May 21st, 1836.

MY DEAR SIR,—I have been exceedingly anxious to hear from you, and your letter has brought me a great deal of comfort. Now the disease is conquered, I trust our friend will be restored to us in good health. I have scarcely done anything since I came up; I have been restless and anxious: I have laboured day after day, and produced nothing: I have done more since I received your letter this morning, than I did in three days previous. I have been putting several figures into the second picture.

* * The country is charming, delightful, and the green grass as Mr. R. loves to see it. I regret that so much beauty should be lost to him, and to you also; for you might as well be sick as pent up in the city. I shall hardly venture to commence another large picture until you have seen this. I remain yours, very truly,

THOMAS COLE.

May 22d.—The season of beauty is here once more, and I enjoy it. Since I last wrote in this book, there has been a fierce and terrible winter. As I now look upon the fields and the groves, I am astonished at the wonderful power of nature. Fresh grass and golden flowers are stirring in the sweet breeze, where, not much more than a month ago, the cold snow drifts were lying. A spirit of peace and gentleness breathes over the landscape. I feel that I ought to enjoy it more deeply than I do. But cares occupy the heart, and draw me away from nature. A few years ago, I suffered no opportunity to pass of holding with her the most intimate communion, nor permitted the common affairs of life to interfere with my studies. Now the multitudinous affairs of the world dash more and more heavily upon the shores of my little kingdom of the mind. It is a hard battle I have to fight. How material, how unspiritual is that fuel which general society affords for the fire which burns in the soul! * * *

My large picture is completed; but not to my satisfaction.

TO MR. DURAND.

Catskill, June 7th, 1836.

MY DEAR SIR,—My nephew brought me a letter from you. I am much obliged to you for the trouble you have taken about the horse,

and I do not know when I shall be out of your debt—particularly as I am about to trouble you again. I am indeed much in want of a horse. "A horse, a horse, my kingdom for a horse!" I do not want a tame pony, holding up one foot to shake hands with you, but a horse rampant, rearing. I have seen such somewhere. Is there not a good horse in the Academy which might be lent to me? If there is, could it be boxed up, and sent without breaking its neck? I should esteem it. Has not the Italian plaster man, in William street, (I think,) something of the kind? I must have a hobby of some kind, plaster, bronze, or wood. If you cannot obtain a horse for me, will you get a man?—the little fighting gladiator—him or the horse I must have. I might be satisfied, though, for the present, with a rampant lion, or a roaring one. If you can obtain one of these animals for me, and can send it by the sloop—the sooner the better—I should certainly be benefitted greatly. * * * *

I am pleased that you have attacked a landscape, and have no doubt you will succeed to the satisfaction of all except yourself. In the hope that this will find you in good health and spirits, and that our friend is recovering rapidly, and that you have not forgotten you are to come here again shortly, to gather up the flesh you dropped from your bones when last here, I remain,

<div align="right">

Yours, very truly,

THOMAS COLE.

</div>

June 13th.—On the 11th inst., I returned from the city, to which I had been called upon the melancholy occasion of the death of Mr. Reed, my best and kindest friend. He died on the morning of the 7th inst., after a sickness of five weeks. His mind was clear and calm to the last. In Mr. Reed, I have lost a true, a generous, and noble friend. I could expatiate upon the grief I feel at his departure. But words are poor things: I will simply say, he was admired and beloved, and cannot be forgotten. * *

August 1.—The last of the summer months! * * * This morning is as beautiful to me as ever fell upon the earth: the air cool and transparent; the mountains clear and blue; the woods dense with a juicy foliage; every leaf seems glittering with the gem-like dew. I hear a robin in the grove singing his never-closed song, and a little wren in the cedar near the window warbling with all his might.

I took a walk, last evening, up the valley of the Catskill, where they are now constructing the railroad. This was once my favourite walk; but now the charm of solitude and quietness is gone. It is, however, still lovely: man cannot remove its craggy hills, nor well destroy all its rock-rooted trees: the rapid stream will also have its course. * *

August 18th.— * * I often think that the dark view of things is perhaps the true one. If such a view were always presented, I doubt whether we could long survive. But Heaven has granted us a sunshine of the heart, that warms these barren cold realities of existence, and dazzles and deceives, perhaps, that we may live.

TO MR. DURAND.

Catskill, August 30th, 1836.

My DEAR SIR,—Though I have not heard *from* you, I have heard *of* you, through the "Mirror,"[4] where your landscape has been handsomely reflected. It pleased me to see the notice, but still more to see the picture. For my part, I have been engaged in sacking and burning a city ever since I saw you, and I am well tired of such horrible work.[5] I have about *finished* the city and a picture at the same time, and only want you and Mr. Allen up here to say what sort of a hand I am at destruction. I *did* believe it was my best picture, but I took it down stairs and got rid of the notion. * * * *

I remain, yours truly,

THOMAS COLE.

TO THE SAME.

Catskill, Sept. 11th, 1836.

My DEAR SIR,—If I had consulted my inclination, I should have answered your letter sooner; but I have been so very much occupied that I could not. I am sorry that you are at times so much depressed in spirits; you must come and live in the country. Nature is a sovereign remedy. Your depression is the result of debility, and you require the pure air of heaven. You sit, I know you do, day after day, in a close, air-tight room, toiling and stagnating, and breeding dissatisfaction at all you do, when, if you had the untainted breeze to breathe,

your body would be invigorated, your spirits buoyant, and your pictures would charm even you. This is not all exaggeration, there is much sober truth in it.

I am at work on the last picture of the series, although another day or two must be bestowed upon the fourth. This picture I intend to express silence and solitude. * *

I wrote some time ago a short poem as a tribute to the memory of our lost friend. When you come up, I must show it to you; and though the composition may be wretched, I know the subject will give it favour in your eyes. * * * *

<div align="right">Yours very truly,
THOMAS COLE.</div>

October 29th, 1836.—I have just returned from the city, where I have been with the series of pictures painted for Mr. Reed. When I took them, I was fearful that they would disappoint the expectations of my friends. I have been greatly surprised, for they seem to give universal pleasure.

We are now at the conclusion of Cole's first great work. It was completed early in October, and shortly after exhibited to the public by permission of the family of his lamented patron.

Cooper's opinion of Cole and his pictures. Remarks on the Course of Empire. Cole's marriage.

W ITH these paintings of Cole, "Which," as Bryant says, "are among the most remarkable and characteristic of his works," I would detain the reader by some remarks, prefaced by the following letter from one greatly familiar with art in Europe, Cooper, the novelist; in which also will be found, among other things, language corroborating what was said in speaking about the Florentine pictures.

Otsego Hall, Cooperstown, Jan. 6th, 1849.

* * * * * * *

As an artist, I consider Cole one of the very first geniuses of the age. This has long been my opinion. The Course of Empire ought to make the reputation of any man.

Cole improved vastly by his visit to Italy. This, however, was, as an artist, rather than as a man of genius. The *thought* of the Course of Empire came from within. So far as my knowledge extends, he might have searched all the galleries of Europe for the conception in vain. The series is a great epic poem, in which the idea far surpasses the execution, though the last is generally fine. * *

As a mere artist, Claude Lorraine was the superior of Cole. This arose from advantages of position. As a poet, Cole was as much before Claude as Shakspeare is before Pope. I know of no painter whose works manifest such high poetic feeling as those of Cole. Mind struggles through all he attempts, and mind accompanied by that impulsive feeling of beauty and sublimity that denote genius.

It is quite a new thing to see landscape painting raised to a level with the heroic in historical composition: but it is constantly to be traced in the works of Cole. Some of his Italian views are exquisitely

true, while they are imaginative. But it requires that one should be familiar with that land of lands to appreciate them.

I have heard it said that Cole lost his originality and strength by visiting Europe; but I regard it as a provincial absurdity. * * * The truth is that one easily gets in advance of the public mind of America by a residence among the great works of the old world: and the inexperienced here mistake their own inability to appreciate for a fault in others.

I have heard it said here that Cole's Italian landscapes were over-charged copies from the old masters, and not natural. * * * Cole has overcharged nothing in any picture I have ever seen; and it requires his perception of beauty to come any where near Italian landscape. * *

I do not place the more laboured allegorical landscapes of Cole as high as the Course of Empire. They are very fine pictures, and there is something noble in his constant efforts to unite the moral and intellectual in landscape painting; but the first conception, I fancy, was produced most *con amore*.

Not only do I consider the Course of Empire the work of the highest genius this country has ever produced, but I esteem it one of the noblest works of art that has ever been wrought. There are simplicity, eloquence, distinctness and pathos in the design, that are beautifully brought out and illustrated in the execution. The day will come when, in my judgment, the series will command fifty thousand dollars.

Some of Cole's little American landscapes are perfect gems in their way. He never used his pencil without eliciting poetry and feeling, exhibited with singular fidelity to nature. I mix but little with the world, and rarely visit the exhibitions. When I did, I could tell one of these pieces as far as sight enabled me to see it. On one occasion, I remember to have been misled as to the artist, and to have stood before a small landscape that was said to have come from another hand. "Here, then, is another artist," I said, "who has caught the spirit of Cole." After all it turned out to be a picture by Cole himself. No one else could paint such a picture.

Cole was in advance of the times. It requires a different state of society to appreciate merit of this calibre: and it would not surprise me to learn that Cole died comparatively poor. I believe he never

got an order, or patronage of any kind from a single public body in the country. * * * *

REMARKS ON THE COURSE OF EMPIRE.

"First freedom, and then glory; when that fails,
Wealth, vice, corruption."
Cole's motto to his Popular Description of the Series.

In the life-time of a nation,—for nations like individuals have a life-time, bounded by birth and death—there is a summit-level, up to which, it may be said, it carries itself, and down from which it is carried. Moving forward by the force of native energies and passions, there arrives a time when energies are exhausted, and passions vitiated. That is the hour of its satiety—the limit of accomplishment. No longer a labourer, it is a cumberer of ground. As a cumberer of the ground, it is caught in the arms of avenging, irresistible destiny, and hurried down to extinction. Sin digs its own grave, and piles around it the stones for its own monument.

A visible manifestation of these truths is the Course of Empire. It is the pictorial expression of the poet's view of humanity, in the bonds of a people, travelling in the greatness of its strength, yet with the passport of Providence, with only the cold, innutritious morsels of natural religion, through the cycle of mutation to that point of it— the extreme point of the possible—where the divine anger takes it captive, and hastens away with it to destruction.

However old may be the idea—the great fact—which underlies this fabric of art, as a subject for the pencil it is purely original. It was not intimated by any picture in the world, but leaped, at an early day, from the painter's own imagination.

As a theme of art it is grand. As a theme wholly within the bounds of time, with no living, actual relation, any more than the Iliad, to a life hereafter—to the world of Christian revelation, it has no equal in grandeur in any which has been selected by the painter. As it includes the entire drama of man—man acting only within the lines of this world, without a recognition of the future state brought to light in the gospel, it is, perhaps, the grandest, the most comprehensive topic that lies in the power of selection.

With all this, the subject is yet one of ineffable mournfulness, for

the reason that it does not utter the least whisper of hope or consolation. It ends where the true interest of man begins—in the tomb. It points no finger across it—holds up no torch by which to look out of its cold darkness beyond it. And yet, with all the melancholy that hangs around the grandeur of the theme, it compass, originality, and fine invention, the genius, passion, reach and fertility of thought, visible throughout, and all coupled with the greater or less artistic skill with which it is treated, conspire to render the Course of Empire, not only one of Cole's completest and finest works, but one of the finest in the world.

I am aware that such a judgment of the series should be sustained by careful, reproductive criticism. How far the following—which speaks only of the design and not of the execution—sustains it, the reader will decide. To begin, I pronounce the Course of Empire a grand epic poem, with a nation for its hero, and a series of national actions and events for his achievements.

The great truth to which all leads, "the moral of the strain," is the final nothingness of man, when acting only with reference to things on the narrow theatre of earth.

As it is impossible for the painter, like the writer, to exhibit every thread and figure of the entire piece of his story, he must show such parts of it as will enable the beholder, through his imagination, to understand those other positions which he does not see.

Accordingly, in this instance, the artist seizes those great facts, occurring at long intervals, which have in them a power to suggest what transpires between.

He paints us five pictures. In the first, for example, is shown us, not only what the nation-hero is doing at the moment we gaze upon him, but also what he has *been* doing, and yet *will* do. The second and third show us the same. In the fourth it is shown us, not indeed what the nation-hero is doing, (for his work is done,) but what he is suffering—what an avenging power is doing with him, and yet will go on to do. What that power has done is shown us in the fifth or last.

Five pictures recite, in the painter's bright language, to the eye of the beholder, that which affords to his mind the facility and strength to master, with unconscious ease and rapidity, the entire whole of the poet's fine creation. Now look through them in their order.

In the first picture, the empire appears, not at its birth, nor at its

transition to youth, but at a period which suggests them both. Speeding past us, a creature of new life, it is arrested at a moment vividly expressive of its total childhood. The state in its childhood. To unfold this idea all things tend. To this point all speaks. All motion plays around it. All voices sing of that one central reality.

On the first glance, the beholder is put in possession of the field or locality common to all the five scenes. Looking east, he sees spread out before him a combination of those natural advantages required for the nucleus of a mighty state. A bay, at the western extremity of which he stands, affords at once a fine harbour and a view to the ocean. Here the energies of a kingdom may go and come, and the tribute of countries be wafted in. The nearer shores, while they descend to the water on both hands, in a way well fitted for the building of a city convenient and imposing, are broken into features which, under any modifications of improvement, will always be beautiful and picturesque.

The whole combination of scenery, of great expanse, has the finest characteristics of nature in a wild state—streams, rocks, woods, dells, waters, and mountains, charmingly and effectually disposed.

On the southern or right shore of the bay rises a precipitous hill, crowned with a solitary and remarkable crag, a certain landmark for the mariner at sea, and conspicuous from the whole surrounding country. It therefore enables the beholder at once to understand the several positions to which he is afterwards shifted.

With this wilderness landscape, into the green turf of which the footsteps of the young empire begin to cut sharply, the hour and the season perfectly harmonize in speaking to the one great thought. It is sunrise. It is spring. The year's work is before it, and the days work is before it, just as the work of the empire is before it. And they enter upon their work, the year and the day, in the spirit which accords with the spirit of the empire entering upon its great work. May and morning are both abroad, hand in hand upon the earth. Up from the sea comes the sun, flashing through the heavens and along the land, trampling under its glistening feet the dark wild remnants of night and storm, and sweeping through mists and shadows a wide path for the glorious day. Forward moves the month of odours, airing dell and steep, incensing field and forest, talking along flowery brooks, shouting down from sparkling waterfalls, and singing up among the

juicy greenery of ripe rich things to come. Hope, promise, prepara-
tion, prophecy: such is the expression of the season. It accords with
the hour of the day in lending life, force, and distinctness to the one
thought, eloquently uttered by the living actors of the scene, namely:
That the empire, in its spring and in its morning, is a spirited creature
of the wilderness, just beginning to assert supremacy over land
and sea, and exhibiting the simplest elements of society and the arts.
Canoes ride the swells, scattered huts fling their smokes to the breeze,
the rude inhabitants, clad in skins, send the arrow after the light-
footed deer, or circle the crackling fire with dance and song.

In the second picture, we look in upon the empire in its youth. In
the lapse of years, we are carried forward to the period when the
supremacy, at first asserted, becomes a living vigorous reality. Hopes
now begin to be realized, promises made good, prophecies fulfilled.
The aboriginal canoe and hut are exchanged for the busy village by
the water-side, and the bolder craft that can wing the seas. The
savage is transformed into civilized man, rising from grosser super-
stitions into higher forms of natural religion, progressing in science
and the arts, abandoning the chase for the sober toils of agriculture,
and forgetting scenes of barbarous mirth in the gentler pastimes of
the peasant. Time has tamed and tempered man, man has tempered
and softened the wilderness. The footsteps of empire are heavy upon
the earth and fleet upon the main. They wear the mountains, imprint
the solid rocks, and cleave the billows. The State in its morning, was
our first view: we now behold, at least, the dawn of its grandeur.
Again the season, the hour, and the quality of the scenery, all har-
monize with the general story. The landscape, now seen from a point
of view different from that first occupied by the beholder, has a
milder aspect: the sun, advancing in the sky, shines freely and
pleasantly abroad. Light clouds play around the mountains. It is
summer; the last luxuriant days of June.

The third picture opens the Empire in its manhood. Time, neces-
sary for the fulfilment of all of which the past may have been
prophetic, has rolled away. The dawn of national grandeur is now
succeeded by the full blaze. The nation has carried itself forward to
the summit-level of its long ascending career. The village, that once
little company of buildings down on the shore, now expands into
the vast capital, and crowds the scene. Himself in the skirts of the

great city, the beholder sees it embracing the bay, its foundations in the waves, its crest in the heavens—there, climbing in piles of imposing architecture around the crag-crowned height—here, spanning the waters in successive arches—and yonder, ascending to the horizon a huge assemblage of temples, palaces, colonnades and domes. A fleet sweeps the harbour—war-galleys and barks of costly sails. Multitudes witness the progress of a conqueror enjoying the honours of a triumph. Earth and the waves are mantled with the proud accomplishments of man, and heavy with the gorgeous embroidery of human achievement.

To a vision so replete with earthly glory nature herself, as if in astonishment, gives her countenance and sympathy. Hushed and breathless, she comes in the plenitude of ripening September, and wraps the scene with noon-day effulgence.

In all this sumptuous pageant, smiting the sight, steeping sense in splendour, there is a silent revelation of "things which must shortly come to pass." There takes hold of one, unconsciously, a recognition of those strange and overwhelming doings which God reserves to himself in the final affairs of nations, "to the intent that the living may know that the Most High ruleth in the kingdom of men." One feels, even among richest fancies, the presence of thoughts dark and ominous, like those which, at this stage of the work, began to hasten up in flights, as it were from the future, upon the painter's mind. Behind this glory, of such depth to the outward eye, of such veil-like thinness to the piercing, prophetic eye of the soul, rise in shadowy outline awful presages, breathing wrathful premonitions: "Pride goeth before destruction, and a haughty spirit before a fall." In a word, we feel that of which the scene before us bears the deep impress, namely, the artist's mind. The Empire, no longer fresh and vigorous with a spirit rushing onward, bearing itself and all with it irresistibly upward, is pausing—reposing on its loftiest elevation in a plethora, a voluptuous fulness, between the first abatement of its energies, and the appointed hour, when Omnipotence, wrenching its destinies from its vicious, palsied hands, shall push it on its fate. All this was in the artist's mind. With all this is the great central picture impressed. We feel the impression. And hence, in the all-possessing effulgence of the present, we both have a sense of the past and divine the future. Vividly graphic as a scene of glory, all is yet suggestive of

catastrophe, as the dead luminous calm is often suggestive of the shadowy tempest, or the blue glassy ocean, of the surf whitening far-off shores. The spirit of the beholder is therefore secretly attuned to strong and terrible contrasts, such as would naturally be presented at the violent breaking up, rather than at any period in the decline, of the state. Accordingly,

The fourth picture exhibits the Empire in its fall. The moment chosen for the spectator is that, when, at the end of its rapid downward run, all is in awful motion on the very bend of ruin—that narrow tract of frantic, shivering, fierce foam, just before the vast current slides into the polished green of the cataract. The shades of the now declining day will fall, and the sear leaves of autumn drop, into the abyss that swallows it. Weakened and debased by luxury, "brimstone sprinkled upon its habitations" by the hand of vice, "the breath of the Lord, like a stream of brimstone, doth kindle it." In a word, the once proud capital, sacked by a barbarous enemy, reddens with conflagration and carnage. All appetite for conquest lost in long satiety, there is now, in its effeminacy, not even the power to resist. Enemies, begotten by ambition, and nurtured by tyranny, take those once far-reaching, deeply-beaten, but now grass-grown paths of victory, and follow them in—rush in to their revenge. The vanquished recoil upon the conqueror; the trampled come to trample in their turn, and snatch back, in one terrible hour, all the gorgeous triumphs of the past. The wrongs of ages make a general return. They revel at a festival of blood. The golden head, the jewelled crown of the empire, is fired to light and cheer the revelry.

To complete the tremendous tragedy, nature appears upon the scene, a terrific actor. Clouds and smoke commingled darken the heavens. The sweep of the gale is swift as the spirit of battle. Surge and flame work ruin in the crowded port. The very light is fierce, flashing along the wide gloom, darting upon the sullen shadows. For every wave of mortal wrath and passion, there is a swell of fury in the elements. All palpitates and rushes, swaying to and fro in masses, heaving, rolling, thundering in the surf of wild destruction. The season and the hour still keep pace, and work in harmony. It is, as intimated above, drawing on to the close of one of "the melancholy days, the saddest of the year."

In the first three pictures, to look back a moment, the nation-hero,

as I have chosen to speak, occupies the scene, running from extremes of activity to those of rest—Shouting aloud, in the first: See! I come, as if from crude chaotic nature, all life, all motion, wildly bounding into being—Speaking with milder voice, though not less emphatic, in the second: I go forward, forward still with life, but with repose beginning to wrestle with activity—Sounding it with trumpets in the third: Behold the Empire! Lo, what I have done!—and activity is prostrate under the noiseless wheels of repose. But in the fourth and fifth, an avenging Providence occupies the scene, passing also from extremes of terrible activity to those of awful repose—Saying, first, amid commotions and convulsive throes of going *out* of being: Lo, *I* come!—then whispering through silent desolation (which utterance shuts up the scene): "It is done!" "And after the fire a still small voice," saying, "It is done." Such is the expression of the solemn twilight, the motionless autumnal foliage, the quiet footsteps of encroaching waters, the solitary heron and her nest upon the crumbling column. By the beams of the moon, now rising over the tranquil ocean, and by the last gleams of day, the poet lights the beholder to the tomb of Empire, and gives him voiceless solitude, in which to hear, from mournful ruins and triumphant nature, "the moral of the strain."

COLE'S MARRIAGE.

October and November of 1836 were golden months in the life of Cole. In the first, he gave to the public the Course of Empire; in the next, he was married.

A history of the hopes, and fears, and joys, with which, in those weeks, he was stirred, would fill a volume. As he glided down the Hudson, the glory of autumn was kindling on its romantic banks. Bright pictures, for years waking only his own heart, beaming with brilliancy only to his own mind, had passed out of his imagination, and now existed in a visible form on the canvass. And they were with him on their first voyage to the world. Many eyes were waiting—many voices would soon say whether or not what had been so long moving *him* had in them the beauty, power, and pathos to move *them*. How much the loveliness of nature's colouring helped to beguile many probable anxieties, there is no record.

On his return, the banks were in flames of splendour. The world had opened its eyes upon his painted visions with the voice of applause. The corner-stone of a lasting fame was laid, and he was going forward to what was nearer to his heart than fame. How much the magnificence of nature helped him to forget, for now and then a moment, the almost painful joy of hopes more certain than those founded on the favour of the public, there is, also, no record. The pages which might be written upon the painter's secret life, in those two golden months, are left to the imagination.

The following note to his friend, without date, but postmarked November 8th, may serve to intimate the nature of his feelings at the moment:

MY DEAR DURAND,—Do not disappoint me about coming up. And do more—drum up recruits. I expect Morse, Ingham, Cummings, and Inman. Make them come, if possible. Don't let me stand up to the parson without a single soul to keep me in countenance.

Come—come—come! I will not be disappointed.

Yours truly,

Catskill, Friday. THOMAS COLE.

He was disappointed. They did not come. But he was married, the ensuing week, to Maria Bartow, the young lady previously alluded to.

CHAPTER ❦ 24

Commission for the Departure and Return. Thoughts and occurrences: Retrospection; pictures painted; death of his father; visit to Schroon Lake; scenery; song of a spirit. To Mr. Van Rensselaer: the Departure and Return. Thoughts, &c.: autumn; the dying year. To Mr. Van Rensselaer: description of the Departure and Return. Bryant's criticism. Thoughts, &c.: Death of his mother.

This was the winter of my discontent," said Cole of that sad season in Philadelphia. Certainly, no such application of the poet's words could be made with respect to the winter of 1837.

In addition to several profitable commissions, he received one from Wm. P. Van Rensselaer, Esq., of Albany,[1] for two pictures—a pair, representing morning and evening, and entitled the Departure and Return.

May 14, 1837.—These pages have been neglected for a long time. The winter is past, and many things of interest have transpired since I last touched them. I have been so busily engaged in acting, that I have had little leisure for anticipation or review. I have been married, and my happiness is increased. Nov. 22 was the day; and, I trust, God will grant it to be an auspicious one, and bless us. The Rubicon is passed, and I feel more contented than I should have done had I remained single. It was a serious undertaking for me; but I now rejoice, and believe that I shall always have reason to do so.

In the winter I painted four pictures: A View on the Catskill, for Mr. Sturges;[2] an Autumnal Scene, for a friend of Mr. Inman; a small landscape for Mr. Cooke, and a View of Florence.

My poor father died in September last. And, although the bonds of affection cannot be severed without sorrow, yet we cannot but rejoice that he has escaped from the infirmities which rendered him a burden to himself for several years. He was an indulgent and affectionate husband and father. He possessed a heart always open to the dis-

176

tressed, and indignant at the wrongs of the weak and oppressed. Too generous and unsuspecting of evil to thrive in the world, his life was spent in buffeting successive waves of adverse fortune. He never found a calm haven, until death opened the ports of everlasting rest. He now dwells in that region of spirits on which his mind dwelt in fond and hopeful thought, and is, I trust, reaping the reward of a virtuous life. He was born in Haynford, in Norfolk, England, and was 72 years old at his death.

May 15.—The Fine Arts are an imitation of the Creative Power.

July 8.—I have just returned from a tour of the picturesque. On the 22d ult., Mrs. C. and myself joined Mr. and Mrs. Durand, with the intention of exploring the scenery of Schroon Lake. From the hasty visit I paid it, in the autumn of 1835, I had reason to expect a rich treat. I have not been disappointed. To Mr. Durand the scenery was entirely new: and I am happy in having been the means of introducing the rich and varied scenery of Schroon to a true lover of nature. * * *

24th of June, at B——'s,[3] an unpretending looking house. We arrived in the afternoon, and found ample accommodation: indeed all that we could desire—civility, neatness, excellent fare, and, valued above all, exemption from the curse of fashion and fashionable society. Here we determined to make head quarters for eight or ten days. Several of those were spent on the lake, others in rambling about its shores, and among the surrounding mountains—our sketch-books constantly in hand. * * * * The scenery is not grand, but has a wild sort of beauty that approaches it: quietness—solitude —the untamed—the unchanged aspect of nature—an aspect which the scene has worn thousands of years, affected only by seasons, the sunshine and the tempest. We stand on the border of a cultivated plain, and look into the heart of nature. * * * To the north, and retiring in the purple haze of distance, a company of mountains lift their heads, some dark with ancient forests, others broken, brown, and bare; the whole surmounted by a majestic form, whose serrated summit, at sunset, lifts itself among the clouds, an amethystine mass. I do not remember to have seen in Italy a composition of mountains so beautiful or pictorial as this glorious range of the Adirondack. * * * *

One of our excursions was through the lake. Our boat was rowed by two stout boys, and was just large enough to accommodate us, our wives being of the party. * * * The wind blew strongly down the lake, the waves rose sufficiently to give a good deal of motion to the boat, and to increase the labour of our young oarsmen. Our progress was slow. At length we reached the narrows, where the waters were smooth. Here the lake is contracted by several jutting headlands; one of which, with its long sandy beach and fringe of forest trees, tempted us ashore. It was a beautiful spot. The golden sand sloped gradually beneath the clear waters, and could be seen at a great depth, as we approached the beach.

Leaving this spot, we entered the northern expanse of the lake. * * We landed, and seated on the drifted logs, white from the action of the waves and the sun, and beneath some craggy rocks over-hung with evergreens, we took our simple meal with keen appetites. * * *

One day we diverged from the road, about three miles from B——'s, with the intention of getting a fine view of the great range of mountains to the west. We climbed a steep hill, on which many sheep were at pasture, and gained a magnificent view. Below us lay a little lake, embosomed in hills, and a perfect mirror of the surrounding woods: beyond were hills, partially cleared, and beyond these Schroon Mountain, raising its peak into the sky. Here we sketched. But the cleared hills beyond the pond promised such an opportunity for a complete view of the mountain, that we could not resist the temptation. Hope and enthusiasm drew us on. We dashed down the hill towards the pond—skirted its shores through the swampy forest— scrambled through the black logs of a recent burning—arrived at a new clearing—passed a log-house or two, whose inhabitants seemed aghast at the apparition of two strangers sweeping across their domains without stopping to ask a question, or say "good day"— ascended the cleared hills—once or twice turned round for the east-ern view, and were rewarded. The little lake lay below us, a crystal in an ebony setting: beyond it, and over shadowy woods, gleamed Lake Schroon, and in the atmosphere of distance rose the orient hills soft and dim. But we could not linger. We climbed the topmost knoll of the clearing, trampling down the luxuriant clover, and, beneath some giant denizens of the woods, whose companions had all been

178

laid low, we eagerly looked towards the west, and—were disappointed. A mass of wood on the declivity of the hill enviously hid the anticipated prospect. For once I wished the axe had not been stayed. But we were not to be foiled so easily. We entered the wood, and found it but a narrow strip. We emerged and our eyes were blessed. There was no lake-view as we had expected, but the hoary mountain rose in silent grandeur, its dark head clad in a dense forest of evergreens, cleaving the sky, "a star-y pointing pyramid." * * * Below, stretched to the mountain's base a mighty mass of forest, unbroken but by the rising and sinking of the earth on which it stood. Here we felt the sublimity of untamed wildness, and the majesty of the eternal mountains.

SONG OF A SPIRIT.

An awful privilege it is to wear a spirit's form,
And solitary live for aye on this vast mountain peak;
To watch, afar beneath my feet, the darkly-heaving storm,
And see its cloudy billows o'er the craggy ramparts break;
 To hear the hurrying blast
 Torment the groaning woods,
 O'er precipices cast
 The desolating floods;
 To mark in wreathed fire
 The crackling pines expire;
To list the earthquake and the thunder's voice
 Round and beneath my everlasting throne;
Meanwhile, unscathed, untouched, I still rejoice,
 And sing my hymn of gladness, all alone.

 * * * * * * *

First to salute the sun, when he breaks thro' the night,
I gaze upon him still when earth has lost her light.
 When silence is most death-like,
 And darkness deepest cast;
 The streamlet's music breath-like
 And dew is settling fast;

Far thro' the azure depth above is heard my clarion sound,
Like tones of winds, and waves, and woods, and voices of the ground.
I spread my shadeless pinions wide o'er this my calm domain:
A solitary realm it is; but here I love to reign.

Here we spent an hour, endeavouring to trace, in our sketch-books, the features of the scene. Impressed with a sense of solitude, we pursued our labours silently. It was still and solemn. At times, we heard the sound of running waters, softly ascending from the woods below, but thrilling and impressive as the whisperings of midnight.
* * *

TO WM. P. VAN RENSSELAER, ESQ.

Catskill, July 8th, 1837.

DEAR SIR,—An absence of several weeks from Catskill has prevented an earlier answer to your letter of the 26th ult. Your pictures are on the easel, but far from being finished. I hope you will excuse the delay, as it has arisen in part from previous engagements, (I believe I intimated in my letter I had such,) and partly from the strong desire I have to give you the best of my productions. Your commission was given in a manner so gratifying and agreeable, that I determined neither pains nor study should be wanting in order to accomplish something worthy. I have, therefore, in determining the plan of the pictures, and in making fresh studies from nature to be available in them, spent more time than is usual. My earnest desire is to produce something that will be a source of lasting pleasure to both of us.

Sunrise and Sunset will be the seasons of the pictures. I shall endeavor to link them in one subject through means of story, sentiment, and location. It will, perhaps, be as well not to mention the subject more definitely until the work is about completed. The size of the pictures you left, in a measure, to me; and I hope the canvass I have chosen will not be found too large, as I think the subjects require the size, which is about five feet long. I shall now proceed with them, I hope, without interruption. But I must ask your indulgence as to time. I am afraid that they cannot be finished before autumn. * *

Yours, respectfully,

THOMAS COLE.

August 20th.—Beautiful weather. The forests and meadows never wore a richer, deeper green. O that time would now stay his flight for a while, and let the summer linger!

October 6th.—It is past. Summer is ended. The foliage is now falling in mournful showers. What a harsh and cruel climate! But are not all earthly climes imperfect, and bearing some evil? Where shall we pitch our tent?

* * * * * * *

October 14th.—The winter is upon us.

> Another year, like a frail flower, is bound
> In Time's sere chaplet, withering aye to cling,
> Eternity, thy shadowy temples round;
> Like to the music of a broken string,
> That ne'er shall sound again, 'tis past and gone:
> Its dying sweetness dwells with memory alone.
>
> The green of spring, that melts the heart like love,
> Died with its virgin season: the strong light
> Of hues autumnal kindles in the grove,
> And rainbow-tints array the mountain height:
> A pomp there is, a glory on the hills,
> And gold and crimson stream, reflected from the rills.

TO MR. VAN RENSSELAER:

Catskill, Oct. 15th, 1837.

It would not be surprising if you should consider me dilatory in regard to your pictures. But I hope that the pictures themselves will plead my excuse for the long delay. The subject, I undertook to paint for you, at first apparently simple, has grown on my hands. One picture is, as yet, only completed, and the other upon the easel, although I have been assiduously employed upon them.

Having advanced so far, I thought it might be agreeable to you to learn something of the work which I am about to offer you. I have therefore taken the liberty to give you a hasty sketch of what I am doing; at the same time, let me say, that a written sketch can give but an inadequate notion of my labours.

The story, if I may so call it, which will give title, and, I hope, life and interest to the landscapes, is taken neither from history nor poetry: it is a fiction of my own, if incidents which must have occurred very frequently can be called fiction. It is supposed to have date in the 13th or 14th century.

In the first picture, Morning, which I call The Departure, a dark and lofty castle stands on an eminence, embosomed in woods. The distance beyond is composed of cloud-capt mountains and cultivated lands, sloping down to the sea. In the foreground is a sculptured Madonna, by which passes a road, winding beneath ancient trees, and, crossing a stream by a Gothic bridge, conducting to the gate of the castle. From this gate has issued a troop of knights and soldiers in glittering armour: they are dashing down across the bridge and beneath the lofty trees, in the foreground; and the principal figure, who may be considered the Lord of the Castle, reins in his charger, and turns a look of pride and exultation at the castle of his fathers and his gallant retinue. He waves his sword, as though saluting some fair lady, who from battlement or window watches her lord's departure to the wars. The time is supposed to be early summer.

The second picture—The Return—is in early autumn. The spectator has his back to the castle. The sun is low: its yellow beams gild the pinnacles of an abbey, standing in a shadowy wood. The Madonna stands a short distance from the foreground, and identifies the scene. Near it, moving towards the castle, is a mournful procession; the lord is borne on a litter, dead or dying—his charger led behind—a single knight, and one or two attendants—all that war has spared of that once goodly company.

You will be inclined to think, perhaps, that this is a melancholy subject; but I hope it will not, in consequence of that, be incapable of affording pleasure. I will not trouble you with more than this hasty sketch of my labours. I have endeavored to tell the story in the richest and most picturesque manner that I could. And should there be no story understood, I trust that there will be sufficient truth and beauty found in the pictures to interest and please.

I hope that, in undertaking a work which required so much thought and labour, I have not overstepped your intention, and that, when you see it, you will be gratified. * * * * * *

Placing this among "his noblest works," Bryant says, with great justice, "there could not be a finer choice of circumstances, nor a more exquisite treatment of them than is found in these pictures. In the first, a spring morning, breezy and sparkling, the mists starting and soaring from the hills, the chieftain in gallant array, at the head of his

retainers, issuing from the castle. In the second, an autumnal evening, calm, solemn,—a church illuminated by the beams of the setting sun, and the corpse of the chief borne in silence—these are but a meagre epitome of what is contained in these two pictures."

Buckingham, speaking of Cole and his works, at some length, in his writings on America, says of these paintings: "for beauty of composition, harmony of parts, accuracy of drawing, and power of effect, I have never seen any modern pictures that surpassed them."[4]

October 30th, 1837.—My dear mother is gone. The kindest, most affectionate, the best of parents is departed. She died on the morning of the 20th of this month. Her children, whom she loved so much, were with her in her last moment. I cannot say more. I have too much to say.

> Mother!—O holy name, for-ever blest!
> For-ever dear to man, and most to me!
> I breath it now with sorrow ill-suppressed,
> And rising tears that struggle to be free:
> Thou dost not answer, Mother, from the ground;
> Thy tender ear is closed, nor heedeth mortal sound.
>
> My mother!—sweet the hallowed accents fall:
> It is the natural music of my tongue:
> Sad now its tone, yet potent to recall
> Thy love, thy tears, thy tenderness so strong.
> And call I vainly? Does the tomb enclose
> Thy happy spirit? No—immortal it arose.

CHAPTER ❦ 25

TO MR. DURAND.

Catskill, January 4th, 1838.

MY dear Durand,—Your letters are always welcome visitors, and the last was not the least so, although I have been tardy in returning your Christmas call. But you will excuse me when you learn what mighty events have taken place in the brief space of time since you wrote.

In the first place, I have been rather idle through Christmass, (to what disadvantage I compare with you!) making a new kind of musical instrument, which, if *it* shall ever play, and *I* shall ever play, you shall hear, when you come to Catskill. In the second place—mark, I say the second place, because I do not wish you to think, or ever should think, or have thought, that the matter is to be compared in importance to the construction of musical instruments,—in the second place, then, on New-Year's Day, M. thought she would make me a New-Year's gift, in the shape of a little boy. * * * Now, these weighty matters taken into consideration will certainly incline you to excuse me for not having written sooner.

* * So Rip has toiled up the mountain with the liquor. I should like to see the old Morpheus: and though I may not be blessed with a taste of the somnific cordial, I hope to enjoy the sight of the flagon; and perhaps I may exclaim like the old woman, (I believe in one of Æsop's fables,) who, putting her nose to the bung-hole of an empty wine-cask, cried, "O, if thou art so delightful now, what must thou have been when full?" But your flagon shall not be enjoyed by nose, but by eyes.

1 8 4

And what have I been doing? toiling up mountains, even Schroon mountains, solitary and companionless. I took the notion, and got into a mountain fever, and nothing would do but that I must allay it by painting the sable pyramid from the sketch made in the clearing, before we dashed on to the Grisly Pond. I consider it our grandest view. I have taken the liberty of elevating myself a little, as though on a treetop, to get a glimpse of the nearest pond by which we passed. How I have succeeded you shall judge.

Painting this picture has recalled our Schroon days, and already, in my mind, they begin to take the hue of romance. That was a glorious day, the day of the lake hunt—Grisly Pond day. The thoughts of it stir me now like the music of running waters in an umbrageous valley. Have you not found?—I have—that I never succeed in painting scenes, however beautiful, immediately on returning from them. I must wait for time to draw a veil over the common details, the un-essential parts, which shall leave the great features, whether the beau-tiful or the sublime dominant in the mind.

Haggerty's picture I am about to commence.[1] I think I shall paint one of the Catskill lakes. Will you be angry if I paint, in a small pic-ture, the view of Mount Moriah from the meadow, at the head of Schroon? You have painted it. If I thought you would consider it in the least infringing on your right, or that I should cause the least un-pleasant feeling in your mind, I would relinquish it. The fact is, I have been looking over and over my sketches, for a subject for one of my commissions, and I find none that will suit the purpose so well as this. Write to me, and tell me candidly. * * * Write soon, and believe me,

<div style="text-align:right">Truly yours, THOMAS COLE.</div>

January 12th, 1838.—The weather is lovely. The other evening the mountains were as beautiful as I ever saw them.—exceedingly deep purple.

> I gaze upon the cold and cloudy steep,
> With sad remembrance of each tender dye;
> Of summer, and of autumn, rich and deep,
> The splendid pride of joyous woods; and sigh
> That the soft seasons speed so quick away,
> While winter lingers with unkind delay.

I gaze, but not as in the earlier day,
 With heart too full of youthful hope for gloom,
Ere we beloved ones did gently lay
 Within the bosom of the quiet tomb:
Since then the seasons wear a sadder hue,
And evening's golden tints are faded too.

 * * * * * * *

TO MR. DURAND.

Catskill, January 31st, 1838.

MY DEAR DURAND,— * * * You know ——² chose Medora as the subject for his picture, and I accepted it without considering it in detail. * * I should like to paint it vastly, if the figures may be subordinate to the landscape. Indeed I have a desire. But I am inclined to think there are subjects more capable, and more likely to give general pleasure. I will mention one that I have long thought of painting, and you will do me the favour to speak of it to ——, and also to give him my opinion on the subject of Medora. The subject I would suggest is from Coleridge's poem of Love:

 "Oft in my waking dreams do I
 Live o'er again," etc.

You will readily perceive how fraught with the pictorial is this passage from one of the most tender and exquisite poems in the language. * * * Will you suggest this subject to —— when you see him, and let me hear soon as convenient? I hope he will choose it, though I shall be satisfied with the other. This I will paint if I can.

Now do write soon, and let me know what you are about. I have finished a little view on the Arno for a gentleman in Boston. I am afraid the Arno will create a deluge in Boston: this is the third Arno for Boston. Mr. Haggerty's picture is on the easel; it is one of the lakes in the Catskills. I hope it will be a pleasing picture, of the wild, tranquil kind. * * * I believe you will have to enlarge the exhibition rooms for me, as I shall have such a grist as I never had before. I intend to paint a scene, or a couple of scenes, in Arcadia, (of course in the golden age,) and I know not what else I might do if the sheet was large enough. * * *

Yours truly,
THOMAS COLE.

Early in February, Cole received one of his most important commissions—that which resulted in the two fine pictures, entitled the Past and the Present, painted for P. G. Stuyvesant, Esq.[3]

In a letter dated February 1st, says that gentleman, "I have fully reflected upon your proposition; [alluding to a proposed modification of a commission given in the preceding December,] and, as I prefer having something very valuable, I wish you to proceed with the two pictures of the size of Mr. Van Rensselaer's, not doubting they will give Mrs. S. and myself full satisfaction."

The annexed copy of a letter, without date, appears to have been Cole's reply to the above:

DEAR SIR,—I am gratified that you have given me a more ample commission than your previous one, and I assure you, that I shall avail myself of the opportunity of endeavouring to produce what will be satisfactory. I have not yet commenced, and indeed cannot promise to execute your pictures for several months, in consequence of previous commissions.

You express a desire to have a subject that will embrace two pictures. I am happy to find subjects of this kind attractive. They give more scope for poetical invention, and are, perhaps, more capable of sentiment than subjects requiring only a single canvass. But then they require more labour and study in the execution. If you determine on having pictures of this kind, I think I can find a subject both expressive and pictorial. * * *

TO MR. DURAND.

Catskill, February 12th, 1838.

MY DEAR DURAND,—I am very much indebted to you for Mount Moriah, as I always consider you as holding a share in that stock. But you must not say that my picture will depreciate yours in your own eyes; for that I should be very sorry, even were it warranted by the pictures themselves, which is not likely to be the case. * * *

So Rip is about finished: I long to see him. The Dance on the Battery, too, is going on merrily. You seem to dash along.
* * * I find that there is little need of inventing musical instruments, when there are so many of Adam's patent. I find I have a

pretty loud toned one of that sort. Hoping you have a merry time dancing on the Battery, I remain Yours, very truly,

THOMAS COLE.

TO THE SAME.

Catskill, March 20th, 1838.

MY DEAR DURAND,—Your letter was received among the welcome things, and it gave me great pleasure to learn that you were getting on so well with your picture. I cannot speak so well of my affairs after all my bragging, and you may tell the council that they had better not enlarge the exhibition on my account this season.

I took a trip to Arcadia in a dream. At the first start the atmosphere was clear, and the travelling delightful: but just as I got into the midst of that famous land, there came on a classic fog, and I got lost and bewildered. I scraped my shins in scrambling up a high mountain—rubbed my nose against a marble temple—got half suffocated by the smoke of an altar, where the priests were burning offal by way of sacrifice (queer taste the gods had, that's certain)—knocked my head against the arch of a stone bridge—was tossed and tumbled in a cataract—just escaped—fell flat on my back among high grass, and was near getting hung on some tall trees: but the worst of all are the inhabitants of that country. I found them very *troublesome, very*—they have almost murdered me—alas! I am in their hands yet. But I hope to dispose of them one by one, if I have fair play, and have them hung, as a striking example, in the exhibition of the National Academy, by hangmen of our aquaintance.

Stop!—say you—you began in a dream, and have come down to a dull reality. True. There is one thing, dream or reality, that is pleasant —that is, the river is open, and spring is come: but you know all that. I am like the little dog at Schroon—you perhaps remember it—that was so glad to see us, it picked up a straw: so I offer you a straw, and a great deal of nonsense with it. You must attribute both to a shockingly bad pen—so bad that it can't write common sense. If you can spare time, and have pen and ink, will you let me know when I ought to be down at the hanging: you know I like to see justice done.

 * * * I remain, yours truly,

THOMAS COLE.

THE DREAM OF ARCADIA.

As the honour of introducing the pastoral, after the order of Theocritus, into Roman literature, belongs to Virgil, so the same honour is due to Cole as the parent of true idyl, or pastoral painting in America. And as Greece and Rome never had any equals, in that delightful kind of poesy, to the above-mentioned authors, so may we venture, at the least, to predict that our country will produce few, if ever any, superiors to Cole, in that charming species of picture. That no one will arise who may surpass him in simple portraiture of the country, who would presume to say? That any one will, whose work in its unity and variety shall so entirely consist of poetic language, we may dare to doubt. A master's pencil comes not, in every generation, to the hand of a fine poet. His claim to this eminence rests, it must be admitted, not on the number of his pastorals, but on the excellence of a very few; a sufficient basis, when we discover that in them he has given us all the tokens of the requisite power, as effectually as he could have done in hundreds.

By pastorals let it be understood to mean, not those pictures of the country in which men and animals are subordinate and merely incident to the main design, but those in which they are in such wise actors, that the landscape has, at least, a moral subordination; when all conspires to tell a story, and that a story of rustic life and manners. The Dream of Arcadia is at once an illustration of the picture idyl, and a splendid specimen. Every thing in it ministers to one end—the expression of simple rural life in its most pleasurable flow. Earth and air, sounds and motions, the season, the very temper of the elements, and all living things, serve to gather the sentiments and thoughts of the beholder into the sweetly running current of a joyous existence in the country. A dream, and a most delightful dream, of hearts beating healthily upon nature's breast, was in the poet's brain. To give his vision a palpable frame and dwelling on the earth; to pass this fine creation as a soul into a body, that it might have a substantial, outward being, for the delight of kindred minds, was the intention of the artist in this present work.

It is not upon the mountain-pinnacle, nor on the broad lake, nor the wide prairie, that the mind sinks most naturally down among the affections, but in the valley. Thought subsides more easily in pleasing

sensations when we ourselves sink into the embraces of nature. When her warm arms are around us, and her soft apparel folds us in, then is it that our childhood, our native loves and sympathies more readily get uppermost, and our simple, innocent feelings have a freer and more gladful play. The scene of the pastoral is, therefore, happily laid in a vale; and that, in the romantic bosom of the Peloponnesus. Up, far up a gently-ascending vale, sight wanders westward, on and on, and only pauses at the airy pass through which the last ranks of one of the brilliant days of Arcady are marching to other climes. Earth and atmosphere proclaim that we are on the track of the king of day in a glorious progress. Everything visible seems to have been trampled with a golden magnificence, and rolled with the wheels of a glowing splendour. More than this—the vale is not yet clear of the royal company. Tempted back, the silvery-footed deserters return by thousands through boughs and shrubbery, over rocks and green-sward, to take their parting tenderly of juicy verdure and timid shadows. Rising from the valley, the eye sweeps northward over a high wide track of hill and dale, half lost in soft and hazy shade, and bounded by a range of castellated mountains, the first of which, at the distance of a mile or more, receives, in mid-air, the day's final salute full on its rocky pinnacles and towers. Almost beneath their droppings, we pause at a Greek temple, "a thing of beauty," looking ever calmly down the luxuriant summit of the eastern slope, across which flits a wing of "living light," and at whose base a "river windeth at its own sweet will;" hasting forward under the shades of a Grecian bridge to wed the mountain stream, still nearer on the right, bursting on the senses freshly in a white cataract up a broken chasm. Thus happily united, with a silent company of shrubs and rocks to witness, they glide along by the lilies and herbage, cooling the banks to our very feet. On the left, barely twice the flight of an arrow, spread the tops of a vast and ancient assemblage of trees, in whose leafy chambers are held the first solemnities of twilight, and beneath whose far-receding arches dew-footed evening will presently steal in for vespers. Over all this, the fairest, most luxurious cradle in which Earth, humming her loving lullaby, rocks the new-born June, bends a heaven which subdues an exuberance of pearly light to accord with its own serenity. Such, indeed, is the form, the tint, and the disposal of an almost infinite variety of things—such the feeling and expression of the entire whole,

into which that variety is melted, as to speak of life—life full of mild sweet rest—full, at the same moment, of joyous, innocent festivity. Earthly and ethereal melodies blend into a tide of harmony, the flow and power of which bear away the willing heart, though the intellect may not fix the exact meaning of the language of the song. The spirit of the vale flies in the sky; the spirit of the sky floats in the vale. Something sweet and evanescent as perfume has gone up; something pure, serene, and everlasting has come down. The mellow hue of the clouds, sown through the ether, has an answer in the precious rays broken and strewn along the land. There is an universal All hail; distance speaks to distance, mountain to mountain; grove motions to grove, and bough to bough. The presence of evening is everywhere —*felt* rather than seen; the presence of day is everywhere—*seen* more than felt. Light skips, and darts, and kindles among the moist still shades; moisture quenches, shadows veil, and silence hushes, the live and restless light. Life and gladness leap and bound about, but ever spring into the embrace of shadowy repose. Night has sprung her invisible net, and caught the day's most imaginative moment. Life, joy, and beauty struggle in the dreamy meshes. In a word, so finely attuned is all nature to the spirit of a pastoral, as of itself to suggest happy passages of rural life. Were there no breathing creature in view, we should unavoidably feel ourselves looking upon a land in which there must be, at that instant, hundreds of sheep, shepherds, and peasants, living, loving, and enjoying. To the pastoral actually represented, the "whole visible scene" speaks with perfect fitness, and expresses for it the completest sympathy. Every effect ministers an impusle and feeling in exquisite accord with the sentiments and actions of the persons who appear before us. Out of the remotest object springs thought that flows in like blood, or darts like nervous energy to give vividness and strength to the great central thought, which, in its turn, is ever shedding over all a moral radiance. And so, while the *humanity*, at the heart of the picture, is nourished by its *nature* from every extreme, its nature also receives spirit from its humanity. This gives assurance that the work is a simple harmonious creation—the result of one act of the creative power; and announces its maker, in the truest sense, both the Artist and the Poet.

This might be illustrated by a slight process of reproduction. On the summit of a rocky hill beyond the temple, rendered with exceed-

ing spirit, a bit of pasture declines into softy, misty shadow; there sheep are stirring, busily yet quietly stirring, on the now moistening grass: on the swelling hillside below the temple, the fleecy creatures lie down in their whiteness, bedded in yielding verdure and bathed in sun—kindly promises of luscious rest. Quite down on the right, at the junction of the streams, the skirt of evening is palpably on the mingling waters; there wade in the full-fed cattle, drinking in sweet coldness, and breathing balm upon the dimply element. Roused by the goatherd from some woody nook up the vale, a flock comes trotting homeward to the fold. On that knoll of greensward across the river directly in our front, and within hearing of a kid's cry, a drowsy rustic lies upon his back, with a knot of goats ruminating beside him. Immersed in a gush of warm sunshine, fancy sees him letting down his lazy eyelids, and gathering felicity from all that steals in through his other senses: zephyr wings him in the face; sighs from the full-topped pine above him pour their gentle troubles in his ears; smites sharply the flitting of a quick bird, and tarries the hum of late bees, dusting fragrant smells from the flowery drapery of the brown trunk; close by are the breathing and ever-busy chewing of his full-uddered charge; further off insect and river-murmurings, warblings, lowings, and bleatings, music and voices. Steeped in the quiet delight "of waking dreams," happy fancies, honeyed sensations, like his own kids, chase each other round and round. Every and anon, with eyes half open, looking up through the feathery leafage, he spies, in the same glance, the lofty plumes of the pine gleaming with golden light, and soft fires in the ermine of the cloud, and further still the blue sky; "the soft blue sky melts into his heart,—he feels the witchery of the soft blue sky." And now come nearer. On the river-bank opposite, see a woman finding pleasure less in the loveliness of things, than in the freedom and sportiveness of her children. Three run at will within her call, "and the babe leaps up on his mother's arm." Three run according to choice, and the impulse of their natures—the girl on the lap of the blossomy bank, and the boys to the water. True to the spirit in him, the elder lad dares the stream, and seeks the shining lilies floating on the further side; while the younger, with a flower or two, and his impatience, waits at the current's edge to share the handful of his brother. The heart of the picture, though, beats in the breast of the great grove up to the left. One could search there for

memorials of the fortunate Tityrus, and listen for the strains "of the dainty Ariel:"

> "Merrily, merrily shall I live now,
> Under the blossom that hangs on the bough."[4]

There, upon elastic turf, pastoral life is handed over to the care of one of its rosy seasons. "Whence come they?—whither do they go?" —are no thoughts of ours, any more than they are thoughts of theirs. Ours is only what is theirs—the melody and life, the sweetness, quietness and grace of present enjoyment, irrespective of yesterday or to-morrow. Cushioned on the velvet between the mossy roots "of the huge, broad-breasted, old oak tree," and foremost of the wood, sits a patriarch of the shepherds calmly musing, fancy tells us, on the experience of age, and the hopes of youth: at his feet, rests a loving swain with his gentle shepherdess and dog, holding in a string a playful kid decked with a necklace of flowers: a few steps further on, a rustic leaning against a tree, plays upon a sylvan pipe, and a damsel beats a tambour, to the sound of which another, with a flowery wreath, "foots it featly here and there:" still further in, and around an image of the presiding genius of the grove, a group of children bound, half of them into view, in all the exuberance of youthful merriment. Laughter and frolic, on tiptoe, and down upon the grass, are the order —rather, the graceful disorder of the moment. Of this upleaping, sparkling fountain of innocence, the eye at length quietly takes leave, and glides in over a carpet of living green and gold to the grove's centre, where "shades high overarched embower:"

> "Sober, steadfast, and demure,
>
> * * * * * * *
>
> With even step and musing gait,"[5]

a solitary, half his years in the arms of memory, and half in those of anticipation, feeds on the fond melancholy that comes with loneliness and twilight. Thus childhood and youth; manhood in the bright kindling of the affections; manhood in the paler fires of intellect; and old age atmosphered with mild serenity, all unite spontaneously, each according to the laws of its nature, in giving one accordant response to the genial influences of the place and moment. The force

of nature falls upon, and bounds on the soul's elasticity, and opens up its kindly, salient springs. Gladness breathes in every sentiment, speaks in every action: and all, health, motion, melody, repose, is one odourous flowering of joy.

Regarding the picture as purely an idyl, all accessories, which do not with nature contribute directly to its individuality, may seem to disturb the general harmony. In fact, they do; but designedly, and with the same effect as discords in music, giving it by the force of brief, and sudden contrast, more character. They add to the might and smoothness of the main stream of expression. The temple, fair in its proportions, grand in its elevation, smoking censers and solemnities, the bridge and horsemen, all suggest the state and the metropolis,—the faith, art, and science, power and luxury of Greece in palmy times; thus serving to render the subject itself more definite —giving greater distinctness to the country and its rustic peasantry —bringing them out into clearer social and moral relief, and with stronger effect, while at the same time they complete the symmetry, and enhance the general amenity of the work as a whole.

I have hitherto spoken of the Dream of Arcadia as a pastoral poem. If it be expressive of all that has been maintained, and doubtless it is of much more, then is it a true poem, a fine imaginative creation, "a picture rich and rare," although in a mere artistic sense it might prove defective. In this, however, it is confidently believed analysis will show that it excels preëminently. The more carefully it is studied, the more will it be found to be true to nature in the drawing and qualities of its forms, in its composition and perspectives, in its colour, light and shade; facts which might be urged with respect to most of Cole's greater works, and which should therefore render every earnest critic careful how he finds fault before he has given them his most serious attention.

*Thoughts and occurrences: spring; the fields; his own works compared
with the old; discouragements; the ruined tower. To Mr. Adams: Cole
an architect. To Mr. Durand: the critics. Thoughts, &c.: the summer;
the landscape; vine in the grove. To Mr. Durand. To Mr. Adams: de-
signs for the state-house. Thoughts, &c.: excursion to Schoharie; to
High Peak. To Dr. Ackerly; home amusements.*

MAY 19, 1838.—Spring has burst upon us. We have waited long,
and anxiously. The birds fill the air with music, the fruit-trees are
clothed in blossoms, and the fields offer their grassy slopes, whose
transparent, juicy green tempt the eye to delightful repose. The grass,
at this season, is exceedingly beautiful in colour. Tender, though
strong—soft and melting, though intense—it possesses that due pro-
portion of shadow which softens the crudeness of great masses of
green without destroying its brilliancy; and when sprinkled with the
golden drops of the dandelion, and seen between the spectator and
the sun, it has the most charming effect of colour that nature possesses
in her wide and varied range. But, alas! the painter falls far short in
imitating it. He has not the materials, and with all the skill in the
world must fail.

When I remember the great works produced by the masters, how
paltry seem the productions of my own pencil; how unpromising the
prospect of ever producing pictures that shall delight, and improve
posterity, and be regarded with admiration and respect. Is it my own
deficiency, or the fault of the times and the society in which I live?
This I know, I have the ambition, the desire and industry to do as
much as any man has done, the capacity I may not have; that, how-
ever, has not been fairly tried; no sufficient field has yet been opened
to me. I do feel that I am not a mere leaf-painter. I have higher con-
ceptions than a mere combination of inanimate, uninformed nature.
But I am out of place; every thing around, except delightful nature
herself, conflicts with my feelings: there are few persons of real

taste; and no opportunity for the true artist to develop his powers. The tide of utility sets against the fine arts.

May 22.—I am now engaged in painting a picture representing a ruined and solitary tower, standing on a craggy promontory, laved by the unruffled ocean. Rocky islets rise from the sea at various distances: the line of the horizon is unbroken but by the tower. The spectator is supposed to be looking east just after sunset: the moon is ascending from the ocean like a silvery vapour; around her are lofty clouds still lighted by the sun; and all are reflected in the tranquil waters. On the summit of the cliff around the ruin, and upon the grassy steeps below are sheep and goats, and in the foreground, seated upon some fragments of the ruin, is a lonely shepherd. He appears to be gazing intently at a distant vessel, that lies becalmed on the deep. Sea-birds are flying round the tower, and far off in the dimness below. This picture will not be painted in the most finished style. Still I think it will be poetic. There is a stillness, a loneliness about it that may reach the imagination. The mellow, subdued tone of twilight, the silvery lustre of the moon, the glassy ocean—the mirror of the scene—the ivy-mantled ruin, the distant ship, the solitary shepherd-boy, apparently in dreams of distant lands, and forgetful of approaching night, and of his flocks, yet straggling among the rocks, all these combined must surely, if executed with ordinary skill, produce, in a mind capable of feeling, a pleasing and poetic effect, a sentiment of tranquillity and solitude. This picture will probably remain on my hands. It is not the kind of work to sell. It would appear empty and vague to the multitude. Those who purchase pictures are, many of them, like those who purchase merchandise: they want *quantity*, material—something to show, something palpable—*things* not *thoughts*.

TO MR. ADAMS.

Catskill, May 26th, 1838.

MY DEAR SIR,— * * * * * * *
How vividly your letter and sketches recall to mind days of "auld lang syne!" I cannot say the reminiscence would be agreeable, were it not accompanied by the recollection of your friendship to the poverty-stricken wanderer: *that* shines like a solitary star amid the

darkness of the time. Those days were indeed gloomy and overcast. Inexperienced, ignorant of the profession, I was constrained by outrageous fortune to assume an appearance of knowledge and skill I did not possess. I was next to miserable, and nothing but a hope that could not be quenched sustained me. * * * * * * *

I was much gratified to receive the paper containing the advertisement to architects, and still more so to find your name on the list of commissioners. I commend the choice, and hope that the building to be erected will be an honour to the state and to yourselves. Do you know I am something of an architect?

Our exhibition is now open,—the thin-skinned artist in the field, to be hunted, torn, and worried by the mongrel pack of critics that break forth "ravenous and keen" after their year's fast. I grieve to find criticism so low as it is. Fulsome praise, stupid presumption, and interested detraction make up the amount of newspaper criticism on the fine arts. But enough of this. I will only add—if in any of the papers you see my works extravagantly praised, *do not believe the critic:* if you see them censured extravagantly, *do not believe the critic.* * * * * * * *

Cole was, indeed, as he modestly says above, "something of an architect." Profound in all the science necessary to an accomplished builder he was not. To be so he had neither time nor occasion. But in all that raises architecture from a mere science to an art he was a very fine architect. A monument of his ability, as such, is the State House of Ohio, now in process of erection. Although his design did not obtain the first among the premiums offered, it was at last adopted, slightly modified—so slightly, as not to infringe its claim to originality. Its order is Grecian Doric, embodying the simplicity and majesty peculiar to that style, and preserving the unity of the Greek temple. When completed, it cannot fail to be pronounced, by competent authority, one of the most perfect edifices for just proportion and harmony of parts, on the continent.

TO MR. DURAND.

Catskill, May 28th, 1838.

MY DEAR DURAND,—I have just received your letter, and it was

welcome, although written by a monster with seven heads and ten horns. I should not have the courage, were I not horned and hoofed too. But I find myself among the cast-offs in public favour, as well as odious as a hangman. We hatched a pretty brood, that's certain. The chickens begin to crow before they are fairly out of the shell: some of them make sad wry necks in the attempt, though. But courage, my dear friend! Detraction, you know, always crawls at the heels of merit. We know that, as hangmen, our motives have been pure; and as artists, although advised (that is sure) by some of the knowing ones to take lessons from unlicked and favourite cubs, we know a B from a bull's foot; and although transformed into quadrupeds, we will dance after our own fashion. I believe, with all my weight of woes, I shall have to set up as comforter. Ingham wrote me a few days ago, fiery, though sad. * * * Remember me to all our fellow-hangmen, in the hope that we shall continue to hang together.

I remain yours, very truly,

THOMAS COLE.

July 1.—All around is luxuriant, and full of life. The birds are warbling on every bush and tree. Every tint of green is displayed, every texture of foliage, from the deep tones and dense leafage of the forest trees to the tender transparency of the spreading vine. The meadows glisten, and the grain waves in the wind. What inimitable beauty! The longer I pursue my art, the more my experience, and the more cultivated my eye becomes, the more impotent is my skill to represent on canvass the every-varying features of nature. *

July 22.—There is a climbing plant, attached to an oak in our grove, that I have watched, year after year, and find never getting larger or stronger. In spring, it puts forth a few leaves and tendrils, but the winter kills them, and the slender, woody stem remains without any increase of size.

* * * * * * *

My fate resembles thine:
I toil to gain a sunnier realm of light
And excellence; waste, and pine
In the low shadow of this world of night
The genial seasons sometimes bear me up,

Till Hope persuades, I ne'er again shall stoop;
But quickly comes the withering blast to blight
My rich and valued growth; and I remain
The same poor thing to bud, and fade again.

TO MR. DURAND.

Catskill, Aug. 7th, 1838.

DEAR DURAND,—I have received your note accompanying the book of costumes and the canvass, for which I am greatly indebted to you. The book is amusing; but the costumes are of no age or country; and I am sure that some of the nobles who exhibited in them must have cut ludicrous figures; complete card kings, queens and knaves. * *

So Newburgh has taken your fancy. I want you to tell me something of its advantages. I know there is a pleasing country about it, but I fear there is little rich forest scenery near, and few fine isolated trees; and, as for mountains, where are the Catskills? * * *

I have scarcely done anything since I saw you, although I have worked day after day. I sometimes think I am falling off—have forgotten almost all I know of painting. * * * This last day or two I have been engaged in drawing on the canvass a sort of Giant Grumbo Castle: it will be well if it does not turn into the Castle of Giant Despair, myself his prisoner.

I remain yours, ever truly,

THOMAS COLE.

TO MR. ADAMS.

Catskill, Sept. 10th, 1838.

MY DEAR SIR, — * * * * * * *
For the information you gave me concerning the State House, I am much obliged: and, although my time has been very much engaged in my regular profession, I have been able to design a plan, the drawings of which are nearly executed, though not by my hand—my other avocations would not permit.

Polychromatic embellishment does not seem to have affected you very favourably: and certainly it does knock some of our old notions on the head. But there are very slight grounds, in this polychromatic discovery, for the argument that our notions of beauty are conven-

tional. But the Greeks were not quite such barbarians as you seem to suppose. The sculptures on the metopes were *not* painted. The ground was painted blue. The sculptures might have been *tinted*, as the best modern sculptures are, to take away the cold effect of the marble. The shafts of the columns were not painted: such was the case with several other members. I believe the object in painting architecture was to give value to form: colour was subordinate; it was used to aid, and not usurp the place of form. The vestiges of colour discovered on the temples at Athens, by their arrangement, confirm me in this opinion; and, unwilling as I was to believe that the virgin marble could be improved by paint, I am still more unwilling to believe that Phidias and Ictinus were barbarians in taste. "But enough," you say, "of polychrome; you are a painter, and must speak well of paint; nothing like paint." * * *

<div align="right">

Yours very truly,
THOMAS COLE.

</div>

October 9, 1838.—I do not know when I have enjoyed a week more than I did the last. Feeling the want of fresh air and exercise, I had determined to spend it in the midst of the beautiful of nature. On Monday, in company with Mr. George Griffin, Jr., I set out to visit the great cave of Schoharie. * * * * * *
The cave is near the summit of a hill, and in the woods. Its entrance is a mere hole, having no picturesque or cavernous aspect. We descended by means of ladders, perhaps one hundred and fifty feet, nearly perpendicularly, and then came to a low and narrow passage, which leads to a subterranean lake. Here we found a boat, and were carried, one at a time, beyond the water by our guide, who pushed the boat along with his hands. The passage at first is extremely narrow, but, at a turn, widens, and rises beyond the sight. The water is perfectly clear, and the perpendicular walls of rock descend into it to unknown depths. There was something awful in being suspended in such an abyss. Landing, we climbed a steep passage over tenacious clay, and came to a great chamber, whose sides, in many parts, were not perceptible to us, when standing in the centre, and whose roof, also, in places, was extremely lofty. We explored its recesses, climbing over hills of clay. There were several other chambers. * *
Their decorations, the stalactites, have mostly been carried away.

Nothing is left but the damp, dark walls of limestone, gloomy and silent but for the hissing of bats, which hang from the roof like innumerable drops of black poison. * * We ascended, much delighted with the golden sunshine. * * Returned to Catskill the same day.

The day following was spent in making arrangements for an excursion to the highest of the Catskills, High Peak. This excursion had been long projected, and talked about, by myself and others, but had been delayed, from time to time, until we began to think that High Peak, at which we daily gazed, was in a region too elevated for our slow and heavy feet. But my leisure permitting, or rather, making my time suit my inclination, I determined to accomplish the excursion, and endeavoured to muster our original party, and succeeded, with the exception of the gentlemen, who were recreant. The ladies being of bold spirit, I determined to undertake the journey, though no other man should accompany us. Fortunately, we were not reduced to this strait. Two gentlemen, Mr. Theodore L. Prevost, and Mr. Lewis Prevost, volunteered to be of the party.

* * * * * * *

The day was such a one as we should have chosen—one of our heavenly autumnal days, when the sun shines blandly through a clear and cloudless sky, and the crystal atmosphere casts a veil of beauty over the landscape, rich with the loveliest tints. Sundry baskets, containing many good things, provided by the ladies, were placed in the wagons, giving weighty promise that we should not die of famine among the mountains. We started with high anticipations, and congratulating one another on the weather. * * * It was resolved that we should sleep, the next night, on High Peak. It would be tedious, perhaps, to describe, although anything but tedious was the ride to the Clove. The party was in the highest spirits. If there was not much wit among us, there was abundance of good nature, which is far better. We entered the fine pass, where, on both hands, the mountains rise thousands of feet. The sun shone with golden splendour, and the huge precipices, above the village of Palensville, frowned over the valley like towers and battlements of Cyclopean structure. At the village, our party got out to walk up the steep road.

Scattered in groups, we went loitering along, sometimes stopping to pick a flower or a pebble, and to gaze upon the precipices above us, or into the gulf below, where flows the Caterskill with many a rush and bound, as if it were making merry with its native rocks, before it left them for the quiet windings of the lower country. We crossed a bridge, which spans the stream under impending cliffs. This is a scene truly picturesque. * * But we could not linger to gaze upon this. We were hungry, and the wagons having overtaken us, it was proposed that we should dine at a charming waterfall close by. * We ascended, next day, and traversed some beautiful realms of moss, where the sun, shining in gleams through the tall, dark spruce forest, upon the green, velvety carpet, was extremely fine. It reminded me of the interior of some vast Gothic pile, where the sun comes through narrow windows in slender streams, and lights whatever it strikes with a refulgence almost supernatural amid the gloomy shadows around. There was some hard clambering before we reached the summit; but the ladies did bravely. We remained all night comfortably, and descended next morning in health and spirits.

<div align="center">TO DR. ACKERLY.</div>

Catskill, Nov. 2d, 1838.

MY DEAR GEORGE,—I received yours a few days since, and was much gratified in your opinion of the poem. * * As to ambition, this poem is not the thing with which my ambition wings itself. * * * Tell Sarah we have had a party. I wished for her to help me get up a little exhibition of shadows, something in the manner of "The ducks and the geese they do swim over." The thing took wonderfully. It was performed in the pantry. Maria was the green-room waiter and scene-shifter. By means of paste-board pasted on my face, I represented several characters—Sam Weller, Isaac of York, Shylock, Dante, an Old Woman, Don Quixote, &c. Sarah would have enjoyed it, I am sure, indeed all of you, Ann, and Emma. But we will try it when I come down, if all is well. I have finished the picture, and commenced another, and think of coming down in a fortnight from this.

<div align="right">I remain, your affectionate brother,
THOMAS COLE.</div>

Thoughts and occurrences: winter in the city; commission for the Voyage of Life; the season. To Mr. Adams: Ohio State-house. To Mrs. Cole: Canandaigua. Genesee Waterfall. To Mr. Ward: the Voyage of Life. Thoughts, &c.: death of Mr. Ward. To Mr. Durand: a new painting-room. Thoughts, &c.: religious musings.

MARCH 24, 1839.—Again in the country in sight of the mountains, far from the distracting turmoil of city life. * * Our sojourn in New York was neither pleasant nor profitable. We were indisposed part of the time, and painting seemed almost impossible. I hardly supposed myself to be such a creature of circumstances. I had two painting-rooms, in the course of the winter. The first in the University, which I found too cold, the second in the house where we boarded. But in neither could I paint, warm or cold. I commenced several pictures, but did not finish a single one. * * * *

I have received a noble commission from Mr. Samuel Ward,[1] to paint a series of pictures, the plan of which I conceived several years since, entitled, The Voyage of Life. I sincerely hope that I shall be able to execute the work in a manner worthy of Mr. Ward's liberality, and honourable to myself. The subject is an allegorical one, but perfectly intelligible, and, I think, capable of making a strong moral and religious impression. * * *

May 19.—How magical the change wrought by the hand of nature in a few days! Tender green clothes the landscape, and melts the heart. How aptly has nature chosen her colours!—the soft—the fresh—the healing. The cold, white snows are gone: the blue shadows and the gray clouds have given place to hues, to tints and tones, tempered with warmth, and glowing with freshness and vitality. The murmur of gentle winds,—most gentle because the harsh branches and rocks are mantled with delicate yielding foliage, herbs and flowers,—the hum of bees, the warbling of birds, all unite in a strain sweeter and

more harmonious than ever was struck by human hands. But the season passes as I write. A few days only comprise the spring. Regrets that it will so soon pass invade the actual enjoyment. * * *

<div align="center">TO MR. ADAMS.</div>

<div align="right">Catskill, July 29th, 1839.</div>

MY DEAR SIR,—I have a thousand apologies for not having replied to your letter of the 21st of June; but I will only offer one—I have been absent from home several weeks, on a tour to the White Mountains of New Hampshire.

On the subject of the state-house, I have little to say. I find that my plan is the one adopted, with slight modifications. The plan of advancing a central portico from the main building, you know, is mine. That that portico should be a copy of part of the Parthenon never entered my thoughts. You know my opinions with respect to the Pediment, and I believe you are agreed with me on that point; but I suppose your fellow-labourers were determined to have one. * *

We often think about you, and talk about you, and should like to have you nearer to us. I am as usual engaged in painting, and I hope your visit to these parts will set your easel up again. When you forward Professor Silliman's minerals,[2] you will perhaps favour me with a line. * * Write to me soon, and tell me how the state-house grows, but much more about yourself.

<div align="right">I remain yours, very truly,
THOMAS COLE.</div>

<div align="center">TO MRS. COLE.</div>

<div align="right">Canandaigua, August 3d, 1839.</div>

MY DEAR MARIA,—You will see by the date where I now am, although you will perceive that it is not my hand-writing. The fact is, I got hold of a piece of paper on which somebody else had commenced. * *

We have travelled through a great deal of very beautiful agricultural country: but after all, there are no Catskill Mountains. * *

We spent a part of the evening at Mr. G——s,[3] a Scotch gentleman, who has here really a palace, marble statues, pictures, a beautiful

garden, and the like. I wish you could see it. There is nothing in or about New York to be compared with it. From the top of the house there is a fine panoramic view—gentle hills crowned with grain, dark green woods, and the beautiful Canandaigua Lake.

To-morrow we shall proceed to Geneseo. * * *

<div align="right">Yours, affectionately,
THOMAS COLE.</div>

He was on his way to the Genesee river for the purpose of studying, and taking sketches of its very beautiful and picturesque scenery. The Voyage of Life, which he was now mentally composing, exhibits here and there, in the sweet windings of its stream, in its alternately rapid and placid current, in the fine verdure of its banks and groves, and in its delightful atmospheric effects, the influence upon his mind and feelings of this pleasant and refreshing excursion.

The picture of a cascade, on the upper waters of the Genesee, was painted from a sketch made at the time, not one of his most finished landscapes, perhaps, but translating the very spirit of nature, when she delights and inspires in a quiet way. It cools and refreshes in its most luminous parts. A voice seems to pervade its stillness. The repose of its woods is yet breezy and life-like. Its lofty blue sky possesses that marvellous quality of elasticity and moisture, for which Cole stands almost, if not entirely alone, among both ancient and modern landscape painters.

TO MR. WARD.

From my long silence on the subject of your pictures, I hope you will not infer that I have allowed so many months to pass without making some progress towards their completion. I assure you they have occupied too much of my mind to permit me to be idly deferring their execution. In fact, it has been difficult for me to overcome my impatience to commence the pictures before I had studied them with that care which I know to be necessary to ensure the production of a work of high excellence. The poetical conception of a subject may not be difficult, for it is spontaneous; but to imagine that which is to be embodied in light, and shadow, and colour,—that which is strictly pictorial—is an accumulative work of the mind. * * *

During the summer, I have been engaged in making studies of the subject, introducing and arranging in them all the necessary objects, determining the chiaroscuro, &c., so that when I have the large canvasses before me, I shall be enabled to proceed with certainty and facility. I have made some progress on the first picture, which is six feet six inches long. * * * *

<div align="right">I am yours, very respectfully,</div>

<div align="right">THOMAS COLE.</div>

November.—Mr. Ward, who gave me the liberal commission for the Voyage of Life, is dead. There would seem almost a fatality in these commissions. Mr. Reed died without seeing his series completed. Mr. Ward died soon after his was commenced. * * *

<div align="center">TO MR. DURAND.</div>

<div align="right">Catskill, Dec. 18th, 1839.</div>

MY DEAR DURAND,—Being ensconced for the winter in sight of the grayheaded mountains, and feeling as though the river ought to close soon, and consequently, as though my friends in New York were removed one thousand miles further off, I begin to think I should like to commence a correspondence with you, in order that the chain which binds us may not be broken by stress of time and distance, and in the hope that, through you, I shall, from time to time, hear a little news from the world of art. * *

Do you know that I have got into a new painting-room? Mr. Thompson has lately erected a sort of store-house, and has let me have part of it for a temporary painting-room. It answers pretty well—is somewhat larger than my old one, and being removed from the noise and bustle of the house, is really charming. What I shall be able to produce in it heaven knows. The walls are of unplastered brick, with the beams and timbers seen on every hand: not a bad colour this pale brick and mortar. I am engaged upon my great series.

<div align="right">Yours truly,</div>

<div align="right">THOMAS COLE.</div>

December 26th.—The latest footsteps of the year are now being impressed on the unstable, sandy beach of time—that shore which

skirts the ocean of eternity. It is a narrow shore that man treads. Before him spread thick mists and darkness: and, ever and anon, we hear the plunge of some one who has fallen into the deep. But let us not fear. It is the corporeal part of man that sinks. The soul soars over that vast sea, and finds a fitter dwelling place.

> Why do ye count your little months, your years,
> Or e'en your ages? They are nought: they are
> The measure of your feeble breath, your fears.
> Ye are as misers, hoarding up with care
> A glittering mass, a cold insensate dust,
> That ne'er to spirit can be changed: nor gold,
> Nor years are chattels of the soul; they rust,
> Or perish: her possession is the trust
> In God; the love which tongue hath never told;
> And immortality which death shall soon unfold.

CHAPTER ❦ 28

J ANUARY 1, 1840.—How strange appear the characters in which we write the title of the new year! What mingled emotions of pain and pleasure arise in contemplating them. They announce that the old year is past, with all its good and evil, its hopes and fears, its cares and enjoyments,—that another year enters upon the stage of time. With veiled face and hidden form it comes up from eternity,—like the cloud of Elijah, no bigger than the hand. But who can foretell whether it bear in its bosom dark storms, or refreshing rains and gentle airs? God grant, that to me and mine it bring no great evil! I cannot hope for all good, for life is a mingled tissue. This day is one that makes a deep impression on my mind: it is the first of the new year; it is the birth-day of our son Theodore.

* * * * * * *

Thy name, too, hath a meaning,—Theodore—
 The gift of God; that I would ne'er forget.
And may the Giver on the gift outpour
 His choicest blessings, and before thee set
His shield: so, in the world's tumultuous roar,
 Thou shalt be strengthen'd, and sin's arrows fall
 Innocuous—thy virtue conquering all.

If 'tis thy lot to live through many years,
 And this, the utterance of a parent's love,
Shall meet thy gaze, think, think what anxious fears,
 What hopes thy mother's breast and mine did move,
As, watching thee with tenderness and tears,
 We looked into the future, knowing well
 That sin and sorrow in the world do dwell.

And may the love, which now I would express,
 Bring to thine eyes a tear,—strength to thy mind
To battle with temptation—onward press
 In virtue's path, e'en for our sake, and find,
In our fond love, a cause for lovingness;
 And prove, my son, when earth's dark vale is trod
Thou wert, indeed, the very gift of God.

TO C. L. VER BRYCK, ESQ.[1]

Catskill, Jan. 10th, 1840.

My dear Sir,— * * * Although we are somewhat nearer the north pole than you, we manage, nevertheless, to keep pretty comfortable; at least, we are not so completely frozen through as to prevent a warm wish, now and then, for our distant friends, from growing in our hearts.

The mountains have on their wintry garb, but they are exceedingly beautiful, and I am sure you would be delighted to see them. Our sunrises and sunsets have been exquisite this season, as seen from the windows of our warm rooms. Don't you wish to take a peep?

I am indebted to you for the extract from Mr. Huntington's letter: and I cannot but feel gratified, as the remarks come from one whose opinion I value highly. He has expressed himself elegantly, and I shall be happy if, when he sees my pictures again, he will not cease to esteem them as he does now.

You ask me how the Voyage of Life is progressing. I can hardly say. I think the first picture is about finished, that is, will be in three or four days. But it generally happens that when I have just finished, I have not half done. Little things that appear easy, and of a few minutes only, sometimes, by some unaccountable infelicity, if I may use such a word, require days. The Angel's face has given me a great deal of trouble. Angels' visits to me are really so few and far between that I forget their features. Sometimes the expression would be sulky, sometimes cross, and sometimes silly. I have, at length, finished one which I suppose will be found a compound of all the expressions of which I have spoken. But I will not disparage myself. I hope the picture is the most complete one I have ever painted. I should be happy to have you see it. I want other eyes: mine are accustomed to the picture. * * *

We look forward to next summer with the pleasing expectation of seeing you here. * * * Pray give my best regards to Mr. Bryant, when you see him, and tell him, that when I look at the mountains, I often think of him.

 * * * * * * *

<div align="center">Yours, very truly, THOMAS COLE.</div>

February 1, 1840.—My birth-day. How they accumulate, these years!—subtracted one by one from the appointed sum, and thrown into the past—things that may be counted, but not enjoyed, except they leave the remembrance of virtuous actions.

<div align="center">TO MR. ADAMS.</div>

<div align="right">Catskill, February 26th, 1840.</div>

MY DEAR SIR,—* * * With respect to the Voyage of Life—the fictitious one is going on slowly, but the real one rapidly. I suppose you have read a great deal about the Daguerreotype. If you believe everything the newspapers say, (which, by-the-by, would require an enormous bump of marvellousness,) you would be led to suppose that the poor craft of painting was knocked in the head by this new machinery for making Nature take her own likeness, and we nothing to do but to give up the ghost. * * * But I was saying something about Daguerreotype matters—this the conclusion: that the art of painting is a creative, as well as an imitative art, and is in no danger of being superseded by any mechanical contrivance. "What fine chisel did ever yet cut breath?"

You desired me to write when I had nothing to say; so I have filled the sheet with nothing. If you find it difficult to comprehend, light your cigar with it; it will then become smoke, which is a little heavier than nothing. Write soon.

<div align="right">Yours, very truly,
THOMAS COLE.</div>

<div align="center">TO REV. J. F. PHILLIPS.</div>

<div align="right">Catskill, March 21st, 1840.</div>

MY DEAR SIR,—I am obliged to you exceedingly for the kind criticism with which I have been favoured on the subject of the direction

of the stream in my pictures of The Voyage of Life. And while I cannot perceive the weight of your objection, I owe it to your kindness to give my reasons for differing from you.

In the first place, the subject is a poetical one, and, of course, poetic reasons are valid. There are many windings in the stream of life, and on this idea I have proceeded. Its course towards the Ocean of Eternity we all know to be certain, but not direct. Each picture I have wished to make a sort of antithesis to the other, thereby the more fully to illustrate the changeable tenor of our mortal existence. I am convinced the opinion of spectators will be various on the subject of the direction of the stream. This I have gathered from remarks already made. That which you have thought might be a defect, has been considered a beauty.

But I may be permitted to defend my work on stronger ground than this: I mean on that of pictorial necessity. This the painter must consider equally with poetical propriety: the circumstances of colour, form, and chiaroscuro, have to be held in view: he is not aiming merely to express a poetic thought, but to express it picturesquely. Now to apply this to my subject. In order to give the same direction to the stream in each picture, I should be constrained to have the same view of the boat and figure or figures—nearly the same all through the several parts of the work: this would be monotonous, and would strike the beholder as having arisen either from incompetency to execute, or from poverty of invention, and that pleasure which arises from novelty would entirely be lost.

I will say a few words explanatory of my conception of the subject, from which, perhaps, you may be enabled to gather my reasons for executing it as I have.

The first picture represents infancy. The infant lives in the present. It neither looks back into the past, nor forward into the future. It enjoys the strange world into which it has come; but its views and capacities are limited to a very small circle.

The second picture represents youth on the verge of manhood. In that season of life all is hope and expectation. The world spreads out before us a wide paradise. Visions of happiness and glory rise in the warm imagination.

In the first, therefore, I have placed the infant in the allegorical scene where the objects upon which it gazes are all near. There are

flowery banks, but not wide-spreading landscapes to meet its feeble vision. By painting the cavern in the back-ground of the picture, and not very far from the spectator, and by bringing the stream directly towards him, I have confined the scene as much as I knew how, with due regard to poetical effect.

In the second, I have endeavoured to represent the scene extensive, luxuriant and magnificent. The stream flows from the beholder, stretching far away directly towards a visionary pile of architecture, suspended in the air over the distant horizon. Here you will perceive the pictorial necessity of which I have spoken. A picture is not like a scene in nature, where the eye can embrace the whole circle of the horizon, but is bounded like a view taken through a window. The greatest scope of vision is from the foreground to the extreme distance. Now, if the river had flowed in any other direction than the one I have chosen, how could the aerial architecture have been introduced so as to have been placed in full view of the youthful voyager? it must have been imagined as existing out of the picture, which would be a tax on the imagination of the spectator, that few would be willing to pay.

In the third, the stream will flow across the picture, for I do not require in it an extensive view.

In the last, the stream is to be seen mingling with the great Ocean of Eternity. * * *

I have written these remarks hastily, and perhaps unintelligibly; but you will be kind enough to make every excuse.

<div align="right">I am, yours, very respectfully,

THOMAS COLE.</div>

<div align="center">TO MR. DURAND.</div>

<div align="right">Catskill, May 26th, 1840.</div>

MY DEAR DURAND,—

Do you know I have received a letter from ——,[1] telling me that neither he nor his friends like the picture I have painted for him, and desiring—expecting me to paint another in place of it, composed of "*rich and various landscape, history, architecture of different styles and ages, &c.,* (these are his words) *or ancient or modern Athens?*" His letter is interlarded with fulsome panegyric on my excellence in

such pictures: "My friend Cole is celebrated for painting rich land-scapes with architecture, history, &c., intermixed." You and I painting modern and ancient Athens would, with "the aid of prints, &c., have made pictures full of poetry, full of reality, and full of the most in-tense interest to everybody of literary character who should behold them"—and full of *trumpery*, if they had resembled this twaddling. After having painted him a picture as near as I could accommodate my pictorial ideas to his prosaic voluminousness,—a picture of im-mense labour, at a much lower price than I have painted pictures of the same amount of work for several years past—he expects me again to spend weeks and weeks in pursuit of the uncertain shadow of his approbation. I will not do it; and I have written to him, saying that I would rather give him his books back, and consider the commission as null. The picture was painted for him—is his. I am sure you would commend the course I have taken, if you knew all the circumstances. On this subject I will say no more. But beware how you paint for the same patron. * * *

I remain yours truly,
THOMAS COLE.

The work of which Cole speaks in the foregoing, and which was exhibited the same spring in the National Academy of Design, was the Architect's Dream, a large picture painted for an architect: as Bryant expresses it, "an assemblage of structures, Egyptian, Grecian, Gothic, Moorish, such as might present itself to the imagination of one who had fallen asleep after reading a work on the different styles of architecture."

However much the design of the picture failed to satisfy, it might, at least, have pleased by its airy, rosy, bright distance over the glassy waters, and its sky—one of those great breadths of almost cloudless, yielding blue, for which Cole is remarkable, glowing with the rich warmth of an Italian sunset.

August 3, 1840.— * * * *
This abnegation of themselves, this *un*egotistical spirit possessed by the Gothic artists, so foreign to our own times, has been, I believe, the true source of excellence in the fine arts, in every age; and as there has been more or less of that chaste devotion, so have the arts risen or

2 1 3

sunk. In the art of Greece this lofty feeling can also be traced: parts, for instance, of the Parthenon, which the Athenian multitude never gazed upon, ruin has revealed to modern eyes, sculptured into forms as elaborate and exquisite as any of the parts most exposed: the work was to Minerva, and not to man. Every great artist works to God, forgetful of the caprices, the prejudices, and even the desires of men: he labours to gratify his soul's devotion to the beautiful and true which are centred in God.

When artists descend to labour merely as a means of obtaining reputation and emolument, they abandon the path that leads to the highest excellence, and are found forever grovelling with the sordid spirits of this world.

Late in the autumn, Cole gave his second great series to the public. The following is a popular description of it by himself:

THE VOYAGE OF LIFE.

An Allegorical Series. The subject is comprised in Four Pictures. The first represents the period of Childhood; the second, Youth; the third, Manhood; the fourth, Old Age.

1. CHILDHOOD.—A stream is seen issuing from a deep cavern, in the side of a craggy and precipitous mountain, whose summit is hidden in clouds. From out the cave glides a Boat, whose golden prow and sides are sculptured into figures of the Hours. Steered by an Angelic Form, and laden with buds and flowers, it bears a laughing Infant, the Voyager, whose varied course the Artist has attempted to delineate. On either hand, the banks of the stream are clothed in luxuriant herbage and flowers. The rising sun bathes the mountains and flowery banks with rosy light.

The dark cavern is emblematic of our earthly origin, and the mysterious Past. The Boat, composed of figures of the Hours, images the thought, that we are borne on the hours down the Stream of Life. The Boat identifies the subject in each picture. The rosy light of the morning, the luxuriant flowers and plants, are emblems of the joyousness of early life. The close banks, and the limited scope of the scene, indicate the narrow experience of Childhood, and the nature of its pleasures and desires. The Egyptian Lotus, in the foreground of the

picture, is symbolical of human Life. Joyousness and wonder are the characteristic emotions of childhood.

2. YOUTH.—The stream now pursues its course through a landscape of wider scope, and more diversified beauty. Trees of rich growth overshadow its banks, and verdant hills form the base of lofty mountains. The Infant of the former scene is become a Youth, on the verge of Manhood. He is now alone in the Boat, and takes the helm himself, and, in an attitude of confidence and eager expectation, gazes on a cloudy pile of Architecture, an air-built Castle, that rises dome above dome in the far-off blue sky. The Guardian Spirit stands upon the bank of the stream, and, with serious, yet benignant countenance, seems to be bidding the impetuous Voyager God speed. The beautiful stream flows for a distance, directly toward the aeriel palace; but at length makes a sudden turn, and is seen in glimpses beneath the trees, until it at last descends with rapid current into a rocky ravine, where the Voyager will be found in the next picture. Over the remote hills, which seem to intercept the stream, and turn in from its hitherto direct course, a path is dimly seen, tending directly toward that cloudy Fabric, which is the object and desire of the Voyager.

The scenery of the picture—its clear stream, its lofty trees, its towering mountains, its unbounded distance, and transparent atmosphere—figure forth the romantic beauty of youthful imaginings, when the mind elevates the Mean and Common into the Magnificent, before experience teaches what is the Real. The gorgeous cloud-built palace, whose glorious domes seem yet but half revealed to the eye, growing more and more lofty as we gaze, is emblematic of the day-dreams of youth, its aspirations after glory and fame; and the dimly-seen path would intimate that Youth, in its impetuous career, is forgetful that it is embarked on the Stream of Life, and that its current sweeps along with resistless force, and increases in swiftness, as it descends toward the great ocean of Eternity.

3. MANHOOD.—Storm and cloud enshroud a rugged and dreary landscape. Bare, impending precipices rise in the lurid light. The swollen stream rushes furiously down a dark ravine, whirling and foaming in its wild career, and speeding toward the Ocean, which is dimly seen through the mist and falling rain. The boat is there plunging

amid the turbulent waters. The Voyager is now a man of middle age: the helm of the boat is gone, and he looks imploringly toward heaven, as if heaven's aid alone could save him from the perils that surround him. The Guardian Spirit calmly sits in the clouds, watching, with an air of solicitude, the affrighted Voyager: Demon forms are hovering in the air.

Trouble is characteristic of the period of Manhood. In childhood, there is no carking care: in youth, no despairing thought. It is only when experience has taught us the realities of the world, that we lift from our eyes the golden veil of early life; that we feel deep and abiding sorrow: and in the Picture, the gloomy, eclipse-like tone, the conflicting elements, the trees riven by tempest, are the allegory; and the Ocean, dimly seen, figures the end of life, which the Voyager is now approaching. The demon forms are Suicide, Intemperance and Murder; which are the temptations that beset men in their direst trouble. The upward and imploring look of the Voyager shows his dependence on a Superior Power; and *that* faith saves him from the dstruction that seems inevitable.

4. OLD AGE.—Portentous clouds are brooding over a vast and midnight Ocean. A few barren rocks are seen through the gloom—the last shores of the world. These form the mouth of the river; and the Boat, shattered by storms, its figures of the Hours broken and drooping, is seen gliding over the deep waters. Directed by the Guardian Spirit, who thus far has accompanied him *unseen*, the Voyager, now an old man, looks upward to an opening in the clouds, from whence a glorious light bursts forth; and angels are seen descending the cloudy steps, as if to welcome him to the Haven of Immortal Life.

The stream of life has now reached the Ocean to which all life is tending. The world to Old Age is destitute of interest. There is no longer any green thing upon it. The broken and drooping figures of the Boat show that time is nearly ended. The chains of corporeal existence are falling away; and already the mind has glimpses of Immortal Life. The angelic Being, of whose presence, until now, the Voyager has been unconscious, is revealed to him; and, with a countenance beaming with joy, shows to his wondering gaze scenes such as the eye of mortal man has never beheld.

Bryant, in his Oration, calls the Voyage of Life "of simpler and less elaborate design than the Course of Empire, but more purely imaginative. The conception of the series is a perfect poem. The child, under the care of its guardian angel, in a boat heaped with buds and flowers, floating down a stream which issues from the shadowy cavern of the past, and flows between banks bright with flowers and the beams of the rising sun; the youth, with hope in his gesture and aspect, taking command of the helm, while his winged guardian watches him anxiously from the shore; the mature man, hurried onward by the perilous rapids and eddies of the river; the aged navigator, who has reached, in his frail and now idle bark, the mouth of the stream, and is just entering the great ocean which lies before him in mysterious shadow; set before us the different stages of human life under images of which every beholder admits the beauty and deep significance. The second of this series, with the rich luxuriance of its foreground, its pleasant declivities in the distance, and its gorgeous but shadowy structures in the piled clouds, is one of the most popular of Cole's compositions."

It was Cole's aim to give, in all his landscapes, that spiritual meaning which he himself drew from nature, and to teach, when the subject admitted of it, a strong moral lesson. How well he succeeded in this, in the Voyage of Life, an incident may serve to illustrate. The distinguished engraver*[3] of the Second of the Series, called Youth, going early one morning into the exhibition room, found there a single person only, a middle-aged man, seemingly lost in deep thought before those pictures of Cole. "Sir," said he, at length, addressing the artist, who had been noticing his face, a striking one, with a peculiarly melancholy air, "I am a stranger in this city, and in great trouble of mind. But the sight of these pictures has done me great good. They have given me comfort. I go away from this place quieted, and much strengthened to do my duty."

* Mr. Smillie.

CHAPTER ❧ 29

JANUARY 31, 1841.—

This day has closed another of my years.

* * * * * * *

I know that there have mingled in the tide
The light, the dark, the painful and the glad.
But as I gaze into the future's depths,
And strive to learn what yet remains of life,
Whether of seasons, months or moments, Oh,
'T is blank, mysterious, and my mortal ken
Is lost in gloom. Am I disconsolate
That all is dark? O God forbid! for though
Not yet is granted prescience to man,
Him to sustain is given immortal hope
Who gave my being knows the time to take.
That time, O Lord, I wait. Grant that the hour,
Whene'er it come, may find my trust in Thee.

TO MR. ADAMS

Catskill, April 8, 1841.

MY DEAR SIR,—The exhibition will open in a few weeks. I wish I could meet you there. The mountains are now covered with snow; and our spring is a sort of wrestling match between bitter February and sour April. Between the two, a green thing is not allowed to appear, except the evergreens, and they are black and blue and brown from the bruises they have received in the conflict. O for a single blade of grass! if it were only one inch in length, it would cheer my drooping spirits. But this you will call "a green and yellow melancholy;" do so; but pray that I may not be bilious.

I sent you my printed description of The Voyage of Life. I hope

you were pleased with the plan of the subject. It would gratify me if you would come and see the pictures. Do come on. I have not built my house yet; but you know we are not roofless. Hard times, and an adage which a knowing friend of mine uttered—"fools *build* houses and wise men *live* in them"—entered my soul like a two edged sword; so I am playing Fabius, and hope to conquer by delay. Do come. Although the new house is not built, the old one is here, and we can take our "cakes and ale," though we are grown prudent; and when we are filled, we can go and see the site of the new house, and say how magnificent *it is to be:* that you know is not *expensive.* I really begin to think these kind of enjoyments are about as substantial as any others, except * * * but come, and I will tell you the rest.

<div align="center">Yours &c.

THOMAS COLE.</div>

May 30, 1841.—Summer is glowing around us. The blossoms cover the paths like snow, and the woods are clothed in green. A sigh escapes us that the footsteps of spring are so fleet. Let us rejoice in the beauty around us, thanking Almighty God that He has given us this glorious season, and hearts capable of feeling the fulness of its beauty. We are wakened in the morning by the song of birds; we open our eyes upon the green fields; and the leaves, tender and playful as children, cover the gray arms of the oak and chestnuts of our grove; sweet smells salute us, and we breathe with delight the fresh and fragrant air. It is indeed a beautiful world. O, that the cares, the turmoil, and the sin of the world were not! The children are happy in these days. There is no keeping them within doors. It would be a sin to do so.

July 17.—This afternoon we made an excursion to Canoe Lake, about three miles off. We found the valley, in which the lake *sometimes* is, * * * covered with weeds and flowers. * * * It is a wild secluded scene; and when the water is there, which at times stands to the depth of thirty feet, it is exceedingly beautiful. * * * * In returning, I remarked that, although American scenery was often so fine, we feel the want of associations such as cling to scenes in the old world. Simple nature is not quite sufficient. We want human interest, incident and action, to render the effect of landscape complete.

<div align="center">* * * * * *</div>

Blue flowers are very fine in the bright sun-light, while in the shade they are of little value. Orange-coloured or red flowers, on the contrary, are disagreeable in the glaring sun. * * They are most beautiful in the shade, which they illuminate with a pleasant glow. In gardening, I would place blue flowers in the light, perhaps intermingled with pink and delicately tinted ones; in the shade, scarlet and orange; in places intermediate, crimson and rich purple flowers.

I am not the painter I should have been had there been a higher taste. Instead of working according to the dictates of feeling and imagination, I have painted to please others in order to exist. Had fortune favoured me a little more than she has, even in spite of the taste of the age, and the country in which I live, my imagination should not have been cramped, as it has been; and I would have followed out principles of beauty and sublimity in my works, which have been cast aside, because the result would not be marketable.

The complaint uttered above breathes a sadness, which, at this time, was haunting the mind of Cole. It gives, indeed, the main cause of his sadness. And that was, that he had not been permitted wholly to pursue the lofty walk of art for which alone he had any abiding love. While he could not but feel, at times, that what he had already done, defective as it might appear in his own severe judgment, would, one day, make his country conscious of his great power, still he could not but confess to himself, that, for the present, he had little hope. Unjust, shallow criticism was injuring his reputation, and lessening his patronage: ill health was undermining his constitution: popular subjects for painting waked in him little or no enthusiasm: abroad there was the possibility of some lucrative commission, which at the moment, he particularly needed: if not that, there were, at least, the delight and improvement of travelling, and the chance of regaining health and spirits. He determined, therefore, to gratify a long and earnest wish once more to visit Europe.

Before we attend him there, a few remarks are ventured with regard to a duplicate of the Voyage of Life, painted while at Rome. Waiving the considerations which made him feel at liberty to reproduce this work, he never would have done so, in all probability, though he frequently meditated it, but for the influence of a kind and

intimate friend, the American consul at Rome.[1] He commended the beauty and originality of its design, and its high artistic merit; he prophesied its great popularity, and probable sale to some of the English, or other travellers. The issue of the undertaking proved, however, that he was mistaken, although, at the general exhibition of Modern Artists, opened during the winter and spring at the Porta del Popolo rooms, the pictures attracted much attention from artists and connoisseurs. Praise was chiefly bestowed upon them for the beauty of the subject. The drawing, execution and colour were considered by many observers as unnatural, incorrect, hasty, and even feeble. They regarded them as the work of a young artist, of admirable genius indeed, but one who yet required much study of nature to correct his taste, and improve his style.

Any one at all versed in the Modern German, French, Italian and English schools of painting might have anticipated for Cole precisely the judgment rendered above. The French, and especially the Italians, are characterized by great extravagance and forced effects. Their pictures speak their national disposition to extremes, and have an affected, self-assuming, flattering air. They are compliments to nature. Religious fervour, even when the subject is professedly devotional, seldom breathes on their canvass. Their colour, with few exceptions, is hard, heavy and positive. Their reds are red, their greens green, their browns and blues brown and blue. One sees little of the modest, gentle blending so beautiful in nature. Crude and affected in their manipulation, their forms, although usually well rendered, are bereft of sweetness and delicacy. From such, the works of Cole, of course, would receive the smallest sympathy. To them they could not but appear weak and devoid of meaning. Steeped in the love of this present life, and soiled with its sensualities, they had no heart for the pure, deep sentiment, the strong moral and religious expression of his pictures.

Among the Germans what is legitimately the means of art is elevated to its end. While they express more of the sentiment of nature in their pictures than the Italians and the French, their ambition appears to be to show a mastery in the machinery of art. A triumph with them is the perfection of manipulation or handling. They aim to draw with the greatest exactness, and to draw every thing down to the minutest detail. They strive to make out every object with the plain-

ness which it really has in nature, but which she ever presents to the eye as we usually behold it. Elaborateness is the grand characteristic of their style. Freedom its fatal deficiency. Their works are frequently prodigies of labour; never specimens of the magical swiftness with which genius, in the plentitude of liberty, evolves its creations. Their excellence is imitation—too often soulless imitation. To mirror the outlines and the limits of nature is the extent of their task: to express her living *spirit* was the task of Cole. And while every bank was fresh with that—every rock haunted with it—every plant, bough, and mossy root swelling with it—every tree, grove and forest alive with it—every space and distance moist and breathing with it—every luminous cloud warm and passionate with it—every shadow pensive with it—earth and heaven stirring, palpitating, beaming with it—what to the German were such pictures as the Voyage of Life, so long as he did not behold foremost his own darling mechanical finish about it? They could sympathize with no one who so outstrode them in intellect and feeling, and sung in landscape with a poet's heart of the presence of God, and of human hopes and fears, joys and sorrows. His imitative pictures—simple views—would have pleased them better, and given them some plainer token of the power and truthfulness of his pencil.

Why the series was not more popular with the English it is difficult to see, if we do not lay it to some little jealousy, and the dislike of a new name among them. There was that in it, in many ways, which resembled British art. In its features, complexion and general expressiveness there were marks of relationship not usually found in German, French and Italian art. Though far more delicate, his colour still resembled that of the English: without its "trick," his execution still resembled theirs: possessing more of the finished accuracy of the German than they, his drawing was of their school. With all this likeness to, still he was not of their school. More accurate, he was without its forced effects: more simple, he was free from its pretension: more tender, he was, at the same moment, more vigorous in the flow of his feelings: more pure, subtle and playful in fancy, he was also far richer and grander in imagination: less of the showery, shadowy noon of England, he was more of the pure translucent day —more of the moist blue firmament of clearer climates—more of the true blaze of sunset, and the mellow, soothing, uncertain twilight of

the wide world. But there was a broad difference, with all the similarities: difference enough to set him off by himself, and make him the originator of a new school of landscape—a distinction which time will inevitably confirm. That doubtless was his crime with the English, as his fresher, tenderer colour, absence of affectation, and poetry of design were with the Italians, and his greater force, freshness and truth of colour, more varied and classical conceptions, and lack of that laboured manipulation, with the Germans.

TO MRS. COLE.

New York, Aug. 6, 1841.

I have a few moments to spare, so I will commence a letter to-day, although I may not finish it before to-morrow. * * I found Mr. Porter on board the boat, whose conversation, in some measure, helped to dissipate my melancholy thoughts on leaving you and the little ones. Indeed I have to strive hard against them. * * *

Mr. Porter has given me letters to Paris. Miss Sedgwick has written me a charming letter, and four introductory ones; one of which is to Mrs. Jameson. Miss S. says at the conclusion of her letter—"cast your cares behind you; or rather let me say, in a better spirit, and grateful that I may say it, cast your care upon the Lord: and God grant that, in due time, enriched by all your foreign experience, you may have a happy return to your dear wife and children, and I trust my eyes will not be too dim to see, and welcome you." * * *

O, how I should like to step in, and see you and Theddy and Mary! I can imagine them trotting about on the piazza.

Mr. Ver Bryck is at work, and has painted a good portrait of a gentleman; and I hope business will begin to come in.

I think there will be quite a number of friends down to the ship, to-morrow, to see me off. * * *

Your ever affectionate husband,
THOMAS COLE.

CHAPTER ❧ 30

TO MRS. COLE.

London, August 21, 1841.

My dear Maria,—This letter, I know, will dissipate some anxiety on the subject of my safe arrival here. * * *

I assure you that, on the evening of my departure from New York, when the shades of night began to descend upon the ocean, I felt melancholy indeed. I felt, every moment I was borne further and further from you and those I love, that the reasons I had for leaving you and visiting Europe, and which I had considered so forcible, were, under this gloomy influence, trifling and unsatisfactory. But next morning the melancholy thoughts were in a great measure dissipated, and I have not felt such deep depression since: and the strong desire to return to you is accompanied by the hope that my visit to Europe will result prosperously. * * *

At the moment I am writing, there are several musicians beneath my windows, playing very plaintively, "O where, and O where, is my highland laddie gone?" It brings the tears to my eyes, for it awakens recollections of home. You know I used to play it on the guitar. They have now changed the tune for one more gay and sprightly, and I ought to change my thoughts also, for it does not do for me to dwell too long on such remembrances. * * * I intend to go into the country, shortly, to see my friends, and make some studies. On my return, I shall, in all probability, remain in London a few days, and then proceed to Italy, where I shall paint the series.

* * * * * * *

CHAPTER · 30

London, Sept. 22d, 1841.

* * * * * * *

Since I last wrote to you, I have been at Kenilworth Castle, Warwick Castle, and Stratford, the birth-place of Shakspeare, besides visiting my uncle William, in Derbyshire, and my uncle, aunts and cousins in Lancashire. The weather was delightful when I was at Kenilworth, the country rich and beautiful, and the ruins went beyond my expectations. I must not attempt to describe them to you now, for the description would fill the sheet: yet the ivy-clad towers, roofless halls, whose floors are covered with green turf and flowers, and cropped by flocks of sheep, and over which, through the dismantled windows and ragged loopholes, the sun casts his wandering rays, inspired me with a melancholy pleasure; more melancholy, my dear Maria, because my mind was half with you. Every flower and mass of ivy, every picturesque effect, waked my regret that you were not by my side. The weather, as I have said, was truly delightful, and there were groups of visitors, chiefly country people; lads and lasses seated on the sunny turf, or clambering the dilapidated towers. Had I been a magician, I would have conjured up the haughty Elizabeth to contemplate the scene which her eye beheld in its "pomp and circumstance," and where now "Ruin greenly dwells!" What a lesson to human pride! I made several sketches, from one of which I intend to paint a picture for Mr. Faile.

From Kenilworth I went to Warwick Castle, only a few miles distant. It is the most complete specimen of Feudal architecture. The Warwick family still reside there: it is as perfect as in olden time. The gates, the towers, the port-cullis, the courts, the walls panneled with oak, and covered with ancient armour, all conspire to carry one away from the steamboat and railroad world in which we now live. From Warwick I went to Stratford. The house in which Shakspeare was born is much more humble than I expected. I made a sketch from his bust in the church, which is different from the pictures we have.

* * * * * * *

Paris, Oct. 7th, 1841.

Well, you see I am in Paris. I did hope to be further on my way to Italy before this. I left London on the day mentioned in my last, Mrs. Jameson in company.[1] Possessing, as she does, so much knowledge of art, artists, and pictures, she could not fail to be an interesting companion.

* * * * * * *

You know that, when I was in Paris before, I did not see the pictures of the Louvre, in consequence of an exhibition of modern works. I have now seen them. The collection far exceeds in number and beauty what I had expected. Imagine a most splendid gallery, a quarter of a mile long, with walls on each side covered with the choicest pieces of ancient and modern art. * * *

There is one thing I am sure you will be pleased with, that is, I feel more of an artist than I have done for years. * * * *

How I do long to be a little richer. There are such beautiful things of all kinds here, that they tempt me at every step. I have been purchasing a good many casts: I have children, sheep and dogs, horses, dancing-figures, hands and heads around me, and one very exquisite thing, called the guardian angel, that comes home to my heart, and makes me think of home, you, and my dear little rogues. * * *

This is surely a wonderful place, wicked and sensual to be sure, but with a multitude of excellent and fine things in it. Mr. Rossiter[2] and I have taken our places in the diligence for Switzerland: we shall set off to-morrow. * * *

Yours, affectionately, THOMAS COLE.

October 7th I spent at the Louvre. In recalling what I saw there, I find that my mind dwells with most pleasure on the works of N. Poussin, Correggio, Titian, Claude, and of painters earlier than Raphael. N. Poussin, in my estimation, was one of the greatest masters; although in his historical works we do not find the most agreeable colour; and at times there is a statuesque appearance in his figures: yet we forget these in the admiration of his expression, composition, fine design, and admirable propriety. While his costumes are

not always correct, we never see in him any of that recklessness and violation of truth, so characteristic of the Venetian school. In his compositions there is a simplicity, a chastity, a classic feeling, which, to the refined eye, must ever give pleasure. You are always transported by him from the present into the past: you are in Judea or Arcadia: you live in a world—in a time, far removed from this. His landscapes are equal to his historical pictures; and, if not the first landscape painter that ever lived, he is certainly the first in classic landscape. He has not the glowing and elaborate beauty of Claude, nor the truthfulness of Ruysdael, nor the startling chiaroscuro of Salvator Rosa; but you find in him a breadth and amenity, a largeness and simplicity, which, combined with a silvery tone of colour, and enlivened by appropriate and fine figures, are truly enchanting. He may indeed be called the classic.

Correggio astonishes me with his power. How I regret that Correggio should have exhibited his wonderful skill on such subjects. It was in the spirit of his time, we may say: alas! that one of so much genius could not have soared above the low tastes of his age. * * Ghirlandaio, Lucas of Leydon, and others, have given me much pleasure. There is so much spirituality in them: somewhat rude and dry their works are certainly: but the painter in his deep devotion never dares to obtrude himself or his art. A calm and holy feeling seems to have influenced him. He worked not to show the world his skill: his productions were the outpouring of a devotional spirit.

* * * * * * *

Paris, Oct. 8th, 1841.

I am in the midst of the works of art, * * steeping myself in the great minds of olden time. I have dwelt among pictures since I came here, and feel both delighted and depressed, yet stimulated. I feel that art has not yet arrived at its acme. Much more may be done, wonderful as some of the master productions are. I am conscious that time has too far advanced for me to subject myself to that study, and training of hand and eye which are necessary. I began too late in life. But I will do my best. If I may not be the first, I will not be the last. * * I am hopeful and earnest, and cannot entirely fail, if God grants me health and moderate means.

October 16.—* * * Have just arrived at Neufchatel, after a fatiguing ride from Paris. * * * We were now pursuing our way down the pass, the stream dashing impetuously along a thousand feet below, when a view of Lake Neufchatel, and the distant Alps rising beyond, opened upon us. This was our first sight of the Alps, and a grand one it was. Upon the highest summits clouds were resting, while the level country was smiling in sunshine. The scene of the lake and the distant mountains resembled one from the upper part of the Plattekill Clove, where you see the Hudson and the New England hills beyond.

October 17.—This has been a charming day. We rose early, and found the morning bright and windy, but not cold. The lake, which was of a fine pea-green, dashed on the shores in magnificent style. We made a sketch, before breakfast, of the pass through which we came yesterday, and also one of the Alps, as seen across the lake. * * * We also went to the summit of Chaumont, said to be about 5000 feet above the sea. This commands one of the finest general views of the Alps. In consequence of their great distance, there are, it is said, only a few days in the year when they appear to advantage. We were fortunate, for the atmosphere was clear, and a more sublime sight never opened on my eyes. At sunset, they were lighted like fires in the blue firmament. Where the summits were snowy, they seemed like tents of silvery fabric mysteriously suspended in the sky, while those which were dark melted into atmosphere. As the sun went down, they became more and more brilliant; a ruddy colour overspread them, which gradually faded away into a pale and spectral hue. They did not seem like vast and ponderous masses, but airy things, which the gentlest winds might dissipate. Wonderful and glorious are Thy works, Almighty God! To-morrow for Berne. The new moon, to-night, over my right shoulder. Maria says, good luck. By what links our thoughts are connected with those we love!

October 18.—This morning, at four, we set off in the diligence for Berne. Between the lowlands, of which I have spoken, and Berne, the road crosses two ranges of hills: after we had gained the height of the second,—the road lying through delightful woods—and just on the descent, the most wonderful and sublime view that I ever beheld

burst upon us—the Bernese Alps—vast, towering amid the hazy atmosphere of the morning—their snowy summits glittering in the sun—their bases lost in the haze. The lower mountains, giants in other lands, rose dimly, range after range, until they rested on the nearer hills, glowing in autumnal richness. The snowy Alps, as they are seen afar off, are difficult to describe. They are too beautiful to be compared with anything of earth; they seem of an etherial tissue—like drapery composed of moon-beams, floating in the blue sky, and tossed by the breeze—silvery festoons suspended in the heavens. * * *

TO MISS MARIA COOKE:

Lyons, October.

* * * * * * *

The last week has been a living one to me, and the impressions left upon my mind are such as, I hope, will never be erased. I have enjoyed much; and had some of my dear friends been with me, my pleasure would have been complete: but absence from them throws a shadow over the most sunny landscape, and where I see the most beauty, I feel the strongest regrets. * * * I have seen no picture that represented the Alps truly, and words are incapable of describing them. The imagination searches in vain for comparisons. They are unearthly things—of the texture of the moon, as seen through a fine telescope, beaming with a sort of liquid silvery light—folds of heaven's drapery fallen to the earth. After a short stay at Neufchatel, we proceeded towards Berne, the Jura mountains still about us. How much they reminded me of our own Catskills, their forms and forests. Scenes sometimes burst upon us all American. * * *
From Thun we took the pass of the Simmenthal. * * *
From thence we made a pedestrian tour through the pass of the Dent de Jaman, to the Lake of Geneva. And here I may say, with Byron, "I have been repeopling my mind with nature." Stupendous mountains with snow-clad summits, impending crags, black pinnacles of rock, foaming torrents, valleys of deepest verdure, whose green slopes ascended the mountain sides to mingle on high with precipices and dark forests; shepherds and innumerable cattle, making the vales musical with the continual sound of their large sweet-toned bells;

houses clustered in the depths of the valleys, or perched on the tops of precipices, altogether combined to produce such pictures of savage grandeur and pastoral beauty as one could never have imagined. * * You may fear, perhaps, that the wonderful scenery of Switzerland will destroy my feeling for our own: this will not be the case. I know that, when I return, I shall yet find beauty. Our scenery has its own peculiar charms, and it is so connected with my affections that it will never lose its power. I send, in this latter, a little flower, plucked in the pass of the Dent de Jaman, the forget-me-not; you may not recognize it, in consequence of the imperfect manner in which it is preserved; but it is from the Alps. * * * I have sent two flowers; the pink one is Alpine also: please present it to Elizabeth.

Yours truly,

THOMAS COLE.

Lyons, Oct. 29, 1841.—This morning, we set off in the boat down the Rhone, for Avignon. •

Oct. 30.—* * We have been to Vaucluse. * * As we came in full view of the mountains among which Vaucluse is situated, we enquired of our little driver in what direction it lay. He, pointing to a reddish mass on a bleak mountain side, some six or seven miles off, said, "There is Vaucluse." We were disappointed, and became more and more so as we approached. Nothing could be more dreary than that mountain-side. The valley, through which we were riding, was sprinkled with olive and mulberry trees, but not a tree was to be seen on those barren heights. We came at last to a pass, with high rocks on either hand, and a narrow but fertile valley through which flowed a clear and rapid stream, with greener waters than any I remember to have seen before. A newly painted house stood under a projecting rock. Is this the place that Petrarch selected as his home? A solitude it might be, but where was the grandeur, the beauty, that we had expected in the vale of Vaucluse? We had imagined the rich, the lovely, the luxuriant, although the secluded. A little further on, our road made a quick turn, and a scene different, indeed, from anything I had fancied opened upon us: a few straggling houses stood on the bank of the rapid stream, which descended a deep ravine in a tortuous course, dashing and foaming over its rocky bed. On the right, rose a heap of rocks, several hundred feet high, crowned by a ruin, evidently

a castle of the middle ages; on the left side of the stream, mountainous rocks arose, singularly marked with excavations, like the entrances of caves. At the upper end of the valley, from whence the water seemed first to burst forth, stood stupendous precipices, walls of perpendicular or impending rock, scarred, scooped, marked, and stained, mounting to the sky—a strange and impressive scene! A few fruit-trees and small gardens fringed the water's edge; all else naked rocks, except here and there a few spots of sombre green, where some hardy plant found a crevice for its roots. The scene recalled to my mind my own picture of Infancy in the Voyage of Life, where the stream issues from the foot of the mountain. The rain began to fall, and I feared that it would be impossible to make a sketch from a spot which I thought favourable; but on looking round I saw one of those cavernous excavations; to this I retreated, and effected, though hastily, what I wished. The time was unfavourable, as there was no chiaroscuro. I then pursued my way towards the head of the vale: the grandeur of the scene increased at every step. The beetling crags closed in upon the valley on all sides, and the river, which before was rapid, now dashed furiously down, tossed and tormented, over the jagged rocks. Not an eddy, not a spot of green or smooth water—all was white, like a torrent of commingled hail and snow, and down the glen it thundered, and the huge cliffs reverberated the roar. A little higher still, and how the scene was changed! at the base of a precipice of vast height, was a basin of green water, deep and clear, of small extent, and exhibiting a surface but little troubled. I have seldom felt the sublimity of nature more deeply. There was no arch, no vault, and yet here came forth a river from the mysterious bosom of the earth, as gently as though it had been sleeping in its darkness. I descended the valley, crossed the little bridge at the village, and climbed the crag on which the ruin stands. It commands fine, I may say fearful views of the scene below. Roofless, many of its walls thrown prostrate, its halls and courts are filled with flowering plants and odoriferous shrubs, thyme and lavender. I plucked some flowers as a memento, and departed.

November 9.—Rome. But here I am in the "city of the soul."
* * *

CHAPTER ❦ 31

TO MRS. COLE.

Rome, Nov. 11th, 1841.

* * * So you see I have arrived at Rome at last. I am sure you will congratulate me on having got to a resting place, and painting place once more. I assure you that the pleasure of travelling is usually after it is over. But here I am sitting in my studio, warm enough, but confoundedly flea-bitten, a large canvass on my easel with some chalk-marks upon it, and a small sketch for a picture of Vaucluse, that I finished to day from a drawing made on the spot, and which I intend to make use of on the large canvass. But how can I paint without you to praise, or to criticise, and little Theddy to come for papa to go to dinner, and little Mary with her black eyes to come and kiss the figures in my pictures. Indeed I feel lonesome in my room; but I am determined to paint, and will too, and a great deal in a short time. I long for the time to arrive when I shall again see you. * * *

Rome, November 23, 1841.—Last evening was the anniversary of my marriage. Five years have elapsed, and I am in Rome. What strange leaves open in the book of life! Health, and the necessity of renovating my artistic feeling, and of gathering fresh materials for my profession, have dragged me away from home. My life will be burdened with sadness until I return to my wife and family. I have made

a great sacrifice of affection for what I consider to be duty. God grant that I may not be disappointed in my hopes and labours. I close the book, and leave all to Him.

TO MRS. COLE.

Rome, Nov. 30th, 1841.

MY DEAR MARIA,— * * * *

I have not yet finished the picture of Vaucluse, but it is far advanced. I have been engaged on some other little things. But I shall surprise you perhaps, perhaps make you sorry, when I tell you I am just beginning to paint the Voyage of Life over again. Mr. Greene, the Consul, and several other persons here have urged me strongly to do it, believing it will result greatly to my advantage. I intend to carry them through very speedily. * * * *

December 3.— * * As usual, I have been occupied in painting, sketching, &c. The weather has been delightful—a soft, balmy atmosphere, like the very finest of our spring days, a clear sky and sunsets, in which the air seems like molten gold.

After church-time to-day, I took a walk to St. Onofrio, where Tasso died, and was buried. I picked some leaves from an ancient oak there, that is said to have been a favourite tree of his. You may be sure, I thought of you when I did so, and remembered too with what interest I read, and you listened to his life, in the past winter. I intend to go to St. Onofrio for some sketches, as it commands admirable views of Rome and the Campagna. The English church here is held in a building just out of the gate of the Piazza del Popolo, very near where I live. There is a very good clergyman, and several hundreds attend.

TO THE SAME.

Rome, Jan. 1, 1842.

MY DEAR MARIA,—I wish you a happy new year, and all our dear friends "also, and all the little children that round the table go," as the song says. * * I went to St. Onofrio, and saw the cast in wax which was taken from Tasso's face and head after his death. It

was the next thing to seeing Tasso himself: the very pores of the skin are there. The face is a handsome one—a broad forehead and small chin: on the mouth there is quite a smile, and the eyes are open. Last evening I had a present made me for you—a cameo—Raphael's Madonna del Sisto. It is such a one as you perhaps have never seen; so I have something for you when I come back.

<div align="center">TO MR. VER BRYCK.</div>

<div align="right">Rome, Jan. 31, 1842.</div>

MY DEAR VER BRYCK,—I was delighted to receive your note through Mr. B. Though it contained but few lines, it was from a dear friend, and included a bit of his mind. * * *

This Rome, this "city of the soul," is indeed a place that holds a man's heart like Mahomet's coffin suspended between earth and heaven. It is, indeed, the Mecca of the artist; and I am grieved that the most devout may not always be numbered among the pilgrims. Your company would be delightful here: your enjoyment of the beauties of art and nature would enhance mine. We could walk on the Pincian Hill together, and watch the sun set in gold behind the dome of St. Peter's, and talk of the Catskills, for every sunset takes my heart with it to my distant home. * * *

I have already nearly painted two of the pictures, and a third is commenced. * * I sincerely hope that you are prospering; that, although in the depth of winter, your prospects are blooming like the Roman rose. Present my kindest remembrances to Huntington, Durand, Cummings, Bryant, and all those friends whom you know I prize. * * I assure you, it will be delightful for me to tread with you on the heights of the Catskills, and to sit on that rock which we know so well, and again look over that vast and varied landscape, whose recollections will ever be dear to me for itself, and for associations which are a part of my life. Adieu.

<div align="right">Yours, very truly,
THOMAS COLE.</div>

TO MRS. COLE.

Rome, Feb. 6, 1842.

* * * * * * *

I am getting on bravely with my pictures. The first and the third are completed, and I am building the castle in the second: by the time this reaches you, I think it will be finished, perhaps before. *

Will you be surprised when I tell you that I never went to so many parties in my life, in the same a length of time, or to such splendid ones? Almost every night, for the last month or six weeks, has been spent in making calls, or at dinner-parties and soirees. Several reasons induce me to indulge in these gaieties—the desire to make acquaintances—the desire, I may say the curiosity, which a man in a strange country feels to become acquainted with the forms and usages of society, and to see distinguished personages—and the recreation it affords after the labours of the day—and, perhaps more than all, the pleasure in the anticipation of being able to describe to you persons and things which may be interesting. Among other invitations, I received two from Prince Torlonia, and one from the French embassador; all of which I took advantage of. The embassador's party came off last night. I will give you a slight sketch of these parties, if this rascally Roman paper, upon which I am writing, will allow me.

The company were invited at 8 o'clock. The palace of Prince Torlonia, in which he has his parties, is near St. Peter's. As we approached, (I say we, for I went with several other persons in a carriage,) the street was lined with cavalry. After leaving the carriage, we ascended several long flights of carpeted steps, which led to large entrance halls, in which guards and servants were placed: in the last hall our names were announced by the servants, and we proceeded to the presentation chamber, where the master of ceremonies presented us to the prince and princess, who stood in the middle of the room. We bowed, a few words were passed, and we proceeded to the next room, which appeared to me to be badly lighted, but perhaps for effect. Here were ottomans in the centre of the room, and around it, mirrors, pictures and statues, and a brilliant assemblage of beauty and fashion. I saw more diamonds and emeralds, in one hour, than I ever saw in my whole life before. Here we were regaled with delicious ices, and wandered about "at our own sweet will."

The Princess Torlonia is decidedly one of the most beautiful women I ever saw: indeed I was never so struck with admiration before. This may partly be attributed to her family, and to the dignity consequent upon high station, in spite of republican notions to the contrary, and partly to being seen by candle-light. She is of the ancient Colonna family, about eighteen years of age, rather above the middle height, her form graceful, face classic in its contour, a noble forehead, and fine large Italian eyes of pensive expression. Her head-dress consisted of a wreath of roses round the upper part of the head, a circlet of diamonds below, clasping the top of her forehead. The hair was brought down, as is the fashion here now, plain on each temple as low as the ear, and turned back. She wore a necklace of splendid diamonds. Her dress was white satin, with a very thin lace-like skirt over it, with puffs of satin descending from her waist in front downward in diverging lines: the band at the waist was orna-mented with a rose in front: the sleeves were short, with a small rose in each. She wore massive bracelets; and, on the whole, was elegantly and tastefully dressed. It is not more than two years since she was married. She was then taken from the convent, and had never once seen her future husband. After the presentations were over, the prin-cess, accompanied by Prince Frederick of Prussia, led the way to the ball-room, which was brilliantly illuminated, the music from the orchestra struck up, and the dancing commenced.

The next that attracted the admiration of the company was the Princess Doria, the daughter of the English Earl of Shrewsbury. I never saw such a splendid display of dress and jewels. There were present a number of English nobility, as well as French and Italian. The dancing continued until two o'clock, with intervals. The supper, cold of course, then came in, carried on tables ready set. I left after supper, but understood that the party did not break up until five in the morning. Among the guests were the Countess Guiccioli. She is about forty years old, but a fine looking woman still, and I could not but look with interest on a woman whose name will ever be coupled with that of Byron.[1]

There are some minstrels now singing in the street below my window, and the air so strongly reminds me of home that I can scarcely proceed with my description.

The French embassador's party, at which I was last evening, was

got up with more taste than Prince Torlonia's, and the party, though large, was far more select. The lady of the embassador was present only for a short time, as she is an invalid. She is a very interesting looking person, about thirty years old, with a fine intellectual face. She sat all the time she was present. Her attire struck my fancy exceedingly. She wore a sort of hat, of crimson velvet, and ornamented with diamonds. Her dress was white satin, with a sort of cape. I will stop by saying, it reminded me of some of the most elegant costumes of the fifteenth century. * * *

How I long for you to walk with me in the grounds of the villa Borghese, to see the warm sunlight streaming through the stately pines upon the rich grass, and to listen to the birds that are now singing like ours in May. * *

February 12.—I was just clearing off my palette, after working on that group of trees that gave me so much trouble in the second picture, when your letter of the 27th of December came. It was a delightful treat, and I read it over and over again. I am thankful that you all continue to enjoy such excellent health. How I should have enjoyed your Christmas party, and seeing the children. Your account of Theddy's boots and Mary's dream was next to seeing the little rogues themselves. I wish I was at home to admire Harriet's carnations. During the carnival here, there were cart loads of flowers thrown about. Think of that in the middle of winter! I picked a few violets just like Harriet's, in the Borghese grounds last week. How delighted I shall be when my pictures are finished. * * *

February 16th.—I have seen that, to-day, which will be a lasting subject of thought—which has made an impression on my mind that can never be effaced—the Catacombs of St. Agnes. I went in the company of Mr. Greene, the consul, Mr. G——, Mr. P——, and the Padre who has the charge of the excavations, and has made a plan of the subterranean labyrinth. The sky was cloudless, and before we entered the gloomy regions of the dead, we stood for sometime in the vineyard, gazing at the mountains that rise around the Campagna di Roma. The entrance, about two miles out of the Porta Pia, is by a flight of steps, partly antique, I believe. At the bottom, we found ourselves in a narrow passage cut in the tufa rock. On either hand were excavations in the walls, of various dimensions, which contain

the bones of the early Christians. For two hours, we wandered in these gloomy regions. Now and then we came to a chapel. The passages were, in general, about six feet wide, and from five to twelve feet high, arched, and sometimes plastered. The cells are in tiers, one above another. Many of them were open, and disclosed the mouldering bones of those who flourished in the first centuries of the Christian church. Others were closed by tiles or slabs of marble with cement, which appeared with the impressions of the trowel as fresh as yesterday. Here were the remains of the early martyrs of Christianity. You know them by the small lamp, and the little phial or vase which once contained some of their blood. These vessels were inserted in the cement that sealed up their graves. Impressions of coins and medals, the date of the interment, are also to be seen in the cement, with inscriptions marked with the point of the trowels, usually the name of the individual, with the words "in pace," or "dormit in pace." What pictures cannot the imagination paint here! Yet nothing so impressive as the reality: scenes where Christian hope triumphed over affliction; where the ceremonies of their holy religion were performed far from the light of day. The chapels are generally ornamented with pictures, some of which are in good preservation. They are rudely executed, but with some spirit. One picture represented Moses striking the rock, another Daniel in the lion's den, another the three holy children in the fire, and still another, the Virgin Mary. There were several pictures which represented bishops or priests—men in clerical robes. Occasionally the drippings of the water formed stalactites upon the walls and ceilings. Some of the bones were coated with calcareous deposit.

Some notion of the extent of the catacombs may be formed from the length of time we were walking. There were many passages we did not enter, and many impossible of access from the rubbish with which they were choked up. We came into the open air—into the light of the glorious sun, and again stood and gazed upon the mountains. There they are, as eighteen hundred years ago: they are not changed; as they looked then, they look now.

TO MR. DURAND.

Rome, March 8th, 1842.

MY DEAR DURAND,—I was delighted to receive your kind letter, of

the 16th of January. In this distant land, a letter from home is a god-send—a heart-warming. * *

I intend to set off for Sicily, in a few weeks, when I hope to profit by, and enjoy the beautiful scenery: but it is doubtful whether I ascend Ætna, although, as you know, I have a passion for climbing. After I have visited Sicily, I intend to hurry home as fast as circumstances will allow. * * * We are in the enjoyment of cloudless skies; roses in bloom, at all times, and, at the present, the fields are covered with flowers. Don't you wish I had art enough to bring home some of this climate with me—sufficient for you and me? In the hope of seeing many pictures by your hand, on my return,

I remain, &c., &c.,

THOMAS COLE.

March 20.—Yesterday I was gratified with a visit from Thorwaldsen.[1] He is a grand old man. His remarks on the Voyage of Life were highly gratifying. He seized the allegory at once, and understood the whole intention of the artist. He said my work was entirely new and original in its conception, and executed in a masterly manner. He commended much the harmony of colour, and the adaptation of scenery and detail to the expression of the subject. He remained in my room some time, looking at the pictures. When he went away, he thanked me for the great pleasure I had given him, and asked to come again.

"Cole," says Mr. Greene, "was naturally anxious to have Thorwaldsen see the Voyage of Life, and I arranged the interview. At the appointed hour, ten in the morning, the old gentleman came. The four pictures were standing in a row, the first three completed, the last still wanting in some finishing touches; but all that was essential to the story was there. I never saw Cole so nervous as when Thorwaldsen opened the door. Common criticisms he did not mind, but this was an ordeal to shake even his practised nerves. He walked directly to the first piece, and taking the words from Cole's mouth, as he began his explanation, went through the whole story, reading it from the canvas as readily as if the trees and flowers had been words. When he came to the last scene, he paused, and stood silently before it, his eye resting with an expression of solemn musing on

239

that cloud-veiled ocean, upon which he too was to sail so soon. Twice he returned to examine the other three, and twice returned to gaze again at the closing scene with the same deep expression of earnest sympathy. I hardly ever passed an hour with him after that day, but what he would bring in some mention of Cole: 'When I had heard from him? What was he doing? A great artist! What beauty of conception! what an admirable arrangement of parts! what an accurate study of nature! what truth of detail!' I have often heard him speak of artists, friends and foes, the living and the dead, but never with such a glow of heartfelt enthusiasm as when he recalled his visit to the study of Cole."

TO MRS. COLE.

Rome, March 26th, 1842.

MY DEAR MARIA.— * * * Yesterday, I took a walk, and saw thousands of flowers in the fields. To-day is rainy, and I feel somewhat sad and depressed. I was about to move my pictures over to the studio of Mr. Terry.[2]

* * Well, I have got into a new studio, and a grand one it is, and my pictures look well in it. It is about forty feet long, and twenty-six wide, and as high as a two-story house. I am at work too at the last picture. * * * * *

Last night I went to the Vatican to see the statues by torch-light. The effect was perfectly magical; each column and statue starting out, as it were, from the mysterious darkness around. The life-like effect of those great works of art—the Apollo, the Laocoon, and others—was almost startling. The whole seems to me like a vivid dream of the most beautiful things that can be conceived. * *

TO THE SAME.

Rome, April 2d, 1842.

* * * Won't you be glad when I tell you that the pictures are at length completed? And don't you think I have worked hard to finish them within four months from the commencement? * * A good number of persons have seen them, and I assure you I have every reason to be satisfied with the impression they have made. * * * * * *

Next week I intend to start for Sicily; from thence I shall bend my steps homeward.　*　　*

I went to hear the Miserere in the Sistine chapel. The music was wonderful; but I found myself in purgatory, the crowd was so great.

I am not sure that I told you I had been presented to the pope. I was pleased with the interview as a matter of curiosity, though I did not think proper to kiss his holiness's big toe. He was quite talkative.

I hope Harriet has good luck with her flower-bed, this spring, as I expect to see a glorious sight. You and the girls must begin to think where we shall have my return pic-nic, for I am determined to take more recreation than I have for years past; so I intend to have a jollification on my return, and a pic-nic too, in the course of the season: so make every preparation. My spirits rise as the time approaches, and I hope nothing will occur to damp the pleasure I anticipate. But it is not well to hope too much.　*　　*　　*　　*

THOMAS COLE.

CHAPTER ❧ 32

Journal: south of Italy. Tour of Sicily: Taormina; ascent of Ætna.
Journal: Milan; The Last Supper. Lago Maggiore. Down the Rhine: an
adventure. To Sarah Cole: on the eve of embarking for America.

In April 1842, Cole left Rome to make the tour of Sicily. As usual, nature and the vestiges of antiquity were the great objects of attraction; and the south of Italy afforded him much that was rich in both.

"There is a sad pleasure in wandering among the ruins of these cities and palaces. We look at arches and columns in decay, and feel the perishable nature of human art: at the same glance, we take in the blue sea rolling its billows to the shore with the freshness, strength and beauty of the days, when the proud Cæsars gazed upon it." *

From Palermo he went to Segeste, from Segeste to Selinunte, and from thence to Agrigentum, now musing with inexpressible wonder among the relics of their mighty temples, and then expressing enthusiastic delight at the grandeur of the scenery, and the great abundance of wild flowers. From Agrigentum he journeyed on to Sicily's ancient capital, Syracuse, from Syracuse to the awful wonders of Ætna, and the picturesque beauties of Taormina.

"What a magnificent site!" he exclaims of Taormina: "Ætna with it eternal snows towering in the heavens—the ranges of nearer mountains—the deep romantic valley—the bay of Naxos— * * I have never seen anything like it. The views from Taormina certainly excel anything I have ever seen."

The tour of Sicily, especially the ascent of Ætna, took a strong hold on his imagination. There was, at the time, none of the present conveniences of travelling. The journey was performed with guides and mules, and occupied a month. For the first time perhaps in his life, he took the precaution to carry a pistol in his pocket. But the pocket was presently worn through, and the useless weapon consigned to some secure nook among the luggage. His companion, an

English painter,[1] yet bears testimony to the very pleasant character of the excursion, and the admirable qualities of his friend: "It was the most delightful journey I ever took." * * "Cole was the only man for whom I ever had so ardent an attachment in so short a time." * * "Cole," said he, on their return from the summit of Ætna, "I should never have ascended without your encouragement:" "Nor I," replied he, with that characteristic generosity which loved to concede all to a friend, "without your energy." In their conversations he often spoke of his family with great tenderness, and talked frequently of the beauties of the valley of the Catskill river, and the graceful outline of the neighbouring mountains.

The annexed is a spirited sketch of his ascent of Mount Ætna.

On the ninth of May, we commenced the ascent of Ætna. As the season was not the most favourable, the snows extending further down the sides of the mountain than in the summer, we were equipped, under the direction of our guide, with coarse woollen stockings, to be drawn over the pantaloons, thick-soled shoes, and woollen caps. Mounting our mules, we left Catania in the morning. The road was good and of gradual ascent until we reached Nicolosi, about fourteen miles up the mountain, * * the place where travellers usually procure guides and mules. * * It was our intention to rest for the remainder of the day; but Monte Rosso, an extinguished crater, being in the vicinity, my curiosity got the better of my intention to rest, and I sallied forth to examine it. The road lay through the village, which is built of lava, and is arid and black, and many of the buildings rent and twisted. Monte Rosso was formed by the eruption of 1669, which threw out a torrent of lava that flowed thirteen miles, destroying a great part of the city of Catania in its resistless course to the sea, where it formed a rugged promontory, which at this day appears as black, bare and herbless as on the day when its fiery course was arrested by the boiling waters. And here I would remark, that the lavas of Ætna are very different from those of Vesuvius. The latter decompose in half a century, and become capable of cultivation; those of Ætna remain unchanged for centuries, as that of Monte Rosso testifies. It has now been exposed to the action of the weather nearly two hundred years: with the exception of the interstices where the dust and sand have collected, it is destitute of vegetation. Broken, in cooling, into masses of rough but sharp fracture, its

aspect is horrid and forbidding, and it is exceedingly difficult to walk over. If two centuries have produced so little change, how many centuries must have served to form the rich soil which covers the greater part of the mountain's sides and base!

Our purpose was to see the sun rise from the summit of Ætna; and at nine in the evening, our mules and guides being ready, we put on our Sicilian capotes, and sallied forth. We had two guides, a muleteer, and (as there was no moon) a man with a lantern to light the mules in their passage over the beds of lava. For several miles the way was uninteresting, it being too dark to see any thing except the horrid lava or sand beneath the feet of the mules. At times the road was so steep that we were ordered by our guides to lean forward on the necks of the mules, to keep them and ourselves from being thrown backwards. At length we entered the woody region. Here the path was less rocky; and, as we wound up the mountain's side, beneath the shadows of noble trees, I could not but feel the solemn quietness of a night on Ætna, and contrast it with what has been, and what will, in all probability, be again, the intermitting roar of the neighbouring volcano, and the dreadful thunder of the earthquake. At midnight, we arrived at the *Casa delle Neve*, or House of Snow. This is a rude building of lava, with bare walls entirely destitute of furniture. We made a fire on the ground, took some refreshments which we had brought with us, and in about an hour remounted our mules, and proceeded on our journey. We soon left the region of woods, and, being now at an elevation of seven thousand feet above the sea, felt somewhat cold, and buttoned our capotes closer about us. From the ridges of lava, along which we rode by the light of the stars, which now became brilliant, we could discern the snow stretching in long lines down the ravines on either hand; and, as we advanced, approaching nearer and nearer, until at length it spread in broad fields before us. As the mules could go no further, we dismounted, and, taking an iron-pointed staff in our hands, commenced the journey over the snows. It was now half-past one, and we had seven miles to traverse before reaching the summit. The first part of the ascent was discouraging: it was steep, and the snow so slippery that we sometimes fell on our faces; but it became rather less steep, as we ascended, and, though fatiguing, we got along comfortably. As the atmosphere was becoming rare, and our breathing hurried, we sat on the snow for a

few minutes, now and then. At such times, we could not but be struck with the splendour of the stars, far beyond any thing I had ever seen. The milky way seemed suspended in the deep heavens, like a luminous cloud, with clear and definite outline. We next arrived at the *Casa degli Inglese*, so called; but alas for us! the ridge of the roof, and a part of the gable, were all that rose above the snow. In the midst of summer, travellers may make use of it; but to us it was unavailing, except the gable, which served in a measure to shield us from the icy wind which now swept over the mountain. We again partook of a little refreshment, by way of preparation for the most arduous part of our undertaking, and were now at the foot of the great cone. The ascent was toilsome in the extreme. Snow, melted beneath in many places by the heat of the mountain, sharp ridges of lava, loose sand, ashes and cinders, into which last the foot sank at every step, made the ascent difficult as well as dangerous. The atmosphere was so rare that we had to stop every few yards to breathe. At such times we could hear our hearts beat within us like the strokes of a drum. But it was now light, and we reached the summit of the great cone just as the sun rose.

It was a glorious sight which spread before our eyes. We took a hasty glance into the gloomy crater of the volcano, and throwing ourselves on the warm ashes, gazed in wonder and astonishment. It would be vain for me to attempt a description of the scene. I scarcely knew the world in which I had lived. The hills and the valleys over which we had been travelling for many days, were comprised within the compass of a momentary glance. Sicily lay at our feet, with all its "many folded" mountains, its plains, its promontories and its bays; and round all the sea stretched far and wide like a lower sky, the Lipari islands, Stromboli and its volcano, floating upon it like small dusky clouds, and the Calabrian coast visible, I should suppose, for two hundred miles, like a long horizontal bank of vapour. As the sun rose, the great pyramidal shadow of Ætna was cast across the island, and all beneath it rested in twilight-gloom. Turning from the wonderful scene, we looked down into the crater, on whose verge we lay. It was a fearful sight, apparently more than a thousand feet in depth, and a mile in breadth, with precipitous, and, in some places, overhanging sides, which were varied with strange and discordant colours. The steeps were rent into deep chasms and gulfs, from which issued

white sulphurous smoke, that rose, and hung in fantastic wreaths about the horrid crags; thence springing over the edge of the crater, it vanished in the clear air. I was somewhat surprised to perceive several sheets of snow lying at the very bottom of the crater, a proof that the internal fires were in a deep slumber. The edge of the crater was a mere ridge of scoriæ and ashes, varying in height; and it required some care, in places, to avoid falling down the steep on the one hand, or being precipitated into the gulf on the other. The air was keen, but fortunately there was little wind. After spending about an hour on the summit, we commenced our descent. * * *

* * * * * * *

JOURNAL. May 22.—Two days ago I returned from Sicily. In a few days I leave Rome, in all probability, for ever. I am thankful that I have been preserved in health, and I now look forward with pleasing expectations of being soon united to my family. * * *

MILAN.—The first object of interest I visited was the cathedral. It is truly a magnificent structure. Though not of the purest and best style, it makes a grander impression on the mind than St. Peter's. The view from among its many pinnacles and statues is wonderfully fine. The distant Alps, in their everlasting white, the city and the fertile plains around, make a grand panorama. * *

Among the drawings of Da Vinci, in the Ambrosian library, that which affected me most was a drawing of a head of Christ. The Last Supper of Da Vinci is a sad ruin. I was surprised to find it not a fresco, but a picture in oil colours. It appears that the Austrians intended to have it transferred to canvass, for the purpose of removing it to Vienna, and an experiment was actually made to ascertain the possibility of doing it. It had been considered a fresco: but in consequence of something said in a manuscript at Paris, a doubt arose, and, on examination, it was discovered to have been painted in oil. It is impossible, so they say, to transfer an oil-picture from the wall to canvass; and so the picture was left. The marks of the experiment may be seen. What a fortunate circumstance that it could not be removed! To have done it would have been sacrilege. Little thought Leonardo, when he determined to paint it in oil, what an important decision it was.

LAGO MAGGIORE, June, 1842.—

> O sky and earth, how ye are linked together
> Upon the bosom of this lovely lake!
> See, the wild Alpine breeze is doubtful whether
> It may the calm and sweet communion break.

A small poem, of which the lines above are the beginning, was written by Cole on the banks of that very beautiful sheet of water, as he was passing northward to the Rhine, on his way to England.

In his passage down that far-famed river, he met with an adventure, which he used to relate with inexpressible humour.

About dusk the steamer stopped for the night at ——,[2] where a Frenchman and himself went ashore, and took lodgings at an hotel. In the morning, after breakfast, they went walking very leisurely about the town, returning, as they supposed, in good time for the boat. As they sauntered towards the landing, the bell of the steamer suddenly told them that they had little time to lose. They were just a moment too late. The Frenchman was frantic—a perfect explosion of wrath, gesticulations and shouts, in French and German; while he, the American, with almost his only word of German, plied the departing vessel with cries of "Dampfschiff! dampfschiff!—stop! stop! Dampfschiff!" Dampfschiff, though, moved off quietly, and was presently lost sight of in the windings of the river. A pleasant voyage was thus unexpectedly changed into an anxious pursuit after lost baggage by the first boat from above. Happily, one arrived within an hour, and soon found them, now made quite intimate by misfortune, walking the deck, and talking over, in mingled French, English and Italian, their common calamity. It was impossible, though, not to notice what appeared to be the singular resemblance in the interior arrangements of the steamers on the river Rhine. Here and there were the counterparts of things on board the ill-mannered craft that had so ungraciously left them. Even the men had a familiar air. The bags and boxes seemed to be duplicates of those upon their own boat. More curious still, there were trunks that were the very brothers of their own: and so, indeed, to their agreeable surprise, they *were* their own; and they were going down the Rhine in the right steamer. They had taken it unconsciously, as it returned to the landing, from which,

during the night, it had loosed, and gone above to give place to the one that had so naturally involved them in mistake.

London, June 16th, 1842.

MY DEAR SARAH,—I arrived here yesterday, but was not able to get my letters until to-day. The first letter that I opened was the one that announced to me the death of our dear brother.* I will not attempt to say how much the information affected me. * * I will not dwell upon the melancholy event, but am very thankful that the last days of our brother were peaceful. * *

Since I last wrote, I have travelled through Switzerland, part of Germany, and landed in England from Rotterdam, yesterday. I have so much to say that I cannot write, and leave it in hope that I shall soon see you. * *

Give my love to Ann and Emma. I hope my return will serve to cheer them. * * *

Your affectionate brother,
THOMAS COLE.

* Dr. George Ackerly.

CHAPTER ❦ 33

TO G. W. GREENE, ESQ., CONSUL AT ROME.

M Y DEAR SIR,—I have now been nearly a month at home. * * * You will, I know, be pleased to learn that I arrived in safety, and found my family in excellent health. Of course there was a little commotion on my arrival, which was a day or two earlier than expected. Since then I have been walking, and looking about, marking the changed, observing the unchanged. In fact, I have been in a very idle mood. I have done something towards a beginning to paint, although I have not yet touched a canvass. * * *

Must I tell you that neither the Alps nor the Apennines, no, nor even Ætna itself, have dimmed, in my eyes, the beauty of our own Catskills? It seems to me that I look on American scenery, if it were possible, with increased pleasure. It has its own peculiar charm—a something not found elsewhere. I am content with nature: would that I were with art!

I wish I could transport you here for a few days to enjoy with me these magnificent mountains: I know you would be willing to repay me in kind, and take me out of the Porta Pia to get a sight of Mont Albano. * * *

Yours truly, THOMAS COLE.

TO WM. A. ADAMS, ESQ.

Catskill, Aug. 26th, 1842.

DEAR ADAMS,— * * * At my silence for the last year you will not be altogether surprised, when I inform you that year was

spent in the Old World, from which I returned only a month ago. The last winter I spent in Rome: since that I have travelled through Sicily, and on my homeward way viewed the far-famed Rhine. I have seen much, and, I trust, acquired knowledge. My health has been much benefitted, and I shall now be able to go to work with renewed spirit and capacity. I wish you had been with me when viewing the wonders of ancient art, the remains of antiquity, and the magnificent works of nature; for, although, at times, I was favoured with congenial companions, I often turned round in vain for some one to whom I might say, "How beautiful is this."

I have been an idle, do-nothing sort of person since my return. I have had so much to see, so much to talk about, so much to enjoy in the society of my wife, children and friends, that it has been impossible to work. But, in all human probability, the next week will see some canvass spoiled. * * *

<div align="right">Believe me, yours truly, Thomas Cole.</div>

November 27, 1842.—It seems strange to me that I have not written a word on these leaves since my return from Europe. It is not because there has not been anything of interest to write, but rather that there has been too much. I returned, July 30th. The Great Western entered the harbour of New York—never was there a more beautiful morning. Everything looked brilliantly, the sky, the water and the earth, and my spirits were in harmony with all. The same evening, I left, in the boat, and arrived at home after midnight. I was hardly expected so soon, but was not the less welcome. I found all well—Maria—children—all. For a few weeks after my return I felt happier, perhaps, than I ever did in my life. Would that such bliss were more enduring! But it may not be in this world. The cares and anxieties of life will crowd upon us, and we are only now and then permitted to get a foretaste of the joys that, we hope, are in store for us hereafter. These brief seasons of happiness are bought by months of painful care. * * How much I grieved during my absence. But, thank God, I am once more at home, and have learned to value more highly than ever my own fireside.

Snow-squalls to-day—during the intervals, brilliant sunshine. The woods are roaring in the blast. I fear the river will soon close.

"What now as beauty thou dost know,
Shall one day come to thee again as truth." SCHILLER.

Doubtless the true and beautiful are one in art and nature. Truth is the fixed and unchangeable standard of taste. A work of art, however it may please the fancy and amuse the eye of the multitude at first, unless built upon truth, will presently pass away: on the contrary, one which has truth for its foundation will remain permanent, and make its way to the mind and heart at last, though it struggle for a season with neglect. By truth in nature, I mean anything's fulfillment of the objects and purposes for which it was created. The true leaf or flower, for instance, will be that which perfectly performs its various functions, and so accomplishes its appointed work. In the human form the true and beautiful will be that which is completely developed for the ends and offices of life. By the true in art, I mean the imitation of the true in nature, not the imitation of accidents, nor merely the common imitation of nature indiscriminately. All nature is not true. I may instance the withered vine, the imperfect flower, the stunted tree. These are false, and deformities. I would say, the true and the beautiful in art are the reproduction of the perfect in nature, and the carrying out of principles which nature suggests. Art, in its true sense, is, in fact, man's lowly imitation of the creative power of the Almighty.

The Apollo, the Farnesian Hercules, the Venus di Medici, are as true as anything art has achieved. In the Apollo are embodied dignity, agility and grace; in the Hercules, force and masculine power; in the Venus, the excellence of feminine form, destitute in great measure of intellectual expression. These works are true, having their type in nature. All forms, all principles of beauty live in nature. To her the artist must always turn if he would produce a work of immortality.

Upon the principle laid down, the lowliest creature in the world may be beautiful; for instance, the oyster: so indeed it is. But not pictorially beautiful, perhaps.

Not to follow the subject further, one thing is clear to my faith. When, to our clay-clogged perceptions, and to the dimness in which all objects at present are immersed, shall succeed the fine medium of eternity, and the piercing vision of the soul in its new and glorious

body, then shall we behold, according to the poet, that that has come to us as truth, which once we knew as beauty.

A subject which Cole had, for some time, been revolving in his mind very prayerfully, but of which we find no record in his secret journal, was that of his becoming a member of the church. The step was taken after his return from Europe, when he received baptism, and the rite of confirmation, and came to the communion. How he adorned his profession may be gathered from concluding chapters.

TO F. W. EDMONDS, ESQ.[1]

December 17th, 1842.

MY DEAR SIR,—The Ætna was sent to New York yesterday, * * and as something explanatory of the subject may be desired, I take the liberty of saying it to you.

The view is taken between Caltagirone and Lentini; the time just after sunrise. Ætna, which is about forty miles distant, lifts its snowy head in the warm sunlight, while the base of the mountain is partly veiled in the vapoury atmosphere and the mists of the morning. On the left, and nearer than Ætna, is a range of broken hills. Upon the peak of one is seen a tower, which is said to have been occupied by Nero during an eruption of the Volcano. Between the foot of the mountain and the middle ground is an undulating country, with here and there a village or tower rising from the hazy shadows into the golden glances of the sun. The middle ground is composed of bean and grain fields, with groves of olive trees. On the left, in the fore-ground, is a large Caruba tree, and upon the right the remains of an aqueduct.

It may be supposed that the flowers are too abundant in the picture. This is not possible. It must be remembered that the scene is not far from the fields of Enna. * *

Yours, &c.,
THOMAS COLE.

The Ætna of which he speaks above, the first of four, of nearly the same scene, was painted for the American Art Union.

January 1, 1843.—It is not without sadness that I write the title of the coming year. * * The departing year has been an eventful one to me. It has had deep anxieties, and heartfelt pleasures. * * I have arranged my studio, settled down to my old painting habits, finished several pictures, and am now looking out over the snow-clad landscape. What a contrast between this winter and last! Yet I delight in the clear air, when it is not too cold. * * * *

TO G. W. GREENE, ESQ.

MY DEAR SIR,—I live, you know, in a remote sort of place, and in winter, have little intercourse with the great world, and have not been able to learn what has occurred respecting the Roman Consulship. * * I do not feel perfectly satisfied here. Reputation, ability, are little prized among us. We talk much about them, and pretend to be proud of them. At the same time every tyro in art is said by the critics to rank with the great artists, ancient and modern; and the youth in his teens, who can paint a cabbage, is lauded as a Zeuxis or a Raphael. I care not for the censure or praise of such critics, except in so far as it affects me in a pecuniary way. But one who has gained some reputation, and hopes he is not entirely unworthy of it, ought to be able to live by his profession, although younger artists are in the field. There is little of real art in our atmosphere, and to me but few congenial minds. I languish, sometimes, for the intercourse I enjoyed last winter, and feel that there is little to bind me here but my family, and my own dear Catskills. But then a man must not be a vagabond, and roam all the days of his life. He ought to cast anchor in some quiet harbour. He who lives for himself alone, will find himself, at last, lone and melancholy. * * *

How I should love to see Thorwaldsen. It would do my heart good to see him at work, as I have seen him. I hope he is well. If you think he would remember me, tell him that I would tender my sincere regards. * *

I told you in my last that Crawford's bust of Orpheus was sadly shattered about the neck; but I have repaired it, and intend to put it in the exhibition. I hope he is well, and bravely at work.[2] The Orpheus must be far advanced by this time. * * *

Would you know what is going on here in the way of art? It is

difficult to say, except that Tom has painted a portrait which shames the old masters; Dick has just finished a red herring to the very life; and Harry has completed his grand historical picture of the Pig-Killing. But this is too bad. Huntington has finished a very fine picture from the Pilgrim's Progress. Page is painting Jeptha's Daughter. For myself, I have been engaged "pot-boiling" all winter: drudgery, drudgery, and precious time flying.

I told you in my last that I arrived happily at home: and I *was* happy. But, alas! there is no exemption from mortal cares. My wife is well, and the children rosy and noisy. The Catskills are as beautiful as ever. We are now closed up by winter, which is long and severe. What a contrast? You are among the green things of spring, I in the midst of snows. * * *

<div align="right">Yours, &c., THOMAS COLE.</div>

TO C. L. VER BRYCK.

<div align="right">Catskill, Jan. 17th, 1843.</div>

MY DEAR VER BRYCK,—"O, are you sleepin' Maggie?" I am not going to sing you a Scotch song, but to expostulate. I well remember a certain melancholy sort of gentleman, who, in spite of his Jaques-like vein, had much of music in him: but, at times, he hung up his harp, and the listeners listened in vain. He would promise a strain, but it came not: and those who expected pleasure, received disappointment. * * * I knew a person too who had a friend, whom he esteemed very much; he resided in a remote place, the friend in a large city. * * * The friend, compassionating the recluse's solitary situation, promised to send a book or two from the great city, in order that the long winter evenings might be shortened, and the tedious storms mitigated through their benign influence. A letter was likewise promised with news from the great world, so that the wondering ears of the recluse's wife might be gratified with the strange doings and events of that same world. Perhaps the harper and the friend may be the same person. I should be led to infer as much, because both had promised what they did not perform. * *

I am desirous to know something about the world of the fine arts. I have heard, of late, next to nothing. I am in a remote place. I am forgotten by the great world, if I ever was known. What a dismal

situation! Yet I hope to survive. I take a little mountain refreshment, now and then a good bowl of sunrise, and another of sunset, which is more than you can get, unless it is vilely smoked. Pray write to me soon, but do not promise anything, as you love me.

I remain yours, until you let me forget you,

THOMAS COLE.

TO THE SAME.

Catskill, February 21, 1843.

MY DEAR VER BRYCK,— * * * I am afraid the resolutions you made, when last here, have been put to flight by a certain little, trickish fellow, sometimes called Cupid. He is a sad fellow at times; though, like the sun and the rain, we cannot get along without him. * * *

The catalogue of fine works of art in New York is certainly not a long one, and heaven knows when it will be creditable to so large a city. Nevertheless, I wish I had been with you and Huntington. You think I do not lose much by residing in this remote place. Perhaps not much; and I would not exchange for the city. Yet the little I lose is important: the intercourse with a few congenial minds is stimulating and healthful in its influence. * * *

I have just read in the New World,[2] that Huntington has completed his historical picture, and that it is considered a fine work. I have no doubt it is so. I am anxious to see it. But our critics are strange creatures, half-fledged chickens, that twist their necks with a crow, perfectly ludicrous at times. Your mention of Ætna reminds me that I have of late been delivering a lecture before the illustrious and learned Lyceum and gentry of Catskill, on Sicilian scenery and antiquities. * * * *

Do you know I have had the ineffable pleasure of sitting on the grand jury of late, and have been studying cases of assault and battery, bigamy, larceny, etc., to my heart's content, rather discontent? You see what a public man your friend is becoming. * * *

Your letter commenced very plaintively, and I am obliged to you for Ophelia's strain. But a little more of the allegro in your letter would have given me heartfelt pleasure. * * *

I remain yours, as ever,

THOMAS COLE.

February 26th, 1843.—How the soul is linked in harmonies and associations! A word spoken now recalls one spoken years ago. A strain of music, a single tone of the voice, wings the mind into the distant past. A mountain here sends one, in a thought, to a mountain in a foreign land; the streamlet, warbling at one's feet, is answered to by another on a far-off continent. Things not only suggest their like but their very opposite. A feather can remind us of greatness and empire; a mist, of Heaven; a rock, of the very lightness and mutability of things upon earth; a leaf, of the unchangeable nature of paradise. By this magnetism of ideas is the world of the mind drawn together, and bound. This world of the mind is, in infancy, a point: it increases with the hours, the weeks, the years. As old age approaches, the accumulated materials begin to fall away,—the latest first, and so on towards the point of infancy.

CHAPTER ❧ 34

THE FALLS OF THE CATERSKILL IN WINTER.

Winter, hoary, stern and strong,
Sits the mountain crags among:
On his bleak and horrid throne,
Drift on drift the snow is piled
Into forms grotesque and wild:
Ice-ribbed precipices shed
Cold light round his grisly head:
Clouds athwart his brows are bound,
Ever whirling round and round.

March, 1843.—We have often heard that the Falls of Caterskill present an interesting spectacle in mid-winter; but, despite our strong desire to visit them, winter after winter has passed away without the accomplishment of our wish, until a few days ago. Feb. 27th, a party of ladies, who, to do them justice, are generally more alive to the beauties of nature than our gentlemen, invited Mrs. C. and myself to join in this tour in search of the wintry picturesque.

The preparation of our whole party was short; but anticipated pleasure made us prompt. The pantries were ransacked; cloaks, moccasins and mittens were in great demand, and we were soon glancing over the creaking snow. The sleigh-bells rang in harmony with our spirits, which, as usual, when we can break away from our ordinary occupations with a clear conscience, and breathe the fresh air, are light and gay.

On approaching the mountains, we were somewhat fearful that a snow-storm would put an end to our journey; but it proved transitory, and, in truth, added to our enjoyment, for by partially veiling the mountains it gave them a vast, visionary, and spectral appearance. The

sun, which had been shorn of his beams, broke forth in mild splendour, just as we came in view of the Mountain House, seated on the bleak crags a few hundred feet above us. Leaving the House to the left, we crossed the lesser of the two lakes. From its level breast, now covered with snow, the mountains rose in desolate grandeur, their steep sides bristling with bare trees, or clad in sturdy evergreens; here and there was to be seen a silvery birch, so pale and wan that one might readily imagine that it drew its aliment from the snow that rested round its roots. The Clove valley, the lofty range of the High-Peak and Round-Top, which rise beyond, as seen from the road between the House and the Falls, are in summer grand objects; but winter had given them a sterner character. The mountains seemed more precipitous, and the forms that embossed their sides more clearly defined. The projecting mounds, the rocky terraces, the shaggy clefts, down which the courses of the torrents could be traced by the gleaming ice, were exposed in the leafless forests and clear air of winter; while across the grizzly peaks the snow was driving rapidly. There is beauty, there is sublimity in the wintry aspect of the mountains; but their beauty is touched with melancholy, and their sublimity takes a dreary tone.

Before speaking of the Caterskill Falls, as arrayed in wintry garb, it will be necessary, in order to render myself intelligible to those who have never visited them, to give a hasty sketch of their appearance in summer.

There is a deep gorge in the midst of the loftiest Catskills, which, at its upper end, is terminated by a mighty wall of rock; as the spectator approaches from below, he sees its craggy and impending front rising to the height of three hundred feet. This huge rampart is semi-circular. From the centre of the more distant or central part of the semi-circle, like a gush of living light from Heaven, the cataract leaps, and foaming into feathery spray, descends into a rocky basin one hundred and eighty feet below; thence the water flows over a platform forty or fifty feet, and precipitates itself over another rock eighty feet in height; then struggling and foaming through the shattered fragments of the mountains, and shadowed by fantastic trees, it plunges into the gloomy depths of the valley below. The stream is but a small one, except when swollen by the rains and melted snows of spring and autumn; yet a thing of light and motion is at all times sufficient to give

expression to the scene, which is one of savage and silent grandeur. But its semi-circle cavern or gallery is, perhaps, the most remarkable feature of the scene. This has been formed in the wall of rock by the gradual crumbling away of a narrow stratum of soft shell, that lies beneath gray rocks of hardest texture. The gray rock now projects sixty or seventy feet, and forms a stupendous canopy, over which the cataract shoots; underneath it, if the ground were level, thousands of men might stand. A narrow path, tolerably even, but raised about twenty feet above the basin of the waterfall, leads through a depth of this arched gallery which is about five hundred feet long.

It is a singular, a wonderful scene, whether viewed from above, where the stream leaps into the tremendous gulf scooped into the very heart of the huge mountain, or as seen from below the second fall—the impending crags—the shadowy depth of the cavern, across which darts the cataract, that, broken into fleecy forms, is tossed and swayed, hither and thither, by the wayward wind—the sound of the water now falling upon the ear in a loud roar, and now in fitful, lower tones—the lonely voice—the solitary song of the valley.

But to visit the scene in winter is a privilege permitted to few, and to visit it this winter, when the spectacle (if I may so call it) is more than usually magnificent, and, as the hunters say, more *complete* than has been known for thirty years, is indeed worthy a long pilgrimage. What a contrast to its summer aspect! No leafy woods, no blossoms glittering in the sun, rejoice upon the steeps around! Hoary winter

"O'er forests wide has laid his hand,
 And they are bare;
They move and moan a spectral band,
 Struck by despair?"

There are overhanging rocks, and the dark browed cavern; but where the spangled cataract fell, stands a gigantic tower of ice, reaching from the basin of the waterfall to the very summit of the crags. From the jutting rocks, that form the canopy of which I have spoken, hang festoons of glittering icicles. Not a drop of water, not a gush of spray is to be seen; no sound of many waters strikes the ear, not even as of a gurgling rivulet or trickling rill; all is silent and motionless as death; and did not the curious eye perceive, through two window-

259

like spaces of clear ice, the falling water, one would be led to believe that all was bound in icy fetters. But there falls the cataract, not imprisoned, but shielded like a thing too delicate for the blasts of winter to blow upon. It falls, too, as in summer it falls, broken into myriads of diamonds, which group themselves as they descend, into wedge-like forms, like wild fowl when traversing the blue air. I have said that the tower or perforated column of ice reaches the whole height of the first fall; its base rests on a field of snow-covered ice, spread over the basin and rocky platform, that in some parts is broken into miniature glaciers. Near the foot it is more than thirty feet in diameter, but is somewhat narrower above. It is in general of a milk-white colour, and curiously embossed with rich and fantastic ornaments; about its base are numerous dome-like forms, supported by groups of icicles. In other parts are to be seen falling strands of flowers, each flower ruffled by the breeze; these were of the most transparent ice. This curious frost-work reminded me of the tracery and icicle-like ornament frequent in Saracenic architecture: and I have no doubt that nature suggested such ornament to the architect, as the most fitting for halls where ever-flowing fountains cooled the sultry air. Here and there, suspended from the projecting rocks that form the eaves of the great gallery, are groups and ranks of icicles of every variety of size and number. Some of them are twenty or thirty feet in length. Sparkling in the sun-light, they form a magnificent fringe.

The scene is striking from many points of view; but one seemed superior to the rest. Near by, and overhead, hung a broad festoon of icicles: a little further on, another cluster of icicles of great size, grouped with the columns all in full sunlight, contrasting finely with the sombre cavern behind. The icicles in this group appear to be broken off midway some time ago, and from their truncated ends numerous smaller icicles depend: they look like gorgeous chandeliers, or the richest pendants of a gothic cathedral wrought in crystal.

Beyond these icicles and the column, is seen a cluster of lesser columns and icicles, of pure cerulean colour; then come the broken rocks and woods. The icy spears—the majestic tower—the impending rocks overhead—the wild valley below with its contorted trees—the lofty mountains towering in the distance, compose a "wild and wondrous" scene, where the Ice-king

"Builds, in the starlight clear and cold,
A palace of ice, where the torrent falls,
With turret and arch, and fretwork fair,
And pillars blue as the summer air."

We left the spot with lingering steps and real regret, for in all probability we were never to see these wintry glories again. The royal architect builds but unstable structures, which, like worldly virtues, quickly vanish in the full light, and fiery trial.

It may be asked, by the curious, how the gigantic cylinder of ice is formed round the water-fall. The question is easily answered: the spray first congeals in a circle round the foot of the Fall, and as long as the frosts continue, this circular wall keeps rising until it reaches the summit of the cataract, as is the case this winter; but ordinarily, the column only rises part of the way up. Even when imperfectly formed, it must be strange to see the water shoot into the hollow tube of ice fifty or one hundred feet high, and I have no doubt it would amply repay any one for the fatigue and exposure to which he might be subjected in his visit.

March 26, 1843.—It is still winter, inexorable winter. Snow-storm has followed snow-storm, furious winds have blown from the north-west, and drifts of great depth been piled up. * * We never longed so much for spring. Maria wishes to be in the garden among the flowers, and I wish to ramble over the hills. But we must wait patiently. A fine comet is now flaming in the heavens. The train is of great length, stretching across one-third of the sky.

July 30.—It is a year to-day since I arrived from Europe. It was a happy day. I have had pleasant days since; but many of them strongly seasoned with the troubles of this uncertain world. I have worked hard, but fear that I have produced little of great beauty or value. The pictures I have painted are a small view of the Torri di Schiave; Campagna di Roma; View of Mount Ætna at Sunrise; Ruins of Temples at Agrigentum; Temple of Segeste; Kenilworth Castle; Rubligh Mountain, Switzerland; Aqueducts, Campagna di Roma; Snow piece, and several sketches. I am now engaged on a large picture, which, I trust, will be of more importance than anything I have done for a length of time.

I have painted it in a serious spirit, and I hope its effect will be religious. * * * *

261

After the Temptation, or "The Angels Ministering to Christ in the Wilderness," was one of Cole's largest sacred landscapes. It is spoken of as it *was*, rather than as it now is. It represented an immense tract of uncultivated country, Judean in its character, a little after day-break. The beholder is looking east. The left foreground was a fine example of the broken and rocky. The eye swept instantly down into a great gulf, opening off to the north, and then as instantly rose out of its blackness, following up the ribbed sides of an impending prec-ipice, and the piled rocks mountain high. Into that abyss the Tempter, an evil-looking form, was seen descending.

Christ and the two angels form a bright group in the right fore-ground. The radiance, which is their own, and not of the dawning, is heightened by the heavy mass of mingled foliage and darkness above them.

In from the foreground, the picture widened almost to the bound-less, giving an horizon of grandest circle, and weary extents of earth, with their manifold features of varied grace and ruggedness, still dim and sleeping beneath a veil of soft and vapoury twilight. Morning is, as yet, only wakening the *heavens:* the fire of the red day-break is just catching along the under folds of the low, sullen clouds of night, yet gloomily mantling the scene. It had great grandeur, great solemn-ity, great repose. So predominant were these qualities of the picture, as a simple piece of nature, that the group of celestial figures were thereby thrown into the false position of accessories. To redeem them from that, and give them their due importance, Cole was per-suaded by an officious friend to cut the canvass down to its present size; in which, indeed, there is visible all the subtle, spiritual beauty of the silent, solemn hour represented, but with a sad diminution of its original grandeur as a landscape.

Allston is dead![1] As a man he was beloved by all who were so fortunate as to be acquainted with him. It was not my lot to have a very great intercourse with him: that which I had has caused me to regret his loss exceedingly.

He was truly a distinguished artist, and has executed works which will never cease to be highly prized, and considered great works of art. His taste was pure, and elevated far above that of most of his contemporaries. He always aimed at the highest beauty, both of

execution and sentiment, ever considering the former as the servant of the latter. His Dead Man Restored by touching the bones of Elisha, and his Miriam, may be considered among his finest works. His Belshazzar I have not seen. Some of the small pictures painted in later years are exquisite. The sketches, and half-finished pictures, which I have seen in his studio, are charming. It is to be regretted that they were never finished. * * * *

He was a great artist, a good man, an honour to his country—one whose name should be revered and respected. In person, he was about the middle size, and when I knew him, spare and almost emaciated. His countenance was pale, marked with deep lines, and full of mobility. His eyes were very prominent, his forehead retreating, and his hair falling on his shoulders in silvery ringlets. His walk was peculiar, a sort of springing gait, as though his spirit could scarcely be kept from rising by its mortal cumbrance. He is gone to that land where the love and beauty which dwelt so much in his soul will be perfected and glorified.

A SUNSET.

I saw a glory in the etherial deep;
 A glory such as from the higher heaven
Must have descended. Earth does never keep
 In its embrace such beauty. Clouds were driven,
As by God's breath, into unearthly forms,
 And then did glow, and burn with living flames,
 And hues so bright, so wonderful and rare,
That human language cannot give them names;
And light and shadow strangely linked their arms
 In loveliness: and all continual were
In change; and with each change there came new charms.

Nor orient pearls, nor flowers in glittering dew,
 Nor golden tinctures, nor the insect's wings,
Nor purple splendours for imperial view,
 Nor all that art, or earth to mortals brings,
Can e'er compare with what the skies unfurl'd.

These are the wings of angels, I exclaimed,
 Spread in their mystic beauty o'er the world.
 Be ceaseless thanks to God that, in his love,
He gives such glimpses of the life above,
 That we, poor pilgrims, on this darkling sphere,
 Beyond its shadows may our hopes uprear.

CHAPTER ❧ 35

Picture of Ætna from Taormina. To Mrs. Cole: the Sketch Club. To Mr. Parker; L'Allegro and Il Penseroso. Campagna di Roma. To Mr. Wadsworth: proposed pictures, Sowing and Reaping; Life, Death, and Immortality. To Mrs. Cole: the Mill at Sunset. To the Same: Moon over the left Shoulder. Poem of the Voyage of Life. Thoughts, &c.: death of Ver Bryck. Pictures of 1845–6. To Mrs. Cole: the Elijah. Church, the painter. Twilight.

Tʜᴇ ensuing autumn and winter, Cole made an exhibition of some of his pictures, first in Boston, and then in New York, but not with the success anticipated.

The following, dated New York, December 9th, 1843, was written to his wife, a few days previous to the opening of his exhibition in the old gallery of the Academy of Design, in Clinton Hall:

"Since I last wrote I have been as busy as anybody possibly can be. Mrs. Reed could not let me have the Course of Empire, which, you know, is a great disappointment, as it must diminish the effect of my exhibition. But I have determined to make up for it, and have commenced a large picture, larger than the Angel's Ministering to Christ, of Mount Ætna from Taormina. I have already finished two-thirds of it, and have only painted on it two days. I never painted so rapidly in my life."

He might have added, "nor with more delight." It was painted in the gallery, with the pictures ready for exhibition around him. During its progress his sister paid him a visit. With a great brush, his palette piled with colours, and with coat off, he went rushing to the canvass. "Ah, Sarah," said he, as she entered, "this is the room to paint in—and this is the way I love to paint."

Speaking of this work, Bryant says, "It was a miracle of rapid and powerful execution. It was not so generally admired as many of his works, and no doubt had in it some of the imperfections of haste; but,

264

for my part, I never stood before it without feeling that sense of elevation and enlargement with which we look upon huge and lofty mountains in nature. With me, at least, the artist had succeeded in producing the effect at which he aimed, I have no doubt that he painted it with a mind full of the greatness of the subject, with a feeling of sublime awe, produced by the image of that mighty mountain, the summit of which is white with perpetual snow, while the slopes around its base are basking in perpetual summer, and on whose peak the sunshine yet lingers, while the valleys, at its foot, lie in the evening twilight." Subjoined is Cole's description of the picture:

MOUNT ÆTNA FROM TAORMINA, SICILY.

The scene, from which the artist took this picture, is considered one of the finest in the world. In the distance rises Mount Ætna, clad in snows, which the fires of the volcano never entirely dissolve. Its height is about eleven thousand feet above the Mediterranean, which, on the left of the picture, is seen to indent the eastern coast of Sicily. In the middle distance of the picture, forming part of the vast base of Ætna, is a varied country, broken yet fertile, and interspersed with villages, olive groves and vineyards. Crowning a hill, on the right of the picture, may be seen part of the village of Taormina, anciently a city of consequence, and now interesting to the traveller from the numerous remains of Grecian and Roman antiquity, which still exist. In the foreground, is the ancient theatre of Taormina, one of the most remarkable remains of antiquity. This theatre was built by the Greeks. The Romans afterwards altered it, so as to adapt it to their less tasteful and refined exhibitions. It afterwards became a Saracenic palace and fortress, and more recently, the villa of a Sicilian nobleman. It has been abandoned for many years, and has suffered from time and violence, and is now in the state in which it is represented in the picture. The time is soon after sunrise.

TO MRS. COLE:

New York, Jan. 5th, 1844.
* * The Hartford people wish to have my picture of Ætna for their new Lyceum, where they have a fine exhibition-room. They will give me $500 for it. Pretty good for five days work. * *

I had the club here on Friday last. There has never been a fuller meeting, nor a more pleasant one. The article on Sicily seems to please. I suppose you have gotten your Knickerbocker before this?[1]

* * * * * * *

TO MR. CHARLES PARKER.

New York, Jan. 8, 1844.

DEAR SIR,—* * I now write to say, unless you suggest something from nature, of which I have sketches, or from poetry or history, I intend to commence two pictures, to be called L'Allegro and Il Penseroso. In the first, I should represent a sunny luxuriant landscape, with figures engaged in gay pastimes or pleasant occupation. In the second, I would represent some ivy clad ruin in the solemn twilight, with a solitary figure musing amid the decaying grandeur around. I hope the subject will suit your taste, for it is one on which I can work con amore. I have just finished two pictures for Miss Hicks. One is a view of the Campagna di Roma, the other a fancy piece.

* *

I remain, yours truly,

THOMAS COLE.

The Campagna di Roma, (using the appropriate language of Bryant,) with its broad masses of shadow dividing the sunshine that bathes the solitary plain strown with ruins, its glorious mountains in the distance, and its silence made visible to the eye, is one of those pictures of Cole which we most value, and most affectionately admire.

TO MR. WADSWORTH, OF HARTFORD, CONN.[2]

DEAR SIR,—* * * I have been dwelling on many subjects, and looking forward to the time when I can embody them on the canvass. They are subjects of a moral and religious nature. On such I think it the duty of the artist to employ his abilities: for his mission, if I may so term it, is a great and serious one. His work ought not to be a dead imitation of things, without the power to impress a sentiment, or enforce a truth.

If it is not taking too great a liberty, I will attempt to describe one

or two of the subjects which I am desirous to paint. One is to be called Sowing and Reaping, in four paintings.

The first would represent a rich and beautiful landscape in spring—streams, waterfalls, trees, cottages and a rainbow. In the foreground, as a principal figure, should be a husbandman sowing grain. Others might be seen engaged in the various occupations of agriculture of the season. It should be a fresh and vigorous landscape, full of motion. In this the husbandman, trusting to bounteous Heaven, commits the seed to the earth.

The second would represent a battle-field: a conqueror riding over the slain in pursuit of a defeated enemy, cornfields and villages burning, every thing to depict the horrid effects of war. In this picture, the conqueror, trusting in his own strength, sows his seed of ambition.

The third picture would represent reaping. The same scene as the first, but in harvest time—the reapers coming from the field, or bringing the last loaded wagons into the barn; the husbandman sitting at the door of his dwelling, under his vine and porch, in the midst of his happy family. Here the husbandman reaps the honest fruits of his labour.

In the fourth picture the conqueror is seen sitting with gloomy brow in a magnificent chamber of his palace, by a table, upon which is a dagger, and a paper inscribed with names, and headed Proscription. In the background are seen conspirators stealing from behind massive columns to assassinate him. In this the conqueror reaps the fruits of ambition. In this series the moral lesson would be obvious.

Another subject under consideration I would call Life, Death and Immortality—a series of three pictures.

The first picture, Life, would represent day—a magnificent landscape—distant mountains, flying clouds casting their shadows over the green hills, rivers, waterfalls, luxuriant trees and fields of waving grain, vessels wafted by the breeze; all sunny, figures variously engaged, children and old men—every thing to indicate the fullness and variety of life.

The second picture, Death, should be night—a wild and dreary landscape—a few leafless trees stretch their branches across the gloomy sky, a distant view of the ocean, a few faint streaks of light on the horizon, the vestiges of departed day, a vast cavern seen in the sides of a mountain, and descending into it a funeral procession,

torch-light, the corpse covered with white drapery, and followed by a few mourners. The cavern will be lighted by torches, the rocks, arches and columns retiring into the deep gloom, here and there a sarcophagus or other monumental form, showing that this is the sepulchre of the multitudinous dead. A tone of solemn gloom and darkness must pervade this picture.

The third, Immortality. Any description of this picture would, perhaps, only mislead, as its effect will depend mostly on its execution. It will consist of angels conducting a spirit towards the gates of heaven, a flood of light bursting from on high upon the ascending figures, and piercing the trackless gloom that lies behind them.

In this series, the transient fullness of Life is contrasted with the gloomy silence of succeeding Death, which again is the preparation for the glories of Immortality, intimated, but not disclosed.

In painting these pictures there would, of course, be changes and variations from what I have written, in order to the accomplishment of pictorial effect. The figures, in general, would be comparatively small.

TO MRS. COLE:

New York, March 15, 1844.
 * * * My picture is in a state that I cannot well leave it. And to-night there is a second meeting of gentlemen at Mr. Sturges' on the subject of establishing a permanent gallery of pictures in the city of New York. The Reed gallery is to be purchased as a commencement. The Course of Empire, in such a case will be disposed of in a manner most agreeable to me. * * *

The picture of which he speaks, called the "Mill at Sunset," is one of those rare creations of the pencil that touch the thoughtful beholder like a rich and tender melody. If the expression may be allowed, it is a pictured song; one of the finest of songs too, and most beautifully pictured. The manifold sounds and activities of the day are so far quieted that the cattle, ruminating or grazing in the luxuriant pasture, the children sporting on the flowery green, and the busy mill, are left as striking characteristics of the scene, and sing to

the heart, while the rich vesture of the month, the glassy lake, reflecting the quiet beauty of the floating clouds, and all bathed in the day's last delicious light, fill the senses, and entrance the soul. For beauty of composition, fine colouring, graceful line and delicacy of touch, and that moist, living air, so peculiar to Cole, few of his pictures are superior to the "Mill at Sunset."

Dissatisfied with the subjects which circumstances now required him to paint, and saddened by the death of Ver Bryck, Cole found, during his favourite month of June, exercise for thought, as well as solace for his grief, in the composition of a poem, in four cantos; a kind of translation, in heroic verse, of his painted Allegory of the Voyage of Life, and containing passages of great strength, beauty and pathos. Among his larger poems, this, for the music of its verse and some other qualities, would undoubtedly stand first with the mass of readers.

July 9, 1844.—Since writing on these pages, many months have elapsed. I spent the winter in the city, but sorrowfully, for I was separated from my dear wife and children. It seemed well on account of business. I exhibited the largest collection of my pictures that I ever placed before the public, at one time.

This spring, I lost my dear and valued friend Ver Bryck. He had been long ill. I was with him an hour before he died. He went away in peace—Christian peace. His mind was clear to the last. Where shall I turn for the companionship of so congenial a mind—of one so pure, so refined? * * *

A more lengthy tribute of affection to his friend is a memoir, written at the request of the National Academy of Design, and published in the Evening Post.[3]

A token of Cole's goodness, as well as an additional memorial of his love for Ver Bryck, is a small, but carefully painted picture, executed for him some time after his death, to answer a commission given him by a generous patron. The subject, selected by Ver Bryck himself from his own sketches, not long before he died, is a tranquil sylvan scene in summer, on the Thames, and expresses in its treatment that sweet and fresh repose, upon which the heart of the sufferer would naturally love to dwell.

TO MRS. COLE:

Boston, Aug. 22d, 1844.
* * * I arrived here last evening. I spent a day with Mr. Church,[4] at Hartford, very pleasantly. This afternoon, it is my intention to proceed to Dresden, on the Kennebec, where Mr. Pratt is gone, and will meet me. We shall then go to the Penobscot. I intend to be as spirited as possible, and to get as many fine sketches as I can. Mr. Church will be with you in a few days after you get this. * *

Cole was on his way to Mount Desert Island, on the coast of Maine, for the study and sketching of sea views.

August 29.—We are now at a village in which there is no tavern, in the heart of Mount Desert Island. One might imagine himself in the centre of a continent with a lake or two in view. The ride over the island took us through delightful woods of fir and cedar.

August 30.—The view from Beech Mountain—sheets of water inland, fresh-water lakes, and mountains, the ocean with vessels sprinkling its bosom—is magnificent. * * *

September 3.—The ride here to Lynham's was delightful, affording fine views of Frenchman's Bay on the left, and the lofty peaks of Mount Desert on the right. The mountains rise precipitously—vast bare walls of rock, in some places of basaltic appearance. Those near us, I should suppose, were not far from 2000 feet above the sea. The road was exceedingly bad, stony, and overhung with the beech and spruce, and, for miles, without inhabitant. We lost our road too, and came to a romantic place near a mountain gorge, with a deserted house and a piece of meadow. One might easily have fancied himself in the forests of the Alleghanies but for the dull roar of the ocean breaking on the stillness. The beeches of this region are remarkably fine. Sand Beach is the grandest coast scenery we have yet found. Sand Beach Head, the eastern extremity of Mount Desert Island, is a tremendous overhanging precipice, rising from the ocean, with the surf dashing against it in a frightful manner. The whole coast along here is iron bound—threatening crags, and dark caverns in which the sea thunders. The view of Frenchman's bay and islands is truly fine. Some of the islands, called porcupines, are lofty, and belted with

crags which glitter in the setting sun. Beyond and across the bay is a range of mountains of beautiful aerial hues.

Some pecuniary embarrassment, arising from an imprudent investment, and requiring too much of his time, together with his dependency upon commissions, which seldom allowed satisfactory scope to his pencil, served for a time to interfere greatly with that serenity of mind which Cole now desired more earnestly than ever in order to the successful pursuit of his art. He executed, though, during this period, (1845 and 46,) numbers of pictures, large and small, several of which are among his finest landscapes.—Twilight, a view up the Catskill river, with great extent of woodlands, and the distant, dark blue mountains—the delicate skirt of a brilliant summer afternoon. The Cross in the Wilderness—the last hour of an autumnal day, with vapoury air and rich yellow light. The Mountain Ford—wonderful for the moisture and clarity of its deep heaven, and the vitality of its atmosphere. Campagna di Roma and Torri di Schiave—that subtle effect, impalpable but to the eye of the keenest observer, of the moonlight stealing in from the east upon the retiring twilight. The Catskill Mountain House—the eastern slope of the south mountain with its broken tangled forests of oaks and maples and steepled pines, as viewed from the lofty northern crags. L'Allegro—a joyous spirited picture of a rural scene in Italy. Il Penseroso, Lake Nemi after sunset—expressive of the tender, pensive spirit of the hour, and the pleasing loneliness of shadowy woods and waters. The Pic-nic Party—a sylvan scene, all American, wide, bright, polished waters, manifold woods, over all the sweet glad light and quiet air, and every where the sense of beauty with wildness. Home in the Woods, The Hunter's Return—both large landscapes, and full of the rarest excellencies of the pencil; more especially the latter, which opens upon the beholder one of those wild picturesque dells, peculiar to the Alleghanies, where the wooded mountains, the atmosphere and sky are steeped in the still solitary splendours, the crimson, gold and purple, of an autumnal sunset, all conspiring to make it, next to the Good Shepherd, the most complete of his picture idyls, and certainly one of the finest simple landscapes to be found. To mention one more, The Arch of Nero—a quickly painted picture, but one powerfully expressive of the activities of nature, of great harmony and

perfection of parts, "and rendered to the eye," says Bryant, "with an easy and happy dexterity, so natural, at this time, to the pencil of Cole."

New York, March 3, 1845.

I arrived here safely with the pictures. I have not quite finished the Catskill yet, but have commenced sketching on the canvass for the Sea View. There was a very pleasant club-meeting at V. P.——'s,[5] on Thursday. Mr. Sturges is pleased with the Ver Bryck picture.

I forgot to tell the children they must be very good when I am away. I hope Theddy draws, and Mary. Ask Mr. Church if he will not give Theddy a little lesson. Tell Mr. C. that I expect to see something quite fine on my return. I am not quite certain whether I can come up before next week. I wish to finish my pictures and sell them.
* * *

The pictures, to which he alludes above, are more particularly the Sea View, from one of his studies made the summer before, at Mount Desert Island, on the coast of Maine, and Elijah at the mouth of the cave in the mount of God—a large picture, painted in a week; having no doubt some of the unavoidable faults of haste, but many very bold and striking features, and embodying real grandeur of conception. Although not popular, Cole insisted upon it that it was one of his most effective works.

From the foregoing letter, it will be perceived that Frederick Church was, at the time, a pupil of Cole. Although a mere youth, and fonder, perhaps, of the beauties spread in profusion around him than of the painting room, he yet exhibited in his sketches of nature a facility and correctness of drawing that gave high promise of that excellency which now justly places him among great and true landscape painters. "Church," said Cole, on several occasions, "has the finest eye for drawing in the world."

Those pleasant days, when his artistic talents were directed by his distinguished master, will ever occupy a large place in the memory of the pupil, now growing into his celebrity. An excursion to Black Head, or the Dome Mountain, as Cole loved to call it, one of the finest portions of the Catskill, must always continue to be, both to

the present writer and the living painter, one of the luminous points of the past. Our ride, in the morning, over the finely broken, intervening country, through the fresh air, sweetly scented with millions of flowers in the fields and along the road-side, the likeness of which we see in many of Cole's rich pictures, was one of those rides the very memory of which is beautiful and fragrant. At noon, thirsty and panting on the moss beneath the black fir trees of the summit, we gazed and listened, and grew cool and rested;

> "While from all around—
> Earth and her waters, and the depths of air,—
> Came a still voice."

Then followed the descent—the plunge down the wooded steeps, and the laughable mishaps, from slips upon the slant wet rocks, and trips among the roots, vines and brush-wood; and all concluding with a pensive return homeward, in the dark, loaded with blooming boughs, gathered while yet the golden rays of the sun were upon their crimson and snowy clusters.

TWILIGHT.

The woods are dark; but yet the lingering light
 Spreads its last beauty o'er the western sky.
How lovely are the portals of the night,
 When stars come out to watch the day-light die.

The woods are dark; but yet yon little bird
 Is warbling by her newly furnished nest.
No sound beside in all the vale is heard:
 But she for rapture cannot, cannot rest.

CHAPTER ❦ 36

Thoughts and occurrences: anticipations of a great work; birth-day; the Tread of Time; death in the family; lost time. Excursion to the Sha-wangunk. Excursion to South Peak. A new studio. Its view. Excursion to the Adirondack Mountains. Thoughts, &c.: Christmas-day; birth-day; death in the family. Niagara. To Mr. Falconer: sculpture and painting. Thoughts, &c.: New Year's-day; the season. Cole's last letter: mental and moral habits of artists. Thoughts, &c.: Cole's last notes.

JANUARY 1, 1846.— * * I long for the time when I can paint whatever my imagination would dictate without fear of running into pecuniary difficulties. This painting for money, and to please the many, is sadly repulsive to me. Thoughts, conceptions crowd upon me, at times, that I would fain embody. I am kept from them by necessity. I am like one who, travelling through a desert, comes to a deep stream, beyond which he sees green fields, and fruits, and flowers, and fears to venture in the rushing waters. But I am about to venture. I have determined to commence, in a short time, indeed I have already commenced drawing on the canvasses, a series of five pictures. The subject is the Cross and the World. I have no commission for the work, and my means are scarcely competent for me to accomplish so great an undertaking. But the work, I trust, is a good one, and I will venture in faith and hope.

February 1, 1846.—This is my birth-day. The air is keen, but calm; the sky almost cloudless at sunrise. The mountains received the first rosy light in deep serenity. It is Sunday, and a holy calm seems to rest on hill and valley, and the voiceless air. O that this morning's tranquil beauty may be an augury of the coming year to me!—that my soul may be possessed by that holy peace which descends from heaven!

THE TREAD OF TIME.

Hark! I hear the tread of time,
Marching o'er the fields sublime,

Through the portals of the past,
When the stars by God were cast
On the deep, the boundless vast.

Onward, onward still he strides,
Nations clinging to his sides:
Kingdoms crushed he tramples o'er:
Fame's shrill trumpet, battle's roar
Storm-like rise, then speak no more.

Lo! he nears us—awful Time—
Bearing on his wings sublime
All our seasons, fruit and flower,
Joy and hope, and love and power:
Ah, he grasps the present hour.

* * * * *

Underneath his mantle dark,
See, a spectre grim and stark,
At his girdle like a sheath,
Without passion, voice or breath,
Ruin dealing: Death—'tis Death!

Stop the ruffian, Time!—lay hold!—
Is there then no power so bold?—
None to thwart him in his way?—
Wrest from him his precious prey,
And the tyrant robber slay?

Struggle not, my foolish soul:
Let Time's garments round thee roll.
Time, God's servant—think no scorn—
Gathers up the sheaves of corn,
Which the spectre, Death, hath shorn.

Brightly through the orient far,
Soon shall rise a glorious star:
Cumber'd then by Death no more,
Time shall fold his pinions hoar,
And be named the Evermore.

July 1, 1846.—I open this book once more, and to record an event which has brought upon me new cares. The death of Mr. Thompson,

my wife's uncle, with whom we have lived ever since we were married. * * * He died in his seventieth year, in the communion of the Holy Catholic Church, and in the hope of a joyful resurrection. * * * * *

The gardens and orchards, for weeks past, have shown evidences that their master's hand is no longer here. Useless shoots disfigure the trees. Weeds riot in the beds, and the grape-vines are trailing on the ground. The beautiful around us is tinged with melancholy, and even the vine and tree converse with us of one who has left us for ever. No, not for ever. God grant that we meet him in those gardens of eternal joy where death can never enter.

July 28, 1846.—The summer is in a great measure past, and I have produced very little in my art. Circumstances have waylaid and robbed me of much precious time. These seasons of lying fallow occur from time to time in the minds of most men whose pursuits are intellectual,—seasons when the mind seems incapable of executing any great work. It has, in fact, lost its enthusiasm, without which nothing fine in art can be produced. I trust this unproductive season will soon pass by, and that I shall be engaged earnestly upon some important work.

If Cole, as he complains above, had, for the while, little enthusiasm for painting, he was full of enthusiasm in gathering for it fresh materials from nature. The months of Aug. and Sep. were mainly devoted to mountain excursions.

His first, in company with McConkey, then his pupil, and a couple of friends, was to the Shawangunk, those picturesque hills of Ulster county, from whose heights the eye looks south upon the Highlands, and to the north upon the blue Catskills, and the distant fields and summits of New England. A couple of days were spent in this pleasant summer region, and several choice studies of the remarkable lake, which sleeps in a high fissure of the mountain, and of its singularly wild shores of perpendicular precipices and huge crags, evidently the ruins of a portion of an adjacent peak, added to his already large collection.

Of several amusing incidents, occuring at the time, a single one is here related. At the close of an unusually happy day, under a heaven of most perfect loveliness, and in the midst of strikingly romantic

scenery, climbing and creeping among crags and shrubbery, singing, shouting, bathing, gathering mosses, and "huckleberries," when not engaged in the more quiet employment of sketching, all returned to the little mountain inn to supper. During the evening, while they were recounting the pleasant toils and adventures of the day, to which mine host, a short-spoken Dutchman, sat gravely listening, with the smoke of a rank old pipe curling round his head, the pleasing anticipations of the morrow were quickly put to flight by the following intelligence, seasoned with a caution: "Better be a little careful about the pond there. It's all rattle-snakes. A man shot sixty there, one day, and never got out of his tracks." An involuntary shiver, with cold chills and exclamations of horror, instantly ran over the whole party. A conversation upon snakes, serious and comic, was kept up until a late hour, and now and then renewed from bed to bed during the night. All dreamed of snakes, and waked in the morning to renew the theme. Cole and McConkey returned after breakfast to the scene, to complete their sketches, but with very different feelings from those with which they had, the day previous, sought the picturesque lake of the Shawangunk.

A half finished picture, exquisitely beautiful in its sky, remains as a memento of this delightful excursion.

This was succeeded by an exhilarating jaunt to South Peak, perhaps the finest for views in the whole range of the Catskills. It was accomplished in two days with a party of twelve, the larger part of whom were ladies.[1]

The following is Cole's description of the manner in which the night was passed upon the summit.

* * * * * * *

Evening now closed around us. The red flame shot up its long tongue with a loud crackling when the gummy foliage of the evergreen fir was sportively thrown upon the fire, and the smoke rolled up and away in luminous billows over the tree-tops, waving to and fro in the fresh night-breeze, and shining in the pale green light. The heavens seemed, even in their starry blue, awfully dark—immeasurably deep: the trees more closely about us stood out in strong relief from the broad gloom of the great mountain forest; and the bough-

house, all glowing with a flood of light except its dark recesses, presented a scene of singular beauty. Within reclining forms were dimly seen: in front, figures in grotesque costumes of shawl and blanket, both sitting and standing, caught the vivid brightness on their faces and vestments. Every light was clear; every shadow mingled with the shadow of the surrounding woods, giving a unity of effect that ceases to exist by day. Every form, thus united with the great shadow of the wilderness, became, with trees and grass, a part of the mountain top.

And now came songs and pleasant jests, recitations, snatches of old plays, and bits of romance. Ever and anon a shrill whoop went like an arrow into the vast solitude. Last of all, when the general excitement had abated, and a solemn quiet had settled upon every heart and countenance, (as we were a Christian band,) came prayer and the *Gloria in Excelsis.* As the last strains died away, and we realized ourselves far above the common world, in the cold, pure region of the clouds, thoughts of earth, with its cares and turmoils, took their departure—thoughts of heaven, with its eternal order, stole upon the soul, and attuned it to quiet songs of joy and thankfulness.

Then came the hours of repose. One by one we sank down upon the fragrant fir, the ladies in the more retired part, the gentlemen on the outer edge of the bough tent, one in shawl or cloak, another in his blanket, and I in my brown monk's dress. After a fragmentary conversation in low tones, here and there, like scattering shots after a day of battle, all was silent. Though weary, I had no disposition to sleep; and so, with closed eyes, I either made pictures in the dark, or opened them, and looked through the eaves of our leafy roof into the pure blue of the heavens, now beginning to pale in the rising moon. As she ascended she darted her silvery rays, through the trembling leafage of the interposing wood, full upon my face. In the meantime, the ear was busy drinking in both soothing and awakening sounds. The weary sleepers breathed heavily; the breeze, at one time softly whispering over head, came at another rushing over the forest tops with a fitful melancholy roar—now afar off like the sea surf, and now making the branches swing about in the dim light of our declining fire. Solemn, awful midnight! A thousand fancies came thronging on my mind. Stillness, however, did not reign uninterruptedly through the night. There was music between the acts of our silent

drama, sleep. Two of the gentlemen rising to renew the fire, one of them,[2] familiar with Indian life and manners, sang with characteristic gestures an Indian song. From low guttural tones the voice rose in mournful strains, higher and higher, to the utmost loudness; then, sinking to the same deep note from whence it first commenced, it presently swelled again in fitful modulations to the shrillest pitch, and concluded abruptly with a yell. After this wild and unique melody, the gentlemen resumed their places upon the evergreens, and all was still again, except the breeze and the crackling of the brilliant fire. Not a cricket chirped. In the surrounding woods the winds sang their songs alone. When the gray dawn broke in mildly, a solitary robin on the mountain side below us was warbling his morning hymn. I shall never forget the quiet sorrow with which, in the course of the forenoon, we bade farewell to South Peak, and slowly took our way down the mountain to our conveyances at the farm-house.

A matter of much interest to Cole, after these mountain wanderings, was the building of a new studio. It is constructed somewhat in the Italian villa style, and with reference to a spacious gallery, soon to have been built for the large works he contemplated painting. Its situation commands a view of vale and mountain of the rarest beauty. At a distance of ten miles, a portion of the Catskills, fronting the Hudson, for some thirty miles in extent, rise abruptly to the height of three and four thousand feet, having an outline along the sky of exceeding grace, and presenting, in Cole's own words, a very good resemblance to the base of Mount Ætna. A fancy sufficiently lively to supply the appropriate summit, would thus enable the beholder to form, from the door of the studio, a tolerable conception of that grand volcano. The space overlooked from the studio to the foot of the mountains is singularly beautiful and picturesque, having numberless wooded hills and rocky points, interspersed with softest meadows and pasture-lands, and here and there enlivened with the sparkling waters of the Catskill river. Along the flowing outline of the mountains are seen, now behind one summit and then behind another, as the season changes, some of the finest sunsets; at one time rivaling those of Italy in tenderness, at another, inexpressibly wild and gorgeous.

In the September following, Cole, with a friend and McConkey,

made a fortnight's excursion to the Adirondack Mountains, and the wild shores of Long Lake. It is not, perhaps, generally known that, to this day, a jaunt through that region of the State of New York will ordinarily subject the tourist to more privation and fatigue than almost any other he can take in the United States, this side of the Mississippi. The wilderness, haunted by the great moose, the wolf, the bear and panther, seems almost interminable, and nearly houseless: the mountains, some of them reaching into the sky, ragged, rocky pinnacles, and robed with savage grandeur, are pathless and inaccessible without a guide: the lakes, which are every where, and often strikingly beautiful, repel by the oppressive loneliness in which they slumber. The excursion, certainly one of the wildest and most fatiguing, was also, with its varied incidents, one of the most agreeable Cole had ever taken in America in search of the picturesque. Bursts of sunshine, shouts and merriment, cheered the tiresome hours through the gloomy shades of the vast woods: songs and firelight, with the recollections of the past day, and the anticipations of the coming, turned the rude encampment under the dewy forest boughs into a kind of festivity: even the long twenty miles down Long Lake, (that Lago Maggiore of the woods, as Cole himself called it,) in a little skiff— the painter and his companions, with their guide, a boy, alternately at the oars,—and the longer twenty miles back again, next day, in the cold rain, had their intervals of pleasing excitement, from trout-fishing, from a night's repose in the forest, and from the ever-changing scenery on the shores and islands, now and then transferred to the sketch-book.

Among the most picturesque of his sketches, taken in this Alpine wilderness, were those of the Indian Pass, a gorge of wonderful sublimity and wilderness, in the neighbourhood of Tahawus, the Mont Blanc of New York, and the ironworks of Mr. McIntyre, from whom Cole and his friends received every hospitality. John Cheney,[3] as remarkable with his single pistol among the fierce denizens of those savage woods, as Hood with his bow in the wilds of Sherwood, was both guide and entertainer. As instances of his prowess with this little weapon, and of his simplicity in speaking of it, he clipped off the head of a pigeon sitting upon a high tree; and said, "Some bucks came from the city with fancy rifles to shoot with me; but I generally beat them, because they sometimes missed." The ride

out to Lake Champlain, sixty miles, portions of the way through the darkest forests, will ever be remembered by his companions as one of the merriest, if not the most comfortable, of their lives. It was upon a "buck-board," a single plank laid on the two axle-trees of a lumber wagon, upon which you sit sideways, with the feet resting upon a parallel chain.

Christmas day, 1846.—
I am now sitting in my new studio. I have promised myself much enjoyment in it, and great success in the prosecution of my art. But I ought ever to bear in mind that "the night cometh, when no man can work." I pray to God that what I am permitted to accomplish here may be to his glory. If I produce fine works, I must ascribe the honour to the Giver of the gift. * * *

February 1.—My birth-day. How they steal on! one by one they come. But their coming will cease, and this day no more be commemorated in this book. Few are the steps across the fields of life, and there is no return. Eternity opens before me: how deep, how dark the gulf! O God, be thou my help, my support, when the last step is taken. "In Thee have I trusted; let me never be confounded." This day I have painted the sky in the first picture of the Cross and the World.

April 6.—"The Lord gave, the Lord hath taken away." Our infant daughter died yesterday afternoon. Its pilgrimage in this world has been short and sinless. God, in His great mercy, has taken it unto Himself before the world could defile its spiritual garments.

September 4, 1847.—On Tuesday last, Maria and I returned from an excursion to Niagara. Niagara I have visited before. Its effect on my mind was perhaps as great as when I first saw it. But I am convinced that, sublime and beautiful as it is, it would soon cease to excite much emotion. The truth is, that the mind dwells not long with delight on objects whose main quality is motion, unless that motion is varied. Niagara, stupendous and unceasing as it is, is nevertheless comparatively limited,—limited in its resources and duration. The mind quickly runs to the fountain head of all its waters; the eye marks the process of its sinking to decay. The highest sublime the mind of man comprehendeth not. He stands upon one shore, but sees not the other. Not in action, but in deep *repose*, is the loftiest

element of the sublime. With action waste and ultimate exhaustion are associated. In the pure blue sky is the highest sublime. There is the illimitable. When the soul essays to wing its flight into that awful profound, it returns tremblingly to its earthly rest. All is deep, unbroken repose up there—voiceless, motionless, without the colours, light and shadows, and ever-changing draperies of the lower earth. There we look into the uncurtained, solemn serene—into the eternal, the infinite—toward the throne of the Almighty.

The beauty of Niagara is truly wonderful, and of great variety. Morning and evening, noon and midnight, in storm and calm, summer and winter, it has a splendour all its own. In its green glancing depths there is beauty; and also in its white misty showers. In its snow-like drifts of foam below, beauty writhes in torment. Iris, at the presence of the sun, at the meek presence of the moon, wreathes its feet with brighter glories than she hangs around the temples of the cloud. Yet all is limited. It cannot bear comparison with that which haunts the upper abysses of the air. There is infinity in the cloud-scenery of a sunset. Men see it, though, so commonly, that it ceases to make an impression upon them. Niagara they see but once or so, and then only for a little while; hence the power it exerts over their minds. Were there Niagaras around us daily, they would not only cease in most cases to be objects of pleasure, but would, very likely, become sources of annoyance. But great, glorious, and sublime Niagara—wonder to the eye of man—I do not wish to disparage thee. Thou hast a power to stir the deep soul. Thy mighty and majestic cadence echoes in my heart, and moves my spirit to many thoughts and feelings. Thy bright misty towers, meeting the vault on high, and based upon the shooting spray beneath, are images of purity. Thy voice—deep calling unto deep, with a might that makes thy hoary cliffs to tremble, leads back the soul to Him, speaking upon Sinai's smoking summit. Thy steep-down craggy precipices are the triumphal gate through which, in grand procession, pass the royal lakes and captive rivers. The soul is full of thee. Favoured is the man who treads thy brink. Thankful should he be to God for the display of one of His most wonderful works. But they are blessed who see thee not, if they will accept the gift which God vouchsafes to all men, —which, in beauty and sublimity, does far surpass Niagara—the sky.

O that men would turn from their sordid pursuits, and lift their eyes with reverential wonder there.

<center>TO MR. JOHN M. FALCONER.[4]</center>

Catskill, Dec. 29th, 1847. * * * It seems to me that sculpture has risen above par, of late: painters are but an inferior grade of artists. This exaltation of sculpture above painting, which in this country has prevailed, is unjust, and has never been acknowledged in the past. There is no necessity for insisting upon the superior claims of either, and particularly upon those of sculpture, for they are the least tenable.

Taking painting in all its departments, its influence is certainly more extensive than that of sculpture: and to excel in painting requires a combination of a greater number of faculties than to excel in sculpture. Sculpture is more limited. He who cannot distinguish one colour from another may be a sculptor. I only intend to say that undue importance has been given lately to sculpture. * *

Yours truly, but in haste,

THOMAS COLE.

January 1, 1848.—I thank God for the blessings of the past year. They have been manifold. Another year, a stranger whose face is yet unknown to us, is announced. Mysterious strangers they are, these years. Pilgrims of time that wander through eternity to do homage, and sing praises at the foot of God's throne. * * Of my series, the last picture of the Pilgrim of the Cross is about finished and the second of the Pilgrim of the World somewhat advanced. I am painting a smaller picture from a passage in the Psalms. * * *

The epistle below, written upon his birth-day, was Cole's last letter:

<center>TO MR. FALCONER:</center>

Catskill, February 1st, 1848. My DEAR SIR,—* * * * I assure you that a letter from you is an incident, a source of great pleasure to us. It breaks

in upon the calm stillness of our country life, which would, but for such incidents, become too monotonous, perhaps stagnant. Yours is the pebble thrown into the lake, which hitherto has only reflected fixedly its neighbouring banks, but now images things far and near, the woods, the clouds and distant mountain tops and circling ripples along its shores. But hold! I am forgetting you in thinking of the lake. * * * I have little to say about myself, only that I have been somewhat ailing of late. I am busy on the second picture of the Pilgrim of the World, the fourth of the series. I have not been able to comply with my half-promise to write something for the Art Re-union. I would do so; but my time has been so much broken in upon, by matters out of the art, that I begin to fear failing in the accomplishment of my large pictures within the time proposed.

If I had written to them, it would have been on the subject of the mental and moral habits of the artist. The substance of it would, perhaps, have been this: That on those habits the success of an artist mainly depends. Genius has but one wing, and, unless sustained on the other side by the well-regulated wing of assiduity, will quickly fall to the ground. An artist should be in the world, but not of it: its cares, its duties he must share with his contemporaries, but he must keep an eye steadfastly fixed upon his polar star, and steer by it whatever wind may blow.

There is no doubt that we have fallen on evil days. The world requires much of us that was not demanded of the artist of antiquity: the mind of the latter was not dissipated by newspaper indulgences. He probably speculated little in politics, nor did he theorize much on the sublime and beautiful. His faith was fixed. He was no cosmopolite in theory, though he worked for all mankind. His sympathies were concentrated, and the whole current of his artistic life was shut in by high banks, and like a sacred stream flowed deep and unruffled. On the contrary, our stream of life, in this leveling age, flows over a great extent, and, fretting and rippling over its gravelly shallows, is too often evaporated in the arid atmosphere of the great world.

The artist must be exclusive, if he would be great, since art is long and life is short: he must be exclusive in his tastes, exclusive in his enjoyments, in his society, in his reading. He must work always: his eye and mind can work even when his pencil is idle. He must, like a magician, draw a circle round him, and exclude all intrusive spirits.

And above all, if he would attain that serene atmosphere of mind in which float the highest conceptions of the soul, in which the sublimest works have been produced, he must be possessed of a holy and reasonable faith.

 * * * * * * *

<div align="right">

Believe me yours, very truly,
THOMAS COLE.
</div>

 The notes, with which this chapter concludes, were the last exercise of Cole's pen.

 February 1, 1848.—My birth-day. Once more has the wheel of life revolved, and again advances on the untried road of another year. * * The past year has had its afflictions; but yet they have been light in comparison with its blessings. Amid many interruptions, consequent on the business of the estate, (which business is very distasteful to me,) I have been able to make considerable progress in my pictures, and hope to finish them before the coming year is gone. I have painted several smaller pictures, one for the Art Union in Cincinnati, two for the Art Union in New York, Home in the Woods, and Genesee Scenery, and also a picture for Mrs. Gideon Lee, "The Lord is my Shepherd," &c. * * I have myself been much ailing this year, probably from want of sufficient exercise. This winter has been a very unpleasant one. Last night it snowed, and we are glad to see the black, unsightly landscape covered with the pure mantle. The sun shines, and the heart rejoices in the change.

CHAPTER ❧ 37

Cole's mental maturity. Cole, a master. His great works yet in anticipation. Feelings with respect to those already accomplished. The consolation for their moral defects found in his hopes of a future, and his greatest work. Pictures preceding it. Pictures succeeding it. Conception of the Cross and the World. The Prometheus Vinctus, and Proserpine gathering flowers in the fields of Enna.

T HE powers of Cole had only now reached their maturity—a proof of their extent and greatness. Whatever may be said of his poetic, artistic and religious life, prior to his last two or three years, must be said as of one yet in the progress of large developments. Pictures, even such as the Campagna di Roma, the Mill at Sunset, Home in the Woods, the Mountain Ford, the Hunter's Return, the Arch of Nero, and others, wakening in his old admirers greater delight than ever, were productions not of the entirely unfolded, but still unfolding man. Each one, in some point an improvement on the picture painted before it, was yet less than that which succeeded. Whatever the altitude in his upward progress, it was no more than one of those shoulders of the mountains he was wont to climb. A height was yet above him; his path was still ascending. But now, to continue the figure, he had reached his summit-level. To look back was to look below; forward, was to see the high plain, the broad table-land of ripening years, where the really greater works of his life were yet to be done. The illustration is no mere fancy of the writer, but suggested by a conversation of the artist himself. It was only now that he felt firm upon the stand-point where he saw himself ceasing to be the learner, and becoming the master—the master of himself, as well as of the science and instrumentalities of his art. Musing over the several stages of his career, sinking in the perspective of time behind him; catching joyful views of great poetic forms, rising from the expanse bounded by the circle of the future, he used to say, "*I have only learned how to paint.*" After all, he felt that he had done little more

than plume his wings for the true flight into the skies of art. Cells and chapels he had been constructing hitherto; now the great temple itself should rise into the air, and its pinnacles and spires pierce the heavens.

"O, that I had the Course of Empire yet to paint!" was an expression of great earnestness. It was a theme upon which he felt he should love to exercise his powers, now ripened and seasoned with the Christian faith. Learned in the language of art, he felt assured that he could now treat the subject more skilfully, with greater beauty of artistic diction, and leave upon its every feature the token that it was at least painted by a christian man, though the story itself, as originally conceived, should forbid his making it decidedly a religious work. It was not wholly a pleasing thought, that he was leaving behind him a monument bearing his name, but not one symbol of that glorious faith affording the relief and consolation to which all should ever be pointed amid the crimes and desolations of the world.

He had no such feeling or wish with respect to the Voyages of Life. Although a work evincing less of the plentitude of his poetic faculty, less of dramatic power, less, also, in some things, of the real capabilities of his pencil than the Course of Empire; it had, nevertheless, the superior virtue of a Christian character. Whatever its faults might be, it was dear to him for the reason that it was a memorial of the time when his heart was moving into the blessed religion of Jesus Christ. True, it is the work of a man in the infancy of the divine life, with its dawning only upon him, its noon far before him, his views of the gospel partial and incomplete, and hence, as a work expressive of that, incongruous and imperfect. Still, as such, he was content to leave it where he had left it. It would serve to mark the childhood of his Christian character as later works would mark its manhood.

Such thoughts were the more consolatory in view of a great work —in contemplation his crowning work—which should have, it may be said, the Voyage of Life, the Cross and the World, and other purely religious productions, stand to it somewhat in the relation of episodes, as the Departure and Return, the Past and the Present may be said also to stand in the relation of episodes to the Course of Empire: I mean (what had not yet its settled title, but which might have been called) the Kingdom of Christ, or the Course of Sacred Empire, —a grand, divine epic, generalizing, and truthfully relating religious

facts with regard to "many nations," as his great, profane epic does with regard to one; opening with the Advent of the Incarnate Son of God, and closing, not with the decay of ruins and the sleep of the tomb, but with the repose of Glory and Immortality.

In the cheering anticipation of these great labours, Cole went first to the Cross and the World. Sowing and Reaping would have followed it, very likely in the order of execution unbending and refreshing his mind for the grander task of depicting the long march of the church, the spiritual Israel, under Christ, to the heavenly Canaan. To this would have succeeded, in all probability, Life, Death, and Immortality,—a kind of three-fold psalm, in which he would have sung again his own Christian experience; that experience, though, nearer the unapproachable light than when he sung of it in the Cross and the World. To this let me now return.

Upon his first mention of it, it seemed to leap spontaneously into being, no mere outline of a creature, but a living whole, in good degree complete in all its manifold parts. No objection, no suggestion, could change his own original conception of it, no fancy of another in the least modify his invention. However lengthy had been its mental elaboration, when it sprung to view, in his conversation, it sprung with a wonderful entireness. It was more like the description of a work completed than the unfolding of visions yet to be embodied. His studies of it were the rapid labour of a few hours. A chief mistake was the size of the canvass upon which he began to paint it. The limits were too narrow for the lines and spaces in his mind. He proceeded awhile with a painful sense of restriction, and then gave up.

It was during this season—thrown back from his great work, his mind teeming with forms of grandeur—that he found relief in giving sweep to his pencil in the Prometheus Vinctus, and the Proserpine gathering flowers in the fields of Enna. The selection of such classical subjects, at the time, is accounted for on the principle of one occasionally having recourse to recreation after a season of intense devotion. It was a retreat to a moral extreme that would allow of his returning to the work of his heart with feelings fresh and unworn.

The Prometheus is an image of the physical sublime. Earth and air —dark blue depths of illimitable ether—vasty foundations—mighty summits helmeted with the crystal of eternal winter, glittering under

the white cold Jupiter, in the first golden flashes of the day. It is the huge embodiment of that single thought, haunting the universe, THE EVERLASTING; and all is wrapped in solitary, solemn repose. True to the law by which a great poet works, when he moulds his creations to the measure of the sublime, it knows little of variety: it is almost utter simplicity—one and simple as a role of thunder. It is the product of a single blow of genius. It is as if the creative voice of the imagination had said, if one may reverently use the words, "Let there be light!" It bursts in through the spotless, awful space, and smites with fire the icy peaks of the mighty Caucasus. "Have you seen," said a pupil of his, kindling with enthusiasm, while the picture was in progress, "what Cole is doing? He is putting in the big strokes."

When the Prometheus was yet fresh from the easel, and without varnish, its sky was one of those marvellous approaches to nature but few times reached by the pencil. It seemed all but that dark vault itself, known only to those who, from the tops of lofty mountains, have seen the light break in, the day-star sparkling in the skirts of night, where they hang in the rosy breath of morning. Previous to its exhibition, at Westminster Hall, in London, (where, by the way, it was hung in a manner that entirely destroyed its effect,) it was coated with a kind of varnish that has much injured its depth and purity, and nearly taken away those subtle qualities, etheriality and moisture, for which it was really wonderful. It is not impossible, however, that it may yet, in good degree, be restored.

The failing of the Prometheus—no great, if we choose to drop the name, and call it the Alps, or Andes in the dawn—is its deficiency in moral meaning. The sense of suffering is well nigh hushed in the deep strong voice of visible nature. The passion of the figure (wisely, if not necessarily, made subordinate on so grand a theatre, but in which really lies the immense capabilities of the subject) is almost entirely swept away in the tide of the one mighty expression of the landscape: and would have been so, had that figure been painted by Michael Angelo himself.

The Proserpine, owing to the unfinished state of a large fore-ground, must now be regarded simply as a landscape. All that portion of it, which should have given it moral expression, is still crude and imperfect. Incomplete as it is, it is yet a picture in which the painter has reproduced, for the third or fourth time, but by far with

the greatest perfection, his impressions of Mount Ætna. At a distance of forty miles, it appears to rise before you, stupendous and full of grandeur, with its snowy cone now reddening in the fine Mediterranean morning. It is the twin brother of the Prometheus; the offspring of a mind at home in the contemplation of the vast.

The middle ground, (which he first painted in water colours, in order to see its effect,) combining the main features of the picturesque scenery of Sicily, is a masterpiece of land-painting. It is full of boldness, strength and grace; abounding in the richest variety; truthful in the quality of its objects; rich and harmonious in colour; nature itself in its aerial perspective; expansive, perhaps, beyond all other middle grounds, yet of surface infinitely broken. It is a broad page of vigorous language, all eloquent with meaning, heaving with nature's mighty passion, significant of untravelled paths below—the walks of the earthquake. There is a power in its lines and surfaces, in its manifold swellings and depressions, that tells of a mind rocked with a sense of the globe's irresistible forces.

The sky is what the Prometheus might have been, just at sunrise— the lately dark, deep, dewy ether, now all full of warm light: far away beyond heaven's few ruddy fleeces, one soft, serene and tender waste of sweet, bright, smiling azure: the silvery and the rosy fainting into the infinite blue, and all breathing of expectation, delight and love; the very image of the peaceful, the joyous and the beautiful.

Distance, airy luminous space, breadth and grandeur of masses, are the main characteristics of this unfinished, though still fine, Sicilian landscape, and its leading sentiment, repose,—repose the more sensible, because just ready for its flight, on the verge of the lively, sounding day.

When his hand reached the foreground of this picture, his heart hastened away to the Cross and the World: to which he went, as one would go from labour to worship, with reverent step, yet with the enthusiasm of an earnest, whole soul.

The Voyage of Life, an exponent of his religious faith at the time it was painted. The Cross and the World, the exponent of a ripened and true faith. Its theology. First picture of the Cross and the World. The second picture, the Trial of Faith. Its unity. Feeling with which it was painted. Its characteristics.

As before intimated, Cole's religious, with his poetic and artistic life had only now reached its maturity. The days of the Voyage of Life, even, were only those of his Christian childhood. But as divine truth opened to him more and more its inner power and beauty, his own interior, spiritual life kept growing and unfolding. While the first three pictures of the Voyage of Life tell the story of all his moral experience up to the period, at which the series was executed, the last may be regarded as the true exponent of what Christ then was to him, as an object of faith, and what were his own spiritual yearnings and Christian experience. Christ, hitherto an historic personage, and an object of thought rather than of religious faith, was then a precious presence, overshadowing his soul with real love and sympathy, and shedding down upon him something of the joy, while it lifted his belief and trust to the glory, of heaven. It was Christ, crucified indeed, but yet without His cross. The cross was lost in "the excellent glory." The beauty of Jesus glorified veiled the anguish of Jesus crucified. And so, fresh in the release from long yearnings of the heart, and free from the shackles of mistake, and at ease from the pangs of doubt and error, he contemplated the wondrous revelation with faith indeed, but with the faith of one whose soul the sunrise of truth is just beginning to expand—a child's faith, and hoped with his hope, and loved with his love, (in so far as new faith, hope and love may be likened to those of a child,) and embraced religion as a joy, without a sense of its suffering; speaking, thinking, understanding, with respect to the trying realities of Christianity, as a child in Christ. With experience, though, came the profound knowl-

edge and sense of the cross. Time brought sorrow to his joy. "Afflictions abide me," was the voice of his experience, speaking even from the bosom of "joy and peace in believing." Out of the brightness of Jesus glorified appeared Jesus crucified. Christ was no more to him without wounds, without the cross. Not a consolation came from above without presenting the great symbol of suffering, and imparting its sense. Hence, the precious presence (to whose pictured pavilion of brightness the guardian angel points his aged charge, in the last of the Voyage of Life) is, at length, exchanged for the cross, shining forth from beyond the mists of the world, and reflected both in nature, and in himself.

The Christian religion, not only a religion of rejoicing, but of suffering: the Christian, a sufferer, as well as a rejoicer—with these ideas, in the experience of these, was the Cross and the World conceived and painted. While it reflects the religion of the Incarnate Son, it is also a reflection of himself—of Cole, the Christian, including all his past and future Christian experience. But as every such experience may be said to have two sides, the spiritual and the carnal,—this side predominating in one person, that in another, and thus, in all together, presenting the two entire sides—therefore both sides are represented separately by themselves in their completeness, making the work, in regard to Christian experience, of universal, while of individual application. Such we may call the philosophy, the theology rather, of this fine Christian picture-poem.

It seems proper that it should be stated, as, at the present time, it may be liable to some misconception. To assume the persons represented, as sinners up to the time that they appear,—the one accepting, the other rejecting a gospel, of which, until they hear it from the evangelist, both have been equally ignorant and careless,—the former thenceforward unswervingly beating the sacred path, the latter, the profane path, is a total misapprehension of the artist's main idea, and a falsification, not only of the painter's own theology, but of fact, at every turn and stage of the Christian course. The truth, with respect to them, may be expressed thus: The two Pilgrims, call them, baptized in infancy, and now quite unconscious of any time when they passed through a technical "experience of religion," enter before us upon life's journey, at an age competent to assume the vows and promises made, in their name, at their baptism, and met, as those

henceforth responsible for themselves, by the commandments of God. Hence their way—up to this point one and the same—ascends from the water, and, although now dividing, takes its direction across the earth, its spiritual, divine side symbolized by the cross, its carnal, sinful side symbolized by objects indicative of the world. It is life's journey still, equally to both. Both are in time; both are creatures of sense; both have one and the same nature, the same fallen nature once blessed with the same gift of regenerating grace, only, from the predominance of the spiritual in the one, and the carnal in the other, their *ruling* affections, aims, motives and objects of pursuit are different. One pursues the cross; but, with all his gracious endowments, still carries with him the burden of his old nature, with its strong sympathies for the world yet around him: the other pursues the world; but, notwithstanding his old nature, still bears with him a hidden, gracious gift, the principle of a new nature with its sympathies for the cross, yet shining upon, and attracting him. Thus both journey forward—the one, in the abundance of divine light, having his fearful trials; the other, in the plenitude of sin, having some manifestations of grace; until grace, (in the one case forfeited,) and trials, (in the other case overcome,) are removed, and the end and reward, meet for each, are revealed.

Again to state a fact with respect to the series, as applicable to the artist himself: while the Voyage of Life is the expression of his own full conviction of, and conversion to, the truth of the gospel, this is the manifestation and memento of his regeneration or spiritual birth, and also of his sanctification, renewal, or spiritual growth.

The first picture, from its being a common centre to the other four, was a work of some difficulty. Involving, we may say, two distinct trains of thought, and therefore necessarily complicated, and requiring a variety of parts and details, it must still maintain such simplicity of design, and harmony of expression, as to give utterance, and that with force and clearness, to but one voice, rather several voices in a single concordant volume, like the music of a choir, and intimating, at the same moment, the two currents of thought, flowing off from one common fountain or point, in the foreground, at a moral angle, the extremes of whose diverging lines are as wide apart as heaven and hell. Any thing less than this would resolve the picture into two, undo its unity, and thus destroy it as a genuine work of

art. But all this is finely done. Whatever would break down the right of the picture from the left is subordinate to that which is main and common to the whole. The same land underlays all; the same "blue sky bends over all." However strong the earthy and aerial on the one hand differ from the same on the other, both are embraced in the all-encompassing arms of one master effect. If they are two sides, they are as the two sides of one body. All exists in one individual space. One atmosphere pervades all. One feeling lives through all. Lightning from its heavens would brighten the whole: an earthquake in its depths, jar the whole. Thought has its paths running around and through, coursing from end to end. Within hearing of the same authoritatively, holy voice, both pilgrims go; the waters of baptism behind them, above them the clouded rocks—the end of a chain of mountains, separating to the last their respective roads, although admitting through its inaccessible gorges some glimpses of the regions peculiar to both. With all this artistic unity, each side, as intimated before, announces with proper emphasis a different purpose. What is actual in the two pictures on the right hand, and in the two on the left, finds in this its prophecy in the half next to them. Each half of the central picture is a simple, but eloquent argument of its own portion of the poem.

To the sensual mind Christianity is not the way for the aspiring and spirited, but a gloomy by-path, a humble track for the timid and feeble-hearted; therefore to the *left* a straight and narrow path leads along solitarily at the foot of the mountains, and is lost in a rugged pass, ascending through the broken distance, down which there beams the pale, pure light of a bright cross in the sky, at once "the fountain-light of all his day, the master-light of all his seeing," and, in its recent rising, an emblem of his Christian morning. The outset of the young pilgrim is through fields clothed with the common verdure, and spangled with the usual flowers of spring, the carnation and the lily, intimating the early part of the Christian life neither difficult, nor uninviting, and signifying, by the naturalness of all, the truth and reality of religion, in contrast with the falsehood and hollow show of the world, of which the unreal, exaggerated beauties around his fellow pilgrim are emblematic. At some distance, a dark shower conceals from the pious way-farer the approaching difficulties of his journey, and betokens the sorrows which of necessity befall him.

The prospect of his companion is better suited to the wild, exuberant fancy of youth. A broad and winding way leads down to the right to a most beautiful country. Stretching forward through pleasant landscapes, it is lost, at last, and leaves the eye to loiter on to the misty domes and pinnacles of a great city. Far and nigh, the scene is alike fitted to excite his imagination, and please his senses. Nature herself has turned flatterer, and ministers, in a May all too flush and blooming for her own, deceit and allurement. In their unreal splendour and profusion, the very flowers lie, and the slant beams of morning impart a golden hue to the atmosphere unnatural to the hour, and smiles to rugged cliffs. By-paths, serpent-like, steal up the soft, green slopes of the mountain, inviting to the waterfall, and the enjoyment of a wider prospect.

It was Cole's intention to paint this side of the series first. That would enable him to go through with all that was less acceptable to his feelings, and reserve the pleasing toil of depicting a vision of holy repose for the last. He proceeded, accordingly, with the worldling, in the next picture, nearly to its present imperfect state of completion, but there paused. He did not love his labour. His love had gone out upon the other path. He resolved, therefore, to follow the leadings of his heart, and pursue first the fortunes of the Child of the Cross.

True to what is intimated in the central picture, those fortunes are here adverse. The disciple of a suffering, as well as a rejoicing religion, the pilgrim appears now in the character of a sufferer. The cross of Jesus is ever both a burden and a consolation. Now it is exhibited as a burden. While he hopes in, and follows, he yet bears it; breasting its afflictions while he travels in its light. "Christ himself went not up to joy, but first he suffered pain: He entered not into his glory before he was crucified. So truly our way to eternal joy is to suffer here with Christ." The picture symbolizes that suffering, illustrating the inspired saying, "that we must through much tribulation, enter into the kingdom of God." It does not, as it was never intended, symbolize the entire Christian life, but the cross of it. It is Faith's battle-field, and her knight in the thickest of "the good fight of faith;" going on to victory, but not yet having won it, not yet wearing the crown; struggling with the trials "in believing," not reposing in its "joy and peace." Hence we see not, as we should not, but in the heavenly banner gleaming through the tempest, a solitary signal of

relief or consolation. What we look into is a gloomy mirror of adversity, reflecting images of fear, forms of dreadful power. It is nature in wrath, weapons in her hands, and threatenings in her language. Terrific in its voice and countenance, storm "has the mastery of" that horrid wilderness of chasms, crags and mountain precipices, and sends its fiercest torrent to dash the now manly, though almost despairing pilgrim into the abyss, along the rocky verge of which he travels. Lone "prisoner of hope!" where is "the strong hold" to which he may turn? Whither look for a portal of release? Sacred light from the symbol of redemption, now high in the heavens, comes bursting through "clouds and darkness," opening down the gloom a track of brightness, impassable, indeed, to the eye of sense, but easy to faith and affection.

Unlike the middle picture, this has nothing subtle, nor complicated in its design. It is perfectly simple, bearing its great thought, its one meaning upon its surface as visibly as the ocean, a solitary ship. For unity it is wonderful. It was painted with a single spring-tide of feeling, and consequently with the greatest freedom, rapidity and vigour. The pencil swept on, fired with passion, and swiftened by excitement, emotion in its every touch, spirit in all its strokes, giving it the fresh, live impress of his own high-wrought, imaginative state, almost as completely as if it had been done in one moment of "fine frenzy," and left palpitating in its every extreme as if from one great central throb.

An incident, trifling in itself, will give a hint, at least, of the press of feeling under which Cole was now working. A friend, deeply interested in the progress of the picture, tapped, one morning, at the door of his studio. With brush in hand and palette covered with colours, he hastily opened it. He was trembling with excitement. The slight flush on his very pale face, the vivid brightness of his eyes, and the tone of his voice, all spoke the liveliest emotion of mind. With a quick smile, said he, or in words to the same effect: "O, go away!" An unexpected visit from a gentleman and some ladies, with whom he could not well take a similar liberty, actually destroyed the St. John Baptist in the Wilderness, a first-class sacred landscape. Nothing less than the fire with which he was darting forward when he was interrupted, and which the stay of his visitors effectually quenched,

would enable him to go on satisfactorily. The face of the canvass is yet against the wall, to which he sorrowfully turned it.

Cole was better satisfied with a portion of this second picture than with almost any thing he ever painted. The part, in particular, alluded to, is the high, woody foreground on the right. It is the perfect rendering of one of nature's strongest, grandest passages. The artist and the connoisseur are invited to its study, and then to name, not its superior, but its equal. As simple, wild landscape, it is certainly one of the happiest triumphs of the pencil. If nature could be said to act the tragic, it is pictured here with that mingled rashness and refinement characteristic of high genius, and mastership in art. For drawing, composition, quality of objects, colour, light-and-shade, strength of expression, power of action, sound and motion, it is consummate, —imaging most vividly those forceful activities which find their true antithesis in the everlasting, holy repose, depicted on the next canvass.

*Manner of life in his last days. Book on art. A volume of poems. Life out
of doors. His conversation. Favourite topics. Ripeness of his Christian
Character. The Triumph of faith, the last of the pilgrim of the Cross.
Painted in solitude. Miltonic in its character. The Lord is my Shepherd,
last pure landscape. As a work of art. An Italian pine in the Proserpine,
his last painting. Death.*

BEFORE proceeding with the third and last of the Christian pilgrim,
it will be well to note that manner of life and conversation which,
while it shows us more of the man, will also give a clearer insight into
the deep, spiritual meaning and beauty of his pictures than any mere
criticism. Upon a small writing-table lay, with the authors he was
then reading, a Bible filled with marks, the Book of Common Prayer,
and Bishop Wilson's Sacra Privata, intimating the fact that his paint-
ing-room was likewise a study and an oratory. What has been told
of some few Christian artists came to be a habit with Cole—he
prayed before he painted. To thoughtful, theological reading, of a
practical kind mostly, and rather choice than extensive, he added the
study of works on art. Among the last read, and with singular delight
and approbation, were the Sketches of the History of Christian
Art, by Lord Lindsay. Whether the effect upon himself of this excel-
lent author, abounding with a spirit so congenial to his own, was, in a
measure, the cause of inciting him also to compose a book upon art,
it is certain that he came to the determination of writing one. Of his
entire competency to contribute to art-literature in a way that would
have been most honourable to himself, and of high value to his coun-
trymen, no one, aware of his much and careful reading, and enjoying
his private conversation, could have doubted for a moment. As a
sketch of what, in all probability, his proposed book would have been
may not be deemed unimportant, one is here subjoined.

Art and criticism in America. Encouragement of art by the gov-
ernment and people. The low state of art, and its causes. Effects of

art-unions and academies. Influence of foreign opinion and criticism. Until free from their trammels art cannot flourish: it must be independent: to be truly good it must spring from the genius and character of Americans. Art, ancient and modern. In what way modern art is likely to develope itself in this country. The duty of American artists: the necessity of combination for the purpose of improving both the people and artists, and of controlling criticism. Nature and Art. Morals and habits of artists. Exceptions to English art: imitated here more than any other: that vindicated. Americans have strong desires for excellence, and a love for nature. Love of nature more intense and diffused among the moderns than the ancients. One cause of it—the wilderness passing away, and the necessity of saving and perpetuating its features. Comparison between painting and sculpture. Remoteness from the old world is not a disadvantage as many suppose, but decidedly beneficial. See the effects of the old masters on modern Italians. Nature is the foundation upon which to build, and not past art. Profit by the toils of the past, but be not its slave. Visit, and study in the galleries of the old masters, but do not live in them. A fatal fallacy is it, that we cannot rise but upon the old. From whence rose art in Greece? She had no elder Greece to go back upon. For us to commence anew would, indeed, be folly, were it possible. We may go, as pilgrims, to the venerable shrines of art: but, if we would triumph, we must live in nature.

A literary undertaking, like the above, in the midst of all his artistic labours, shows great mental activity, and versatility of talent. The same qualities are exhibited in another work more imaginative, a volume of poetry. It is known but to a few that Cole was the author of many and extensive poems. To some of these the reader has already been introduced. A person less familiar with his pictures than his verse might easily make the mistake, and suppose that his actual vocation was that of the poet rather than the painter. The volume alluded to was a selection of his smaller poems. These he was correcting for publication.

Cole's out-door life, corresponding mainly with that of earlier years, is particularly worthy of mention. He watched, and sketched the skies, especially at sunset, almost daily; walked, and sketched the landscape, snatching as he walked its choicest details, wandering away through the rich, broken country of the Catskill river,—through the

cloves, and up to the peaks of the mountains, for the gathering of thoughts, and the kindling of his feelings, as well as for making fresh studies. Many of the pleasant afternoons, and now and then a whole day, were spent in this manner. His last excursion to his favourite mountains, arrayed, at the time, in the colours of October, occupied two days. He went to the top of the huge precipice, on the side of South Peak, a point visible from his house at a distance of some twenty miles, and commanding a wonderful prospect. From this dizzy crag, Cole took a long and silent look up and down the beloved valley of the Hudson. He had gazed upon it, from other points unnumbered times, alone and with companions, such as Bryant, Durand, Ver Bryck and Huntington. It had filled his heart for years. This was his last look. A few hundred feet below, by a rivulet, expanding into a small, glassy pool, bordered with moss, and roofed with the gay foliage of the month, he took his final mountain repast, a sandwich and an apple, seasoning a cool and quiet hour with his usual pleasantry. The way to and from this height was through a steep and tangled ravine, named, at the time, Helmet Gorge, from a rock resembling the crest of a helmet, near which he gathered some beautifully-coloured leaves, a favourite amusement with him in autumn.

To his near friends there were few higher pleasures than to go with him upon these walks. To every interesting object and fine view there was added the charm of Cole himself—something of his own character, or of that of his profession. While, without designing it, he imperceptibly impressed one with the greatness of art, it was impossible not to feel that he himself must be one of its noblest masters, and that the subjects meditated for the future, together with the one then in hand, were suited to his pencil.

It is questionable whether his pictures, the real basis of his fame, after all, show the greater part of the man. It might be said that they reveal less of his soul than did what may be called his wood-and-field-talk. At times, his conversation was extraordinary. Not so from any mere brilliancy, or music, or rapid flow of language, popular requisites of fine talking; but extraordinary for its transparent simplicity, as a medium of thought, and for the thoughts themselves. These were given, not unfrequently, in a brief sentence, startling by their suddenness and exceeding truthfulness, and extinguishing from the memory,

by their force and beauty, often instantly and for ever, the few plain words in which they were spoken. Many an excellent fancy, if it does not lose its way altogether, comes to the listener changed and mutilated in its long travel through a labyrinth of language. Not so with Cole, especially in his later conversations. Beauteous, sublime thought would dart home to the hearer along the subtle wire of some simple expression with magnetic swiftness. This rare power—rarer than that which enchants with the mere splendour of words—coupled with his own earnest, unaffected manner, together with the lofty character of the topics upon which it seemed most natural for him to converse, were certain tokens of what indeed he was, in their noblest sense,—the Poet and the Christian.

A favourite theme was the Church, in whose welfare his spirit was fast becoming all absorbed. As an illustration of this, may be mentioned a single expression, uttered to his sister Sarah, after one of his last visits to the city: with a motion of his hands, as if casting all worldly things from him, he said, with emphasis, "*I am going to work for the Church.*"

The Christian life was another favourite subject of conversation. His sense of it, now enlivened by experience, gave to all temporal prosperity a baptism of sorrow, and the signing of the cross, and to every adversity, in which the Christian may see himself burdened by the cross, a compensating mercy. Grief and joy—strife and conquest —the pain of self-sacrifice, and the peace of its rewards, were familiar themes in the sunny fields and shady woods, by the quiet brooks, along the noisy torrents, and upon the solitary mountain cliffs. Speaking of his own religious trials, he was wont to attribute the most serious of them to ambition. To win renown had been, from his youth, a ruling passion. In the light of religion, that passion stood forth as his master sin. To vanquish it was his most difficult labour. How aspiring, how unhappy it had often made him he could only tell, now that he had, after many struggles, mainly overcome it. How far he had really done so, might have been gathered from remarks expressive of no impatience at the praise of any true artist, and of little anxiety with respect to his own, and from oft-repeated determinations to work no more at the bidding of the world, but to labour as one living above it; to spend no more time on works merely

salable and popular, but to paint according to the promptings of his heart, and consign his pictures to the seclusion of his own private gallery, there to bide their time.

Equally a favourite with these, now mentioned, was the kindred subject of death and immortality. There was that of them in his words, at some moments, especially in his latter months, as of one whose footsteps were consciously nearing their mysterious presence. An autumn afternoon is recalled, when this was so to an extent ever to be remembered. The hour was verging towards one of those marvellous twilights too full of repose and beauty not to lead the thoughts to the glory and rest of heaven. The Hudson was bright and glassy, reflecting banks and sky like a mirror—the great eastern slope of the Catskills was losing its colours in one broad and solemn shade—over a distant summit the eye escaped through an opening of the refulgent clouds far into the rosy depths—the path was leading down from an eminence to a wood: with a kind of audible musing, Cole broke the silence of a few previous minutes, in his simple, sententious way, and then paused, leaving profound impressions of what was, at the moment, in the grasp of his faith and imagination, viz. the Christian rest—eternal peace, and death their shadowy portal,—The last conflict, and the final triumph,—The great and awful experiment, at which we shudder,—The great, immortal experience, for which we yearn, whose image is unspeakably sublime, and whose realities must, at the longest, soon burst upon every living Christian. The whole man, voice, countenance and mind, seemed fragrant with "good things to come," and breathing of the holy, everlasting calm, in which his spirit was so soon to be immersed. The allotted three-score-and-ten seems requisite for men generally to "perfect holiness." God, it may be, ripens quickly the religion of some, those especially whom he designs to call away from the midst of pious works. The former grow slowly, perhaps, because they are to grow a long time; the latter, rapidly, because, like the arctic plants, their season of growth is soon to close. Cole appeared to be one of these. Although his Christian life could number hardly ten years, not ten years old as "a child of God," yet did he reach the Christian strength and beauty of a divine old age. The woods of his last autumn were not more surely touched with nature's brightness than his own heart with fire from heaven.

In the fulness of such a heart, did Cole follow the Pilgrim of the Cross to his triumph, unfolding a scene that fulfills all of which the preceding is prophetic, and bears the mind onward towards the unapproachable light, the centre and source of which is God, the Glorified Redeemer, of whom the cross, now refulgent with glory, is the symbol. Upon this transcendent vision the sight of the Pilgrim, now venerable with years, and kneeling in devout rapture, opens from the mountain top, just rising into, and forming the foreground of the picture. Here, as we should, we behold in all, except in the gloom of rocky pinnacles and dark recoiling mists, behind and below the figure, lively tokens of those unseen, unheard, unimaginable "things which God hath prepared for them that love him." What we gaze upon is glory's dazzling glass, reflecting the Infinite and Eternal. It is nature transfigured,—her countenance all shining, her raiment glistering;—"a new heaven and a new earth," "and no more sea." The ocean is gone, and in its place sky—everlasting, etherial deeps, parted from the heavenly depths above by a boundless sea of magnificent clouds, threading immensity like lustrous harp-strings, or, like ruddy breath of incense, rolling among them majestically in solemn, awful harmony. It is Faith's victory, and her knight waiting to wear the honours, which by grace he has won. Faith is all changing into sight, hope into the inheritance itself: angels approach with the palm and crown.

Of all his pictures—one might almost say of all *pictures*—there is no one of which it is so pleasing, and yet so difficult to speak as of this; and for the reason that it was *painted* with most difficulty, and with most love. With most *love*, because it was his highest approach, in art, to the end and object of all love: with most *difficulty*, because the most spiritual of all thoughts was to be expressed by the most sensuous of all languages. But yet love has triumphed. The great spiritual thought is there—The Peace of God that passeth all understanding, infinite, eternal, pure, in the illimitable blue. The Rest that remaineth for the people of God, in the still, small voice, the musical motion of the sea of clouds—in all their countenances The Love of Christ that passeth knowledge, unutterable love in the sweetness of manifold colours, and the immortal calm. The life and freshness, youth and beauty of the saint's last days on earth, in the verdure of the mountain top, springing up in the warmth of celestial sunshine,

with the hues and luxuriance of the Lord's garden. The ineffable repose of the sanctified heart, in the silence of the luminous path over the level clouds to the bliss of paradise. The gushes of love and grace from the Lamb, in the descending angels; and the Holiness of the divine presence, in the marvellous light flowing from the cross, diffusing brilliancy over all, and inviting and drawing the soul nearer and nearer to Him. Whether all this can be better expressed by the painter's sensuous language, we have yet to see. That he has made it so powerfully expressive, and spoken through it, not less than we could have desired, but more than we could have imagined it capable of conveying, make his work liable to no criticism from any shortcoming, and triumphantly vindicate his claim, that the capabilities of landscape for great poetic purposes—for the expression of the true and beautiful—are as high as any other branch of the pictorial art.

Unlike the pictures preceding, this was painted in a devotional solitude. Not even his wife, who used to read much to him while painting, was permitted to see it until it was done. Regarding himself as one engaged in a great act of faith and devotion, he shut out every influence which might in the least ruffle the repose so needful to that divine exercise, and to the more perfect play of the feelings and the imagination. The first effect of his work upon the few, who had been impatiently waiting its completion, was all the artist himself could have wished. It was then that they felt it irresistibly, if they had never felt it before, that Cole's was a great poetic soul, walking high among holy truths, and working itself out in these visible forms of art. A picture was before them, "which," in the words of Bryant, "could only have been produced by a mind of vast creative power quickened by a fervid poetic inspiration." The Thought, and the forms in which it was embodied, were, as one expressed it at the time, of Miltonic magnitude and beauty,—a remark that recalls what Bryant, in his concluding sentence upon this painting, relates of another: " 'The idea is Miltonic,' said a friend, when he first beheld it. It *is* Miltonic; and it is worthy to be ranked with the noblest conceptions of the great religious epic poet of the world."

It was while he was poising in the highly devotional and imaginative state, to which he had been wrought up by the execution of the foregoing work, that he painted his last picture,—that most

exquisite and most perfect of all his simple landscapes, founded upon the opening of the twenty-third Psalm, in which he has sought to express, by terrestrial imagery, the same mind which he had just expressed, by celestial imagery. It is the spontaneous outpouring of the soul still possessed of its grand theme, only, instead of the heroic, in the simpler form and language of the idyl, standing in the relation of a concluding hymn to the greater act of faith and worship, and meet for the closing hymn to his whole artistic life.

"The Lord is my shepherd; I shall not want.
He maketh me to lie down in green pastures:
He leadeth me beside the still waters."

The same eye of faith, which, in the Pilgrim of the Cross, adoringly beholds, from time's last mountain height, the "new heavens," here, with a loving sense of the divine tenderness which seeks and saves that which is lost, looks out, from the edge of life's thorny wilderness, upon the "new earth." The world's angry floods are crossed, its desert tracks all passed: a pastoral scene refreshes the sight: the flock is shepherded in the "green pastures," and by "the still waters" of the heavenly Canaan. Psychologically considered, both works are as twin children, born of the same poetic state of mind, of one and the same pure religious passion. By thus understanding the relation between them, we gain from the former the true key to what is significant in the latter.

So far, the picture as a divine song, expressive of the poet and the Christian. As a work of art, it evinces a pencil at home with excellence, and used to the most precious grace and beauty. While it is the mirror of a mind sublime in the contemplation of immortal holiness and serenity, it shows a thorough knowledge of all the painter's proper means, and manifests a hand skillful as well in the most delicate, subtle touches as in all bolder ways and freer motions, and quickened by an imagination of the most singular purity and brilliancy.

It was Cole's intention, upon the completion of the left side of the series, to proceed at once to the right. One or two vain attempts were made to this effect. Scenes in which the pleasure, fortune and glory of the world were to appear in magnificence and vanish in gloom, carrying their deluded votary from hollow, short-lived joys to his

dark destiny of death, and presenting him, at each step, in strong contrast with the follower of the cross, required some change of feeling. The one scene was too earthly and sensual, the other, too disquieting and sorrowful for his then serene, spiritual frame of mind. From images of pomp, effeminancy and despair he recoiled, and painted the simple piece of nature, in which the organic, the solid and aerial are alike tempered to the tone and quality of his sentiments, all giving back the purity and tenderness of his emotions, flowing and breathing in the likeness of his affections, and whispering the peaceful mind, the still ineffable joy, the quiet happiness of a soul reposing in the confidence of divine grace, and hopeful of its acceptance with God.

From this picture he turned again to the series, but with a reluctant mind, and a body over-worked, and unrefreshed by his usual recreation. After a few touches, he resolved to postpone its completion until he had finished the Proserpine gathering flowers in the fields of Enna. The particular object to which he applied himself was an Italian pine, one of his most perfect and beautiful trees, mingling with whose outermost boughs is seen the distant outline of great Ætna. This was on Saturday, the 5th of February. He laid his remaining colours under water, cleansed his palette in his customary way, and left his studio. He never returned to it again. On Sunday he engaged in the services of the church, and partook of the holy communion. In the following night he was violently taken with a disease which terminated in an inflammation of the lungs. Early in the evening of the ensuing Friday, the eleventh, he felt the touch of death, and desired with great earnestness the immediate administration of the Lord's Supper. At the close of the service, through all of which he went with a deep, serene devotion, he sank exhausted upon his pillow, and said, "I want to be quiet." These were his last words. At eight o'clock he expired, aged forty-seven and a few days.

CONCLUSION

The personal appearance of Cole, if we except his head and face, was not particularly striking. A little above the medium height, and rather spare, he stooped from the labours of the easel, and walked with a peculiar rising and sinking motion. In dress he was plain, but always scrupulously neat. His head was one of the very finest. So well constituted was his brain, as to quantity and balance, as to give him, according to the laws of phrenology, a combination of intellectual and moral qualities of the rarest kind. Thought had, prematurely, so thinned his soft brown hair as to require it to be brought up from the temples across the head, in order to cover a partial baldness. His forehead, beautifully proportioned, was much his finest feature when his countenance was in repose: when enlivened, his eyes. Of a bluish gray, large, and under rather prominent brows, few were more completely expressive of thought and emotion. The nose and chin, somewhat large, indicated less than the rather large mouth, which spoke force of character. His face, though pale to whiteness— not a good complexion—was, when animated, one of the most pleasing. The charm of Cole's appearance, when at all engaged in talking, was an earnestness combined with an honestness and simplicity of manner, that won, at once, the sympathy and faith of his listener. Then, as he warmed, his countenance was all life, motion, at times, brilliancy. His usually low, gentle voice became quick and energetic, full of emphasis, thoroughly expressive. Cole was an admirable listener. His sensitive soul delighted in being touched by the recital of anything capable of eliciting reverence, innocent merriment, or sorrow. There was a singular heartiness in his laugh. His eyes were ever filling with tears at the pathetic. A tolerable judge of character would, at once, have pronounced Cole, from his ordinary look and manner, very much what he was: full of all tenderness and sweet humanities,—one of the most modest, most feeling, most benevolent of men.

307

The substructure of the whole head and heart of the man was faith,—faith always deeply religious—in his latter years, pre-eminently Christian. To believe and trust—they were great necessities of his being. He loved the simple act of them for its own sake. Will, purpose, patience, perseverance, were their strong and healthy offspring.

Cole's intellect was one essentially poetic, and ranging with those that seek the summits of the true, the grand, and the beautiful, whether in nature, in man, or revelation; and so more naturally at home in those regions where pure affection and the serene mind love to expatiate, than in those where wit and humour or mere sentiment delight, or passion plays. Hence Dante, Milton, Wordsworth were his spontaneous choice, instead of Byron, Hood and Burns. With a pure fine fancy, and an imagination of great reach and brightness, he possessed an excellent faculty of invention, or power of finding out new, or selecting and combining old ways of embodying the creations of the fancy and imagination.

What, therefore, the thoughtful critic would naturally expect to see in the works of his pencil, he finds—poetic expression. "I wish," he used to say, "my pictures to express my conceptions and emotions." They do express them. They are poems, ranging from the sonnet and song to the ballad and romance, and so on to the epic. As mere landscapes, aside from all poetic utterance—if it be possible to view them with that set aside—their grand quality is TRUTHFULNESS TO NATURE—nature, in the shape and qualities of her countless things and forms,—nature, in the arrangement and colour of her forms and things—nature, in the accompaniment of light-and-shade, in and by which they are seen; in and by which things and forms, colour and arrangement, (involving what are called composition and perspective,) qualities and shape or figure are all made visible with proper force and measure. Hence Cole had an eye true to the outline and figure of objects and masses, and a hand obedient to his eye. He drew truthfully—to the life. He had an eye true to the surface of things, and a touch of the pencil obedient to his eye. He touched or painted truthfully—to the life. Hence, again, he had an eye true to the arrangement, the disposition, or placing of objects in a way conformable to an exquisite sense of the beautiful, as nature sometimes, but not always, places or disposes objects. He was a truthful—a

judicious, fine composer. He had also an eye true to the countless hues and tints of the visible world, and a skill to combine and blend his paints, and to apply them according to the bidding of his eye. He was a truthful—a great, and judicious colourist. He was not always on the stretch to be a *splendid* colourist, for that would have been to be false to nature. Splendid effects of colour were not the end of art, but something far more difficult—faithfulness to nature: for art—true art—high art—is but nature continued by the artist, and continued conformable to nature. He put colours on canvass, not to dazzle by their numbers, brilliancy, and peculiar and striking arrangement, not merely to amuse the superficial spectator, but to affect as nature affects. His compositions of colour were made conformable to nature's compositions. His emphasis of colour, her emphasis of colour. He was therefore, a truthful, and because truthful, a great and judicious colourist. Hence, yet again, he had a sight familiar with the presence and absence of light—light-and-shade, and a pencil faithful to represent it, and a sense correct and acute to temper it to accord and harmonize with the general scene, to produce the requisite tone, and to give each part and particular their proper force or faintness. His light-and-shade was a rare reproduction of light-and-shade in nature. And hence, lastly, he had a right perception of space, and of the atmosphere which fills it, and of the magnitude or smallness of objects immersed in it—their distinctness or dimness according to their nearness or remoteness to the eye. What he thus perceived aright he attained the skill of imitating on canvass, in such a manner, that the effect of the imitation corresponded with the effect of the real nature imitated. His perspectives were true to nature —the perspective of his lines—the perspective of his air. And because the latter is most difficult, and but seldom accomplished truthfully, in aerial perspective, he may be called consummate. It may be added, Cole had a just apprehension of all the forces and vitalities of nature— of the warmth and animating principle wherewith the heavens palpitate and breathe, and things grow, bloom and fructify on the land —of the motion of the air, of the winds in the clouds, in the woods, and upon the waters—of the motion of the waters, the running of the brooks, the rushing of the torrents, the gliding of river currents and the rolling of the waves—of the explosive power below, upheaving the earth, and breaking its surface into infinite irregularities—of the

levelling power of attraction, rounding the pointed and smoothing down the rugged—of the softening, finishing, and beautifying manipulations of beams from the sun, and of rain from the clouds, of frost and tempest. To a just apprehension of these forces and vitalities of nature, add that of her sounds and voices, her silence and her solemn repose. What he thus justly apprehended of the material world, moved him like inspiration when he painted it. The effect of pictures so painted was expressive of the manifold forces and vitalities, voices, silence and repose of nature.

With regard to the works of Cole, therefore, I say again, aside from their poetic expression,—expression of human emotions and conceptions—their distinguishing quality is TRUTHFULNESS TO NATURE. Bear witness to this, especially the pictures of his last five years, and more especially the completed three of the Cross and the World, and the Good Shepherd. There, earth answers to earth, waters to waters, woods to woods, and skies to skies. What marvellous truth to nature in these pictured heavens! What electric activities, what impetuosity in the stormy clouds of one! What infinite, endless depths of sky in the others! Beyond the clouds lie the illimitable fields of ether, where the light keeps Sabbath in the blue. What extent! what subtle beauty! what repose! And here, how cool and breezy—there, how genial and warm—and every where and forever, how elastic, how yielding, and how moist! Go to Claude, they tell me, for glories of the sky; but come from Claude, even from Claude, to Cole, for sweet, refreshing moisture, without something of which the most glowing heaven is but brass.

But are there no faults in Cole? We cheerfully admit them, since he himself confessed them. Faults are inevitable from the very necessity of the case. Pigments in themselves are often but feeble means, many times utterly inadequate to express the living glories of God's marvellous world. When that world is made the test by which to try the painted images of it,—and by no other test should landscape art be tried—they will, of course, not endure it. He who, on the whole, comes near it, is the master. He who, on the whole, in most points, comes nearest, is the greatest master. The true question, then, is not one as to faults, but as to excellencies and virtues: not whether there are faults, but how many, and how great are the virtues. That is the true question. Judgment according to nature, and not according to past

art, must determine. At that tribunal let Cole.be arraigned and tried. And there he shall be tried. I say so fearlessly, because I know that there, hereafter, he must, and will be tried. He who walks with nature will not tremble, rather triumph in anticipation of the verdict.

It is said Cole fails in the human figure. It was not necessary that he should excel. His figures are only subordinate actors in his scenes. But look, are not his men and animals painted up to the mark to effect his purposes?

It is said that some of Cole's landscapes are without air. They are without dust, smoke, or mist, or coloured rays, visible accidents of air, but certainly not without the *effect* of that invisible element. They are simply true to one of the aspects of American landscape. Hours there are, at every season, when the distant Catskills, bathed in pure white light, are seen through a perfectly transparent atmosphere. It is also said, that some of his pictures, the Dream of Arcadia, for example, are crowded. Nature itself, in which he lived, was crowded. He was only in such cases, if the point be yielded, too true to nature. The fault was the excess of virtues—the usual error of a fertile genius.

While, though, we may, with Cole himself, confess to faults, let us be mindful, if one might thus express it, that he had the rare grace of repentance and amendment of pictorial sins; and would have given us works manifold, had he lived to common old age, in which he would have exchanged his faults for more virtues, new and fresher beauties; and multiplied the proofs, as he drew near and more near the glory of the works of the GREAT ARTIST, that landscape may be raised to the dignity of the historic; and that, not only as a great designer, but as an originator of a new school of painting, he deserves, to-day, what the future will certainly award him—a place among the Spencers and Miltons of poetic art.

NOTES

Preface

1. This alludes of course to the original title. The paragraph remained unchanged in the 1856 printing.

2. Caleb Sprague Henry (1804–1884), clergyman, educator, author. Ordained a Congregational minister, he was later a priest of the Protestant Episcopal Church. Though serving as rector of churches in several communities, he gave his main efforts to literary and educational pursuits. An inspiring and dynamic teacher, he became Professor of Intellectual and Moral Philosophy at Bristol College, Pennsylvania, and at the University of The City of New York. In 1852 he retired from teaching to devote himself to writing, editing, and translating. He served as political editor of the *New York Times* for several years.

Chapter 2

1. Saint Eustatius, one of the islands in the West Indies, where Cole probably gathered the material for his short story "Emma Moreton, A West Indian Tale," which appeared in the *Saturday Evening Post,* June 14, 1825.

Chapter 3

1. William Wordsworth, *Lines Composed a Few Miles above Tintern Abbey.*

2. Benjamin Tappan (1773–1857), United States senator, antislavery leader, and jurist. Born in Northampton, Massachusetts, he was apprenticed to a copperplate printer and engraver, studied portrait painting under Gilbert Stuart, and received a legal education from Gideon Granger. As a local judge in Steubenville, his decisions for the years 1816–1819 became the first published law reports for the state of Ohio. He was a presidential elector in 1832, and became United States senator in 1838.

Chapter 4

1. Des Combes, a Dutch limner, with whom Cole was later to conclude a treaty of peace in Zanesville, the conditions of which were proposed by Des Combes: "If you will say notink apout ma bigtures, I will say notink apout yours." William Dunlap, *History of the Rise and Progress of the Arts of Design in the United States,* ed. Frank W. Bayley and Charles E. Goodspeed (Boston, 1918), III, 144.

2. William Althorpe Adams (1797–1878,) a jurist and amateur painter, who, born in Boston, established his career in Ohio. In 1840 he opened a law office

in Cincinnati, and there earned a reputation as a judicious critic of art. He painted portraits and exhibited sketches at the National Academy, of which he was an honorary member.

Chapter 5

1. The theme of Belshazzar was a very popular one among nineteenth-century romantic painters, notably John Martin and Washington Allston, appealing largely because it contained many of the elements of the sublime as defined by Edmund Burke in his essay of 1754, *Ideas of the Sublime and the Beautiful*. This essay, discussed in the Introduction to the present edition, became exceedingly popular and formed the basis of English aesthetics in the nineteenth century. The ideas of the sublime outlined by Burke were eagerly adopted by American artists and writers.

2. Emergence from the studio to observe nature at first hand was one of the basic tenets of the Hudson River School, which thus anticipated the Barbizon School of Fontainebleau. It helps explain how painters of the Hudson River School achieved their exceptionally accurate renditions of natural objects. This communion with nature is illustrated in the painting by Asher B. Durand called "Kindred Spirits," which shows Thomas Cole and William Cullen Bryant standing over a deep Catskill gorge conversing while observing a sublime view of the American wilderness below them.

Chapter 7

1. These were three of the most influential men in American art. John Trumbull (1756–1843), son of Connecticut's Governor Jonathan Trumbull, as a youth knew John Singleton Copley, and was influenced by Benjamin West, with whom he studied in London during the Revolution. On his return to the United States in 1789 Trumbull painted the portraits of the founders of the Republic; later he was commissioned to paint four of the eight large canvases that decorate the Capitol rotunda. Trumbull's few landscapes are in the topographical style, somewhat stiff and literal in approach, and are made up almost entirely of a series of views of waterfalls, including scenes of Norwich, Yantic, and of Niagara.

William Dunlap (1766–1839) was the great biographer of early American artists, and was in addition a theatrical manager, naturalist, and assistant paymaster-general of the New York militia. Like Trumbull, Dunlap studied with West in London, and then, between 1814 and 1816, traveling through New York as paymaster, observed nature directly, making sketches and water colors of the natural objects which attracted his attention in a factual but undistinguished fashion. He, like Trumbull and many other American painters of the early nineteenth century, did several sketches of Niagara Falls.

Asher B. Durand (1796–1886) was one of the founders and perhaps the chief spokesman of the Hudson River School. His engraving of Trumbull's "Declaration of Independence" established him as the foremost engraver in America. Largely due to the portrait commissions and the encouragement of

NOTES

the leading art patron of the day, Luman Reed, Durand beginning in 1834 devoted himself almost exclusively to painting. After Reed's death in 1836, with the patronage of Jonathan Sturges, Durand visited Europe with John William Casilear, John Frederick Kensett, and Thomas Pritchard Rossiter, members of the second generation of the Hudson River School. There he studied particularly the work of Claude Lorrain and Salvator Rosa. From 1846 to 1862 Durand was president of the National Academy and in that capacity exercised great influence in the world of American art. His *Letters on Landscape Painting* appeared serially in the *Crayon* in 1855 and 1856 and helped establish the aesthetics of the Hudson River School.

Chapter 8

1. Philip Thicknesse, early friend, patron, and biographer of Thomas Gainsborough, was a querulous, evil-tempered individual, a soldier by profession, who had been imprisoned for libeling a superior officer; he broke with Gainsborough in circumstances which remain obscure.

2. This "unworthy patron" was George Featherstonaugh. Bryant, in his *Funeral Oration* (pp. 11–12), said of Featherstonaugh: "a dashing Englishman, since known as the author of a wretched book about the United States, who had married the heiress of an opulent American family, professed to take a warm interest in the young painter . . ." Bryant's outspoken contempt for Featherstonaugh is echoed in articles appearing in the *New York Evening Post* on June 21 and July 16, 1844. But additional letters suggest that Featherstonaugh was perhaps not so unworthy as Noble made him out to be and may indeed have been helpful to Cole.

3. The National Academy of Design was founded in 1826 by a group of artists led by Samuel F. B. Morse and Thomas S. Cummings, who were dissatisfied with the contemptuous attitude of the lay-controlled American Academy of Art toward its artist students. The new organization, chartered in 1828, was entirely controlled by artists, and it evolved into the most influential professional organization in nineteenth-century America.

Chapter 10

1. Daniel Huntington (1816–1906) was a friend of Thomas Cole and painted a sensitive portrait of him. Huntington began his career by doing neoclassical historical subjects but abandoned these in favor of portraiture. His work has a photographic quality unpalatable to modern taste, but in his own day it was very well received. Huntington had numerous commissions from members of New York society. He was elected president of the National Academy from 1862 to 1870 and from 1877 to 1890, and also served as president of the Century Club from 1879–1895.

2. The first two quotations are from William Wordsworth's *Moods of My Own Mind*; the third is from *Ode: Intimations of Immortality from Recollections of Early Childhood*. Actually Wordsworth died in 1850, three years before the publication of Noble's volume.

NOTES

Chapter 11

1. William C. Bryant, *A Funeral Oration Occasioned by the Death of Thomas Cole, delivered before the National Academy of Design, New York, May 4, 1848* (New York, 1848). All subsequent quotations of Bryant by Noble are from this oration.

2. Robert Gilmor, Jr. (1774–1848), a wealthy Baltimore merchant, owned one of the best collections of paintings in America. He became instrumental in the development of Cole's career by providing Cole with the funds to visit Europe and urging him to observe nature closely, record it directly, and avoid the urge to transform or edit it. Gilmor's artistic opinions were highly respected; Dunlap quotes him at length in his *History of the Rise and Progress of the Arts of Design in the United States.*

3. Samuel F. B. Morse (1791–1872), inventor of the telegraph, regarded himself primarily as an artist. He studied in England under Washington Allston; in London he was associated also with West's studio. He was an organizer and first president of the National Academy of Design. Morse was interested principally in historical painting, but he did portraits as well; his portrait of Lafayette and his painting of the House of Representatives were among his best works.

Henry Inman (1801–1846), like Cole, was born in England. Moving to the United States as a boy, he served a seven-year apprenticeship to the portrait painter John Wesley Jarvis. Recognized as one of America's leading portraitists, Inman served as vice-president of the National Academy of Design, and enjoyed a temporary financial success which he chose not to endanger by devoting much time to studying nature and composing landscapes.

Charles C. Ingham (1796–1863) was born in Dublin where he learned the art of portrait painting, which he practiced almost exclusively in the United States.

4. Alvan Fisher (1792–1863) is an unfortunately neglected master of the Hudson River School. He traveled widely, sketching directly from nature, and, like Cole, kept sketch books which served as travelogues for his peregrinations. Fisher had a true devotion to American scenery, but his work suffers from the imposition of a rigid formula that depended on a sunny mist, behind which water and mountains were depicted in a Claudian pastoral fashion.

Thomas Doughty (1793–1856) was one of the earliest members of the Hudson River School. An avid hunter and fisherman, he enjoyed painting landscapes directly from nature, and was one of the first in America to address himself exclusively to this occupation. Doughty illustrated Cooper's *Pioneers* and began to enjoy considerable success in the early twenties, gaining election to the Pennsylvania Academy in 1824. Cole, living at the time in Philadelphia, remarked that he felt humble before Doughty's work. Doughty, like Fisher, employed a sunny haze in most of his canvases which served to unify the elements of the pastoral Claudian formula: trees and water in the middle distance receding gradually to mountains in the far distance. Doughty's later paintings were not popular, but his work was highly respected during his lifetime.

5. Henry C. Pratt.

NOTES

Chapter 12

1. Wordsworth, *Ode: Intimations of Immortality from Recollections of Early Childhood.*
2. Almost every artist worth his salt in America had tried his hand at the falls; Cole completed several sketches and paintings of them.

Chapter 13

1. Samuel Taylor Coleridge, *The Wanderings of Cain*, introduction.
2. Richard Wilson (1712–1784) was the founder of the British classical school of landscape painting, importing the formulas of Claude Lorrain.
3. Samuel Rogers (1763–1855), English poet, patron of literature, and banker. In 1792 he published anonymously his most famous work, *The Pleasures of Memory*, which was tremendously successful, and quickly went through fifteen editions. In 1802 he visited Paris and thereafter established himself as a connoisseur of art. His elegant London house became a center for both artists and social leaders. He was offered the poet laureateship in 1850 on the death of Wordsworth, but declined.
4. The two Americans were probably Charles Robert Leslie (1794–1859) and Gilbert Stuart Newton (1794–1835). The former was born in England of American parents, and spent most of his adult life in England, becoming a member of the Royal Academy and achieving great popularity with his genre and historical paintings. Newton, the nephew of Gilbert Stuart, was a historical and portrait painter who was born in Nova Scotia but spent most of his life in London.
5. Sir Thomas Lawrence (1769–1830), the painter, was guided in his youth by Sir Joshua Reynolds but failed in his initial attempts at classical art and devoted himself exclusively to portraiture. In 1792 when Reynolds died, Lawrence was appointed to the office of painter in ordinary to the king, and in 1794 he was made an academician. Between 1798 and 1813 Lawrence exhibited ninety portraits at the Royal Academy. He left at his death a matchless collection of Renaissance drawings now in the university galleries at Oxford University.
6. Joseph Mallord William Turner (1775–1851), the great English landscapist.
7. Archibald Alison, *Essays on the Nature and Principles of Taste* (Edinburgh, 1790) p. 337.
8. Thomas S. Cummings (1804–1894), English born, was apprenticed in New York in 1821 to Henry Inman, from whom he learned to make miniatures. In 1825 he helped found the National Academy of Design and was its treasurer for forty years. Though Cummings was a professor, head of a school of design, and an organizer of the New York Sketch Club, he was a devoted portrait painter and was recognized in his day as one of the best miniature painters in the United States.
9. John L. Morton (1792–1871) was a painter active for many years in the National Academy of Design to which he was elected in 1831; he later served

NOTES

as its secretary. His best known painting was a scene from Scott's *Ivanhoe*. Cole presented his painting "Mountain Sunrise" to Morton.

10. George W. Hatch (1805–1867), an engraver of banknotes, who was also a pupil of Asher Durand and engraved a number of portraits and landscapes.

11. Robert W. Weir (1803–1899) was born in New Rochelle and studied painting in John Wesley Jarvis' studio. He went to Italy in 1825, returning two years later to spend his talent on making embellishments for gift books. In 1834 he became Professor of Drawing at West Point. Congress commissioned him to do the canvas "Embarcation of the Pilgrims" for the Capitol rotunda.

Chapter 14

1. Ary Scheffer (1795–1858), born at Dordrecht, studied in Paris with Pierre Guérin. He became well known as a painter of small genre scenes which gained popularity through lithographs, and was appointed drawing master to the children of Louis Philippe. His later work was based mostly on religious and literary subjects; it had a poetry of sentiment and a devotional fervor which probably appealed to Cole.

Chapter 15

1. Poggi Bonzi.

2. Henry Greenough (1807–1883), younger brother of Horatio Greenough, was an architect, author, and amateur painter who joined Cole, John Cranch, John Gore, and S. F. B. Morse in Florence in Professor Bezzuoli's classes at the Royal Academy of Fine Arts. On Washington Allston's death in 1844, Henry Greenough was hired to clean the unfinished "Belshazzar's Feast" and prepare it for exhibition.

3. John Cranch (1807–1891) of Washington, D.C., studied art with King, Harding, and Sully. He began painting portraits in 1829 and went to Italy in 1830, where he remained for four years.

4. William Roscoe (1753–1831), Liverpool historian and philanthropist, wrote a very popular life of Lorenzo de' Medici in 1796.

5. Horatio Greenough (1805–1852) was America's first professional sculptor and established through his own career those steps which subsequently young Americans who wished to become sculptors were to follow. His writings on art were many years ahead of his time and although his own work was neo-classical, he preached a functionalism and an organicism in sculpture and architecture fifty years before Sullivan and Wright. The sculpture Cole refers to, Medora, was named after the pirate's lover in Byron's "The Corsair," who died of a broken heart.

6. Wordsworth, *Lines Composed a Few Miles above Tintern Abbey*.

Chapter 18

1. Identified in the manuscript as Lane.

NOTES

Chapter 19

1. Luman Reed (1787–1836), was the foremost art patron of his generation and Cole's most generous patron. A wealthy merchant, he began to collect the works of the old masters in the conventional fashion, but soon turned to the native school. In 1834 he visited the annual exhibition of the National Academy of Design to reform his collection. In the three years before his death in 1836 he commissioned ten paintings from Cole, including *The Course of Empire;* eleven from Durand, eleven from Flagg; and two from Mount. But most significant was Reed's great personal sympathy and friendship for the artists. He was a prototype of the merchant patron who felt it a pleasure both to offer "encouragement and support to better men than myself" and to share in the patriotic enterprise of delineating the characteristics of American nature. Instead of attempting to influence the artists by telling them what to paint, as Gilmor did, Reed bought what they produced and encouraged them by loans, financing European tours, employing members of their families, and reassuring them when their spirits sank.

2. Identified in the manuscript as Downs.

3. Francis Alexander (1800–1880), portrait painter, was born on a Connecticut farm, and studied in New York at the school of Alexander Robertson, secretary of the Academy of Fine Arts. In 1831 he went to Italy, carrying a letter of introduction from Colonel Trumbull to Gilbert Stuart, where he renewed his acquaintance with Thomas Cole and journeyed with him to Rome. Alexander shared rooms with Cole in Rome for three months, and with him visited Naples, Herculaneum, Pompeii, and Paestum. He returned to Boston in 1833 and spent the next twenty years there. In 1853 he went back to Europe and died in Florence in 1880.

4. Identified in the mauscript as Law.

5. Literally, "the friend of your lover," an awkward and very literary Italian phrase.

Chapter 20

1. Psalms 55:6.

Chapter 21

1. Identified in the manuscript as Rakley.

Chapter 22

1. George W. Flagg (1816–1897), the nephew of Washington Allston, was an excellent portrait painter who, like so many of his compatriots, had traveled to Italy to study painting.

2. Charles King (1789–1867), owned and edited the *New York American* from 1823 to 1845. The son of Rufus King, the prominent Federalist leader, he became president of Columbia College in 1849.

3. Identified in the manuscript as Clover.

NOTES

4. A weekly journal devoted to literature and the fine arts in which many of Cole's paintings were favorably reviewed.

5. A reference to the fourth painting in *The Course of Empire*, "Destruction."

Chapter 24

1. William Patterson Van Rensselaer (1805–1872), a wealthy and socially prominent New Yorker, was a direct descendant of the original patroon, and ran the family estate.

2. Jonathan Sturges (1802–1874), the partner and son-in-law of Luman Reed, was a generous patron to many Hudson River School painters, and formed an imposing collection of American paintings. A member of the Century Club, he was a fervent supporter of the Union during the Civil War and became president of the Union League Club of New York.

3. Identified in the manuscript as Beebe's.

4. James Silk Buckingham, *America, Historical, Statistic and Descriptive* (London, 1841), I, 213.

Chapter 25

1. This painting was "Sylvan Lake, Catskill Mountains, Twilight" painted for the New York merchant and patron of art, Ogden Haggerty. It was exhibited at the 1838 exhibition of the National Academy of Design.

2. Identified in the manuscript as Faile.

3. Peter Gerard Stuyvesant (1778–1846) was a New York lawyer, a descendant of the colonial Dutch governor of that city. He was a founder of the New-York Historical Society, of which he was president from 1836 to 1840.

4. Shakespeare, *The Tempest*.

5. Milton, *Il Penseroso*.

Chapter 27

1. Samuel Ward (1786–1839), banker. A pivotal figure in New York banks' resumption of specie payments in 1838, Ward helped found the Bank of Commerce and the University of the City of New York. He was a patron of the fine arts and had a gallery of paintings in his home at the corner of Broadway and Bond Street which he opened to the public.

2. Benjamin Silliman (1779–1864), professor of chemistry and natural history in Yale College from 1802 to 1853, was perhaps the most prominent and influential scientist in America during the first half of the nineteenth century.

3. Identified in the manuscript as Greigs.

Chapter 28

1. Cornelius Ver Bryck (1813–1844), the brother-in-law of Daniel Hunting-

ton, studied under S. F. B. Morse in 1835 and was elected to the National Academy of Design five years later. Cole, in a very touching tribute to him after his death, declared that Ver Bryck loved nature, and that the sight of mountains moved him deeply. Ver Bryck's paintings, Cole wrote, were few, and he expressed regret that the high quality of his work had gone unnoticed by the public (*Evening Post for the Country*, New York, August 7, 1844).

2. Identified in the manuscript as Ithiel Town. Town (1784–1844) was an architect trained in the school of the Boston architect Asher Benjamin. He designed the Center Church and Trinity Church in New Haven, and later many buildings in New York and Hartford. In 1820 he was granted a patent for a truss bridge, and thereafter became the country's most prominent bridge builder. He had one of the best collections of books on architecture and the fine arts in the country.

3. James Smillie (1807–1885) was born in Scotland and was apprenticed to an engraver. In 1821 the family moved to Quebec, and Smillie worked with his father, a jeweler, and his brother, an engraver. He settled in New York in 1829. His main source of income was derived from banknote engraving, although his fine steel engravings of landscapes and figurepieces by famous artists won him election to the National Academy in 1851.

Chapter 29

1. George Washington Greene (1811–1883) of Rhode Island. Grandson of the Revolutionary General Nathaniel Greene, he moved to Europe at the age of 16, and remained there twelve years. His friendship in this period with Henry Wadsworth Longfellow considerably influenced his career. His first historical essays appeared in 1835 in the *North American Review*. From 1837 to 1845 he lived in Rome, serving as American consul, and wrote his *Life of Nathaniel Greene*. His major project for the ensuing years was a three-volume work vindicating his grandfather. In 1871, he became lecturer in American history in the new Cornell University.

Chapter 30

1. Mrs. Anna Brownell Jameson (1794–1860). A well-known author and traveler, Mrs. Jameson visited America from 1836 to 1838, and later wrote many books about European art and artists.

2. Thomas Pritchard Rossiter (1818–1871), one of the lesser lights of the second generation of the Hudson River School, had gone to Europe with Durand, Casilear, and Kensett in 1840, and spent six years studying there.

Chapter 31

1. Bertel Thorwaldsen (1768–1844) was the most prominent of the neo-classical sculptors. In 1796 the work of this Danish student in Rome drew praise

NOTES

from Antonio Canova, the master neoclassical sculptor. Thorwaldsen's success was great and he remained in Italy for twenty-three years, returning to Denmark to make the gigantic series of statues of Christ and the apostles. His most distinguished works were statues of pagan deities which exhibit the classical faculty for proportion and purity of design.

2. Luther Terry (1813–1869) studied art under Philip Hewins of Hartford, and settled permanently in Rome in 1838. His work was exhibited in the American Art Union, the Boston Athenaeum, and the National Academy, of which he was elected an honorary member in 1846.

Chapter 32

1. Samuel J. Ainsley (1820–1874).
2. Probably Arona on Lake Maggiore.

Chapter 33

1. Francis William Edmonds (1806–1863), genre and portrait painter, was a banker by profession. He was an officer of both the National Academy, where he was a frequent exhibitor under the name of E. F. Williams, and the American Art Union.

2. Thomas Crawford (1814–1857), sculptor, studied in New York under Frazee and Launitz and went to Italy in 1835 for further work with the great Thorwaldsen. He was considered on a par with Hiram Powers and Horatio Greenough; several of his works are in the United States Capitol, including the statue of liberty atop the dome.

3. A weekly literary magazine published in New York.

Chapter 34

1. Washington Allston (1779–1843) was the outstanding landscape painter in America during the first two decades of the nineteenth century. He grew up on a South Carolina plantation, but moved to Newport, Rhode Island, where he was encouraged in drawing by Samuel King and Edward Malbone. At Harvard College he painted several works largely influenced by the popular gothic romances of terror. In 1801 he and his friend Malbone visited England, where Allston became extremely friendly with Irving and Coleridge. In 1811 he returned to Europe with his wife and his pupil S. F. B. Morse. He painted several landscapes in the neoclassical style at this time, portraits, including one of Coleridge, and several large religious subjects, of which "The Dead Man Revived" is a notable example. In 1818, under a lasting melancholy from his wife's death, Allston returned to Boston with several canvases, including the huge "Belshazzar's Feast" (16′ × 12′), on which he continued to work during much of the next quarter century. His greatest achievements were his landscapes, but nature in Allston's canvases was quite different from the direct, closely-observed representations by Cole. Allston idealized his vision, forcing it at times through the Virgilian formula of Claude, at times through the romantic inventions of his imagination; but nature without historical asso-

ciations rarely appeared in his work. Increasingly he devoted his attention to the more philosophical aspects of his art. In 1830 he remarried and settled outside Boston in relative seclusion, turning down commissions and devoting himself almost exclusively to the nightmarish frustration of "Belshazzar's Feast." He died in 1843 with the great work uncompleted.

Chapter 35

1. The reference is to "Sicilian Scenery and Antiquities," *Knickerbocker Magazine*, vol. 23, no. 2 (February 1844), pp. 103–113; and no. 3 (March 1844), pp. 236–244.

2. Daniel Wadsworth (1771–1848), a wealthy Hartford merchant and the son of Colonel Jeremiah Wadsworth of Revolutionary fame, was one of Cole's early patrons. He founded the Wadsworth Atheneum gallery in 1844, and donated many of his own paintings. Cole visited Hartford in the 1820's, as a protégé of Wadsworth, who commissioned a painting of his family seat, Monte Video. He owned several other Cole paintings including "A View in the White Mountains," and "John the Baptist in the Wilderness."

3. *Evening Post for the Country*, New York, August 7, 1844.

4. Frederick Edwin Church (1826–1900) went to Catskill in 1844 to study with Thomas Cole. Before Cole died four years later he succeeded in communicating to Church his sensitivity to the dramatic and sublime qualities in nature. Church's travels included two trips to South America, and a journey to Labrador in 1859 with Louis Legrand Noble to paint icebergs. His canvases were immense, and the conceptions he attempted to embody were grandiose. But he never developed the didacticism and symbolism so prominent in his master's final phase, and he lacked Cole's imaginative powers and capacity to transform the minutiae of natural scenery into a single concentrated effect.

5. Gulian Crommelin Verplanck (1786–1870), author and congressman, was a member of a prominent New York Federalist family. He was admitted to the bar in 1807, and in 1817 founded the *New York American*, in which he published distinguished political satires. A member of the New York Assembly, in 1824 he was elected to the United States House of Representatives. Verplanck was largely responsible for passing a law in 1831 protecting the copyrights of authors. He was a member of many literary societies; from 1828 to 1830 he edited, with Robert C. Sands and William Cullen Bryant, *The Talisman*, an annual; and he wrote a serious attempt at Shakespearean scholarship, *Shakespeare's Plays: with His Life*, in 1847.

Chapter 36

1. "The party consisted of Maria and my sister Harriet—Misses Catherine, Maria and Elizabeth Cook, Miss Brookes, the Rev. Messrs. Noble, Kidney and Olmsted, Mr. Cook, Mr. McConkey and myself." Cole MSS, Diary, Thoughts and Occurences, August 14, 1846, New-York Historical Society.

2. Noble himself.

3. John Cheney (1801–1885), an engraver, lithographer, and portrait painter. He trained under Asaph Willard and at Pendleton's engraving establishment in

Boston. He lived in Europe from 1830 to 1834, and worked in Philadelphia on his return.

4. John M. Falconer (1820–1903) came to the United States from Edinburgh in 1848. He did portraits, landscapes, and genre, and was an enameller, etcher, and water-colorist. He exhibited his work at the American Art Union, Boston Athenaeum, Pennsylvania Academy, and National Academy, of which he was an honorary member. He was also the owner of many American paintings, including landscapes by William Hart and J. F. Cropsey, members of the Hudson River School.

PAINTINGS MENTIONED IN THE TEXT

PAINTINGS MENTIONED IN THE TEXT

INDEX

INDEX

INDEX

INDEX

INDEX